William Morris

For
Katherine and Nicola

William Morris

Design and enterprise in Victorian Britain

CHARLES HARVEY
and JON PRESS

Manchester University Press
MANCHESTER and NEW YORK

distributed exclusively in the USA and Canada
by ST. MARTIN'S PRESS

Copyright © Charles Harvey and Jon Press 1991

Published by Manchester University Press
Oxford Road, Manchester M13 9PL, England
and Room 400, 175 Fifth Avenue, New York, NY 10010, USA

Distributed exclusively in the USA and Canada
by St. Martin's Press, Inc., 175 Fifth Avenue, New York, NY 10010, USA

British Library cataloguing in publication data
Harvey, Charles
 William Morris : design and enterprise in Victorian Britain.
 1. English visual arts. Morris, William, 1834–1896
 I. Title II. Press, Jon
 709.2

Library of Congress cataloging in publication data applied for

ISBN 0 7190 2418 8 *hardback*
 0 7190 2419 6 *paperback*

Designed by Max Nettleton

Photoset in Linotron Clearface
by Northern Phototypesetting Co Ltd, Bolton

Printed in Great Britain
by Bell & Bain Limited, Glasgow

Contents

List of plates, figures and tables

Figures

Tables

Acknowledgements

This book is not a conventional biography, nor a company history. It is a study of one important, but largely neglected, aspect of the life and work of William Morris: his career in business: as a partner in the firm of Morris, Marshall, Faulkner & Co. (1861–75); as the sole proprietor and later senior partner in Morris & Co. (1875–96); and as owner–manager of the Kelmscott Press (1890–96). However, when analysing the work, decisions and actions of a man as complex and multi-faceted as Morris, it is at once impossible and undesirable to examine one part of his rich experience in isolation from all others. Thus, whilst concentrating on the business world of William Morris, with the aim of adding to the sum of knowledge about him, biographical, artistic, literary, intellectual, and more general contextual issues and information form part of the weave of our narrative. In this, we follow E. P. Thompson, whose masterly study of Morris's intellectual development might equally be described as biography with a definite focus.

Any new book on Morris, whether sharply focused or more general, must inevitably draw in some measure on the work of earlier, pioneering scholars. J. W. Mackail's two-volume *Life of William Morris* (1899), despite its acknowledged flaws and omissions, remains a fundamental source, and in many respects the work has never been bettered. Aymer Vallance's *Life and Work of William Morris* (1897) also supplies valuable information. A number of other general studies add significantly to Mackail and Vallance; especially noteworthy are Philip Henderson's *William Morris: His Life, Work and Friends* (1967), Paul Thompson's *The Work of William Morris* (1967), Jack Lindsay's *William Morris: His Life and Work* (1975), and Peter Faulkner's *Against the Age: An Introduction to William Morris* (1980). E. P. Thompson's *William Morris: Romantic to Revolutionary* (1955 and 1977) is a work of exceptional originality which makes an important contribution to many aspects of Morris studies while providing a compelling account of his intellectual growth and political activities. Of the more specialised studies, a few are outstanding: Ray Watkinson's *William Morris as Designer* (1967); Charles Sewter's *Stained Glass of William Morris and His Circle* (New Haven, CT, 2 vols., 1974/75); Linda Parry's *William Morris Textiles* (1983); William Peterson's *Bibliography of the Kelmscott Press* (Oxford, 1984); Peter Stansky's *Redesigning the World: William Morris, the 1880s and the Arts and Crafts* (Princeton, NJ, 1985); Amanda Hodgson's *Romances of William Morris* (1986); and Jan Marsh's *Jane and May Morris: A Biographical Story* (1986). We have drawn heavily on each of the above-mentioned works; and, although we do not accept everything that is in them, we would like to acknowledge our debt to their authors. In the same spirit, we would like to mention the invaluable service performed by Norman Kelvin as editor of *The Collected Letters of William Morris*; we have drawn extensively upon the first two volumes (Princeton, NJ, 1984 and 1987) of this splendid collection.

One of the great pleasures in writing this book has been the generous support and encouragement of friends and colleagues. Much useful information was provided by Hans Brill, Justin Brooke, Peter Cormack, Mike Dickinson, Norah

Acknowledgements

Gillow, Warwick Gould, Charles Munn, Philip Ollerenshaw, Linda Parry, Richard Reed, Michael Thomas, and Christine Woods. The staff of the following libraries and record offices gave freely of their time and specialist knowledge: Bath College of Higher Education Library, the Birmingham Central Reference Library, Bristol University Library, the British Museum, Companies House, Cardiff, Devon Record Office, the Fitzwilliam Museum, Hammersmith Public Library, National Westminster Bank Archive, the Public Record Office, Royal Holloway and Bedford New College Library, the Sanderson & Sons Ltd Archive, Society of Friends Library, the Victoria and Albert Museum, and the William Morris Gallery.

We should also like to record our gratitude to the Twenty-Seven Foundation, which kindly supported our research through the provision of funds for travel and other expenses, and to the Trustees of the Isobel Thornley Bequest, who made available a generous subvention towards the cost of colour illustrations. Research seminars at Royal Holloway and Bedford New College, the University of Bristol, and the Centre for Metropolitan History, University of London, considered aspects of the work and assisted in clarifying our thoughts on various matters. The whole or parts of our draft manuscript received the critical attention of Professor J. Mordaunt Crook, Peter Faulkner, Terence Rodgers, Ray Watkinson, and Jim Will. The book is much improved as a result of their comments and suggestions. We alone, however, are responsible for any errors, omissions or deficiencies of interpretation that remain. Finally, we would like to thank the staff of Manchester University Press, and most especially Ray Offord and Jane Carpenter, for their consideration and warm support throughout.

C. H.
J. P.

Note Place of publication in references is London, unless stated otherwise.

Illustrations Black and white illustrations in this book are reproduced by kind permission of the following: The British Library, 23; The National Portrait Gallery, London, 9a–d; The Royal Commission on the Historical Monuments of England, 22; The William Morris Gallery, Walthamstow, cover, 2–8, 10–21, 24, 25.

The colour plates are reproduced by kind permission of The William Morris Gallery, Walthamstow, with the following exceptions: those facing pages 86 and 87, copyright Peter Cormack; and those facing pages 118 and 167, reproduced with the kind permission of The Board of Trustees of the Victoria and Albert Museum, and of the Norfolk Museums Service (Norwich Castle Museum), respectively.

Introduction

William Morris: writer, designer and social critic

The writing of a new book about William Morris may be thought to require an explanation, if not an apology; for if the sheer number of books written about a man was on its own a measure of greatness, then we would unreservedly place Morris among the great. Few men have been so powerful a lure to the interests of successive generations of scholars. There are not only general biographies, which have flowed in a steady stream since the appearance of J. W. Mackail's excellent *Life* in 1899; there are also many works that deal with specific aspects of his career – Morris the political writer and activist, Morris the artist and designer, and Morris the man of letters. He was, after all, a man of unusually wide-ranging interests and achievements, whose performance in various fields was of a high enough quality to command the attentions of specialists in each.

Morris's literary fame rested, in his own time, mainly on his poetry, and towards the end of his life he was seriously considered as Tennyson's successor as Poet Laureate. But today, as a writer, Morris is more known about than read; the longer poems are now little studied, though some of the shorter ones are still anthologised. Peter Faulkner, for one, has argued that *The Defence of Guenevere*, an early work, 'remains for the modern reader . . . one of the most original and striking single volumes of the age'.[1] Few modern critics, though, would go as far as to echo Oscar Wilde's fulsome tribute: 'to Morris we owe poetry whose perfect precision and closeness of word and vision has not been excelled in the literature of our country'.[2] The prose romances have fared less well. The quasi-archaic syntax, and at times truly archaic vocabulary, was not widely popular with contemporaries, and for most modern tastes this style is too self-conscious, and too lacking in authenticity. Even at present, though, they do not lack defenders.[3]

As craftsman and designer, Morris's skills and achievements have been highly praised. Wilde called him 'the greatest handicraftsman we have had in England since the fourteenth century'.[4] Wilde, perhaps, is not the most reliable guide to the arts, yet Paul Thompson does not even allow his historical qualification: 'recent criticism of William Morris, while reinterpreting his historical significance, has categorically reasserted his

1

highlights some of the factors which make for the success and continuity of a small business, not least specialist and personal knowledge. Yet this is not the most important reason for studying the career of William Morris. There was and remains a wider significance to his activities. For too long economists and economic historians have been content to analyse the business system predominantly in terms of units of input and output, whilst largely ignoring the nature of demand and the manner in which human wants are stimulated. Our wider purpose is to draw attention to the important but neglected issues of how tastes are changed, styles set and markets formed. For the Morris business did more than set a passing fashion. It helped to create a new business concept: that of the specialist interior design firm able to offer a complete range of products to its clients. Capitalism is ever-hungry for ideas, and these can be drawn from many sources. William Morris, irrespective of his hostility to the capitalist system, was one such source. His contribution to the world of business was substantial and enduring: he created a company which traded for almost eighty years, and a range of products which have proved persistently popular down to the present day, providing a model and an inspiration for industrialists as well as craftsmen–designers.

1 P. Faulkner, *Against the Age: An Introduction to William Morris* (1980), p. 26.
2 O. Wilde, 'The English Renaissance of Art' (lecture, New York, 1882), reprinted in R. Ross, *The First Collected Edition of the Works of Oscar Wilde: Miscellanies* (1908), p. 251.
3 For an interesting discussion of Morris's language, see N. Talbot, ' "Whilom, as tells the Tale": The Language of the Prose Romances', *Journal of the William Morris Society*, Vol. VIII (1989), pp. 16–26. For a very positive view of the romances, see A. Hodgson, *The Romances of William Morris* (Cambridge, 1986). Since the 1960s, they have also acquired something of a following in America, where they have all been reprinted.
4 Wilde, 'The English Renaissance of Art', p. 252.
5 P. Thompson, *The Work of William Morris* (1967), p. 112.
6 R. Watkinson, *Pre-Raphaelite Art and Design* (1970), p. 196.
7 P. Floud, *Victoria & Albert Museum Exhibition of Victorian and Edwardian Decorative Arts* (catalogue, 1952), p. 38.
8 P. Stansky, *William Morris* (Oxford, 1983), p. 1.
9 E. P. Thompson, 'The Communism of William Morris', in S. Nairne (ed.), *William Morris Today* (1984), p. 129.
10 S. Coleman, 'The Economics of Utopia: Morris and Bellamy Contrasted', *Journal of the William Morris Society*, Vol. VIII (1989), pp. 2–6.
11 E. P. Thompson, 'The Communism of William Morris', p. 135.
12 Ibid.
13 M. J. Wiener, *English Culture and the Decline of the Industrial Spirit* (Cambridge, 1981).

Chapter 1

The quest for a life of purpose: Morris before the firm, 1834–61

From his earliest youth, William Morris was accustomed to the privileges of the wealthy. His father, William Morris Snr, was a successful member of the business community who conducted his activities at the very heart of the capitalist system. William Morris Snr had been born in Worcester in June 1797, the second of four brothers, and had moved to London with his parents around 1820. What little we know of him is suggestive of an ambitious man, anxious to secure the financial fortunes of his family and make a mark in the world. Attracted by the prospect of good financial rewards, he made his way to the City where he joined the firm of Harris, Sanderson & Harris (known as Sandersons), discount brokers.[1]

Discount brokers dealt in bills of exchange, which were orders to pay a specified sum at a given date; a payee could obtain cash at once by selling on the bill at a discount before the due date. The buyer in turn could either wait to collect the full value when it became due, or sell again – again at a discount – to someone else. It was a risky business; but firms which survived the periodic crises that shook the commercial and financial world tended to emerge strengthened.[2] Sandersons had been established in 1812, specialising in 'discounting the bills drawn by the Cheapside wholesale houses upon their customers in the provinces'.[3] By 1825 it was one of the four leading discount houses in the City of London.[4]

For a young man newly arrived in London and setting out to make his way in the world, a position with this prestigious firm must have seemed to assure a bright future. His good fortune may have been due to some extent to his own abilities – subsequent events indicate that he was both able and hard-working – but, as so often the case, it was a family connection that laid the basis of a successful career. The Morrises were distantly related by marriage to two of the three partners, the Harris brothers, who were willing to offer him employment and training. Religious affiliations also played a part in bringing him to their attention. Robert Harris and Joseph Morris (most likely an uncle of William Morris Snr) were both members of the Society of Friends in Reading, and in 1794 Joseph Morris's son Richard married Robert Harris's sister Anna. The Quaker community was strongly represented in banking and bill-broking circles. Lloyds Bank, for instance,

which helped finance Sandersons in its early years, was in the hands of leading members of the Society of Friends.[5]

William Morris Snr must have impressed the Harris brothers as a man of sound judgement and dependable character, for he was groomed to take over the business from an early stage in his career. The problem of succession in business partnerships often caused difficulties for City firms.[6] If the right man or men could not be found, dissolution would result, whereupon the retiring partners or the heirs of dead partners frequently lost capital. It was preferable for new partners to be introduced, who might build up their capital while retired (sleeping) partners gradually withdrew funds from the enterprise. This was the procedure favoured by the Harrises. Joseph Owen Harris retired in 1824, and his brother Robert joined him two years later. They were replaced in January 1826 by William Morris Snr, then only twenty-eight years of age, and Richard Gard, another young employee of the firm. The partnership continued trading as Sanderson & Co.[7]

Soon after becoming a partner, Morris married Emma Shelton, one-time neighbour and the daughter of a prosperous Worcester merchant. For several years they lived in Lombard Street, in rooms above the office, where their two eldest children, Emma and Henrietta, were born.[8] In 1834 the family moved to Elm House, a plain but spacious building at Clay Hill, Walthamstow, and it was here that William Morris was born on 24 March 1834, to be followed by four brothers and another two sisters. At the time, Walthamstow, a suburban village on London's north-east periphery, was a pleasant spot, close to Epping Forest, and had not yet become 'cocknified and choked up by the jerry builder'.[9]

In his infancy, William Morris was of delicate constitution. According to his mother, he had to be kept alive by calves-foot jelly and beef tea.[10] Outdoor activities helped overcome his early infirmities; he spent much of his boyhood in the open air, as often as not playing imaginative games on his own, and he became stocky and unusually strong. He also developed a love of nature, an enduring passion, which in later life came to dominate his approach to pattern design and the decorative arts in general. The outdoor life must have become particularly enticing when, in 1840, the family moved to Woodford Hall. The new home – a large Georgian mansion in the Palladian style, standing on the edge of Epping Forest – had its own fifty-acre park, and was surrounded by farmland. Morris spent much time looking after his own patch of garden and exploring the park and home farm; and he enjoyed roaming in Epping Forest, especially amongst the dense thickets of pollarded hornbeams which gave it its unique character. 'I was born and bred in its neighbourhood,' he said,

> and when I was a boy and young man knew it yard by yard from Wanstead to the Theydons, and from Hale End to the Fairlop Oak. In those days it had no worse foes than the gravel stealer and the rolling fence maker, and was always

interesting and often very beautiful . . . Nothing could be more interesting and romantic than the effect of the long poles of the hornbeams rising from the trunks and seen against the mass of the wood behind. It has a peculiar charm of its own not to be found in any other forest.[11]

The surrounding countryside too created a strong impression; the Essex bank of the Thames had not yet been swamped by the expansion of London, and was lovingly described by Morris towards the end of his life in his utopian novel, *News From Nowhere*:

> Eastward and landward, it is all flat pasture, once marsh, except for a few gardens, and there are very few permanent dwellings there, scarcely anything but a few sheds and cots for the men who come to look after the great herds of cattle. What with the beasts and the men, and the scattered red-tiled roofs and the big hayricks, it does not make a bad holiday to get a quiet pony and ride about there on a sunny afternoon of autumn, and look over the river and the craft passing up and down, and on to Shooter's Hill and the Kentish uplands, and then turn round to the wide green sea of the Essex marshland, with the great domed line of the sky, and the sun shining down in one flood of peaceful light over the long distance.[12]

Another childhood love which was to stay with him all his life was the medieval world. Woodford Hall retained some vestiges of a medieval manor-house, for the people there baked their own bread and brewed their own beer, and also celebrated some of the old festivals, like Twelfth Night and the Masque of St George.[13] Probably more important, though, in shaping Morris's mind and patterning his emotions, was his discovery of some of the great Romantic novels. Reading came easily to him; he later said that 'ever since I could remember I was a great devourer of books. I don't remember being taught to read, and by the time I was seven years old I had read a very great many books good, bad and indifferent.'[14] His reading eventually included all the Waverley novels. Scott became a lifelong favourite, especially *The Antiquary*, which he read and re-read many times. In 1886, he told W. T. Stead, the Editor of the *Pall Mall Gazette*, 'I should like to say here that I yield to no-one, not even Ruskin, in my love and admiration for Scott.'[15] Scott had made a name for himself in the early years of the century, publishing verse romances which were generally well received. But when, in 1814, *Waverley*, a prose romance about the 1745 Rebellion, appeared, he immediately became a best-selling novelist.

Scott's approach to historical fiction was quite new; no writer before him had so conscientiously attempted to re-create the past in its own terms. Quite simply, *Waverley* was the first of a genre – the historical novel. Scott's genius lay in his ability to give his readers a seemingly authentic, almost tactile sense of the past. He was probably the greatest populariser of Romanticism and the Gothic. Many of his scenic descriptions conformed to the canons of the picturesque, as laid down by writers

7

like William Gilpin, and the enchanting lure of medieval architecture and values was a recurrent theme. This guaranteed success: there was at the time already a feeling that science and technology were putting an end to an historical continuum which stretched back to the ancient Mediterranean civilisations, and many of his readers were inclined to draw an unfavourable contrast between traditional and contemporary society.[16]

A remarkable fact of Morris's childhood, and one of no small significance in the formation of his personality, was the freedom he was given to explore his surroundings and his emotional responses to them. From an early age he was intimately acquainted with the medieval churches and country houses of the Essex countryside. Queen Elizabeth I's shooting-lodge at Chingford Hatch in Epping Forest made a profound impression, with its 'room hung with faded greenery', as did the church of Minster in Thanet – so much so that he was able to describe it in loving detail fifty years later. On one memorable occasion, when he was eight, his father took him to gaze upon the Gothic splendours of Canterbury Cathedral. It was, he said later, as if the gates of Heaven had been opened to him.[17]

Membership of a large family seems to have done little to discourage Morris from introversion. Throughout his life, he was emotionally self-contained, drawing but infrequently on others for support at times of difficulty. As a child he was somewhat solitary, awkward and sensitive, close only to his eldest sister Emma, to whom he later wrote frequently and sent copies of his early poems. Nor does he appear to have had a particularly close relationship with his parents. Although he continued a dutiful correspondence with his mother until her death in 1894 at the age of eighty-nine, he did not refer to his father or mother often in later life. This must be partly due to the fact that, like most well-to-do middle-class parents, they sent their son away to be educated; 'my parents . . . shook off the responsibility of my education as soon as they could; handing me over first to nurses, then to grooms and gardeners, and then sending me to school – a boy farm, I should say. In one way and another I learned chiefly one thing from all these – rebellion, to wit.' Nor did his parents' religious beliefs appeal to him: 'since we belonged to the evangelical section of the English Church I was brought up in what I should call rich establishmentarian puritanism; a religion which even as a boy I never took to'. On another occasion he noted that 'I used to dread Sunday when I was a little chap.' The children were not allowed to mix with most Nonconformists; only Quakers, of whom there were many living around Walthamstow, were considered suitably respectable.[18]

William Morris's youthful fascination with the medieval world made him critical of contemporary urban society. Visits to London never held much attraction for him. On the day of the Duke of Wellington's funeral, when his friends joined the large crowds attending the ceremonies, he preferred to remain behind, and went for a solitary ride to Waltham Abbey.

In 1851, when his mother took him to see the Great Exhibition, he remarked that it was all 'wonderfully ugly'.[19] But Morris, even in his boyhood years, was not a naïve 'Merrie Englander'. At an early age he was able to differentiate between the noble and the vulgar or pretentious, and this ability might be considered the most important of all factors governing his approach to the world.

The development of Morris's critical faculties proceeded rather more rapidly than his formal education. Certainly he was a quick enough learner when his interest and enthusiasm had been engaged, but tedious matters like learning to write and spell correctly caused him a good deal of anguish. He never became a good speller, and his handwriting remained poor until he developed an interest in calligraphy. Up to the age of nine he received somewhat desultory tuition from his elder sisters' governess. He was then sent to a preparatory school a couple of miles away in Walthamstow as a day scholar. Later he became a boarder, and remained at the school until the autumn of 1847, when he was thirteen.

By then, his family had become very wealthy indeed, as the move to Woodford Hall in 1840 suggests. Three years later William Morris Snr obtained a grant of arms from the College of Heralds, to set the seal on his standing in society. William Jnr, who was six at the time of the move to Woodford Hall, later told the Austrian socialist Andreas Scheu that his

Plate 2 Water House, Walthamstow, where the Morris family moved in 1848. Now the William Morris Gallery

family had lived 'in the ordinary bourgeois style of comfort'. It may indeed have felt 'ordinary' to the young William Morris, but the standard of living at Woodford Hall was, we might deduce, way above that enjoyed by most members of the Victorian middle class, let alone the majority of the population. Only with a large income from the partnership in Sandersons could the Morrises have afforded to rent a house at £600 a year.[20]

A comfortable home and a substantial income might have satisfied the ambitions of many businessmen. But this was not the case with William Morris Snr. Sandersons had developed an extensive network of business connections, both in the City and the provinces, and he began to speculate in the flourishing share market of the 1840s with a small group of like-minded men. Among them were his brothers Thomas, a coal merchant in Camberwell, and Francis, a member of the Coal Exchange. Closely involved with the Morris brothers were the stockbrokers William Alexander Thomas and his brother John.[21] West of England copper-mining ventures, which increasingly were seeking capital in London, soon came to the attention of the Morris and Thomas brothers. The first half of the nineteenth century was the apogee of copper mining in Devon and Cornwall. Improved technology meant that existing mines were being worked deeper and deeper, and many new ones appeared. Between 1800 and 1850 copper ore raised by West of England miners realised over £13 million, and by mid-century there were over 100 mines in production, of which about seventy had earned more than £100,000.[22]

The group's involvement in mining in 1844 was prompted by an approach from Josiah Hugo Hitchens, a Cornish mining expert. Hitchens had been seeking permission to begin prospecting in Blanchdown Woods, on the Devon bank of the Tamar, part of the estate of Francis, seventh Duke of Bedford. The Duke, who was one of the biggest landowners in south Devon, fearing that his pheasant coverts would be ruined, was very reluctant to agree to mining operations on his land. He insisted on substantial royalties on ores and compensation clauses, and rejected several proposals because the applicants lacked sufficient capital.[23] Hitchens's impressive reputation, however, ensured a more favourable reception, and he was engaged to promote the new venture on the Duke's behalf. He was firmly instructed to secure the backing of London financial interests rather than local adventurers, who were dismissed as mere dabblers only interested in immediate returns.[24]

Later in the century, Hitchens would have found many City stockbrokers with a specialist and keen interest in mining company finance.[25] The choice in 1844 was far more limited, and his enquiries soon led him to the door of P. W. Thomas & Sons. The Thomases were by no means pioneers in the field, but certainly they were early participants. The firm and associates such as the Morris brothers were seasoned risk-takers, and were actively seeking first-class mining opportunities. The Thomases

were very favourably impressed by Hitchens and his plans, and at an early stage William Morris Snr was brought into the negotiations. Morris in turn brought in his brother Thomas and partner Richard Gard. Without delay, the consortium decided to invest heavily in the venture.[26] The lease was finalised with the Duke of Bedford's land agent on 26 July 1844, and work began on 10 August.[27]

In the following year, the Devonshire Great Consolidated Copper Mining Co. (or Devon Great Consols as it was later titled) was formally registered as a joint stock company, with an authorised capital of £10,240 in £10 shares. William Morris Snr held 272 shares, and his brother Thomas thirty-two. The Morris family therefore had a substantial stake in the business from its inception – 304 out of 1,024 shares, or nearly 30 per cent of the total. William Morris Snr's 272 shares was a major commitment; his potential investment was £2,720, a sizeable sum to risk in such a speculative venture, even for a wealthy man. As things turned out, however, he was not obliged to pay the full £10 per share. Profits flowed freely from the start, and were more than sufficient to meet development costs. After an initial call of £1 per share the investors were not troubled by requests for additional funds.[28]

The new concern was astonishingly successful. In the first year of operation, 13,292 tons of ore were sold for £116,068. After all operating costs had been met, £72,704 (£71 per share) was available for distribution to the shareholders. Expenditure soon began to mount, however, and the initially excellent rate of return could not be maintained. A variety of technical problems demanded large injections of capital, and dividends were cut first to £25 a share in 1846/47, then to £15 in 1847/48.[29] But the decision to invest heavily rather than distribute a large part of the profits was undoubtedly correct. In the long run the company's shareholders reaped the benefits of the work carried out in the later 1840s. The end of the decade saw an upturn in Devon Great Consols' fortunes which ushered in a period of regular, substantial dividends (see Figure 1).

The acquisition of a large stake in Devon Great Consols proved both fortunate and timely for the Morris family. The year 1847 was marked by unforeseen tragedy. On 8 September, William Morris Snr died suddenly at the age of fifty. Seven days later Sanderson & Co. suspended business with liabilities amounting to £2,606,569. Shock waves reverberated throughout the City.[30] Morris's death was not the sole cause of the Sandersons crisis, although it may well have 'accelerated the suspension of the House'.[31] Indeed, it is quite likely that his fatal illness was brought on by worries over the general commercial crisis which hit Britain in 1847–48. By 1847 Morris Snr was the only partner with any knowledge of the day-to-day affairs of the firm; Richard Sanderson had not involved himself in them for some time, and Gard had retired. Creditors were informed that:

11

It is with extreme pain that we have to announce to you that our house is under the necessity of suspending its business, an event which was wholly unforeseen and unexpected by us. The retirement, some time ago, of our late partner, Mr Gard and recently the sudden and lamented death of Mr Sanderson's remaining partner, Mr Morris, threw upon Mr Sanderson alone the responsibility of the concern, the details of which had been chiefly under the management of his late partners; and this, with the pressure of the times, has left him no alternative but to proceed to wind up the affairs of the house.[32]

As things turned out, the financial situation of the firm was healthier than had been feared. Most of the debt was covered by securities lodged with creditors, and the balance could be met by assets held by the partnership. All creditors received the full 20 shillings in the pound, and the firm eventually resumed trading as Sanderson, Sandeman & Co., with a new partner, T. Fraser Sandeman, who had stockbroking and banking interests.[33]

The collapse and reconstruction of Sandersons came as a severe financial blow to the Morris family. Emma Morris lost not only her husband's regular income, but also his share of the partnership capital, which in the normal course of events might have been withdrawn and reinvested in gilt-edged securities. Moreover, it seems likely that she had to liquidate some personal assets in order to help pay off Sandersons' creditors, although precisely how much was involved is impossible to say. Morris Snr died intestate, and there is no detailed information about his estate. When his wife applied for Letters of Administration, which were duly granted in October 1847, it was valued at some £60,000.[34] The 272 shares in Devon Great Consols accounted for much of this, even though

Figure 1 Dividend income of the Morris family from Devon Great Consols, 1845–75

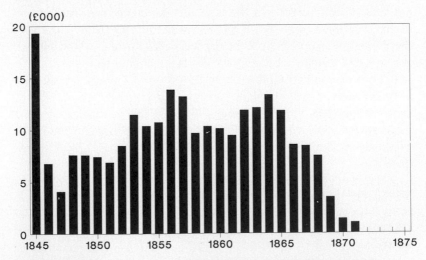

Source: PRO, BT31 142/445, 8645/63035, 1613/63035; Companies Registration Office, Cardiff, 211T.

reduced dividends in 1846/47 had caused their market value fall to a low point of £150.[35] Assuming that William Morris's holding was assessed at this price, its market value would have been £40,800, or roughly two-thirds of his estate.

The Morrises had to give up Woodford Hall. In the autumn of 1848 the family moved to a smaller, more manageable home, Water House in Walthamstow (now the William Morris Gallery). The yellow-brick exterior was, and is, unremarkable; but inside were a spacious hall and staircase, and the principal rooms were generously proportioned. The grounds (now a public park) were also attractive, including a wide moat and broad lawns.

The family was now heavily dependent upon the fortunes of Devon Great Consols, and, when the share price began to recover, Emma sold some shares in order to invest in less profitable but safer securities. Twenty-two shares were sold in 1850 and fifty in the following year, realising just over £20,000. In the 1850s, the annual income from the remaining shares in Devon Great Consols was more than sufficient to maintain the Morris family in considerable comfort, but the sale was justified when in later years dividends declined and eventually ceased altogether.

Evidently, Emma Morris coped well with the responsibilities placed upon her by her husband's death, but the troubles of 1847 must have had a traumatic effect on the Morris household. For William Morris Jnr, they brought early acquaintance with business failure, explaining in part why in later years he was so anxious to maintain his personal income and the financial security of his family. And the experience of his mother after his father died intestate was no doubt in his mind when, much later, he had his own will drafted with great care to provide for his own wife and daughters.[36]

Shortly before his death, Morris Snr had purchased a nomination to Marlborough College for his eldest son. Morris entered Marlborough in February 1848, just before his fourteenth birthday, and remained there until Christmas 1851. Fortunately for him, the school had not yet acquired the typical characteristics of the late Victorian public school. It had been founded in 1843, with 200 boys, but it proved popular with upper middle-class parents, and numbers soon rose to over 500. This rapid growth caused severe problems. Morris himself later described it as 'new and very rough'.[37] The housemasters lacked experience, and the school was badly organised and inadequately funded. As a result, the boys were allowed a good deal of individual freedom; there were no organised games, no prefect system, and all the boys below the fifth form were gathered together in a single large schoolroom. Morris later told the poet Wilfrid Scawen Blunt that he 'was neither high nor low in his form, but always last in arithmetic; hated Cicero and Latin generally', but was attracted to 'anything in the way of history'.[38]

One hesitates to commend such a regime from the point of view of

13

educational theory; but it suited Morris very well, for he was able to spend much of his time exploring the nearby Savernake Forest, walking over the Downs, and visiting prehistoric sites like Avebury and Silbury Hill. He later wrote that

> as far as my school instruction went, I think I may fairly say I learned next to nothing there, for indeed next to nothing was taught; but the place is in very beautiful country, thickly scattered over with prehistoric monuments, and I set myself eagerly to studying these and everything else that had any history in it, and so perhaps learned a good deal, especially as there was a good library at the school.[39]

The library was particularly well endowed with works on archaeology and ecclesiastical architecture. He read swiftly; as Mackail noted, 'his power of assimilation was prodigious; and he left Marlborough ... a good archaeologist, and knowing most of what there was to know about English Gothic'.[40]

He was also renowned for the inventiveness of his storytelling, and kept his classmates amused with endless romantic stories of ancient chivalry. Most of the boys, however, thought him a little mad, remembering him best for his outbursts of rage. One of his schoolfellows described him as already 'a thick-set, strong-looking boy, with a high colour and black unruly hair, good-natured and kind, but with a fearful temper'.[41]

At Marlborough, Morris came under the influence of the High Church movement; for the school, though not founded by any theological group, acquired a distinctly Anglo-Catholic character. The Oxford Movement had begun in the 1830s when John Henry Newman, John Keble and Edward Pusey attacked the lack of spirituality and idealism in the Church of England. Their *Tracts for the Times*, a series of pamphlets inaugurated in 1833, stimulated discussion of issues like the relationship between Church and State, and generated a new, serious interest in the priesthood and sacraments, the liturgy and church ritual. Opposed to the Evangelical insistence on conversion through prayer and preaching, the Tractarians, as they became known, emphasised the doctrines of apostolic succession and sacramental grace. Although its reputation was severely dented by controversy over Tract 90's account of the Thirty-nine Articles in 1841 and Newman's defection to Roman Catholicism four years later, Tractarianism was widely influential, especially with the younger generation. Morris found Tractarianism, with its emphasis on the early history and traditions of the Church, much more congenial than the 'rich establishmentarian puritanism' of his parents. By the time he left school, he had become an enthusiastic Anglo-Catholic, and had actually decided to take holy orders.[42]

Of the reasons for this decision we know little. Mackail notes that his favourite sister, Emma, was powerfully influenced by the High Church

revival, and that in 1850 she married Joseph Oldham, a young cleric of pronounced Anglo-Catholic views, who had been curate at Walthamstow from 1845 to 1848. He tells us that Morris felt the separation keenly when she went to live in Derbyshire with her husband, for they had shared their thoughts and enthusiasms, and it must have been largely due to her that Morris decided to enter the Church.[43] More generally, it seems likely that the young Morris had himself meditated on questions of good and evil and the potent forces inspiring the building of the great medieval churches he so admired. The idea of a life dedicated to God must have helped satisfy his yearning for a life of noble purpose.

With this career in mind, it was more or less inevitable that Morris should be entered for Oxford; and for Marlborough boys, this generally meant Exeter College. But Morris was not yet ready for university. He was not strong in conventional learning – his dislike of Latin has already been noted – and the chaos of Marlborough was an inadequate preparation. After the boys had rioted in the autumn of 1851, Morris's mother removed him from the school. He was sent to a private tutor to prepare for matriculation. The tutor was the Revd F. B. Guy, later Canon of St Albans and at that time master at the Forest School in Walthamstow. He took in a few private boarders, and Morris remained with him for nearly a year. Guy was no narrow-minded ecclesiastic, but a 'High Churchman of the best type'.[44] He was an excellent choice of tutor for the imperfectly educated William Morris. Guy had the professionalism to ensure that his pupils gained the required grounding in the Classics, but, as a gifted teacher, with interests ranging from theology to art and architecture, he could also inspire the boys under his charge. He was a member of the Oxford Society for the Study of Gothic Architecture, and from him Morris absorbed many of the prejudices, attitudes and insights then common among Gothic revivalists.

The growth of interest in architecture, in particular the revival of the Gothic, is worth dwelling on as one of the most remarkable phenomena of the first half of the nineteenth century. For most of the eighteenth century, Classical styles had predominated, and interest in Gothic was confined to rich collectors and antiquarians. With the advent of Romanticism, and its delight in asymmetrical silhouettes and picturesque ruins, there began a gradual turning-away from Classicism. The popularity of the poetry and novels of Sir Walter Scott played a large part in this process, as too did Abbotsford, the Gothic mansion which he had constructed between 1816 and 1823. As Charles Eastlake later remarked, 'it would be difficult to overrate the influence which Scott's poetry has had on both sides of the Tweed, in encouraging a national taste for medieval architecture'.[45]

In the late eighteenth and early nineteenth century, though, Gothic was primarily considered suitable for secular use, reflecting a concern with

15

aesthetics rather than archaeology. Often the use of Gothic features was no more than superficial. But later Gothic Revival architects based their work much more closely on the medieval originals, and the revived style acquired a spiritual significance which made it, by the mid-Victorian period, the most appropriate – indeed for many people the only conceivable – style for ecclesiastical buildings.

Serious study of the Gothic began in the early nineteenth century with the work of Thomas Rickman and John Britton. Rickman's thinking was particularly influential; for his nomenclature – Norman, Early English, Decorated and Perpendicular – ended much of the contemporary confusion about styles and chronology, and remains the accepted method of classifying medieval English architecture. Only with the work of Pugin, however, did Gothic begin to acquire moral purpose and spiritual significance. Pugin was actually the architect of relatively few buildings, but his books were widely read and of great importance. He attacked early nineteenth-century architects like Nash, Smirke and Soane – in particular their superficial approach to Gothic and Classical features. Pugin's fundamental tenets of architectural design were that every feature of a building should have a practical function; and that ornament might legitimately enrich any feature, as long as it did not disguise it. In short, buildings should be honest. He also assertively advocated the supremacy of Gothic. Gothic, he felt, was essentially English, unlike Classical or Renaissance styles, which he thought Italian and popish. More important, however, was the religious argument: Classical architecture was essentially pagan, and a Classical church symbolised worldliness. Gothicism, on the other hand, was essentially spiritual, for the soaring vaults and spires of a Gothic church drew the eyes and mind of the Christian upward towards Heaven.

Pugin's arguments were echoed, to varying degrees, by many of his contemporaries and successors. Particularly important was the Cambridge Camden Society, later known as the Ecclesiological Society, whose object was 'promoting the study of ecclesiastical architecture and antiquities, and the restoration of mutilated architectural remains'. It was founded in 1839 by a group of Trinity undergraduates led by John Mason Neale and Benjamin Webb, and, being Anglican, the movement was less suspect to many than the work of Pugin (who became a Roman Catholic in 1834).[46]

Ecclesiology was influenced by Romanticism, but differed from it in some important ways. Certainly Neale and his friends were romantic medievalists; but their purpose was not mere antiquarianism. They felt an insistent demand for a more imposing, spiritual and symbolical form of worship within the Church of England, and 'dreamt of converting England by repeating the architectural triumphs of the Middle Ages and by placing the Prayer Book services in a setting of medieval ceremonial'.[47] No detail of church buildings escaped their scrutiny, and their precise notions of what

was right. Everything had to aim towards a particular religious end, and it followed that only the theologically sound should be allowed to build Anglican churches. Ecclesiologists had no doubts as to the architectural style proper to places of worship. Early English was considered primitive, and therefore suitable for small, rustic churches. Perpendicular Gothic was debased or degenerate. Their ideal church was in the Decorated Gothic of the late thirteenth and early fourteenth centuries,[48] with a nave, aisles and porch, and preferably a tower and spire at the west end. The font should be at the west end of the nave (or better still the south-west), and the pulpit and lectern at its east end. Low benches were preferred to box pews which prevented worshippers from seeing the altar, and which, being reserved for the better-off, might drive the poor into Nonconformism.[49] Chancels had to be raised a step from the nave, and contain stalls for the clergy and choir. The altar, which replaced the pulpit as the most important feature, should be raised again, two steps up from the chancel. Ecclesiologists claimed, perhaps with some justice, that this plan was useful as well as correct and beautiful.[50]

But inevitably, their rigid, at times even absurd insistence upon 'truth' and 'correctness' sometimes led to unfortunate results; able and inventive architects might be pilloried for expressing original ideas, and it often happened that supposedly 'incorrect' medieval work was torn down and replaced by 'correct', but often stiff and mannered Victorian work. Yet the ecclesiologists were largely responsible for what we now regard as the typical place of Anglican worship; and the issues which they pronounced upon were passionately debated by a wide cross-section of mid-nineteenth-century society.

The Ecclesiological Society's Oxford counterpart, the Oxford Society for Promoting the Study of Gothic Architecture, was established in March 1839, and was, according to Eastlake, 'almost identical in object' with the Cambridge society.[51] Members included John Ruskin, several leading architects, and, as noted above, the Revd F. B. Guy. Under Guy's tutelage, William Morris's fascination with medieval architecture was transformed into a deeper and more systematic understanding, and an awareness of the finer points of church ritual and symbolism.

In the summer of 1852 Morris went to Oxford to take the matriculation examination at Exeter College. He intended to go up after the Long Vacation, but the College was full, and he did not go into residence until January 1853. At that time, Oxford still retained many medieval features, unblemished as yet by late nineteenth-century suburban growth. Much fifteenth-century street architecture remained; the colleges had not yet begun the substantial expansion and rebuilding work of the mid-Victorian period; and the University Museum, the most important secular building in Britain since the reconstruction of the Houses of Parliament, was planned but not yet built.

To Morris, it still conjured up 'a vision of grey-roofed houses and a long winding street, and the sound of many bells'.[52] Matthew Arnold, who saw Oxford as a great champion of civilisation against philistinism, heard 'whispering from her towers the last enchantments of the Middle Age'.[53] Classical studies and theology still dominated the world of learning. Many students expected to enter the Church after graduation. Others, however, the young bloods of the ruling classes, continued to indulge in the traditional pursuits of the wealthy undergraduate – hunting, rowing, eating and drinking to excess. The Evangelicals' 'call to seriousness' and the High Church revival had done but little to moderate the prevailing coarseness of morals and manners. Not surprisingly, in such an environment formal lecture programmes were often unsatisfactory: either delving among the more arcane aspects of classical scholarship or theology, or, alternatively, yielding to lethargy in tacit acceptance of the students' lack of ability or interest. For someone who had arrived in Oxford enthusiastically seeking knowledge and intellectual stimulation, the result could be profoundly disappointing. Throughout his adult life, Morris remained bitterly hostile to the educational system and intellectual life of mid-nineteenth-century Oxford.[54]

Yet if formal studies disappointed, Morris's undergraduate years were nonetheless one of the great formative periods of his life. Within a few days of his arrival he had found a kindred spirit in Edward Burne-Jones, the son of a picture-framer and gilder from Birmingham, who had sat next to him at the matriculation examination. Burne-Jones was also profoundly disillusioned by his initial experience of Oxford, feeling out of sympathy with many of his fellow-students. With their meeting, however, began a devoted and inseparable friendship, which was to last for more than forty years until Morris's death in 1896. They went for long walks almost daily. In the evenings they read together. Burne-Jones later recalled the impression Morris made upon him at this time:

> From the first I knew how different he was from all the men I had ever met. He talked with vehemence, and sometimes with violence. I never knew him languid or tired. He was slight in figure in those days; his hair was dark brown and very thick, his nose straight, his eyes hazel-coloured, his mouth exceedingly delicate and beautiful. Before many weeks were past in our first term there were but three or four men in the whole college whom we visited or spoke to.[55]

Like Morris, Burne-Jones was intended for the priesthood, and the two of them enjoyed long hours together reading aloud works of ecclesiastical history and theology. Amongst these were works with a strong Roman Catholic flavour, such as Kenelm Digby's *Mores Catholici* and Robert Wilberforce's treatises. Digby had been converted to Catholicism at Cambridge in the 1820s. Like his close friend Ambrose Phillipps de Lisle (later a patron of Pugin), Digby had been struck by the richness of Catholic art on

18

the Continent, and the strength and dynamism of the medieval Catholic Church. Wilberforce wrote extensively on the Eucharist, Baptism and the Incarnation. He joined the Church of Rome in 1854. For a short time, the appeal of their arguments drew Morris and Burne-Jones, like many of those who responded to the High Church revival, close to conversion to Roman Catholicism.[56]

This, however, was not their only channel of intellectual inquiry. As their friendship grew, they concentrated less and less on theology, and began to consider the possibilities of mythology, history, poetry and art. Burne-Jones had already read ancient Celtic and Scandinavian literature. He introduced Morris to the Icelandic sagas, which were later to become one of his enduring loves. Surprisingly, in view of their fascination with the medieval world, they did not discover Chaucer until the middle of 1855, nor Southey's 1817 edition of Malory's *Morte d'Arthur*. But Morris and Burne-Jones were certainly aware of other works on the Arthurian cycle which derived ultimately from Malory, such as Bulwer Lytton's *King Arthur: An Epic Fable in Twelve Books*, first published in 1848, and Tennyson's Arthurian poetry. One of Burne-Jones's memories of his first term at Oxford was of Morris reading aloud *The Lady of Shalott* 'in the curious half-chanting voice, with immense stress laid on the rhymes, which always remained his method of reading poetry'.[57]

Of course, Arthurian legend in no way depicts the realities of medieval life. The stories worked at a different level; it requires no great powers of discernment to see the idealism that lies behind the wonderful, fantastic colours of the surface. But could idealism of that kind, or indeed any kind, be sustained in a society whose greatest achievements seemed to be the construction of machines and the making of money?

Not the least important of those who asked this question was the Scottish polemicist and essayist Thomas Carlyle. His essay 'Signs of the Times', published in 1829 in the *Edinburgh Review*, formed the basis of his subsequent work. He characterised the nineteenth century as 'the Mechanical Age', in which the machine drove the artisan from the work-bench, and helped to widen the gulf between rich and poor. As Raymond Williams has remarked, he saw 'with a terrible clarity, the spiritual emptiness of the characteristic social relationships of his day, "with Cash Payment as the sole nexus" between man and man'.[58] Even more significant for Morris and Burne-Jones was *Past and Present*, first published in 1843, in which Carlyle continued his vigorous assault upon modern industrial society. In *Past and Present* Carlyle drew upon a medieval text, the *Chronicle of Jocelin of Brakelond*, which had recently been reprinted. From it, he took the story of Abbot Samson and the twelfth-century monastery of St Edmundsbury; a medieval community which, in Carlyle's account, possessed a dignity, order and self-sufficiency entirely lacking in modern society.

19

As E. P. Thompson notes,

> Carlyle's books, with their perverse, ejaculatory, repetitive and arrogant style, find few readers today. Consistency is not among his merits: pretentious mysticism, white-hot moral indignation, pious mumbo-jumbo, lie side by side. But his writings are amongst the greatest quarries of ideas in the first half of the nineteenth century, shot through with occasional gleams of the profoundest revolutionary insight.[59]

Politically, Carlyle was a reactionary, and there was much in his thinking that was purely negative. But, to quote again from Thompson, 'it is in Carlyle's disgust at the reduction by capitalism of all human values to cash values that his greatness lies: it is this which exercised most influence over Morris . . . It is the perpetual refrain of *Past and Present*.'[60]

But it could not be said that Morris ever became a disciple of Carlyle, great though Carlyle's influence upon him was. More lasting inspiration came from a gentler, more aesthetic source: John Ruskin, art critic and social philosopher. Morris had read the first two volumes of *Modern Painters* and the *Seven Lamps of Architecture* (1849) before arriving at Oxford, and in 1851–53 there appeared the seminal *Stones of Venice*. At first, Morris was drawn to Ruskin by the power of his prose; it was particularly impressive when read aloud, as was Morris's habit. Sometimes irritating, dogmatic and verbose, Ruskin was nevertheless remarkably eloquent and evocative; as in his celebrated descriptions of Venice and her mother-city Torcello, or his wonderful evocations of Turner's skies and landscapes.[61]

Other aspects of Ruskin's work – notably his ideas on architecture and his social thinking – were soon to become even more fundamental to Morris's intellectual development. In *The Stones of Venice*, Ruskin was really the first person to provide a description of the social function of architecture in a defined community. He was *not* writing merely about the buildings, and his judgements were *not* purely stylistic and aesthetic. Particularly influential was the chapter in Volume II entitled 'The Nature of Gothic'. This chapter developed the idea that the architecture and art of a particular society reflect the values of its entire culture. According to Ruskin, architecture and its attendant arts should be judged according to the amount of freedom of expression allowed to the individual workman; perfection and precision were suspect since they 'implied direction, and therefore repression'.[62] This led Ruskin into social criticism, and he contrasted medieval Gothic and the relationships it engendered favourably with the industrial society of the nineteenth century, which seemed to him to place more restrictions on the workman than any preceding age had done.

Ruskin's influence upon Morris was profound and durable. For the rest of his life, Morris 'retained towards him the attitude of a scholar to a great

teacher and master, not only in matters of art, but throughout the whole sphere of human life'.[63] 'The Nature of Gothic' was later reprinted by Morris at the Kelmscott Press, and in his preface he commented:

> To my mind, it is one of the most important things written by the author, and in future days will be considered as one of the few necessary and inevitable utterances of the century . . . For the lesson which Ruskin here teaches us is that art is the expression of man's pleasure in labour; that it is possible for a man to rejoice in his work . . .; and lastly, that unless man's work once again becomes a pleasure to him, the token of which change will be that beauty is once again a natural and necessary accompaniment of productive labour, all but the worthless must toil in pain.[64]

Although Morris and Burne-Jones associated with few of their fellows at Exeter College, they did become intimate with a small group of students from Birmingham, most of whom had been Burne-Jones's schoolfellows. William Fulford, Richard Dixon and Charles Faulkner were at Pembroke College, and the group also included Cormell Price, who came up to Brasenose a little later. Fulford, two years senior to the others, had devoted himself to the study of literature, and was generally considered to be on the threshold of a brilliant career, although he never fulfilled his early promise. Dixon, a great admirer of Keats, was himself a poet of some ability. He subsequently took holy orders, eventually becoming a Canon of Carlisle Cathedral, and is best known today for his encouragement of Gerard Manley Hopkins. Cormell Price, a painter and capable teacher, ended his career as a headmaster in Devon. Faulkner, a mathematician, was the least artistic of the group, although skilled with his hands; he was the only one not intended for a career in the Church.[65]

The small circle of friends soon took to meeting every evening in Faulkner's rooms to discuss their latest enthusiasms and discoveries. Together, they excitedly discussed the poetry of Tennyson, Keats and Shelley, and the prose writing of Carlyle, Kingsley, De Quincey, Thackeray, and Dickens, amongst others.[66] It was a wonderful experience for Morris, who had so often hitherto been isolated and solitary. Now he was part of a group which shared his own interests, and with whom he could talk and develop ideas.

Before long, the friends had conceived the idea of a forming a semi-ecclesiastical brotherhood, devoted to art and literature. This was quite a popular notion in the early Victorian period. In 1841, before his conversion to Roman Catholicism, John Henry Newman had set up a small community in the village of Littlemore, near Oxford, where he lived with a few friends under a rule of silence. Similarly, the architect G. E. Street, who had moved to Oxford in 1852, had proposed the establishment of a combined college, monastery and workshop where the principles of religious art could be studied and applied. A couple of generations earlier, there had been the example of the Nazarenes, led by the German painters

21

Overbeck and Cornelius; they had set up a quasi-monastic community in Rome in the early nineteenth century, and have often been considered the precursors of the Pre-Raphaelite Brotherhood.[67] For a while, the friends' letters made frequent reference to the projected brotherhood, although their monastic ideals gradually faded during 1854 and 1855.

Dixon later recalled that 'at that time Morris was an aristocrat and a High Churchman. His manners and tastes and sympathies were all aristocratic.'[68] Yet, as Mackail noted, he was already beginning to change: 'Before Morris had been a year at Oxford, the acquiescence of unquestioning faith was being exchanged for a turmoil of new enthusiasms.'[69] Although he was the junior member of the group, he soon became its driving force. It was his vitality and physical strength which at first impressed his friends, but soon they began to appreciate the quickness of his intellect. They also respected the depth of his knowledge, selective though it was; for he knew a great deal about many matters of which the rest of the circle knew little, especially architecture; and it was Morris who persuaded them of the genius of Ruskin.

In the early months of their friendship, the members of the 'Morris set' were held together mainly by their literary interests, but soon – largely due to Burne-Jones – the visual arts as well as literature began to attract their attention, though they remained largely ignorant of the work of the great masters. At the time it was very difficult to obtain good-quality reproductions of famous paintings, and as yet neither Morris nor Burne-Jones had travelled abroad to see the originals. For a while they had only a few poor copies to excite their imaginations. Early in 1854, however, they began to hear of a group of contemporary painters whose ideas and work had brought about something of a revolution in artistic circles.

The Pre-Raphaelite Brotherhood (PRB) had been formed in 1848 by a group of painters led by Dante Gabriel Rossetti, Holman Hunt and John Everett Millais. They saw themselves as the leaders of a new English school of painting, challenging the established canons of art by insisting on accurate observation and vividness of colour. Early in 1854 Morris obtained a copy of Ruskin's *Edinburgh Lectures* in which he praised the PRB's insistence on truthful rendition and the need to paint direct from nature, concluding that 'With all their faults, their pictures are, since Turner's death, the best – incomparably the best – on the walls of the Royal Academy: and such works as Mr Hunt's "Claudio and Isabella" have never been rivalled, in some respects never approached, in any period of art.'[70]

Such praise, from such a respected quarter, naturally excited the interest of Morris and Burne-Jones. 'I was reading in my room,' recalled Burne-Jones,

> when Morris ran in one morning bringing the newly published book with him: so everything was put aside until he read it all through to me. And there we first saw about the Pre-Raphaelites, and there I first saw the name of Rossetti. So

many a day after that we talked of little else but paintings which we had never seen.[71]

Shortly thereafter, though, they saw Millais's *The Return of the Dove to the Ark* at an Oxford dealer's, and then, as Burne-Jones later said, they 'knew'. In May 1854, too, they saw Holman Hunt's *The Awakening Conscience* and *The Light of the World* at the Royal Academy, and while they were in London they visited the home of B. G. Windus, one of the PRB's earliest patrons, where they saw Ford Madox Brown's celebrated *The Last of England*. Most exciting of all, however, was their first sight of one of Rossetti's paintings, *Dante Drawing an Angel in Memory of Beatrice*. They had already read his poem 'The Blessed Damozel' in a copy of *The Germ*, a literary magazine briefly published by the PRB, and as Burne-Jones said, 'at once he seemed to us the chief figure in the Pre-Raphaelite Brotherhood.'[72]

During the Long Vacation of 1854, Morris went abroad for the first time, to Belgium and Northern France. In Belgium, he encountered the paintings of Van Eyck and Memling, and he obtained copies of Dürer's engravings. He also studied the collections of medieval art in the Musée de Cluny and the Louvre, and at Amiens, Beauvais, Chartres and Rouen he saw some of the finest ecclesiastical architecture France had to offer. Rouen in particular made a profound impression: in 1887, he wrote that

> less than 40 years ago . . . I first saw the city of Rouen, then still in its outward aspect a piece of the Middle Ages: no words can tell how its mingled beauty, history, and romance took hold on me; I can only say that, looking back on my past life, I find it was the greatest pleasure I have ever had.[73]

In the following year William Morris came of age. This was of more than symbolic importance; for his mother gave him thirteen shares in Devon Great Consols, assuring him of a substantial income from dividends: £741 in 1855, and £715 in 1856 (see Table 1). To his fellow-undergraduates, such sums amounted to a fortune, and when Burne-Jones visited his friend at Walthamstow for the first time he was astonished to discover how well the Morris family lived. Wealth afforded him many opportunities denied to others. He hardly had to think twice before buying books like Ruskin's *Stones of Venice* at six guineas or *The Seven Lamps of Architecture* at a guinea.[74] In 1855, when Morris and Burne-Jones discovered Sir Thomas Malory's *Morte d'Arthur*, Burne-Jones had no choice but to read a copy in a bookshop. Morris bought a copy immediately. It became almost a Bible for them; the inspiration of many Burne-Jones paintings, and a good deal of the poetry Morris had begun to write. He could also buy works by the Pre-Raphaelite painters he admired, and whom he was now beginning to meet. In 1856 he bought five Rossettis for a total of £200, Ford Madox Brown's *Hayfield* for £40 and Arthur Hughes's much-admired *April Love* for £30.[75]

23

Morris's cash also proved useful when Richard Dixon suggested to him that they, together with Burne-Jones, Fulford, Faulkner and Price, should produce a literary journal. The idea was eagerly seized upon, and the friends worked hard on the first issue in the summer and autumn of 1855. Wilfrid Heeley, an undergraduate at Trinity College, Cambridge, and an

Table 1 Income of William Morris from Devon Great Consols, 1855–77

Year	Dividend per share (£)	No. of shares sold	No. of shares bought	No. of shares held	Income from sales (£)**	Income from dividends (£)	Income from directors' fees (£)	Calls on shares (£)	Net income (£)***
1855	57.00			13		741			741
1856	55.00			13		715			715
1857	63.00			13		819			819
1858	60.00			13		780			780
1859	44.00			13		572			572
1860	47.00			13		611			611
1861	46.00	1		12	350	552			902
1862	43.00	1		11	440	473			913
1863	54.00			11		594			594
1864	55.00			11		605			605
1865	62.00			11		682			682
1866	55.00			11		605			605
1867	40.00			11		440			440
1968	40.00			11		440			440
1869	36.00			11		396			396
1870	17.00			11		187			187
1871	8.00		14	25	(1,540)	200			(1,340)
1872	6.00		1	26	(120)	156	105		141
1873*	0.00			260		0	105		105
1874	0.00	80		180	80	0	105	90	95
1875	0.00	80		100	200	0	105	40	265
1876	0.00			100		0			0
1877	0.25	100		0	475	25			500
									9,768

Notes: * Company reconstituted 31 Aug. 1872. 10 for 1 share issue. Authorised capital raised to £51,200 in 10,240 £5 shares, 10p paid.

** (Bid price × Number of shares sold) less (Offer price × Number of Shares bought (excluding initial inheritance)).

*** Income from sales + Income from dividends + Income from directors' fees less Calls on shares.

Sources: Mining Journal; Mining World; PRO, BT31 142/445, 8645/63035, 1613/63035; Companies Registration Office, Cardiff, 211T.

old schoolfellow of Burne-Jones, Dixon and Price in Birmingham, was also brought in, and it was decided that the new venture should be formally styled the *Oxford and Cambridge Magazine*. The first issue appeared on 1 January 1856. Only Morris's money, though, made publication possible. He was wholly responsible for financing the magazine, and after

organising the first issue himself he agreed to pay Fulford £100 per annum as editor. The venture lasted a year, at a cost to Morris of several hundred pounds. The twelve monthly numbers, each of 60–70 pages, contained essays, tales, poetry and reviews of books. It was closely modelled on *The Germ*, the literary magazine which had briefly been published by the Pre-Raphaelite Brotherhood in 1850. Like *The Germ*, the aim of the *Oxford and Cambridge Magazine* 'was to combine reviews and articles promoting the ideas in which they believed, with poems, stories and occasional etchings, in which those should take creative form'.[76]

Although Morris's substantial private income put him in the ranks of the privileged, it also led him to search, with increasing seriousness, for a true purpose in life. No longer was he content to enter the ministry, for his High Church ideas had been 'corrected by the books of John Ruskin, which were at the time a sort of revelation to me'.[77] Although Morris continued to take part in religious observances for some time, like others before and after him, he was beginning to discover that the love of religious art and music does not necessarily demand a concomitant religious belief. Indeed, it seems that Morris had never really been what may be termed a natural Christian, one of those whose faith is steady, almost instinctive; for him religion was more a hindrance to revelation than a route to it.

At all events, it was about this time of waning faith that the seeds of Morris's socialist beliefs began to germinate – a result, to a large extent, of his becoming acquainted with the ideas of Charles Kingsley: 'I was also a good deal influenced by the works of Charles Kingsley, and got into my head therefrom some socio-political ideas which would have developed [earlier] . . . but for the attractions of art and poetry.'[78] Kingsley's novels, with the exception of *The Water Babies*, and to a lesser extent *Westward Ho*, are little known today; yet, for a while around the middle of the nineteenth century, they were very popular. Kingsley was associated with F. D. Maurice and the Christian Socialists, who 'aimed to save England from exploitative commercialism by a recall to the ethics of Christianity'.[79] Social reform was in the air at that time, especially in the minds of the young, and Kingsley sought to bring the social costs of industrialisation to the attention of the reading public.

Morris's biographers have often emphasised the importance of *Alton Locke, Tailor and Poet* (1850). Vigorously written and full of passion, it is the fictional autobiography of a working man who becomes a victim of the system of sweated labour. Even more significant, however, was *Yeast: A Problem* (1851), which Morris and his friends read in 1855.[80] Whereas *Alton Locke* is about one of the underdogs of the economic system, *Yeast* is about the rich young ruler, and was specifically written by Kingsley as a challenge to wealthy young men. For Kingsley, social transformation would come about under the guiding hand of an enlightened aristocracy. Like Ruskin, Carlyle, and many contemporaries, Kingsley was essentially

25

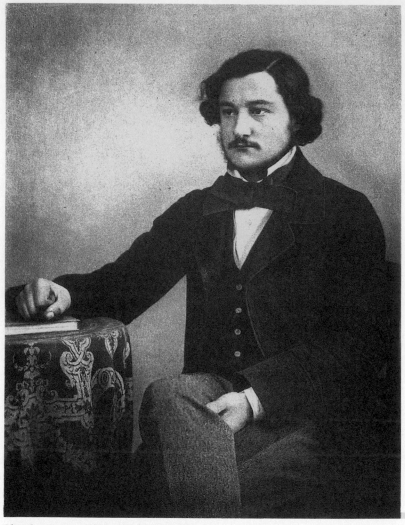

Plate 3 Morris aged 23, at Oxford in 1857

in favour of a hierarchical society: although the ruling elite must become socially aware, nothing fundamental was awry with the existing order. His intention was to provide 'an honest sample of the questions which, good or bad, are . . . rapidly leavening the minds of the rising generation'.[81] It is a sermonising tale, a curious mixture in which narrative and moral criticism are interwoven.

Much of the story must have seemed pertinent to Morris's own situation. The hero is a young man named Lancelot Smith, wealthy, well-educated, and seriously pondering what he should do with his life: 'here I am, with youth, health, strength, money, every blessing of life but one; and

I am utterly miserable. I want someone to tell me what I want.'[82] The answer given by the devout young woman he loves is faith. But this he cannot accept, for Smith, like Morris, was turning away from religion; not for him the attractions of Rome, which had beguiled his cousin Luke. Familiar too for Morris must have been the chapter describing the collapse of a bank run by Lancelot Smith's uncle, and the loss of a fortune. After this disaster he tries his hand at writing and then turns to painting, without finding satisfaction.[83] Blended into the narrative is a description of Smith's awakening conscience about the living conditions suffered by the majority of the working population. In short, the novel articulated all the difficulties of Morris's personal situation.

It must have been painfully obvious to Morris on reading Kingsley that his quest for a life of purpose, rather than being over, had only just begun. In the summer of 1855 he finally abandoned the church in favour of a career in architecture.[84] Nothing could have been more natural. All the major formative authorities – Scott, Guy and Ruskin in particular – pointed to the overarching significance of architecture. His love of the medieval, his personal exploration of buildings and nature, his knowledge of contemporary theology – each, in a different way, provided confirmation of this view. Towards the end of his second European tour, his thoughts and those of Burne-Jones coalesced. Mackail reports that whilst

> walking together on the quays of Havre late into the August night, Morris and Burne-Jones at last took the definite decision to be artists and to postpone everything else in this world to art. They decided that night that the Oxford life should be wound up as quickly as possible; and that thereafter Burne-Jones should be a painter, and Morris an architect.

Burne-Jones later described it as 'the most memorable night of my life'.[85]

On their return, the resolution was put into effect without delay. Morris wrote to Cormell [Crom] Price that

> I am going, if I can, to be an architect, and I am too old already and there is no time to lose, I MUST make haste, it would not do for me, dear Crom, even for the sake of being with you, to be a lazy, aimless, dreaming body all my life long. I have wasted enough time already, God knows.[86]

There remained the painful task of informing his mother of his intention to abandon his plans for a career in the Church:

> I am almost afraid you thought me scarcely in earnest when I told you a month or two ago that I did not intend taking Holy Orders; if this is the case I am afraid also that my letter now may vex you . . . You said then, you remember, and said very truly, that it was an evil thing to be an idle, objectless man; I am fully determined not to incur this reproach . . . I now wish to be an architect, an occupation I have often had hankering of, even during the time when I intended taking Holy Orders . . . If I were not to follow this occupation I in truth know not what I should follow with any chance of success, or hope of happiness in my

work, in this I am pretty confident I shall succeed, and make I hope a decent architect sooner or later.[87]

In January 1856, Morris became articled to George Edmund Street, recently appointed by Bishop Samuel Wilberforce as architect to the Oxford Diocesan Commissioners. Street had begun his career as assistant to George Gilbert Scott before making an independent reputation with a series of modest churches in Cornwall and Berkshire in the late 1840s and early 1850s. By the mid-1850s he was considered one of the leading architects of the Gothic Revival. He later became President of the Royal Institute of British Architects.

Street had an influence on William Morris which is often overlooked; perhaps because Morris was later quite critical of Street's Gothic Revival 'restorations'. It is also the case that Morris spent only nine months in Street's office; hardly long enough, it might be thought, for the master to have much influence on his pupil. But though Morris in fact never qualified as a professional architect, architecture was to remain of fundamental importance to him for the rest of his life. In his mind architecture remained the focal point around which the other arts – painting, sculpture, stained glass, metalwork, and so on – were grouped. And these were heady times in Street's office. He cultivated some of the brightest minds of the younger generation who were just beginning their careers, including some, like Philip Webb, Norman Shaw, and John and Edmund Sedding, who were to rise to the top of their profession.[88] A common set of values, assumptions and aspirations permeated the office, binding Street's pupils together under his tutelage. Webb, who became Street's pupil in May 1854 and had risen by 1856 to the position of chief clerk, became one of Morris's closest friends and collaborators.

Street himself was a respected member of the Ecclesiological Society, and his ideas were powerful and influential, inside and outside his own office. He was partly responsible for the growing acceptance by architects of continental Gothic, principally Italian, but also French and German. This was probably the most important development in architecture in the 1850s; the *Ecclesiologist*, and indeed most people in England, had formerly approved only of English Middle Pointed. The change was not entirely Street's doing. Benjamin Webb's *Sketches of Continental Ecclesiology* had pointed the way in 1848, and Ruskin's *Stones of Venice*, which regarded Italian Gothic as good Gothic, won many converts. Butterfield's All Saints, off London's Regent Street, begun in 1850 as the Ecclesiologists' 'model church', also drew upon continental rather than English precedents. But it was Street who became the leading advocate of features derived from continental Gothic; notably the use of brick for churches, and 'structural polychrome' – bands of horizontal brick or masonry in contrasting colours. An indefatigable traveller, Street became 'perhaps the

most knowledgeable medievalist of his day'.[89] His best-known publication, and the most effective elaboration of his views, was *Brick and Marble in the Middle Ages: Notes of Tours in the North of Italy* (1855). He also made frequent contributions to the *Ecclesiologist*, and lectured regularly to the Ecclesiological Society and the Oxford Architectural Society. In many respects, Street's views echoed those of Ruskin, though expressed in a clearer, more practical form. He was much less interested in symbolism than most ecclesiologists, and more inclined to stress the practical aspects of Gothic.

Street, furthermore, was working through some of the ideas which he was to express in his 1858 lecture 'On the Future of Art in England' when

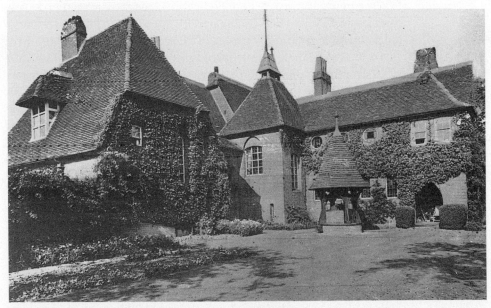

Plate 4 Red House, Bexleyheath, built for Morris by Philip Webb

Morris came to his office. In this lecture, read before the Ecclesiological Society, he bemoaned the fact that few architects were interested or competent in art: 'We should be better artists and greater men if we did a little less in architecture and a little more in painting', for 'three-fourths of the poetry of a building lay in its minor details'.[90] He went on to point out the importance of wall-painting and stained glass, referring on several occasions to the work of the PRB. Street insisted that architects should draw upon related crafts, particularly stained glass, metalwork and embroidery. He himself was proficient in embroidery and in designing church silver and metalwork.

Street's belief that architects should have a good all-round knowledge of the crafts which contributed to interior design and decoration was echoed by Morris. Indeed, some of the ideas on architecture and decorative work

29

which he later set out in his own lectures and speeches may well have derived from Street, rather than Ruskin or other theorists. Morris had already begun to design embroideries, though no early examples of his work have survived, and during his time in Street's office he also tried his hand at modelling in clay, carving in wood and stone, bookbinding, book illumination and calligraphy.[91] But the more mechanical aspects of an architect's training were oppressive, and during the course of the year he turned his attention to painting. For this, Rossetti was largely responsible. Burne-Jones had moved to London in the spring of 1856, to work under the master's tutelage, and Morris was introduced to Rossetti during one of his frequent visits to London. Morris must have found it highly gratifying that the much admired Rossetti had commented favourably on his early poetry, and the two soon became friends, stimulated by a shared love of gregarious conversation. By the end of the summer, Morris, elevated in his love of beauty, had become convinced by Rossetti's argument that painting was the most liberating of all arts. In a letter to Cormell Price, Morris wrote that 'Rossetti says I ought to paint, he says I shall be able; now as he is a very great man, and speaks with authority and not as the scribes, I *must* try. I don't hope much, I must say, yet will try my best – he gave me practical advice on the subject.'[92]

For a while Morris tried to fit his drawing and painting into a schedule dictated by his architectural studies, and in the autumn of 1856, when Street moved his office to London, he went too. Early in 1857, however, he abandoned his articles. He had taken rooms with Burne-Jones in Red Lion Square, and here the two friends worked for nearly two years. Rossetti would often call in to advise them about their work. Ruskin too, whom they held in some awe, had, to their immense satisfaction, become a personal friend. He referred to them as his 'dear boys', and took to calling regularly on Thursday evenings after lecturing at the Working Men's College.[93] That Ruskin should share his thoughts with them and take such an interest in their work must have dispelled any lingering doubts about a career in the arts. More mundane matters, which at the time might have seemed insignificant, must also have featured in their conversations. Their rooms were unfurnished, and Morris could not find furniture in the shops which satisfied his heightened sensibilities. The advice given by Ruskin and Rossetti was that he should not shy away from the challenge of building his own. So he began to design what Rossetti described as 'intensely medieval furniture'; a large table, substantial chairs and, most impressive of all, a large settle. On the flat panels of the settle Rossetti made designs for paintings. On the chair-backs he painted subjects drawn from Morris's early poems.[94]

Morris, however, did not stop writing, for all Rossetti's influence on his notions of artistic priorities. Around this time he began to put together the volume of early poems which was published in 1858 as *The Defence of*

Guenevere. It pleased Morris's friends – who now included Swinburne and the Brownings – but was generally disliked by the few critics who reviewed it, who found the poems obscure and affected. (As yet, neither Rossetti nor Swinburne had published in book form, and Morris bore the brunt of the hostility which still existed towards Pre-Raphaelitism.)[95]

In 1857, Rossetti asked Morris and Burne-Jones to travel with him to Oxford to meet Benjamin Woodward, the architect, who was busy supervising the building of the Oxford Union Debating Hall. Rossetti had previously suggested that the walls should be covered with murals, and he now agreed to assemble a team of artists, who would work without pay. The team consisted of Rossetti himself, Morris, Burne-Jones, and several other young artists including Hungerford Pollen, Spencer Stanhope, Val Princep and Arthur Hughes. The paintings were to be based on themes from Malory, illustrating the story of the quest for the San Graal. Morris himself painted 'How Sir Palomides loved La Belle Iseult'. He also took responsibility for the patterned decoration of the roof. Unfortunately, despite the painters' enthusiasm, some of the panels remained unfinished, and the project failed due to a lack of technical expertise; the murals were not proper frescoes, but were painted in distemper on to the still damp plaster of the new building, and they soon began to fade badly.[96]

Although Morris worked hard at painting, he did not achieve the success demanded by his own high standards. He was always intensely self-critical, painfully aware of his own shortcomings. But his dissatisfaction in no way diminished his sense of mission, and he soon found a more congenial outlet for his talent in the decorative arts, rather than in painting. This was already becoming apparent during the years from 1856 to 1858. Critics of Morris's painting have often commented upon the stiffness of his figure drawing. Yet the only existing painting by Morris, *La Belle Yseult* of 1858 (now in the Tate Gallery), demonstrates his mastery of colour and design – especially in the painting of the dress and the patterned carpet and embroidered hangings. Likewise, the patterned flowers and foliage which he painted on the roof of the Oxford Union proved to be the most successful part of the whole undertaking.

To turn from easel painting to the decorative arts (or 'lesser arts', as they were condescendingly called) might seem to have been something of a climb-down. Yet, as noted above, Morris had been persuaded of the legitimacy and importance of the decorative arts during his association with Street. But it was in John Ruskin that the decorative arts found their greatest champion. In *The Two Paths*, published in 1859, he instructs readers to 'get rid of any idea of decorative art being a degraded or separate kind of art. Its nature and essence is simply its being fitted for a definite place; and, in that place, forming part of a great and harmonious whole, in companionship with other art'[97] This thought must have held particular appeal for Morris at this time. And Ruskin, furthermore, not

31

only legitimised decorative art; he also made the case, in various writings, for the artist, designer and craftsman to be seen as one. 'No person is able to give useful or definite help towards the special applications of art, unless he is entirely familiar with the conditions of labour and materials involved in the work.'[98]

These ideas began to find practical expression in 1858, when Morris became engaged to Jane Burden, the daughter of a livery stable worker, whom he had met in Oxford whilst working on the Debating Hall. Tall, and a striking beauty, she had first caught the attention of Rossetti, who persuaded her to sit for him. Following their engagement, Morris began to think about building a house for himself and Janey. After a long search, a site was found in an orchard at Upton in Kent, ten miles from London, and Philip Webb was engaged to draw up the plans. Largely on the strength of this commission, Webb left Street's office in the spring of 1859 to set up his own practice.

In Webb's house, 'the theories of its owner and architect on domestic building and decoration were to be worked out in practice'.[99] It was known as Red House from its use of red brick at a time when stucco was still commonly used for houses, and at times has been seen as a landmark in domestic architecture. In fact, it is firmly based upon the vernacular work of Butterfield and Street; Street in particular produced a large number of vicarages and rectories in the mid-1850s, and, as Hitchcock has noted, 'these simple works by Street of the '50s, contrasting so sharply with his large churches and his ambitious secular projects, make it evident that much of the credit traditionally assigned to Webb for initiating a new and more straightforward sort of design at the Red House belongs properly to his master'.[100]

Nevertheless, Red House was an impressive achievement, and appropriately marks the start of Webb's career as one of the finest (if least prolific) domestic architects of Victorian Britain. It was designed on an L-shaped plan, with two storeys and a high-pitched red-tiled roof. Visitors commented upon the severely simple and grand interior, with its high ceilings, open beams, and plain brickwork. The hall was particularly noteworthy, featuring a massive oak staircase and patterned roof. All in all, it stood in sharp contrast to the ostentation and pretentiousness of much mid-Victorian building.

William Morris married Jane Burden in April 1859, and the couple lived for a while in furnished rooms in Great Ormond Street until, in the summer of 1860, they were able to move to Red House. They spent five happy years there, during which their two daughters Jenny and May were born. In the early days they spent much of their time decorating and furnishing their new home. This was no easy task, as Morris had a very low opinion of the furniture and furnishings then generally available. He believed that manufacturers had subordinated design to technique and

profit margin, and so, 'with the conceited courage of a young man' (as he later wrote),[101] he set out to design and make his own furniture and decorations. Burne-Jones and his new wife Georgiana, the Madox Browns, Rossetti and Lizzie Siddall, Webb, Charles Faulkner and his sisters Kate and Lucy were all regular visitors at Red House, and each was more than willing to help with the work.

The great settle which the friends had built and painted at Red Lion Square was brought down, and Burne-Jones began to paint a picture based on the medieval German epic poem, the *Nibelungenlied*, on its shutters. For the drawing room, the friends decided to illustrate the story of Sir Degrevaunt, one of their favourite romances. Burne-Jones designed seven pictures from the poem, of which three were painted in tempera. Below them, Morris painted simulated embroidered hangings of forest scenes on which he wrote the motto he had adopted, 'If I Can'.[102] Stained glass panels were gradually inserted into selected windows. Tiles designed by Burne-Jones were used in the fireplaces. Webb provided furniture, table glass and copper candlesticks.[103] The principal bedroom was hung with indigo-dyed blue serge, upon which a pattern of flowers was worked in brightly coloured wools. Morris had begun to learn the techniques of embroidery as early as 1855, studying and unpicking old pieces, and getting worsted dyed by an old French couple. Then the techniques were taught to Janey Morris, Georgiana Burne-Jones and other women friends. Work went on intermittently at Red House for several years, although some projects remained uncompleted, and others were never started – like the plan to cover the walls of the hall and staircase with scenes from the history of Troy.[104]

The building and furnishing of Red House was to prove of seminal importance in launching William Morris on his career as a decorative artist. At last he had discovered a means of expression which suited him temperamentally, and to which he could devote his remarkable abilities and strength of will. One of his early prose romances for the *Oxford and Cambridge Magazine* contained this paragraph, which may be read as a singularly revealing piece of autobiography:

Ever since I can remember, even when I was quite a child, people have always told me that I had no perseverance, no strength of will; they have always kept on saying to me, directly or indirectly, 'unstable as water thou shalt not excel'; and they have always been quite wrong in this matter, for of all men I have ever heard of, I have the strongest will for good and evil. I could soon find out whether a thing were possible or not to me; then if it were not, I threw it away for ever, never thought of it again, no regret, no longing for that, it was past and over to me; but if it were possible, and I made up my mind to do it, then and there I began it, and in due course finished it, turning neither to the right hand nor the left till it was done. So I did with all things that I set my hand to.[105]

In short, his transition from the priesthood to decorative artist by way of architecture and painting was not symptomatic of dilettantism; rather, it

33

indicated the earnestness with which he sought to put his abilities and enthusiasms to good use. It was fortunate that Morris met Ruskin at a crucial time in the late 1850s, when he needed a guide to individual action. Ruskin's legitimation and elevation of the decorative arts, and his recognition of their importance for the quality of life, must certainly have encouraged him to give up painting in favour of a career as designer and manufacturer.[106] Morris's choice of a career was highly unusual, given his social background and education, and the support of such an eminent figure as John Ruskin must have been welcome. Of course, William Morris was by no means unique in his ideas and enthusiasms. The influences of Romanticism and Tractarianism had affected a whole generation – and, indeed, a remarkably wide cross-section of early Victorian society. Likewise, Morris was only one of many people responsive to the impassioned pleadings of Carlyle, Ruskin, Kingsley and others. What made him unique, however, was the immense effort he made during his lifetime to give their ideas practical expression – and, indeed, to extend them in important ways. The vehicle for this practical expression was to be the firm of Morris, Marshall, Faulkner & Co.

1 William Morris Gallery, Walthamstow (hereafter WMG), J163, J. W. Mackail Notebooks.
2 L. S. Pressnell, *Country Banking in the Industrial Revolution* (Oxford, 1956), pp. 101–2; G. A. Fletcher, *The Discount Houses in London: Principles, Operations and Change* (1976), pp. 7–9.
3 W. T. C. King, *History of the London Discount Market* (1936), p. 119.
4 *Post Office London Directories*, 1812–37; King, *History of the London Discount Market*, pp. xviii, 119; *idem*, 'The Extent of the London Discount Market in the Middle of the Nineteenth Century', *Economica*, Aug. 1935, p. 324.
5 Society of Friends Library, Friends' House, London, Biographies of Members; R. S. Sayers, *Lloyds Bank and the History of English Banking* (Oxford, 1957), p. 181.
6 M. Daunton, 'Succession and Inheritance in the City of London in the Nineteenth Century', *Business History*, Vol. XXX (1988), pp. 269 et seq.
7 Mackail, *Life*, Vol. I, pp. 2–3; *London Gazette*, 18 Jan. 1824; 4 Feb. 1826.
8 Ibid., p. 3. In Oct. 1830 and Nov. 1832 respectively.
9 N. Kelvin (ed.), *The Collected Letters of William Morris*, Vol. II (Princeton, NJ, 1987), p. 227, to Andreas Scheu, 15 Sept. 1883.
10 Mackail, *Life*, Vol. I, pp. 4–5.
11 P. Henderson, *The Letters of William Morris to his Family and Friends* (1950), pp. 363–4, to the *Daily Chronicle*, 23 April 1895; 9 May 1895.
12 W. Morris, *News from Nowhere* (1890), in M. Morris (ed.), *The Collected Works of William Morris* (24 vols., 1910–15) (hereafter *Collected Works*), Vol. XVI, p. 68.
13 Mackail, *Life*, Vol. I, p. 9.
14 Kelvin, *Letters*, Vol. II, p. 228, to Andreas Scheu, 15 Sept. 1883.
15 Ibid., p. 513, to the Editor, *Pall Mall Gazette*, 2 Feb. 1886. Stead had asked a number of leading men of letters, including Morris, Ruskin and Swinburne, to submit a list of 100 outstanding books.
16 For a useful assessment of Scott's fame and popularity in the first half of the nineteenth century, see J. O. Hayden, *Scott: The Critical Heritage* (1970), especially pp. 1–23.
17 W. Morris, 'The Lesser Arts of Life' (1882), *Collected Works*, Vol. XXII, p. 254; Mackail, *Life*, Vol. I, p. 10; P. Henderson, *William Morris: His Life, Work and Friends* (1967), p. 6.
18 Kelvin, *Letters*, Vol. II, p. 546, to William Sharman, April 24–30? 1886; ibid., p. 227, to Andreas Scheu, 15 Sept. 1883; J. Lindsay, *William Morris: A Biography* (1975), p. 17;

Mackail, *Life*, Vol. I, p. 10; M. Morris, *William Morris: Artist, Writer, Socialist* (Oxford, 1936), Vol. II, p. 613.

19 Mackail, ibid., p. 26; Lindsay, ibid., p. 35.

20 Mackail, ibid., p. 11; Henderson, *Life, Work and Friends*, p. 4; Kelvin, *Letters*, Vol. II, p. 227, to Andreas Scheu, 15 Sept. 1883; WMG, J163, J. W. Mackail Notebooks.

21 *Kent's London Directory*, 1821, p. 533.

22 D. B. Barton, *History of Copper Mining in Cornwall and Devon* (3rd ed., 1978), pp. 71–2.

23 C. Thomas, *Mining Fields of the West* (1865), p. 79; J. H. Collins, *Observations on the West of England Mining Region* (Plymouth, 1912), p. 265; F. Booker, *The Industrial Archaeology of the Tamar Valley* (Newton Abbot, 1971), pp. 15–17.

24 Devon Record Office, Bedford Estate Papers, L1258/c, John Benson to Christopher Haedy, bundle 52, 22 April 1843 and bundle 54, 10 Jan. 1845.

25 See R. Burt, 'The London Mining Exchange, 1850–1900', *Business History*, Vol. XIV (1972), pp. 124–43.

26 There is no evidence to support Mackail's assertion – based on the recollections of Morris's publisher, F. S. Ellis – that the shares in Devon Great Consols were acquired in part payment of a debt. Mackail, *Life*, Vol. I, p. 14; WMG, J163, J. W. Mackail Notebooks.

27 Public Record Office (hereafter PRO), BT31 142/445, Grant of Settlement, 26 July 1844. On the origins of Devon Great Consols, also see Barton, *Historical Survey*, p. 71; Booker, *Tamar Valley*, p. 146; J. C. Goodridge, 'Devon Great Consols: A Study in Victorian Mining Enterprise', *Transactions of the Devonshire Association*, Vol. XCVI (1964), p. 229; M. Bawden, 'Mines and Mining in the Tavistock District', *Transactions of the Devonshire Association*, Vol. XLVI (1914), p. 258.

28 PRO, BT31 142/445, Balance Sheet and Auditor's Report, 7 May 1845.

29 Ibid., Annual Returns, 1846–48.

30 D. Morier Evans, *The Commercial Crisis, 1847–48* (2nd ed., 1849), p. lviii.

31 W. G. Prescott to Lord Overstone, 4 Nov. 1857, reprinted in D. P. O'Brien (ed.), *The Correspondence of Lord Overstone* (Cambridge, 1971), Vol. 11, p. 763.

32 Sanderson & Co. to Creditors, 15 Sept. 1847, reprinted in the *Economist*, 18 Sept. 1847, p. 1089.

33 National Westminster Bank Archives, 11523, Prescott & Co., Partners' Minute Book, 16 Sept. 1847; 23 Sept. 1847; 11450, Union Bank of London Ltd., Minute Book, 22 Sept. 1847; *The Times*, 21 Sept. 1847, p. 3; *Economist*, 25 Sept. 1847, p. 1114; Evans, *Commercial Crisis of 1847–8*, pp. lviii–lix; King, *London Discount Market*, p. 142. The firm survived until the crisis of 1857, when it was again forced to suspend business on 11 November. On this occasion, its liabilities exceeded £5 million, and, although much of this was backed by sound securities, the firm was wound up. National Westminster Bank Archives, 11524, Prescott & Co., Partners' Minute Book, 12 Nov. 1857; 10 Dec. 1857; 11456, Union Bank of London Ltd., Minute Book, 6 Jan. 1858; Evans, *Commercial Crisis of 1857–8* (1859), pp. 35, 52.

34 PRO, PROB 6/223. This would place Morris Snr amongst the top 1 per cent of estates proven around mid-century: see W. D. Rubenstein, *Men of Property* (1981), p. 29.

35 *Mining Journal*, 26 Nov. 1864, p. 830. Also see Goodridge, 'Devon Great Consols', p. 231.

36 The effect of the 1847 crisis upon the Morris family has not been recognised. See, for example, G. Naylor (ed.), *William Morris by Himself* (1988), p. 18: 'Morris Senior's death made no difference to the family's fortunes.'

37 Kelvin, *Letters*, Vol. II, p. 227, to Andreas Scheu, 15 Sept. 1883.

38 W. S. Blunt, *My Diaries, 1888–1914* (1932 ed.), pp. 231–2. Also see Mackail, *Life*, Vol. I, pp. 15–16; Lindsay, *William Morris*, p. 22.

39 Kelvin, *Letters*, Vol. II, pp. 227–8, to Andreas Scheu, 15 Sept. 1883.

40 Mackail, *Life*, Vol. I, p. 16.

41 Ibid., pp. 17–18.

42 F. W. Cornish, *The English Church in the Nineteenth Century* (1910), Vol. I, p. 238; Faulkner, *Against the Age*, p. 4; Mackail, *Life*, Vol. I, p. 17.

43 Mackail, *Life*, Vol. I, p. 25.

44 Ibid., p. 25.

45 C. L. Eastlake, *A History of the Gothic Revival* (1868), p. 115. For a bibliography of primary and secondary works relating to the Gothic Revival, see the revised edition edited

by J. Mordaunt Crook (Leicester, 1978).

46 G. W. Addleshaw and F. Etchells, *The Architectural Setting of Anglican Worship* (1948), p. 203.

47 Ibid., p. 204.

48 'The late days of early Middle Pointed', to quote the description later used by Charles Eastlake. *History of the Gothic Revival*, p. 233.

49 J. M. Neale, *A History of Pews* (1841), passim.

50 B. F. L. Clarke, *Church Builders of the Nineteenth Century: A Study of the Gothic Revival in England* (1938, reprinted Newton Abbot, 1969), pp. 179–81.

51 Eastlake, *History of the Gothic Revival*, p. 203.

52 W. Morris, *A Dream of John Ball* (1888), *Collected Works*, Vol. XVI, p. 223. Also see *idem*, 'The Aims of Art' (1887), *Collected Works*, Vol. XXIII, p. 85.

53 M. Arnold, *Essays in Criticism* (2nd ed., 1869), preface.

54 See, for example, W. Morris, 'The Aims of Art' (1887), *Collected Works*, Vol. XXIII, p. 85; Mackail, *Life*, Vol. I, pp. 34, 49.

55 Recollections of Sir Edward Burne–Jones, quoted in Mackail, ibid., p. 35.

56 On Digby and de Lisle, see J. Mordaunt Crook, *William Burges and the High Victorian Dream* (1981), pp. 19–22.

57 Mackail, *Life*, Vol. I, p. 38; Faulkner, *Against the Age*, p. 9.

58 R. Williams, *Culture and Society* (1958, Penguin ed. 1971), p. 89.

59 E. P. Thompson, *William Morris: Romantic to Revolutionary* (2nd ed., 1977), p. 29.

60 Ibid., p. 31.

61 See, for example, *Modern Painters*, Vol. I (7th ed., 1867), Section III, 'Of Truth of Skies', pp. 201–64; *The Stones of Venice*, Vol. II (1853), pp. 11–12.

62 Naylor, *William Morris by Himself*, p. 10.

63 Mackail, *Life*, Vol. I, p. 226.

64 W. Morris, preface to the Kelmscott edition of *The Nature of Gothic* (1892).

65 Mackail, *Life*, Vol. I, p. 35; Lindsay, *William Morris*, p. 45; N. Kelvin, *The Collected Letters of William Morris*, Vol. I (Princeton, NJ, 1984), pp. 10, 14.

66 Mackail, ibid., p. 39.

67 Lindsay, *William Morris*, pp. 50–1.

68 WMG, J163, J. W. Mackail Notebooks.

69 Mackail, *Life*, Vol. I, pp. 38–9.

70 J. Ruskin, 'Pre-Raphaelitism', (Edinburgh, 18 Nov. 1853), in E. T. Cook and A. Wedderburn (eds.), *The Complete Works of John Ruskin* (39 vols., 1903–12), Vol. XII, pp. 159–60.

71 Quoted in P. Henderson, *Life, Work and Friends*, p. 16.

72 G. Burne-Jones, *Memorials of Sir Edward Burne-Jones* (1904), Vol. I, pp. 109–10; R. Watkinson, *Pre-Raphaelite Art and Design* (1970), p. 162.

73 W. Morris, 'The Aims of Art' (1887), *Complete Works*, Vol. XXIII, p. 85.

74 *A Catalogue of Books of Various Branches of Literature published by Smith, Elder & Co.* (Feb. 1851).

75 Mackail, *Life*, Vol. I, pp. 108–9, 115; Henderson, *Life, Work and Friends*, p. 37.

76 Watkinson, *Pre-Raphaelite Brotherhood*, p. 163; Also see Mackail, *Life*, Vol. I, p. 91.

77 Kelvin, *Letters*, Vol. II, p. 228, to Andreas Scheu, 15 Sept. 1883.

78 Ibid.

79 Faulkner, *Against the Age*, p. 5.

80 The authors are grateful to Ray Watkinson for first drawing their attention to the significance of *Yeast*.

81 *Yeast: A Problem* (1851, 1908 ed.), p. 195.

82 Ibid., pp. 48–9.

83 Ibid., pp. 192–3, 207.

84 Kelvin, *Letters*, Vol. I, pp. 16–22, to Emma Shelton Morris, 29 July 1855; 7 Aug. 1855; and to Cormell Price, 10 Aug. 1855.

85 Mackail, *Life*, Vol. I, p. 78; G. Burne-Jones, *Memorials*, Vol. I, p. 115.

86 Kelvin, *Letters*, Vol. I, p. 23, to Cormell [Crom] Price, 6 Oct. 1855.

87 Ibid., pp. 24–5, to Emma Shelton Morris, 11 Nov. 1855.

88 H. R. Hitchcock, 'G. E. Street in the 1850s', *Journal of the Society of Architectural*

Historians, Vol. XIX (1960), p. 145.

89 R. Dixon and S. Muthesius, *Victorian Architecture* (1978), p. 203.

90 Reprinted in the *Ecclesiologist*, Vol. XIX (1858), pp. 232–40.

91 R. Watkinson, 'Red House Decorated', *Journal of the William Morris Society*, Vol. VII, No. 4 (1988), p. 12.

92 Kelvin, *Letters*, Vol. I, p. 28, to Cormell Price, July 1856.

93 G. Burne-Jones, *Memorials*, Vol. I, p. 147.

94 Henderson, *Life, Work and Friends*, pp. 39–40.

95 P. Faulkner, *William Morris: The Critical Heritage* (1973), p. 6.

96 Watkinson, *Pre-Raphaelite Art and Design*, pp. 167–8.

97 J. Ruskin, *The Two Paths* (1859), in Cook and Wedderburn, *Complete Works of John Ruskin*, Vol. 16, p. 320.

98 Ibid., p. 319.

99 Mackail, *Life*, Vol. I, p. 139.

100 Hitchcock, 'G. E. Street in the 1850s', pp. 170–1.

101 Kelvin, *Letters*, Vol. II, p. 228, to Andreas Scheu, 15 Sept. 1883.

102 Watkinson, 'Red House Decorated', p. 11.

103 Mackail, *Life*, Vol. I, pp. 158–9; R. Watkinson, *William Morris as Designer* (1968), p. 15.

104 Watkinson, 'Red House Decorated', p. 11; Mackail, *Life*, Vol. I, pp. 158–9; G. Burne-Jones, *Memorials*, Vol. I, p. 209.

105 W. Morris, 'Frank's Sealed Letter', *Oxford and Cambridge Magazine* (April 1856), p. 225, quoted in Mackail, *Life*, Vol. I, p. 79.

106 Ruskin, *The Two Paths*, in Cook and Wedderburn, *Complete Works of John Ruskin*, Vol. XVI, p. 319; E. P. Thompson, *Romantic to Revolutionary* (2nd ed., 1977), pp. 32–9.

Chapter 2

Idealism and action: the early years of Morris, Marshall, Faulkner and Co., 1861–69

Morris, Marshall, Faulkner & Co. (MMF & Co.) was formed on 11 April 1861. The partners were Ford Madox Brown, Edward Burne-Jones, Charles Faulkner, Peter Paul Marshall, William Morris, Dante Gabriel Rossetti and Philip Webb. The reputations of Brown and Rossetti were already well established. Brown, the most versatile artist of the group, had already designed costumes and furniture, while Rossetti, a flamboyant and charismatic figure, had emerged as an example and inspiration to the next generation of painters. He was undeniably an artist and poet of genius, and was not yet prone to the mental instability that afflicted him later in life. Burne-Jones, Morris and Webb were all at the beginning of their careers. Burne-Jones's painting and stained glass designs had become known to a small circle of admirers, whilst Webb was now making an independent reputation as an architect and designer of furniture and table glass. Morris, of course, in searching for a career which matched his talents, had gained sound practical knowledge of art and architecture, and was now absorbed in the decoration of his newly built home. The other partners are less well known to posterity. Charles Faulkner, once part of the 'Pembroke set', was a mathematician who had taken a double first. With the commencement of MMF & Co., he moved to London to assist his friends, also becoming articled to a firm of civil engineers. Marshall, a surveyor and sanitary engineer by profession, was a friend and pupil of Madox Brown and a clever amateur painter. All in all, they made an extraordinarily well-balanced, experienced, and intellectually vigorous team. Each of the partners held one £20 share, of which £1 was called up. The firm began trading with a £100 loan from Morris's mother.[1]

The way in which the firm came into being has long been taken to be evidence that Morris and his associates were casual amateurs in matters of business. Since the publication of Mackail's *Life* in 1899, historians have emphasised that the idea of forming a company arose out of the collective effort to beautify Morris's Red House and simply 'sprang up amongst friends in talk'.[2] Rossetti later remarked that 'it was mere playing at business' and that the partners 'had no idea whatever of commercial success'. He added that 'Morris was elected manager, not because we ever

dreamed that he would turn out to be a man of business, but because he was the only one of us who had money to spare.'[3] Hence it has been concluded that the origins of the firm were 'delightfully casual'; that it was simply a loose association of friends with similar views and aims, and that it succeeded almost by accident.[4]

Rossetti's own attitude to the firm was, as will be seen, certainly 'casual', whether or not 'delightfully' so; but his attribution of the same attitude to the rest of the team does not square with what we know of their professionalism, their aspirations, and their appreciation of the potential of the decorative arts. Burne-Jones, Webb and Faulkner were neither wealthy nor uninterested in money. They were young professionals on the threshold of challenging careers. It is inconceivable that they would have entered into partnership on a whim or simply for reasons of comradeship. Likewise, Madox Brown and Marshall were, as later events proved, driven in large measure by financial motives. And the charge of merely 'playing at business' cannot be made to stick in Morris's case for he, though having the luxury of a private income, was as eager as his friends for success and recognition. Rossetti is not a reliable source for the historian, and his account of the formation of MMF & Co. is best treated with some scepticism.

The primary intention of the firm was to bring together artists, designers and architects with complementary skills to work on decorative art projects. From the outset, though, the partners recognised that some of them would be more involved than others and that the demand for the services of particular individuals would vary. Accordingly, they decided to hold weekly partners' meetings – usually chaired by Madox Brown or Burne-Jones – at which they would share out commissions, fix rates and discuss business matters generally. They devised an accounting system, whereby each partner had a separate account book. All payments – for work carried out, attendance at meetings, regular salary (where applicable) or extraordinary items – were credited to individual accounts as appropriate. Partners could withdraw funds or receive payment in kind (Burne-Jones virtually furnished his entire home in this way), so long as an account was kept in credit. The system had the advantage of flexibility, as individual earnings from the business corresponded to the level of effort each partner was prepared to put in.[5] Rates of pay for similar jobs varied according to the level of skill brought to bear. So, for instance, Burne-Jones, Rossetti and Brown could expect to be paid more for stained glass cartoons than Morris or Marshall. (Despite his own efforts, and the encouragement of Rossetti, Morris was never to match the skills of some of the other partners as painter and cartoonist.) On 15 April 1863, for example, the minute book noted: 'distribution of the 4 major prophets for Bradford East window. Ezekiel and Daniel to Rossetti for £3. Isaiah and Jeremiah to Morris for the small sum of £2.'[6]

39

Morris's abilities were thought to lie elsewhere. Unlike the other partners, he had some experience of business. After receiving his shares in Devon Great Consols, it was considered natural that he should take more than a passing interest in Morris family investments. As early as 1856 he had joined his Uncle Francis on the board of a Cornish mining company in which the Morrises had a stake, giving him a first-hand, if very limited understanding of business finance and management.[7] He had, furthermore, already demonstrated his drive and ability to organise in his work for the *Oxford and Cambridge Magazine* and his contribution to the painting of the Oxford Union in 1857.[8] He was the natural choice for business manager of MMF & Co., and was granted a salary of £150 a year, as was the other salaried partner, Faulkner, who was given general managerial responsibilities and charged with keeping a detailed set of accounts.

The degree of forethought and planning shown by the partners in MMF & Co. is hardly consistent with feckless amateurism or organisational ineptitude. Nor was there anything casual or lighthearted in the thinking which caused the seven partners to band together in this way. Morris and his circle were quite familiar with the concept of an association of artists. The Pre-Raphaelites provided a model and inspiration, as did the Hogarth Club, founded towards the end of 1858 by Madox Brown and his friends. Part social club and part exhibiting society (to make its artist members independent of the Royal Academy), it was also open to like-minded architects, writers and patrons. Its membership included Ruskin, Bodley, Street, Benjamin Woodward and Philip Webb. It proved short-lived – personality clashes abounded – and was wound up in 1861. Nevertheless, it provided a valuable forum for the exchange of ideas.[9]

Even more influential was the 'Art Manufactures' group led by Henry Cole, which was certainly known to Morris and his friends. Since the 1840s Cole and his group had been, along with Pugin, the foremost critics of the vulgar incongruity of much industrial design. Cole was one of the instigators of the 1851 Great Exhibition and Director of the Department of Science and Art, later becoming a founder of the South Kensington Museum. He believed that design standards were low because able designers no longer worked closely with manufacturers. The result was that commercially produced goods, although cheap and competitive, tended to be adorned with tasteless and inappropriate decoration drawn from pattern books. Cole, who had produced designs for Mintons under the pseudonym Felix Summerly, actively encouraged the idea of an association of artists and designers which would provide designs for commercial production. Summerly's Art Manufactures, as the association was called, presented nearly 100 items at the third annual Exhibition of British Manufacturers, held by the Society of Arts in 1848. It was announced that 'their execution should be entrusted only to the most eminent British manufacturers', and that the principal objective was 'to

obtain as much beauty and ornament as is consistent with cheapness'.[10]

But whereas the Art Manufactures group was concerned purely with designing for established manufacturers, the Morris group determined to involve itself in the production and marketing of its designs, bridging the perceived gulf between designer and producer. In this they followed Ruskin's passionate advocacy of the view that designers should learn craft skills, and acquire a working knowledge of the techniques and processes needed to produce an article.[11] Manufacturers, correspondingly, were urged to improve the quality of their goods, to 'forge the market' and educate public taste. Ruskin advised a gathering of businessmen:

> [you] must remember always that your business as manufacturers is to form the market, as much as to supply it. If, in short-sightedness and reckless eagerness for wealth, you catch at every humour of the populace . . . you may, by accident, snatch the market; or, by energy, command it . . . But whatever happens to you . . . the whole of your life will have been spent corrupting public taste and encouraging public extravagance.[12]

The ambition of Morris and his colleagues to set new standards in the decorative arts drew added strength from their realisation of how well placed they were to carry out Ruskin's injunction to form the market rather than merely to supply it; making their products 'educational instruments that would be more influential for all kinds of good than many lecturers on art, or many treatise writers on morality'.[13] An important advantage for MMF & Co. was the partners' knowledge of Gothic architecture, and their strong rapport with increasingly influential neo-Gothic architects – men like G. F. Bodley and G. E. Street, who were particular beneficiaries of the new appreciation of the splendour of the great medieval churches. The era of Gothic Revival church building was at its height, and one consequence of this was a surge in demand for the services of designers and decorative artists; stained glass, carved wood, murals, furniture and a host of other things were needed to adorn the new structures or breathe fresh life into older buildings. Thus splendid opportunities existed for those who could harmonise their thinking on interior design with that of leading architects. Plainly, this was something that Morris and his friends could do. Morris and Webb found they had much in common. A friend of Rossetti called Benjamin Woodward, who had done a good deal to encourage the nineteenth-century revival of stained glass, had introduced Rossetti to Powell & Sons of Whitefriars, the firm which led the return to supposedly medieval principles of stained glass-making in the 1840s and 1850s.[14] Rossetti worked for Powells in the 1850s, and in 1856–57 he brought in Madox Brown and Burne-Jones, who designed for the Whitefriars firm until the formation of MMF & Co.[15] These experiences helped convince the partners that a ready market could be found for work of the originality and quality they aimed to produce.

Indeed, they stated their beliefs and intentions quite unambiguously in the prospectus announcing the formation of the firm. It emphasised that 'artists of reputation' should use their talents in decorative art, and pointed out the advantages of association; a group of artists working together could offer a much more complete service than they could as individuals:

> The growth of Decorative Art in this country owing to the effort of English Architects has now reached a point at which it seems desirable that Artists of reputation should devote their time to it. Although no doubt particular instances of success may be cited, still it must be generally felt that attempts of this kind hitherto have been crude and fragmentary. Up to this time want of artistic supervision, which can alone bring about harmony between the various parts of a successful work, has been increased by the necessarily excessive outlay consequent on taking one individual artist from his pictorial labour.
>
> The Artists whose names appear above hope by association to do away with this difficulty. Having among their number men of varied qualifications, they will be able to undertake any species of decoration, mural or otherwise, from pictures, properly so called, down to the consideration of the smallest work susceptible of art beauty. It is anticipated that by such co-operation, the largest amount of what is essentially the artist's work, along with his constant super-vision, will be secured at the smallest possible expense, while the work must necessarily be of a much more complete order, than if any single artist were incidentally employed in this manner.
>
> These Artists having been for many years deeply attached to the study of the Decorative Arts of all time and countries, have felt more than most people the want of some one place, where they could either obtain or get produced work of a genuine and beautiful character. They have therefore now established them-selves as a firm, for the production, by themselves, and under their supervision, of:
>
> I Mural Decoration, either in Pictures or in Pattern Work, or merely in the arrangement of Colours as applied to dwelling-houses, churches or public buildings.
> II Carving generally, as applied to Architecture.
> III Stained Glass, especially with reference to its harmony with Mural Decoration.
> IV Metal Work in all its branches, including Jewellery.
> V Furniture, either depending for its beauty on its own design, or on the application of materials hitherto overlooked, or on its conjuncture with Figure and Pattern Painting. Under this head is included Embroidery . . . besides every article necessary for domestic use.

The prospectus concluded that 'it is only requisite to state further, that work of all the above classes will be estimated for and executed in a business-like manner; and it is believed that good decoration, involving rather the luxury of taste than the luxury of costliness, will be found to be much less expensive than is generally supposed'.[16] From the first, then, MMF & Co. set out to emphasise and publicise the originality and quality of its work, the high abilities and reputation of its members, and the profes-sionalism of its organisation.

MMF & Co. began life at 8 Red Lion Square, Bloomsbury, close by the rooms once shared by Morris and Burne-Jones. Offices and a showroom occupied the first floor, while the third floor and part of the basement were converted into workshops. The main problem faced by the partners was to generate sufficient work to make the venture worthwhile. The wide-ranging nature of the prospectus, notwithstanding its assertiveness, suggests a degree of uncertainty about the market, about precisely which skills and products they might be able to sell in any quantity. Their strength was that they were personally acquainted with many architects well placed to recommend them. If some of these key individuals could be persuaded to favour MMF & Co., then it might win enough business to take root. Thus, as soon as the partners had moved into the workshops in Red Lion Square, they began to put together a display of examples of the kind of work they might undertake; demonstrating their excellence in design, manufacturing skills, and all-round professionalism. They set out very positively to make a mark and win a good reputation.

Stained glass was the most obvious starting-point for business growth. The fact that Rossetti and Madox Brown were partners inspired enough confidence in some architects for them to recommend MMF & Co. at once as suppliers of top quality stained glass, especially since the partners were never shy about exploiting their connections. Even so, it was necessary for the firm to make up samples of their wares at once for inspection by potential clients.

The urgent need to develop a stock of designs and samples, and the prevailing uncertainty as to which line of business might in the end prove most successful, threw the partners into a bout of creative activity which lasted for more than two years. Webb was particularly active. He designed sets of table glass (wine glasses, finger bowls, tumblers and other items) which were made for MMF & Co. by Powells. He also busied himself designing jewellery and furniture. The jewellery was made by a craftsman who occupied the ground floor of 8 Red Lion Square. A local cabinet-maker executed the furniture designs.[17] Webb's furniture was largely of oak, often stained black, with flat panel decoration. It has been described as 'Gothic' furniture, but it did not have the spiky crockets and other archi-tectural borrowings which the epithet conjures up. Rather, it was plain and substantial. Webb was in fact putting into effect the principles which his mentor, Street, had set out in his 1853 lecture, 'The Revival of the Ancient Style of Domestic Architecture'. Street insisted that furniture should possess 'no sham or incongruous ornaments' such as pointed arches, crockets or finials, but should be 'really simple, with no more material consumed in their construction than was necessary for their solidity'.[18] This was a view shared by all the partners in MMF & Co. Madox Brown, for instance, produced designs for plain rush-seated chairs in stained oak, and is generally credited with having originated the green

43

stained finish which became widely popular towards the end of the nineteenth century.[19]

An analysis of one of the two surviving balance sheets for MMF & Co., drawn up at 31 December 1862, confirms the importance of stained glass, table glass and furniture to the firm. It can be seen from Table 2 that very little investment was needed in plant and equipment, and that the greater part of the capital needed was to finance stock accumulation, work in progress, and deficits on customer accounts. The largest element of the finished goods figure of £341. 60 was £205.60 for furniture, compared to figures of £76.00 and £60.00 for domestic glass and painted tiles respectively. The figure for work in progress is more difficult to disaggregate as most relevant entries in the balance sheet, totalling £278.00, refer to commissions for church decoration, mainly, though not

Table 2 Morris, Marshall, Faulkner & Co.: balance sheet at 31 December 1862

		£
Assets		
Equipment and office furniture		38.00
Stock-in-hand		
Finished goods	341.60	
Raw materials	121.35	
		462.95
Work-in-progress		352.00
Good debts		598.16
Cash		107.27
		£1,558.38
Liabilities		
Debts		
Wages	59.66	
Suppliers	290.95	
Rent	26.60	
Misc. expenses	28.00	
		405.21
Loans		
Mrs Morris	200.00	
W. Morris	400.00	
		600.00
Partnership accounts		
F. M. Brown	20.90	
D. G. Rossetti	6.88	
E. B. Jones	16.50	
P. Webb	95.63	
W. Morris	151.23	
P. P. Marshall	8.15	
C. J. Faulkner	56.75	
		356.04
Accumulated profit		197.13
		1,558.38

Source: Hammersmith & Fulham Archives Department, DD/235/1, MMF & Co., Minute Book, 1861–74.

exclusively, with stained glass. The largest debt to a supplier, as one might expect, was to Powells, which was owed £193.00 for coloured glass and the manufacture of table glass designs. Stained glass, furniture and table glass may have formed the bulk of the firm's early products, but the surviving evidence also points to a tremendous spurt of activity in other crafts. At the end of 1862 the firm had a stock of unworked fabrics worth £42.85, and a stock of paper worth £17.00 ready for printing with wallpaper designs.

It was Morris who took the lead in fabrics and wallpapers. He made designs for coarse serge wallhangings with figures and floral patterns in coloured wool, and other designs for embroidered altar cloths. They were

Plate 5 Sussex rush-seated chairs, first manufactured by the firm in the 1860s, from a Morris & Co. catalogue of c. 1912

executed by Morris himself along with a group of women under the supervision of his wife Janey. The early Morris wallpapers were very simple and naturalistic. The idea for the first, *Trellis*, begun in November 1862, probably came from the rose trellis at Red House. Morris did the basic design and Webb drew birds perched on the trellis nestling amongst the flowers and foliage. *Trellis* was beaten into production by the designs known as *Daisy* and *Fruit*. Morris at first attempted to print his designs at Red Lion Square in oil colours from etched zinc blocks, but the process proved slow and unreliable. Having failed with *Trellis*, he had traditional pearwood blocks cut for *Daisy* and *Fruit*. Once the blocks were cut for *Daisy*, production was subcontracted to the firm of Jeffrey & Co. of Islington, which specialised in 'the highest class of hand printed wallpapers'.[20] *Daisy* was a very simple pattern with clumps of flowers on a stippled background. It was an instant success when it appeared early in 1864, and was for a long time the most popular Morris design, achieving good sales through to the end of the nineteenth century.[21]

Tile painting was another activity which engaged the attention of several partners during the early days of the firm. The process was essentially very simple. Designs were sketched out, then transferred to plain white tiles specially imported from Holland. The tiles were coloured by hand using enamel paint, then refired. The principal designers were Burne-Jones, Madox Brown and Rossetti, whose subjects included legends, the seasons and fairy-tales. Burne-Jones's collection based on the Cinderella story proved especially popular with the public. Much of the painting was done by Morris, Charles Faulkner, Faulkner's sisters, Lucy and Kate, and Georgiana Burne-Jones. The tiles were used mainly for fireplaces, overmantels and entrance porches.[22]

As at Red House, the partners' friends and relations were encouraged to contribute in whatever ways they were able. Albert Moore, William De Morgan and Simeon Solomon, for example, all contributed designs for stained glass or tiles. But the partners and their friends could not supply all the labour needed, and soon additional workers had to be found. The most pressing need was for someone skilled in the manufacture of stained glass. The person recruited was George Campfield, sometime employee of Heaton, Butler & Bayne, one of the most respected firms of stained glass manufacturers. As foreman of the glass-painters, he became one of the pillars of the business. A second man was employed as general assistant, moving goods, packing crates and the like. Other workers were later recruited through advertisements in the *Builder* and the local press. Five men and boys were regularly employed by the end of 1861, rising to twelve a year later.[23]

The capital requirements of MMF & Co. were even more modest than those for labour. Design and craft manufacture were not capital-intensive activities, and the premises at Red Lion Square were rented for the modest

sum of £53.20 per annum. As already noted, some capital was needed for the purchase of raw materials, tools, working expenses and stocking the showroom with examples of standard designs, though it was hoped that even these modest expenses might be met largely from trading profits. Even so, some cash was needed, and it was to Morris that the partners turned for the means to launch the business on a sound footing. The balance sheet presented at a partners' meeting on 11 February 1863 reveals that he had advanced £400 by 31 December 1862, and that his mother had generously loaned a further £200 (see Table 2). Morris had raised the money by selling off one of his shares in Devon Great Consols in 1861, and another in the following year. He later told Wilfrid Scawen Blunt that 'my relations thought me both wicked and mad' to sell the precious shares on

Plate 6 The Herald Announcing the Ball, from a series of painted tiles illustrating the tale of Cinderella. Designed by Edward Burne-Jones for Morris, Marshall, Faulkner & Co. in 1862. Painted by Lucy Faulkner, and probably trial pieces for a panel in Birket Foster's house

which the family income had depended, and, in order to prevent the shares from leaving the family's possession, his mother supplied the money needed, transferring the shares to Stanley, her second son.[24] In addition to loaning the firm money, Morris, like Webb and Faulkner, allowed a substantial surplus to accumulate in his partnership account, thus providing further working capital.

Morris's investment of personal funds in MMF & Co. did not confer upon him any special rights or responsibilities. He was made salaried business manager because he had the time and inclination to take the job on, not because he was regarded by the others as the proprietor of the firm. If there was a senior figure, it was Madox Brown, who was seen as the natural choice to chair meetings, and who also took the lead in raising awkward

47

but very important issues, like the need for a proper deed of partnership, a full set of accounts, and agreement on the ownership of designs.[25] The frequent meetings which the partners held at Red Lion Square in the early days were more than the lighthearted social occasions referred to by some authorities. It was necessary to gather often to lay down the ground rules for the conduct of business. Certainly, meetings began with anecdotes or discussion of cultural issues, but, when the partners turned to business, matters were 'furiously discussed' until twelve, one or two at night.[26] An enormous amount of business was transacted. It was the job of the business managers, Morris and Faulkner, to report on invitations to tender, and to present all estimates sent out. The design work would then be allocated and prices fixed. More general business issues would then be debated, such as the borrowing of money, the issue of bills of exchange or the renting of additional space for a stained glass showroom.[27]

The impression from these surviving records is not one of 'playing at business' as Rossetti – who attended only five out of fifty-four meetings between 1862 and 1864 – alleged. There was a very serious purpose: the creation of an enterprise which through the originality and superiority of its products would catch the eye of the public, making sales and generating income for the partners. One timely opportunity to catch the eye of the public was the International Exhibition held at South Kensington in 1862. The partners seized their chance, renting two stands at a cost of £25 to present exhibits in the Medieval Court – one of stained glass, the other of decorative furniture and embroideries. These attracted much attention. The furniture display included a gilded bookcase, and a cabinet designed by Webb and painted by Morris with scenes from the story of St George. Other items were an iron bedstead, a sideboard, a wash-stand, a sofa, copper candlesticks, painted tiles, and pieces of jewellery. The stained glass included the magnificent *Parable of the Vineyard*, designed by Rossetti, which was later used for the east window of St Martin's, Scarborough.[28]

MMF & Co.'s products were not received favourably in all quarters, however. The tiles were discreetly withdrawn from the display when it was discovered that one of the judges, William Burges, did not like them. The stained glass also led to controversy: some competitors claimed that the partners had merely touched up old glass, and called for disqualification. This incident, in fact, far from damaging the firm, served to demonstrate the excellence of its products. When John Clayton, of the well-known stained glass makers Clayton & Bell, was asked to pass judgement, he generously pronounced it the best work of its type in the Exhibition. And the *Building News*, while critical of some of the drawing, added that 'the work is, however, as lovely, and approaches so nearly the gemlike character of the old glass, that we are glad to admire heartily, instead of seeking out faults'.[29]

In the event, both exhibits received medals of commendation. The

stained glass was praised by the Exhibition Jury 'for artistic qualities of colour and design'. Of the furniture and decorative display, the jury commented that

> Messrs Morris and Co. have exhibited several pieces of furniture, tapestries, &c., in the style of the Middle Ages. The general forms of the furniture, the arrangement of the tapestry, and the character of the details are satisfactory to the archaeologist from the exactness of the imitation, at the same time that the general effect is excellent.[30]

Though welcome, praise of this sort suggests that the objectives of the firm were not entirely understood. Morris and his colleagues never saw themselves as medieval copyists, but as original artists inspired by the medieval example. Nevertheless, MMF & Co.'s products had been well received. Goods worth nearly £150 were sold from the stands, and the Exhibition generated the firm's first large commissions. Orders were received for stained glass for G. F. Bodley's first two Gothic Revival churches, St Michael and All Angels, Brighton, and All Saints, Selsley, Gloucestershire. Bodley, a pupil of Sir George Gilbert Scott, was one of the firm's most important sponsors in the early 1860s. St Martin's, Scarborough was glazed throughout by MMF & Co.[31] For All Saints, Cambridge, begun in 1863, Bodley commissioned the firm to undertake stencilling and other decorative art work as well as stained glass.[32]

The importance of the Exhibition to the firm is further illustrated by the case of Bradford Cathedral (then the parish church). The church was at the time being extended and generally renovated. A local textile manufacturer, John Aldam Heaton, had seen the MMF & Co. exhibits at South Kensington, where he himself had goods on display, and he instantly recognised the outstanding quality of the work. He had no hesitation in recommending the firm to Mrs Tolson and other benefactors of the church. He later expressed his pleasure in the Tolson window in the following terms:

> Compared with modern work generally, the drawing will be found particularly vigorous and forcible; the faces and the limbs boldly defined by line, rather than shaded or minutely worked up, the flesh tints particularly well obtained – a matter often missed – and the colour generally founded on an artist's appreciation of the value of gradation and harmony, rather than delighting in crude colours and striking contrasts . . . Especially I would point to the red, which is everywhere in this window full of lovely gradation from deep mulberry to the most brilliant ruby and passing often into a sort of ruddy cedar tint . . . In the same way greens . . . are here inclining to olive and always in a state of gradation from dark to light.[33]

Heaton maintained his association with MMF & Co. for many years, supplying certain of the fabrics which Morris liked to embellish through embroidery.

Plate 7 The Sermon on the Mount. Cartoon for stained glass in the south nave of All Saints' Church, Selsley, Gloucestershire, by Dante Gabriel Rossetti, 1862

Very early on, Morris, in his capacity as business manager, recognised the potential of the church market for MMF & Co. One of the first purchases listed in the firm's account book was a Clergy List, and one of the clerics who received the firm's prospectus was Morris's old tutor, the Rev. F. B. Guy, to whom he wrote:

My dear Guy, By reading the enclosed you will see that I have started as a decorator which I have long meant to do when I could get men of reputation to join me, and to this end mainly I have built my fine house. You see we are, or

consider ourselves to be, the only really artistic firm of the kind, the others being only glass painters in point of fact (like Clayton & Bell) or else that curious nondescript mixture of clerical tailor and decorator that flourishes in Southampton Street, Strand; whereas we shall do – most things. However, what we are most anxious to get at the present is wall-decoration, and I want to know if you could be so kind as to send me (without troubling yourself) a list of clergymen and others, to whom it *might* be any use to send a circular.[34]

A steady stream of commissions for church decoration in the form of wall-painting, embroidery, altar cloths and floor tiles soon followed the issue of the prospectus in January 1863. Stained glass, however, remained by far the most important of the firm's products in the 1860s. The total number of stained glass commissions undertaken rose fairly rapidly, from five in 1861 to fifteen in 1862, sixteen in 1863 and 1864, and twenty-three in 1865. In 1866, stained glass accounted for £2,300 out of total sales of approximately £3,000.[35]

The acquisition of an impressive reputation for stained glass in such a short time was a remarkable achievement, and one which owed not a little to the fact that Rossetti, Burne-Jones and Madox Brown were already experienced designers before they joined the firm. As noted earlier, all three had worked for James Powell & Sons of Whitefriars in the 1850s, and Burne-Jones had also made a few designs for Lavers & Barraud, another progressive firm which encouraged younger artists to experiment, rather than simply to imitate medieval glass.[36] Thus, having learned about the problems and possibilities of stained glass design, the partners felt confident that they had mastery of the medium.

The link with Powells was, moreover, of enduring importance. Arthur Powell, who ran the Whitefriars glassworks between 1840 and 1894, was dedicated to producing glass of the highest quality according to principles laid down by Charles Winston.[37] Winston (1814–64), a barrister by profession, was a friend of Rossetti with a deep knowledge of medieval stained glass. In his book, *An Enquiry into the Difference of Style Observable in Ancient Glass Paintings* (1847), he had traced the history of medieval stained glass, contrasting it with the debased form of glass painting of more recent times. He raged against the contemporary tendency to imitate oil painting on large panels of thin and featureless glass. A typical example – and one known to Morris and his friends – was the west window of New College Chapel, Oxford. Designed by Reynolds, this was no more than a copy of a Corregio painting coloured with opaque enamels.[38] This was seen as utterly reprehensible. If stained glass were ever again to achieve the standards of past ages, it would, Winston argued, require full recognition of the essential nature of the medium. The emphasis must be on transparency and the use of pure colour. Shading and painting *on* the glass should be kept to a minimum. Winston looked to the qualities of the glass itself (its varying thickness, refractive qualities and colour) to provide

51

much of the character of the window. This in turn led him to analyse the chemistry of old glass, and the methods used in its manufacture. He discovered the secret of producing glass in various pure colours. By the mid-1850s Powells was making glass in a manner recommended by Winston, who continued advising the firm for the rest of his life. MMF & Co. was a major beneficiary of the scholarship and committed experimentation of Winston and Arthur Powell. Throughout its life, the firm never used any glass other than the best Powells could supply.[39]

Morris and his partners naturally shared much of Winston's thinking on designing for stained glass. Of particular appeal was his use of the notion of 'truth to the medium' which echoed the recommendations of Pugin, Ruskin, and other influential critics. The extent to which MMF & Co. appreciated this point is made clear in the following extract from a company brochure, compiled as a guide to its exhibits at the Boston Foreign Fair of 1883. The text is not so much a description of the work on display, as an exposition of the principles which from its inception had underlain the firm's production of stained glass.

> As regards the method of painting and the design, our glass differs so much from other kinds that we may be allowed a word in apology. Glass-painting differs from oil-painting and fresco, mostly in the translucency of the material and the strength, amounting to absolute blackness of the outlines. This blackness of outline is due to the use of lead frames, or settings, which are absolutely necessary for the support of the pieces of glass if various colours are used. It becomes therefore a condition and characteristic of glass-painting. Absolute blackness of outline and translucency of colour are then the differentia between glass-painting and panel or wall painting. They lead to treatment quite peculiar in its principles of light and shade and composition, and make glass-painting an art apart. In the first place, the drawing and composition have to be much more simple, and yet more carefully studied, than in paintings which have all the assistance of shadow and reflected lights to disguise faults and assist the grouping. In the next place, the light and shade must be so managed that the strong outlines shall not appear crude, nor the work within it thin; this implies a certain conventionalism of treatment and makes the details of a figure much more an affair of drawing than of painting; because by drawing – that is, by filling the outlines with other lines of proportionate strength – the force of the predominant lines is less unnatural. These, then, are the first conditions of good glass-painting as we perceive them – well-balanced and shapely figures, pure and simple drawing, and a minimum of light and shade. There is another reason for this last. Shading is a dulling of the glass; it is therefore inconsistent with the use of a material which was chosen for its brightness. After these we ask for beautiful colour. There may be more of it, or less; but it is only rational and becoming that the light we stain should not be changed to dirt or ugliness. Colour, pure and sweet, is the least you should ask for in a painted window.[40]

The design and manufacture of stained glass was an activity which, in one capacity on another, involved all the partners in MMF & Co. There was from an early date a commitment to a house style, and a recognition that

there was much more to making a window than drawing Biblical figures. It was therefore agreed that 'the names of designers of cartoons be withheld from the public'.[41] There was an obvious advantage, of course, at a time when demand was buoyant, in being able to delegate part of the design work to less skilled artists like Marshall, whilst trading on the reputations of Rossetti, Madox Brown and Burne-Jones. These three, in fact, did most of the designing for large figures; Rossetti making thirty-six cartoons between 1861 and 1864, Madox Brown approximately 150 between 1862 and 1874, and Burne-Jones 144 between 1862 and 1865 alone.[42] After the mid-1860s Burne-Jones emerged as the firm's principal designer; unlike the others he generally refused commissions from competing firms. Charles Sewter, in his authoritative book *The Stained Glass of William Morris and His Circle*, credits Burne-Jones with a total of 682 cartoons between the founding of the firm and his death in 1898, many of which were used again on numerous occasions.[43] Morris was never the equal of Burne-Jones, Rossetti and Madox Brown as a designer of stained glass. He was, however, far abler than has been reported by Mackail and other authorities. It is true that most of his designs were small traceries and the like, but, of the 174 designs identified by Sewter, several are of large figures which had such appeal that they were often repeated at the request of customers.[44]

Whatever judgement is passed on Morris the figure designer, there can be no doubting the greatness of his contribution to the art of stained glass making in Britain. This derived, not from a narrow concern with subject, but from a broader vision, and his complete mastery of the manufacturing process. Almost from the beginning, he played the central co-ordinating role in the business. He was responsible for interpreting the design, selecting the glass, and overseeing the assembly and installation of the finished window. The whole process was later described by George Wardle, general manager of the firm between 1870 and 1890. The scheme or general plan of the window was settled by Morris in consultation with the client. He would then distribute parts of the job to selected artists for them to produce the required artwork. Once the cartoons were ready, he examined the stock of glass, or 'pot metal' as it was known, and told the foreman of the glass painters which pieces to use. The various parts of the design were then handed over to the painters, 'whose work as it went on Mr Morris was able to watch, though he usually reserved any comments until the painter had done all he thought necessary'. Morris avoided stippling and shading as far as possible, but it was of course necessary to add fine detail to faces, hands and draperies, and this was done through the application of a yellow stain which was then fired on to the pot metal. Once the figure or picture had been burnt and leaded up, it might be accepted, retouched, or, if seriously flawed, rejected and the part begun again. When all parts of a window were ready, Morris turned to its appearance as a whole. In cramped

workshops this was no easy matter, for it was seldom possible to assemble an entire window for examination. But 'here again Mr Morris showed how quick was his perception and how tenacious his memory. In passing all the parts of a large window one by one before the light he never lost sight of the general tone of the colour or of the relation of this part and that to each other.'[45] All important work he would look at again after it was in place.

There were of course other companies just as technically skilled in the production of stained glass. 'Morris' windows were, however, always distinctive. This was due partly to the ability of the design team; but also to the synthesis of medieval example and naturalistic Pre-Raphaelite influence. As Marilyn Ibach has noted, the original quality of the firm's glass was achieved by 'moving away from the pietistic Gothic style and into a naturalistic and individualistic style whose lines were artistic rather than formally religious'.[46] Above all, though, the creation of successful windows was dependent upon Morris's 'faultless eye for colour', and the skill with which he interpreted the designs he received. 'Morris' windows were characterised by the use of strong masses of pure colour, and the bold use of leadings as an integral part of the design.

By 1864, the firm was beginning to outgrow its premises at Red Lion Square. The idea of moving the workshops to Upton was seriously discussed. It was planned to add a new wing to Red House for the Burne-Joneses, and workshop space was found nearby at low rentals.[47] For a while this proposal reawakened the friends' youthful schemes for a 'palace of art'. A series of misfortunes, however, ruined all their plans. Georgiana Burne-Jones suffered a severe bout of scarlet fever, and gave birth prematurely to a child which soon died. Her husband, himself in delicate health, was experiencing financial worries which kept him in London. Morris too suffered a severe bout of rheumatic fever in the autumn of 1864, and for a while at least was unable to make the daily journey to Red Lion Square. Reluctantly, in November 1865, he was obliged to give up Red House. It was sold early the next year, together with much of the furniture, which was too cumbersome to move. Morris never set eyes on the house again, confessing that the very sight of it would be more than he could bear.[48]

The partners found larger premises in the summer of 1865 at 26 Queen Square, Bloomsbury, which was taken on a long lease of twenty-one years. Queen Square was described by Henry James in 1869 as 'an antiquated ex-fashionable region, smelling strongly of the last century'.[49] Its large, dignified houses dated from the reign of Queen Anne, but they were desirable residences no longer, and many had been divided and given over to light industry. It is not difficult to appreciate the distress felt by the Morrises on giving up Red House to 'live over the shop' in Queen Square. The ground floor of the house was converted into offices and a showroom; a large ballroom became the main workshop, and other workshops were set up in a small courtyard at the rear of the building. Later, as the volume

of business continued to grow, additional space was taken nearby at Great Ormond Yard.

The move to Queen Square may have been unpleasant for the Morris family, but it was certainly good for the business as a whole. When George Wardle first met Morris at Red Lion Square in 1864 he formed the impression that MMF & Co. was rather chaotic and struggling to make a profit. When he joined the firm in 1865, however, he found things much improved. Large sums of money had been spent already on the showroom and living quarters at Queen Square, and the decorative effect was, according to Wardle, 'original and though extremely simple, very beautiful'.[50] The general excellence of Morris and Webb's work at Red House and Queen Square was becoming known to wealthier, more artistically appreciative members of middle-class society, stimulating requests for ideas and plans for the decoration of private houses. Webb, moreover, 'in his practice as an Architect, was glad to have his houses finished by Mr Morris, when he could so far prevail with the client'.[51] One of the earliest commissions for house decoration came from the leading watercolourist Birket Foster. His house, The Hill, at Witley, Surrey, was built in the early 1860s in the Tudor revival style. Foster probably came into contact with the firm through his acquaintance with Rossetti. Morris went to The Hill when it was still being built, and devised an ambitious scheme of interior decoration. It was not all carried out, but enough was achieved to imprint MMF & Co.'s character upon the house. An interesting feature was the use of stained glass panels for a secular project. One set, designed by Burne-Jones, Ford Madox Brown and Rossetti, depicted *King René's Honeymoon*. Another, in the hallway, was based upon Chaucer. The firm also provided tiles for many of the fireplaces. Burne-Jones drew inspiration from the tales of *Beauty and the Beast*, *Sleeping Beauty*, and *Good Women*. Webb designed blue and white patterned tiles, a bookcase and cabinet. A frieze based on the life of St George remained unfinished until 1867.[52]

From about 1866, the partners began work on a few large commissions for public buildings. The most important of these were the decoration of the Tapestry Room and Armoury at St James's Palace and the Green Dining Room at the South Kensington Museum (now the Victoria and Albert Museum) in 1866–67. In both cases the decorative plan was largely the work of Philip Webb, and featured dark panelling on the lower walls. St James's Palace was slightly the earlier of the two, the work being carried out between September 1866 and January 1867. It featured painted pattern work in olive green and gold on doors, dado panels, ceilings, cornices and window cases.[53] The Green Dining Room (1867), in some ways a more elaborate venture, included gesso wall decoration by Webb, and stained glass and painted panels by Burne-Jones depicting the seasons of the year.[54] Aymer Vallance captures the mood of the room in

55

the following passage from his biography of Morris, published in 1897:

> In this room are two windows, containing in all six panels, with figures designed by Burne-Jones in 1866 and 1867. These panels form a horizontal band across the windows, with roundels – another form of window decoration revived by Morris – above and below, of pale greenish white glass painted with a delicate pattern of conventional ornament. The walls of the dining room are panelled with wood, painted green and rising from the floor to about half the height of the room. The upper panels are gilt, the majority of them being decorated with painted sprays of various trees and flowers, while at intervals are panels with decorative figures, in place of these floral designs, painted on them. . . . The wall-space above the panelling is covered with a conventional pattern of foliage in relief; and round the top runs a frieze with panels depicting a chase of animals.[55]

The room is no longer used as a dining room, but has recently been restored and is now used to display some of the Victoria & Albert Museum's collection of works by Morris & Co. Although rather dark for modern tastes, it is nonetheless striking, and an important example of the firm's early work.

By the end of 1867, therefore, MMF & Co. had executed some very substantial and prestigious projects, for both ecclesiastical and secular buildings. How, then, was such a young firm able to obtain such important commissions?

To begin with, it has already been made clear that its products were of a high quality. This was not surprising given the artistic ability – amounting to genius in some cases – of the partners, and the range of skills and interests they possessed. The success of the stained glass produced by MMF & Co., it has been argued, was attributable to the originality of its designs, coupled with a high level of craftsmanship and a mastery of colour. The praise bestowed on other products by the judges at the 1862 Great Exhibition provides just one indication of the quality of the firm's early work.

More generally, MMF & Co. entered into business at a time of market growth, equipped with a good understanding of the needs of fashionable architects. It is important to recognise the substantial demand created by the dramatic upswing in church building which took place in the nineteenth century. Behind the expansion of the ecclesiastical market was the widely held belief that the Established Church was losing its hold on the people of Britain as rapid population growth and urban expansion brought about fundamental changes in society. This notion of the 'church under threat' persisted throughout the nineteenth century, fuelled by prolonged and heated debates over church reform.[56] The Religious Census of 1851 seemed to confirm the worst fears of the Establishment concerning the drift away from the Church of England, for almost half of all the churchgoers recorded by the enumerators were Nonconformists or Roman Catholics. Furthermore, the building of new churches had simply

not kept pace with the increase in population, especially in the rapidly expanding conurbations of London, the Midlands and the North of England.[57]

The first national effort to extend the presence of the Established Church was a consequence of social unrest and fear of revolution in the years of turmoil following the end of the French Revolutionary Wars. A Church Building Commission was created in 1818, charged with increasing church provision. Funds voted to the Commission subsequently helped build 611 churches, but most of the money was spent in the 1820s, and, as the capital sums disbursed began to decline, the work was taken up by others, notably the Ecclesiastical Commission and private church building societies.[58] Private benefactors, too, played their part: the Oxford Movement seems to have stimulated 'rich and pious laymen to vie with the state as patrons of ecclesiastical architecture'.[59] In all, the Church of England built 1,727 new churches in England and Wales between 1840 and 1876, and rebuilt or extensively restored a further 7,144, at a total cost in excess of £25 million. Between 1861 and 1866 alone, the Ecclesiastical Commissioners created 397 new parishes.[60]

All this activity meant that in the middle decades of the nineteenth century more churches were being built or enlarged than at any time since the close of the thirteenth century. And all of them had to be furnished and embellished to increasingly high standards. There was a movement from the somewhat plain Commissioners' churches of the 1820s and 1830s towards the more scholarly Gothic insisted upon by the Ecclesiological Society; and, predictably, the quest for historical and symbolical accuracy meant that churches became more elaborate and more costly.[61] Demand burgeoned for items such as altar frontals and other embroidered work, carving in wood and stone, brass and iron work and the like. Stained glass was particularly favoured, especially after the 1840s and 1850s when memorial windows, or 'grave stones' as Morris called them, became increasingly fashionable.[62] Firms like MMF & Co. benefited enormously from these trends.

It took specialised knowledge to take full advantage of these opportunities. Morris, in particular, as the main point of contact with clients, had to understand their wishes and be able to translate them correctly; advising as necessary on points of detail or the entire content of designs. In this work, his knowledge of the Bible, contemporary theological issues, church ritual and medieval architecture were all valuable assets. On occasion clients would have a subject in mind for a window, and after discussion a general plan would be agreed. At other times, Morris took the lead in suggesting subjects and the way they might be treated. According to George Wardle, some clients required a good deal of persuading, sometimes obliging Morris to compromise before plans were finally settled:

57

The scheme or general plan of the window was settled by Mr Morris, with the concurrence of the client, sometimes not without his extreme opposition. For some customers, pushed by I know not what influence to employ us, resisted with fear and astonishment the proposals submitted to them and the discussion ended, if not by a refusal to go further, then, sometimes in a compromise which impaired the originality and beauty of the first conception.[63]

Other sources indicate a less insistent approach, as in April 1863, when the partners agreed to write to Mrs Craufford, a benefactress, about the glazing of the south transept of the church at Lyndhurst, and offering three alternative combinations of subjects, drawn from a list which included 'the Fall, the Deluge, the Passage of the Red Sea, Saul chosen King, Rebuilding the Temple, the Annunciation, Christ bearing the Cross, the Crucifixion, the Resurrection, and Jonah spewed out of the whale's belly'.[64] In the opinion of Helene Roberts, MMF & Co. was highly responsive to prevailing preferences and restrictions: 'Morris & Co. windows depicted prophets and angels rather than saints; sin and damnation and other problematic themes were avoided in nearly all their designs for stained glass.'[65]

Ensuring that the window met the customer's expectations was almost as important as selecting the right subject. If a design was inappropriate or ineffective in some way, Morris would not accept it until the required changes had been made. Thus in April 1863 it was 'agreed that the managers write to Rossetti asking him to alter the costume of his Mary Magdalene for Bradford east window on account of inappropriateness for its destination'.[66] At a time when the finer points of church ritual and decoration were heatedly debated, success in the stained glass business evidently required a high degree of sensitivity and tact.

But rapid growth in demand, an understanding of the market and high quality products do not completely explain the firm's successes of the 1860s. Members of the firm made effective use of personal contacts in securing commissions, and efforts of this type were crucial to establishing the reputation of MMF & Co. The firm had done this from the outset. Morris's letter to the Revd F. B. Guy, requesting a list of clergymen to circularise, has already been noted. Morris and Webb obtained work from their mentor Street – such as the east window of St John the Evangelist, Torquay – and other architects of their acquaintance. Many early commissions derived from the artistic circles in which the partners moved, the work for Birket Foster being a good example of this.

Rossetti, however, with his forceful and engaging personality, was the firm's most effective ambassador. He had a keen eye for a deal, and a wide circle of friends and admirers; he launched the project to decorate the new Union Debating Hall at Oxford, designed by his friend Benjamin Woodward; he recommended Madox Brown and Burne-Jones to Powells as stained glass designers.[67] And once the firm was set up, Rossetti began to use his connections to win commissions for the partners. It was almost

certainly he who persuaded early patrons like Birket Foster and G. F. Bodley (a fellow member of the Hogarth Club) to use the firm. Rossetti was also consulted for advice about stained glass on a number of occasions by clergymen and others who were involved in building or restoring churches. Naturally, he advised them to commission glass from MMF & Co.[68] But his greatest coup came when he persuaded William Cowper (later Lord Mount Temple), First Commissioner of Public Works, to engage MMF & Co. to carry out the redecoration at St James's Palace in preference to the currently fashionable firm of Crace & Co. of Wigmore Street, which had previously been responsible for decorative work at the Palace. Rossetti had met Cowper and his wife through Ruskin, and, with typical charm, he managed to persuade them of the superior artistic qualities of his own firm.[69]

It was not all plain sailing for the Morris business, however. The experience of the 1860s showed clearly that the firm's early confidence in its ability to influence public taste and lead the market was based on somewhat naïve assumptions. In 1861, Morris had expressed to F. B. Guy the belief that his was 'the only really artistic firm of the kind',[70] and the prospectus made similar claims more publicly. Certainly this might have been true during the first fifteen years or so of Victoria's reign, but not by the 1860s. In the opinion of Peter Floud, 'the most severe strictures so often applied indiscriminately to Victorian taste as a whole are entirely justified if only directed against the products of this initial period'.[71] There was a great revival of design in the middle decades of the nineteenth century, and it was by no means solely consequent upon the work of William Morris and MMF & Co. In fact, it was already under way well before the establishment of the firm. Concern over the training of artists and designers led to a Royal Commission in 1836, and the establishment by the government of a School of Design in the following year. A prominent part was also played by the Royal Society of Arts, whose exhibitions in the 1830s and 1840s to encourage 'art manufactures' were the forerunners of the Great Exhibitions of 1851 and 1862. One might mention too the work of designers like Pugin, Owen Jones and Christopher Dresser, all of whom stressed the need for good design.

By 1861, there already existed a small but growing number of firms trying to broaden the market for original, good quality work. Lavers & Barraud, Clayton & Bell, and Heaton, Butler & Bayne specialised in stained glass; Skidmores of Coventry and the Birmingham firm of Hardmans in ecclesiastical furnishings. F. B. Barraud and N. M. Lavers began their careers with Powells, and like MMF & Co. continued to use glass from the Whitefriars works after setting up in business together in the early 1860s. As already noted, they employed talented designers and sought to produce high quality glass. Clayton & Bell was another relatively young firm, established in 1856 by John Clayton and Alfred Bell, whose glass was

probably at its best – technically and artistically – in the late 1850s and early 1860s. The partnership of Heaton, Butler & Bayne dated from 1862, although Clement Heaton, its senior partner, had run a stained glass workshop since 1852. It took over the mantle of the most original firm working in the Gothic tradition when the quality of Clayton & Bell's glass began to decline after about 1862.[72] The Skidmore Art Manufactures Co. was established by Francis Skidmore in the early 1850s, and specialised in metalwork for churches. It was responsible for the ironwork at Oxford Museum, and for cathedral screens at Hereford, Ely and Lichfield (all to designs by George Gilbert Scott). Skidmore was 'one of the most active and adventurous apostles of Gothic in general, and medieval metalwork in particular'.[73] Likewise, members of the Hardman family were 'among the first who endeavoured to revive the principles of good design in eccles-iastical metal-work and ironmongery'.[74] John Hardman, a Roman Cath-olic, was a close friend of Pugin, who designed an enormously varied range of ecclesiastical metalwork for Hardmans, including crucifixes, candlesticks, holy water stoups, thuribles, chalices and monstrances.[75]

Original and enterprising firms such as these were understandably affronted by MMF & Co.'s sweeping dismissal of the quality of contem-porary work. The designer Lewis F. Day, for instance, recalled having heard about 'a set of amateurs who are going to teach us our trade' when he joined Lavers & Barraud around 1866.[76] In practice, therefore, whatever the beliefs of the partners, MMF & Co. from the very start faced strong competition in both quality and price.

It is impossible to state with certainty how fierce price competition was between the various stained glass makers. Warington Taylor (engaged as a manager of MMF & Co. in 1865) thought it was inconsequential, and was forever complaining that Morris set his prices at too low a level. He argued that 'we only do twenty windows per annum therefore our price must be high . . . This amount of work we shall always get: therefore it is only loss of time to do cheap work.' He recommended that the firm should never charge less than £2.50–£3.00 per square foot of stained glass, plus a charge for the design work.[77] But considering that in 1865 Clement Heaton could quote £1.50–£2.00 per square foot as the price of the best English glass,[78] it is hard to believe that Warington Taylor's assessment was realistic. It seems that at times the firm would, in view of the excellence of its work, have had enough leeway to charge premium prices, but that the size of any such premium could not have been very great.

The commercial dangers of artistic rivalry, changing tastes and market fluctuations also revealed themselves during the later 1860s. The number of stained glass commissions rose impressively until 1865, but thereafter there was a steady decline, from 20 in 1866 to 10–13 a year in 1867–70, down to 6 in 1871 (see Figure 2). This decline was primarily a consequence of the general recession which was experienced by the British economy in

the second half of the decade; in the building industry, gross domestic fixed capital formation in house building maintained a steady upward trend, but expenditure on ecclesiastical and public works fell sharply between 1865 and 1869.[79] However, the decline in the number of commissions was also due to the fact that by the late 1860s most Morris windows were being designed by Burne-Jones, and his increasingly pictorial style found less and less favour. Although the problem later became less serious as Morris glass acquired a certain *cachet* of its own, its distinctiveness undoubtedly affected sales at a time when leading architects and their clients generally wanted straightforward Gothic Revival work. Both Street and G. G. Scott returned to their old favourites Clayton & Bell, whose thirteenth-century Gothic style was more to their liking; and other Gothic Revivalists who had briefly experimented with Morris glass – Butterfield, William White and J. P. Sedding, for example – hardly ever did so after the 1860s. Bodley and his partner, Thomas Garner, showed an increasing preference for the work of C. E. Kempe and Burlison & Grylls.[80]

Figure 2 Number of stained glass commissions received by Morris, Marshall, Faulkner & Co. and Morris & Co., 1861–96

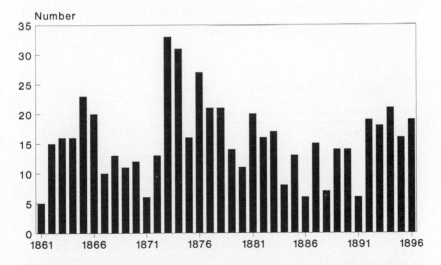

Source: A. C. Sewter, *The Stained Glass of William Morris and his Circle* (New Haven, CT, 1975), Vol. II, passim.

Tough competition had important consequences for the finances of MMF & Co. According to George Wardle, it was not until 1866 that the firm declared a profit,[81] and turnover and profits were so small before the later 1860s that the firm could not repay the £600 start-up loans made by Morris and his mother. In 1866, for instance, stained glass sales of £2,300 (77 per

cent of total sales) earned a gross profit of £250, or about 11 per cent of turnover.[82] Fortunately, other parts of the business had begun to fare rather better, and, in particular, the work carried out by the firm at St James's Palace and the South Kensington Museum in 1866–67 proved lucrative – so much so that the partners were all paid back their original £20 investment in the firm, and a start was made at repaying the £600 borrowed from the Morris family.[83]

The slump in MMF & Co.'s stained glass business in the second half of the 1860s had important consequences for individual partners and the firm as a whole. As the number of commissions dwindled, the enthusiasm and feverish creativity of the early years began to fade. It became ever more obvious that the business would never, in its existing form, provide large incomes for the partners. Apart from Morris, the best paid were Burne-Jones, Webb and Madox Brown. From Table 3 it can be seen that earnings in the 1860s were very modest, and in the trough of 1867, if the £20 capital repayment made to each partner is omitted, Burne-Jones earned just £35.80, Webb £40.45 and Madox Brown £28.00. For Madox Brown this was hardly disastrous. MMF & Co. was never more than a sideline for him: his annual income between 1862 and 1867 averaged £829, peaking at £1,383 in 1865.[84] But Burne-Jones and Webb were not so well placed. Both depended more heavily on their earnings from the firm, and were hard hit by the slump in church sales. In 1867 Burne-Jones actually ended the year

Table 3 Earnings and drawings of Ford Madox Brown, Edward Burne-Jones and Philip Webb from Morris, Marshall, Faulkner & Co., 1861–69*

Year	Madox Brown Drawings (£)	Burne-Jones Earnings (£)	Drawings (£)	Webb Earnings (£)	Drawings (£)
1861	—	13.00	—	74.00	1.70
1862	73.86	133.50	130.00	78.43	54.80
1863	—	147.86	90.73	67.30	108.67
1864	65.99	92.85	69.28	37.75	33.18
1865	25.35	180.15	222.63	56.83	84.70
1866	53.35	137.75	156.91	98.15	124.00
1867	48.00	55.80	151.35	60.45	64.43
1868	n.a.	112.50	38.19	56.46	62.75
1869	105.65	78.15	96.43	27.99	23.02

Notes: * Drawings = the net amount removed from a partnership account in cash, kind or calls on shares. Earnings = the net amount credited to a partnership account for work done, attendance at meetings (1862–64 only), expenses, dividends or capital returned. No details are available for Madox Brown's earnings, and it has been assumed that like the other partners he paid a £19 call on his share in 1862.

Sources: Lady Lever Art Gallery, Port Sunlight, Account Book of Ford Madox Brown; Fitzwilliam Museum, Cambridge, Account Book of Sir Edward Burne-Jones; City of Birmingham Museum and Art Gallery, Account Book of Philip Webb.

with a deficit of £91 on his partnership account, having drawn far more than he had earned in commission.[85] In May of the same year, Webb, who had always worked for MMF & Co. at low rates of pay and who was now seen to be experiencing hard times, was offered £80 per annum 'as consulting manager of the firm to commence from December last'.[86]

Other partners had long since recognised that their future did not lie with MMF & Co. When George Wardle joined the firm in 1866 he found that Rossetti and Marshall were already no more than sleeping partners. Painting rather than designing occupied Rossetti in these years. And Marshall, who even at the height of his commitment had to be chased for designs,[87] had never given up his career in surveying. Faulkner keenly felt his inability to contribute to the creative side of the business, and, although he remained a partner, he returned to Oxford in the spring of 1864 to a fellowship in mathematics at University College. Regular partners' meetings ceased after his departure, and responsibility for the conduct of the business fell increasingly on Morris. Only on occasions when very important matters had to be settled did all the partners again assemble.

Morris did not particularly welcome the challenge of increased managerial responsibilities. He may have had the ability and experience needed to keep MMF & Co. moving forward, but at this stage he was unwilling to dedicate himself to the task. After Faulkner's departure, he continued to supervise the flow of work and make designs, but much of his time was given over to other pursuits. The writing of poetry, in particular, laid claim to much of his time.

Morris's first published volume of poetry, *The Defence of Guenevere* (1858), had not been well received either by the critics or the public, and he had worked only intermittently on literary projects for some years, throwing himself into the decoration of Red House and the launch of MMF & Co. By the mid-1860s, however, the urge to write had again grown strong. He embarked upon two of the longest narrative poems of the Victorian era, the *Life and Death of Jason*, published in 1867, and *The Earthly Paradise*, published in three volumes between 1868 and 1870. Morris's rendering of the story of Jason leading the Argonauts in search of the Golden Fleece was very favourably received by contemporaries who appreciated the medieval spirit imparted by the author to a classical subject. According to Faulkner, what appealed in *Jason* was its 'clarity, picturesqueness, decorum, tenderness and reticence'.[88] And its success encouraged Morris to go on with a projected series of stories under the title *The Earthly Paradise*.

In the book, which runs to over 42,000 lines of rhymed verse, Morris tells how a group of fourteenth-century Norwegian mariners set sail in search of an earthly paradise. They eventually arrive in a distant land where they are welcomed by the local people. Two cultures thus meet, and each

month for a year hosts and guests entertain each other by telling one of the great stories of their people. Through this device Morris is able to relate twenty outstanding stories, alternately classical and medieval. He had found a winning formula. The first volume alone was reprinted five times between 1868 and 1870, and sales were so good that a new contract was drawn up giving Morris a greater share of the profits. The poems were considered ideal family reading, and for most of the nineteenth century Morris was more widely known as the author of *The Earthly Paradise* than as a designer, manufacturer or political activist.[89]

Morris was a prodigious worker with a remarkable capacity to shift effortlessly between very different tasks. George Wardle never lost the astonishment which he felt when observing him in action:

> While he was ... designing for painted glass, for wallpapers, textiles and occasionally for wall decoration, superintending also the whole of the business: he was engaged also with his poems, more or less as opportunity served. His faculty for work was enormous and wonderfully versatile. He could turn his mind at once to the new matter brought before him and leave the poetry or the design without a murmur. How rapidly he wrote you know, almost without correction, page after page, but I may say that I always admired the easy way in which he turned from this ordinarily engrossing pursuit to attend to any other and to resume his favourite work without apparently the loss of a single thread, as calmly as a workman goes back to the bench after dinner.[90]

But, exceptional as Morris may have been, he could not attend with equal efficiency to all aspects of the business whilst writing major works of literature. The effective scheduling of projects, for instance, seems at times to have been neglected. One illustration is MMF & Co.'s failure to complete its work on time at Jesus College, Cambridge, in 1866.

In that year the firm won a commission to decorate the nave roof, recently rebuilt by Bodley, with flat decorated panels and a frieze of angels. The work was to be finished by Christmas, but in November Morris was obliged to write to the Dean, E. H. Morgan, requesting an extension of six months:

> The flat part of the roof I should fancy would be finished in about three weeks, but I am sorry to say that it will be quite impossible to finish the figures round the coved part by the time you mention; I am vexed that this should be the case and would do anything that was possible that the College might not be inconvenienced, but work of this sort cannot be hurried, as the men who are able to do it are very few; if it was merely a case of flat painting we could make a push to get the work done quicker than usual by putting on more men, but for this artistic work they are not to be had.[91]

Morgan was hardly pleased by Morris's explanation, but, after Bodley had reassured him that the firm's work would be well worth waiting for, an extension was granted until 1 April 1867. The job was completed just one week later.[92]

Morris was not blind to the management problems of MMF & Co. after the loss of Faulkner. In 1865 he took on a replacement in the shape of George Warington Taylor, described by Mackail as 'a Catholic, of good family, who had been educated at Eton and was afterwards for some time in the Army; but he had been unfortunate in his affairs and was then almost penniless'.[93] Warington Taylor had met Morris through mutual friends and had impressed with his knowledge of art and music. He was young, intelligent, of good character; and when the opportunity arose Morris hired him. This was a mixed blessing. Warington Taylor's most positive qualities were his organisational good sense, his eye for detail, and his forthright attitude. Georgiana Burne-Jones observed that 'within a few weeks of his appointment the rumour spread among us that he was keeping the accounts of the firm like a dragon, attending to the orders of customers, and actually getting Morris to work at one thing at a time'.[94] He also recognised the need to organise the flow of work in a more efficient manner, matching jobs with resources, and encouraging the partners to meet deadlines. He did his best to reduce expenses, and to hold production costs and design fees down to realistic levels. Morris's personal expenses were singled out for comment, and Edward Burne-Jones's account book included a sour note that his design fee for 'Six angels with kids . . . I regret to say was questioned by W. Taylor.'[95]

Yet Warington Taylor was by no means the 'expert in business methods' described by Mackail.[96] He was shrewd enough to recognise that MMF & Co. could do better than it was doing in the ordinary commercial sense, but his remedies to problems were invariably short-sighted and often wrong-headed. He showed precious little understanding of the market, and his only proposal for increasing turnover was to pressurise Morris, Burne-Jones and Webb to keep up the supply of designs. He told Rossetti in 1867 that 'Morris and Ned will do no work except by driving and you must keep up the supply of designs. Every design less that we get is so much less window.'[97] In expressing such a view, Taylor was reflecting the emphasis on the uniqueness of the product which was characteristic of the early years of MMF & Co. There was no awareness of the possibilities of serial production or the use of outside manufacturers – both of which played a major part in the firm's increasing prosperity after 1870. Nor is there any sign of a search for new markets as a means of generating a higher and more reliable income. Indeed, Warington Taylor would have liked to restrict production to stained glass. He saw few opportunities in the secular market and believed that there was no point in producing more designs for wallpapers, textiles or carpets. Morris must have been quite relieved to be freed from his nagging and narrow-mindedness when he was forced by illness to retire to Hastings in 1866. Out of respect for Taylor's positive qualities as a man and as a colleague he retained the title business manager of MMF & Co. until his death from tuberculosis in February 1870,

aged thirty-two. It speaks well of him that he retained an interest in the firm until the last.[98]

When Warington Taylor retired, his duties passed to George Wardle, who had been taken on a few months earlier as 'draughtsman and bookkeeper and utility man generally'.[99] Morris found Wardle far more congenial than Warington Taylor. He had skills as a designer and craftsman, shared Morris's enthusiasms, and was generally more in touch with the spirit of the enterprise, appreciating its origins and ideals as well as the need to make money. In 1870, following Warington Taylor's death, Wardle was appointed business manager – a position he retained until forced into retirement by illness in 1890.

The efforts of Taylor and Wardle may have improved the organisational efficiency of MMF & Co, but neither had the ideas or inspiration needed to restore to the business its lost impetus. The strength of the firm lay in the originality and quality of its products: its weaknesses stemmed from the small size and variability of its main market – that for stained glass. To break free of this restriction, the firm needed to expand its horizons, to diversify and exploit new markets. This was not at odds with the original ideals of the business as laid down in its prospectus in 1863: MMF & Co. might keep faith with its original concept whilst extending its influence to new spheres. The only person with the vision and authority to accomplish this was William Morris. Between 1870 and 1874, he transformed the firm from a small, specialised concern known mainly to artists and architects into a diversified and lucrative enterprise widely known amongst the affluent classes.

Notes
to chapter 2

1 Mackail, *Life*, Vol. I, pp. 152–3; Faulkner, *Against the Age*, p. 30.
2 Mackail, ibid., p. 149.
3 *Athenaeum*, 10 Oct. 1896.
4 See, *inter alia*, Henderson, *Life, Work and Friends*, p. 63.
5 Hammersmith and Fulham Archives Department (hereafter HFAD), DD/235/1, MMF & Co., Minute Book, 1861–74. The account books of Webb and Burne-Jones have survived, and are respectively in the City of Birmingham Museum and Art Gallery and the Fitzwilliam Museum, Cambridge.
6 HFAD, MMF & Co., Minute Book, 15 April 1863. Also see 10 Dec. 1862, 28 Jan. 1863, 1 April 1863.
7 Boiling Well Mine, Phillack. See Collins, *West of England Mining Region*, p. 417; J. H. Murchison, *British Mines Considered as an Investment* (1855), pp. 85–6; J. A. Phillips and J. Darlington, *Records of Mining and Metallurgy* (1857), p. 257.
8 Mackail, *Life*, Vol. I, pp. 91–3, 121–4, 157.
9 J. Mordaunt Crook, *William Burges and the High Victorian Dream* (1981), p. 75; A. Vallance, *Life and Work of William Morris* (1897), pp. 25–6; Watkinson, *Pre-Raphaelite Art and Design*, pp. 143–4.
10 Sir H. Cole, *Fifty Years of Public Work* (1884), Vol. II, pp. 179–80.
11 J. Ruskin, *The Two Paths* (1859), in Cook and Wedderburn, *Complete Works of John Ruskin*, Vol. XVI, p. 319. Also see *idem*, 'The Nature of Gothic', in *The Stones of Venice*, Vol. II (1853), p. 169.
12 Ruskin, *The Two Paths* (1859), in Cook and Wedderburn, *The Complete Works of John Ruskin*, Vol. XVI, pp. 344–5.

13 Ibid.
14 J. Gordon-Christian, 'The Archives of the Whitefriars Studios, London', *Artifex*, Vol. I (1968), p. 36; Watkinson, *William Morris as Designer*, p. 41.
15 Gordon-Christian, 'Archives of the Whitefriars Studios', p. 36; M. Morris, *William Morris: Artist, Writer, Socialist*, Vol. I, p. 15.
16 Mackail, *Life*, Vol. I, p. 56.
17 Arts Council, *Morris & Co., 1861–1940: A Commemorative Centenary Exhibition* (catalogue, 1961), p. 18; Mackail, *Life*, Vol. I, p. 150.
18 'The Revival of the Ancient Style of Domestic Architecture', lecture to the Oxford Architectural Society, 1853, reprinted in the *Ecclesiologist*, Vol. XIV (1853), pp. 70–7.
19 Henderson, *Life, Work and Friends*,, pp. 70–1.
20 *Who's Who in Business* (1906), quoted in E. A. Entwisle, *A Literary History of Wallpaper* (1960), p. 145.
21 Vallance, *William Morris*, pp. 87–8.
22 Ibid., pp. 80–1; J. Banham and J. Harris, *William Morris and the Middle Ages* (Manchester, 1984), p. 197; I. Bradley, *William Morris and His World* (1978), p. 28.
23 Vallance, *William Morris*, pp. 57–9; Mackail, *Life*, Vol. I, p. 148.
24 W. S. Blunt, *My Diaries, 1888–1914* (1932), p. 283, 31 May 1896; Companies House, Cardiff, 211T, Devon Great Consols, Annual Returns, 1861–2.
25 HFAD, DD235/1, MMF & Co. Minute Book, passim.
26 Letter from Charles Faulkner to Cormell Price, April 1862, quoted in Mackail, *Life*, Vol. I, p. 157.
27 See, for example, HFAD, DD235/1, MMF & Co. Minute Book, 4 Feb. 1863; 22 April 1863.
28 Henderson, *Life, Work and Friends*, pp. 70–1; A. C. Sewter, *The Stained Glass of William Morris and His Circle*, Vol. I (New Haven, CT, 1974), p. 16.
29 Vallance, *William Morris*, pp. 59–60; *Building News*, 12 Sept. 1862, p. 191, quoted in Banham and Harris, *William Morris and the Middle Ages*, p. 147.
30 1862 International Exhibition Official Report, quoted in Vallance, *William Morris*, p. 59.
31 Banham & Harris, *William Morris and the Middle Ages*, p. 148. There were, however, a few later additions by the rival firm of Burlison & Grylls.
32 M. Harrison, *Victorian Stained Glass* (1980), pp. 42–3; M. Morris, *William Morris: Artist, Writer, Socialist*, Vol. I, pp. 16–23; S. Muthesius, *The High Victorian Movement in Architecture, 1850–1870* (1972), pp. 138–9.
33 Quoted in M. Lister, 'Morris Windows in Bradford Cathedral', *The Bradford Antiquary*, third series, No. 1 (1985), pp. 57–8.
34 Kelvin, *Letters*, Vol. I, pp. 36–7, Morris to Rev. Frederick Barlow Guy, 19 April 1861. The 'clerical tailor and decorator' was the firm of Cox & Sons; its 'ecclesiastical warehouse' at 28 Southampton Street supplied a wide range of materials for the decoration of churches, including church plate, illuminated texts, flower vases and artificial flowers. P. F. Anson, *Fashions in Church Furnishings, 1840–1940* (1960), pp. 201–2.
35 A. C. Sewter, *The Stained Glass of William Morris and His Circle*, Vol. II (New Haven CT, 1975), pp. 234–40. (These figures refer to the number of locations at which Morris glass was installed, not the number of individual windows made.) Victoria & Albert Museum (hereafter V & A), 86. ss. 57, Warington Taylor to D. G. Rossetti, Autumn 1867.
36 Watkinson, *William Morris as Designer*, p. 41; Arts Council, *Morris & Company, 1861–1940*, pp. 33–4; Sewter, *Stained Glass*, Vol. I, pp. 13–16.
37 Gordon-Christian, 'Archives of the Whitefriars Studios', pp. 30–40; Sewter, *Stained Glass*, Vol. I, pp. 13–16.
38 Faulkner, *Against the Age*, p. 31.
39 On Winston, see Harrison, *Victorian Stained Glass*, pp. 21–3; Faulkner, *Against the Age*, pp. 31–2; Mordaunt Crook, *William Burges and the High Victorian Dream*, p. 187; Sewter, *Stained Glass*, Vol. I, pp. 5–8; Watkinson, *William Morris as Designer*, pp. 40–1.
40 G. Wardle, *The Morris Exhibit at the Foreign Fair, Boston 1883* (Boston, MA, 1883), p. 27. For another valuable description of Morris's method, see Kelvin, *Letters*, Vol. II, pp. 184–7, to John Ruskin, 15 April 1883.
41 HFAD, DD235/1, MMF & Co. Minute Book, 10 Dec. 1862.
42 Sewter, *Stained Glass*, Vol. I, pp. 66, 73; F. M. Heuffer, *Ford Madox Brown: A Record of his Life and Work* (1896), p. 343.

43 Sewter, ibid., pp. 241–9; Fitzwilliam Museum, Cambridge, Account Book of Sir Edward Burne-Jones.

44 Sewter, ibid., Vol. II, pp. 241–9.

45 British Museum, Add. MSS. 45350, G. Wardle, 'Memorials of William Morris' (1897), ff. 15–16.

46 M. Ibach, 'Morris & Co. Stained Glass in North America', *Journal of Pre-Raphaelite Studies*, Vol. 5 (1985), p. 111.

47 See, for example, HFAD, DD235/1, MMF & Co. Minute Book, 9 Dec. 1863.

48 Mackail, *Life*, Vol. I, p. 165.

49 P. Lubbock (ed.), *The Letters of Henry James* (1920), p. 16.

50 Wardle, 'Memorials', ff. 2, 5.

51 Ibid., f. 5.

52 For a detailed account of the firm's work for Foster, see J. Reynolds, *Birket Foster* (1984), pp. 89–105. Also see WMG, Box 15b; City of Birmingham Museum and Art Gallery, Account Book of Philip Webb; P. Flick, 'A Victorian Artistic House: The Foster Family at Witley', *Country Life*, 4 Dec. 1975, pp. 1548 et seq.

53 PRO, WORK19 129; E. Shepherd, *Memorials of St. James's Palace* (1894), pp. 126, 370; C. Mitchell, 'William Morris at St. James's Palace', *Architectural Review*, Vol. CI (Jan. 1947), p. 38.

54 PRO, WORK17 24.

55 Vallance, *William Morris*, p. 82.

56 There is an enormous literature on the Church of England and reform in the nineteenth century. See, in particular, G. F. A. Best, *Temporal Pillars: Queen Anne's Bounty, the Ecclesiastical Commissioners and the Church of England* (Cambridge, 1964); S. C. Carpenter, *Church and People, 1789–1889* (1933); O. Chadwick, *The Victorian Church*, 2 vols. (1966/70); F. W. Cornish, *The English Church in the Nineteenth Century*, 2 vols. (1910).

57 K. S. Inglis, *Churches and the Working Class in England* (1963), pp. 23–4; Chadwick, *Victorian Church*, Vol. I, pp. 363–9.

58 Cornish, *The English Church in the Nineteenth Century*, Vol. I, pp. 110–17; B. F. L. Clarke, *Church Builders of the Nineteenth Century: A Study of the Gothic Revival in England* (1938, reprinted Newton Abbot, 1969), passim.

59 H. R. Hitchcock, *Early Victorian Architecture in Britain* (New Haven, CT, 1954), Vol. I, p. 57.

60 *Return showing the Number of Churches (including Cathedrals) in every Diocese in England, which had been built or restored at a cost exceeding £500 since the year 1840* (P. P., 1876 LVIII), pp. 553–658; G. Kitson Clark, *The Making of Victorian England* (1962), p. 169.

61 Clarke, *Church Builders of the Nineteenth Century*, pp. 24–30.

62 Wardle, 'Memorials', f. 2. Also see Harrison, *Victorian Stained Glass*, pp. 20–1; Anson, *Fashions in Church Furnishings*, especially pp. 206–17.

63 Wardle, 'Memorials', f. 15.

64 HFAD, MMF & Co., Minutes, 22 April 1863.

65 Lecture by Helene E. Roberts, Fogg Museum, Harvard, 'Morris's Stained Glass as seen against its Religious Background', reported in the *Newsletter of the William Morris Society* (Jan. 1987), p. 6.

66 HFAD, MMF & Co., Minutes, 22 April 1863.

67 M. Morris, *William Morris: Artist, Writer, Socialist*, Vol. I, p. 15; Gordon-Christian, 'Archives of the Whitefriars Studios', p. 35.

68 See for example, Sewter, *Stained Glass*, Vol. I, p. 85, Old West Kirk, Greenock, and p. 90, Harden, Yorks.

69 Mitchell, 'William Morris at St. James's Palace', p. 38; J. Y. LeBourgeois, 'William Morris at St. James's Palace: A Sequel', *Journal of the William Morris Society*, Vol. III (1974), pp. 7–9; J. C. Troxell, *Three Rossettis: Unpublished Letters to and from Dante Gabriel, Christina, William* (Cambridge, MA, 1937), p. 54.

70 Kelvin, *Letters*, Vol. I, p. 37, to the Revd Frederick B. Guy, 19 April 1861.

71 P. Floud, 'Victorian Furniture', in L. G. G. Ramsay and H. Comstock (eds.), *Antique Furniture* (1958), p. 107.

72 Gordon-Christian, 'Archives of the Whitefriars Studio', p. 33; Harrison, *Victorian Stained Glass*, pp. 29–30, 32–4; Mordaunt Crook, *William Burges and the High Victorian Dream*, p. 187–8.

73 Banham and Harris, *William Morris and the Middle Ages*, pp. 142–3.

74 C. L. Eastlake, *Hints on Household Taste* (4th ed., 1878), p. 153.

75 Ibid. Also see P. Howell, *Victorian Churches* (1968), p. 18; M. Trappes-Lomax, *Pugin: A Medieval Victorian* (1932), pp. 151–2.

76 L. F. Day, 'William Morris and his Art', *Easter Art Annual of the Art Journal* (1899).

77 V & A, 86. ss. 57, Letters from Warington Taylor to Philip Webb and Dante Gabriel Rossetti, 1866–69.

78 *The Builder* (1865), p. 139.

79 B. Weber, 'A New Index of Residential Construction, 1838–1950', *Scottish Journal of Political Economy* (1955), reprinted in B. R. Mitchell and P. Deane, *Abstract of British Historical Statistics* (Cambridge, 1971), p. 239; C. H. Feinstein, *National Income, Expenditure and Output of the United Kingdom, 1855–1965* (Cambridge, 1972), Table 40.

80 Harrison, *Victorian Stained Glass*, pp. 43, 47.

81 Wardle, 'Memorials', f. 4. There may have been a small profit in the previous year, although it was offset by losses carried forward.

82 V & A, 86. ss. 57, Warington Taylor to D. G. Rossetti, autumn 1867.

83 HFAD, MMF & Co., Minutes, 16 May 1867.

84 Lady Lever Art Gallery, Port Sunlight, Account Book of Ford Madox Brown.

85 In this year, Burne-Jones leased a large house in Fulham known as the Grange, which he largely furnished with articles from MMF & Co. See Fitzwilliam Museum, Account Book of Sir Edward Burne-Jones.

86 HFAD, DD235/1, MMF & Co., Minutes, 16 May 1867.

87 Ibid., 5 May 1863.

88 Faulkner, *Against the Age*, p. 44. Also see Vallance, *William Morris*, pp. 146–56.

89 Faulkner, *Critical Heritage*, pp. 9–10; *idem*, *Against the Age*, pp. 46–56; Mackail, *Life*, Vol. I, pp. 192–6; Vallance, *William Morris*, pp. 158–67.

90 Wardle, 'Memorials', f. 17.

91 Kelvin, *Letters*, Vol. I, pp. 46–7, to E. H. Morgan, 27 Nov. 1866.

92 Ibid., pp. 48–50, E. H. Morgan, 3 Dec. 1866; 26 March 1867. Also see D. Robinson and S. Wildman, *Morris & Co. in Cambridge* (1980), pp. 37–9.

93 Mackail, *Life*, Vol. I, pp. 175–6.

94 G. Burne-Jones, *Memorials*, Vol. I, p. 291.

95 Fitzwilliam Museum, Cambridge, Account book of Sir Edward Burne-Jones, entry no. 155.

96 Mackail, *Life*, Vol. I, p. 176.

97 V & A, 86. ss. 57, Warington Taylor to D. G. Rossetti, autumn 1867.

98 C. E. Harvey and J. Press, 'William Morris, Warington Taylor and the Firm', *Journal of the William Morris Society*, Vol. VII (1986), pp. 41–4.

99 Wardle, 'Memorials', f. 2.

Chapter 3

Markets and the decorative arts: Morris the man of business, 1869–75

Morris's achievements in the decorative arts in the later 1860s and the general acclaim accorded his poetry would have satisfied the ambitions of most creative people. Still in his early thirties, with a national reputation and widely admired, he 'occupied a position in some ways as enviable as could have been devised for him by his own imaginings'.[1] Yet for Morris this was a time of enormous stress, both in his private life and in his financial affairs.

The novelist Henry James, after dining at Queen Square in March 1869, penned a short but evocative description of the famous poet for the benefit of his sister:

> Morris himself is extremely pleasant and quite different from his wife. He impressed me most agreeably. He is short, burly, corpulent, very careless and unfinished in his dress . . . He has a very loud voice and a nervous restless manner and a perfectly unaffected and business-like address. His talk indeed is wonderfully to the point and remarkable for clear good sense.

But it was Janey Morris who made the deeper impression:

> Oh, *ma chère*, such a wife, *Je n'en reviens pas* – she haunts me still. A figure cut out of a missal – out of one of Rossetti's or Hunt's pictures – to say this gives but a faint idea of her, because when such a shape puts on flesh and blood, it is an apparition of fearful and wonderful intensity. It's hard to say whether she's a grand synthesis of all the Pre-Raphaelite pictures ever made – or they a 'keen analysis' of her – whether she's an original or a copy. In either case she's a wonder. Imagine a tall lean woman in a long dress of some dead purple stuff, guiltless of hoops (or anything else, I should say), with a mass of crisp black hair heaped into great wavy projections on each side of her temples, a thin pale face, a pair of strange, sad, deep, dark, Swinburnian eyes, with great thick black oblique brows, joined in the middle and tucking themselves away under her hair, a mouth like the 'Oriana' in our illustrated Tennyson, a long neck, without any collar, and in lieu thereof some dozen strings of outlandish beads.[2]

The relationship between Morris and this exotic beauty was far from conventional: nor was it a source of unremitting delight or even contentment. Indeed, it would seem that the couple only fleetingly shared real love and understanding. After just a few years of married life, Janey began

to distance herself from her husband's inner thoughts and feelings. She grew ever closer to Rossetti, accompanying him to social events, and at some point towards the end of the 1860s they began an affair.[3] She spent a good deal of time at his house in Cheyne Walk, and from 1865 to 1869 he painted a series of portraits of her, often sensual and quasi-mystical. References to Janey in his poetry too became more open. When reviewing a collection of Rossettl's poems in 1870 for *The Academy*, Morris must have been painfully aware that many of them were clear expressions of the author's increasingly passionate devotion to his wife. Janey, on her part, was less deeply attached to Rossetti than he was to her, though his affection and tenderness must have provided something lacking in her marriage. At home in Queen Square, Janey took refuge in intermittent invalidism.

In public, at least, Morris demonstrated no sign of bitterness or dislike towards Rossetti, accepting the situation with apparent forbearance. But the strain must have been enormous. Though capable of becoming deeply absorbed in his work, he was not self-centred, neither was he 'almost empty of love or hatred' as Mackail believed.[4] Some of the misery and sense of disillusion which Morris was feeling at this time is apparent in his letters to Aglaia Coronio. She was the daughter of Constantine Ionides, a leading member of London's Greek merchant community. Members of the Ionides family and their friends were amongst the most important patrons of Morris and the Pre-Raphaelites, and in the early 1870s Aglaia became Morris's close friend and confidante. She flattered and rather embarrassed Morris but managed to break down his reserve. His letters to her reveal something of his private thoughts and feelings. To her he spoke of 'this failure of mine', later adding 'I am ashamed of myself for these strange waves of unreasonable passion: it seems so unmanly: yet indeed I have a good deal to bear considering how hopeful my earlier youth was, and what overweening ideas I had of the joys of life.'[5] Equally personal thoughts were shared with Georgie Burne-Jones, for whom Morris had tremendous admiration and respect, and perhaps more than a little love. Georgie, like Morris, believed in the maintenance of personal dignity in the face of domestic tribulations. Even when, in the late 1860s, her husband's affair with the beautiful young Greek Mary Zambaco became public, Georgie never lost faith with him, staunchly resisting any urge to confrontation and censure.[6]

Early in 1871 the Morrises decided to take a country home. Janey in particular disliked the workshop atmosphere of Queen Square; but they both missed the opportunities for relaxation which had been afforded by Red House. In May, Morris saw an advertisement for Kelmscott Manor, on the upper Thames near Lechlade, and at once went to see it. The house was an excellent and little-altered example of the architecture of west Oxfordshire, east Gloucestershire and the Cotswolds, built of local stone,

71

with split stone roofs. It dated from about 1570, and had been extended to the north-east in the mid-seventeenth century. At the time, it seemed to Morris 'a heaven on earth',[7] remote and peaceful, and even today the house and its surroundings seem little changed.

At first, however, Morris was unable to enjoy his new home: for in June 1871 he decided, surprisingly perhaps, to take a joint tenancy with Rossetti, sharing the rent of £60 a year. This arrangement probably came about because the Morrises had reached a tacit agreement to avoid scandal. Janey and her lover were evidently determined to be together, and staying at a house jointly tenanted with her husband was less likely to provoke comment than visits to a country retreat rented by Rossetti alone.[8] Moreover, Rossetti was becoming a serious worry to his friends. By now, he was in a highly disturbed mental condition, and it was hoped that the peace and quiet of Kelmscott would help restore him to health. A few days after he first arrived, Rossetti wrote to his mother that the

> house and its surroundings are the loveliest 'haunt of ancient peace' that can well be imagined – the house purely Elizabethan in character, though it may probably not be so old as that . . . It has a quantity of farm buildings of the thatched squatted order, which look settled down into a purring state of comfort . . . My studio here is a delightful room, all hung round with old

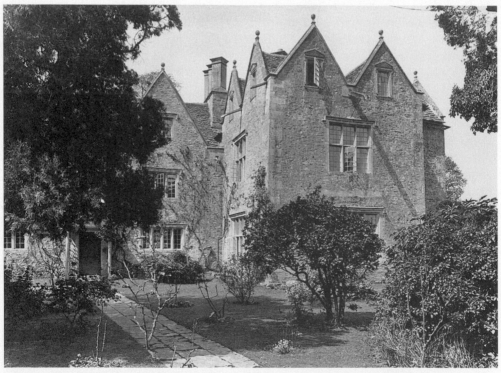

Plate 8 Kelmscott Manor, Oxfordshire, from the south-east

tapestry . . . The garden is a perfect paradise, and the whole is built on the very
banks of the Thames, along which there are beautiful walks for miles.[9]

Rossetti lived there more or less permanently for two years; Janey was
often with him, although Morris, as one might expect, kept out of the way
when Rossetti was in residence.

Life at Kelmscott Manor did not in the event restore Rossetti to his
former self. At times he seemed in the best of spirits, but concern over his
relationship with Janey, continuing guilt over the death of his wife, and
mounting criticism of the sensualism of his poetry caused further mental
deterioration to a state of near-paranoia.[10] He never really fitted in at
Kelmscott, disliking its dampness and draughts, offending the neighbours
and resorting to ever-increasing doses of chloral and whisky to counteract
his insomnia. Morris remarked that 'he has all sorts of ways so
unsympathetic with the sweet simple old place that I feel his presence
there as a kind of slur upon it',[11] and he was profoundly relieved when, in
the summer of 1874, after another mental breakdown, Rossetti gave up his
share in the tenancy. Rossetti's close relationship with Janey finally ended
in 1876, although they continued to meet and correspond infrequently
until his death in 1882.

Morris took refuge from the pain and distress of his failed marriage in
hard work. He continued to write poetry prolifically, notably Volumes 2
and 3 of *The Earthly Paradise*, published in 1868–70, and *Love is Enough*,
published at the end of 1872. He also renewed his interest in calligraphy –
which he had first begun to study just before or during his time in Street's
office – and from 1869 to 1875 it became his regular Sunday relaxation.
Several of the beautiful texts he produced in this period were given as
presents to Georgie Burne-Jones; most notably *A Book of Verse* in 1870,
and a copy of *The Rubáiyát of Omar Khayyam*, completed two years later.

The study of Icelandic culture and language, which he began in 1868,
offered another welcome distraction. Morris had read some of the Norse
legends with Burne-Jones whilst at Oxford, but it was only after he had met
the dedicated Icelandic scholar, Eiríkr Magnússon, that the sagas really
fired his imagination. As always, Morris worked at breakneck speed; 'you
be my grammar as we go along', he told Magnússon. The first fruit of their
collaboration was the publication of a translation of *The Saga of Gunnlaug
the Wormtongue* in the *Fortnightly Review* for January 1869. Later that
year there appeared *The Story of Grettir the Strong*, a translation from the
Grettis Saga. In May 1870, they published *The Volsunga Saga*. In the
preface, Morris expressed his surprise that it had never been translated
into English; 'for this is the great Story of the North, which should be to all
our race what the Tale of Troy was to the Greeks'. Like *The Earthly
Paradise*, it met with critical acclaim, but Morris was disappointed to find
it much less popular with the reading public. Nevertheless, his fascination

73

with Iceland and its sagas continued unchecked until his death. In 1875, there appeared *Three Northern Love Stories, and Other Tales*; in 1877, the verse *Story of Sigurd the Volsung, and the Fall of the Nibelungs* was published, another long poem consisting of four books in nine, ten, fifteen and seven sections respectively. This was Morris's personal favourite among his epic poetry, and was later described by the distinguished old Norse scholar E. V. Gordon as 'incomparably the greatest poem – perhaps the only great poem – in English which has been inspired by Norse literature'.[12] Towards the end of his life, in 1891–92, he collaborated with Magnússon on two volumes of Icelandic tales for Bernard Quaritch's Saga Library.[13]

Morris visited Iceland for the first time in 1871, together with Magnússon and his old friend Charles Faulkner. During the trip, which lasted for about six weeks, he was able to trace the footsteps of the heroes and heroines of the great sagas. The stark beauty of this inhospitable landscape made a deep and lasting impression, reinforced by a second visit in 1873. Increasingly, he turned to the culture of Northern Europe for inspiration and example. For, despite the success of the poems which he had based on Greek myths, Morris was never much attracted by the cultural heritage of southern Europe. He had a miserable time when he visited Italy with Burne-Jones in 1873; finding little to admire in Florence and Siena, and detesting most of the work produced by the Italian Renaissance. To Morris, southern culture smacked of degeneracy, whereas that of the north had a noble, living quality, as he explained in the introduction to the Saga Library volumes:

> Although Iceland is a barren northern island, of strangely wild, though to the eye that sees, beautiful scenery, the inhabitants of it neither are nor were savages cut off from the spirit and energy of the great progressive races . . . Still more, while over the greater part of Europe at least, all knowledge of their *historical* past has faded from the memory of the people . . . in Iceland every homestead, one may almost say every field, has its well-remembered history, while the earlier folk-lore is imbedded in that history, and no peasant, however poor his surroundings may be, is ignorant of the traditions of his country, or dull to them; so that a journey in Iceland to the traveller read in its ancient literature is a continual illustration, freely and eagerly offered, of the books which contain the intimate history of its ancient folk.

Above all, Morris was powerfully affected by the hardiness and courage of people who made a livelihood in such bleak and rugged countryside: their ability to rise above adversity deeply moved him at a time when he himself was beset by personal problems. He later wrote that 'the delightful freshness and independence of thought in them, the air of freedom which breathes through them, their worship of courage (the great virtue of the human race) took my heart by storm'. And in more universal terms, Morris thought that the Icelanders' tight-knit communities suggested a general

principle: 'I learned . . . that the most grinding poverty is a trifling evil compared with the inequality of classes.'[14] This insight was of fundamental importance to the subsequent development of Morris's social and political thought.

At this stage in his career, however, Morris did not have the freedom or the desire to devote himself full-time to writing and travel; in the late 1860s and early 1870s the need to secure his own financial situation was becoming increasingly pressing. Since 1847, the fortunes of the Morris family had depended largely upon the income from their shares in Devon Great Consols. The company had now been generating enormous profits for upwards of two decades, and its shareholders had come to expect a continuing flow of substantial dividends. But from 1865, when the dividend per share was a very high £62, the price of copper ore and output from the mines both began to fall, and with these the dividends: in 1870, only £17 a share was paid, and the downward trend looked set to continue. As a result, Morris's income from dividends fell progressively from £682 in 1865 to £396 in 1869 and just £187 in 1870 (see Table 1). Nor did his other mining interests help to make up for the shortfall. The British Mining & Smelting Co., for instance, of which Morris had been a promoter in 1865, soon began to face the same problems as those besetting Devon Great Consols. Its steady decline towards eventual liquidation in 1874 did not, in fact, cause Morris to lose a great deal of money; but it was by now plain that mining investments would no longer assure him of a large and reliable income.[15]

Morris had become used to a comfortable lifestyle on an annual income of between £1,000 and £1,500; but now, if this were to be maintained, for the first time he would actually have to make his work his livelihood – a necessity which in the end led to the dissolution of the partnership. That end, was, however, as yet unforeseen. By the end of the 1860s, Morris's most pressing need was to expand both the scope and the output of the firm, which simply was not generating enough profit to provide a decent income for any of the partners. In 1868, for example, a turnover of £2,000 had produced a net profit of about £300,[16] and although this might have sufficed if Morris had been sole proprietor it was quite inadequate when it had to be apportioned amongst seven partners.

Morris must have seen very quickly that, if the firm were to expand, it would have to end its excessive reliance on sales of stained glass. These had in any case dropped sharply from the high points of 1865–66 (see Figure 2). As noted in the previous chapter, there were two main reasons. One was that changing tastes in the ecclesiastical market had caused a swing back towards the thirteenth-century imitations preferred by Gothic Revival architects. The other, probably more important, was that the stained glass market was subject to strong fluctuations in demand. This was because orders for stained glass tended to result from programmes of public

building – both secular and sacred – and though these programmes were largely occasioned by the steady growth in population, they were not themselves steady, but rather came in waves, first catching up with demand, then falling behind, and so on (see Figure 3).

Figure 3 Gross domestic fixed capital formation in dwellings and non-residential building at constant prices, 1856–99

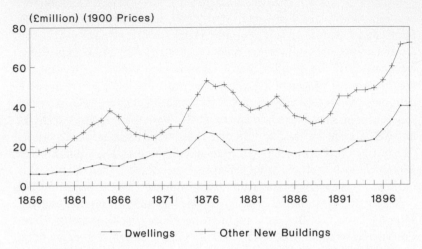

(£million) (1900 Prices)

—•— Dwellings —+— Other New Buildings

Source: C. Feinstein, *National Income, Expenditure and Output of the UK, 1855–1965* (Cambridge, 1972), Table 40.

Thus the St James's Palace and South Kensington Museum commissions of 1866/67 were both very profitable; but once completed they did not automatically lead to more of this type of work for MMF & Co. Indeed, apart from the restoration of the College Hall and Combination Room at Peterhouse College, Cambridge, begun by the firm in 1868 and completed in 1874,[17] there were no more big secular commissions for some years.

Fortunately, however, a more reliable market for the firm's other products did exist, and it was to this that Morris now turned his attention. The firm owed a good deal to the artistic circle in which it was well known, and which had hitherto helped to establish its reputation with the general public; but Morris now decided that it was time to move beyond this circle, and seek new customers amongst the prosperous middle classes. This market was more than simply stable: the demand for a wide variety of products to decorate and beautify the home was growing fast, and continued to do so during the second half of the nineteenth century. This was partly due to a large increase in the housing stock, which was fairly well in line with the growth of population, although of course by no means all the new houses being built were for the middle classes.[18] Demand for goods and services was further fuelled by the process of urbanisation. Already in 1851, more than half the population of England and Wales lived in towns

or cities, and by 1900 there were twenty-four urban areas with populations of more than 100,000 and 185 with populations of over 20,000.[19]

At the same time, many people were experiencing improved living standards. Notwithstanding significant regional and sectoral variations in incomes, wages and salaries were in general rising sharply in the third quarter of the nineteenth century, and they continued to rise, albeit more slowly and erratically, for the rest of the century. Furthermore, falling prices helped to raise living standards: between 1874 and 1896, prices fell by about 40 per cent.[20]

The middle classes were by no means the only beneficiaries of these developments, but there is little doubt that the third quarter of the nineteenth century saw a rapid growth in the salaried middle class in terms of both numbers and prosperity. (It has been calculated from income tax statistics that the number of people with an annual income of £150 or more rose from about 310,000 in 1860–61 to 530,000 in 1874–75 and 705,000 in 1881–82.)[21] With rising incomes came rising demand and rising expectations. The maintenance of a respectable middle-class household in the third quarter of the nineteenth century required expenditure on a widening range of items: furniture, wallcoverings, carpets and rugs, paintings, musical instruments, and the like. The Victorian middle classes attached enormous importance to the symbols and trappings of prosperity. At the same time new industrial techniques of mass production were bringing prices down, so that machine-made carpets – Brussels, Wiltons, Kidderminsters, and Patent Axminsters – and wallpapers, too, were now within the range of most middle-class pockets. The price of wallpaper was further reduced by the abolition of the excise tax on paper in 1860.[22]

To meet this demand, new shops were appearing, aimed specifically at middle-class customers. Many of them were soon to become household names, such as Frederick Gamage's shop in Buckingham Palace Road, established in 1858, John Lewis's in Oxford Street (1864) and Arthur Liberty's in Regent Street (1875). With the growth of middle-class suburbs such as Knightsbridge and Kensington there appeared shops such as Derry & Toms (1862) and John Barker (1870). Existing firms, such as Peter Robinson, Oxford Street (1833) and Maples, Tottenham Court Road (1842), likewise became increasingly popular and profitable. Although this trend was most marked in London, there were similar developments in the other major cities, with the expansion of stores such as Jollys of Bath and Bristol, David Lewis in Liverpool, Manchester and Birmingham, and Debenham & Freebody, established in Cheltenham in the 1840s.[23]

The strategic decision to diversify into the upper middle-class market for household goods and services, to take advantage of the abundant purchasing power of the metropolitan elite, cannot have been taken lightly. It must have been apparent to Morris from the beginning that the character

77

of MMF & Co. would have to change: that instead of concentrating on production, more attention would have to be given to selling; that instead of emphasising the uniqueness of its products more attention would have to be given to matters of supply, costs and prices. This was compromise rather than capitulation, for the ideals of the early 1860s were never completely abandoned; the firm continued to insist on the need for excellence in design and manufacture, in the belief that good quality was cheapest in the long run. But with the perception that the firm could not impose its standards and ideals upon the public came the recognition that it would have to respond to some extent to the dictates of the market-place.

All this was easier said than done. The ability of MMF & Co. to compete in the house furnishing and decoration markets was at first quite limited. The firm did not have ready access to goods whose quality satisfied Morris, and which he might draw upon when commissioned to decorate a set of rooms. A whole new range of products was needed, including such basics as wallcoverings, fabrics and carpets. A major effort in design, sourcing and marketing was thus called for, and for a small firm with limited capital this was no easy matter. As is so often the case, much depended on the energy, tenacity and talent of the individual entrepreneur: in this case, William Morris.

The least of Morris's problems was the supply of good quality wallpapers. Since 1864, Morris's early designs – *Daisy*, *Trellis* and *Fruit* – had been printed for the firm by Jeffrey & Co. of Essex Road, Islington. This company was established around 1836, when it began producing undistinguished machine- and hand-made papers typical of the period. Later, however, it was transformed by Morris's association with Metford Warner; a junior partner in the early 1860s, he had become sole proprietor of Jeffreys by 1869. Warner was both an idealist and a successful businessman. He became one of the best-known wallpaper manufacturers in Britain, and powerfully influenced later generations of designers. It was not only the technical quality of his products that set him apart from other wallpaper manufacturers: other firms such as Scott, Cuthbertson & Co. and William Woollams & Co. were just as proficient at hand- and machine-printing to a high standard. But Warner also acquired a reputation for treating designs sympathetically; and he insisted on the need to encourage leading designers and architects to produce designs for wallpaper. William Burges, E. W. Godwin, Charles Eastlake, Walter Crane and Lewis Day, amongst others, were subsequently commissioned to design wallpapers for Jeffrey & Co. It was doubtless this commitment to excellence that attracted Morris. Under Warner's guidance, Jeffreys produced block-printed papers for MMF & Co. to a consistently high standard. Morris was delighted with Jeffreys' work, and the company continued to print all Morris & Co.'s papers until the 1930s, when it was taken over by Sandersons.[24]

Confident that he could safely leave the execution of his designs to Jeffreys, Morris began the task of adding to the variety of patterns which MMF & Co. might place before its clients. Nine new wallpapers entered production between 1872 and 1876. Their names – *Jasmine, Acanthus, Vine, Larkspur*, and so on – confirm that Morris's inspiration came from nature, but they were much less naturalistic than the three early designs. As Faulkner notes:

> Morris bases his pattern and colours on nature, but shows his genius in the way in which these motifs become part of satisfying wholes. The range of density is considerable, from the delicacy of *Jasmine* with its varied greens and tiny red dotted flowers to the richness of *Acanthus*, the subtle colour gradations of which required sixteen blocks for printing.[25]

The effort needed to secure pleasing ranges of other products was much greater than for wallpapers. In 1868 Morris began to market a limited range of printed furnishing fabrics. He had decided that, for his purposes, the centuries-old method of block printing was preferable to the use of engraved rollers, which had now been adopted by most of the leading textile manufacturers of his day. Block printing, although slow, offered greater control over colour, and was well suited to short production runs. After a long search he discovered that Thomas Clarkson's Bannister Hall Print Works near Preston had used the older process until the 1830s or 1840s. Some of the sets of wood blocks had survived, and 'the processes of printing the patterns was not yet forgotten, though long since superseded by modern "styles" '.[26] Morris persuaded the Lancashire firm to supply him with several patterns of printed wool and cotton fabrics which had first been produced in the early 1830s. At least two featured Chinese roses on white backgrounds; they were naturalistic, very typical of early Victorian printed cottons, and quite unlike Morris's own designs of the 1870s and 1880s. Clarksons went on to print Morris's first textile design, *Jasmine and Trellis*, which, in combining green, yellow and brown, worked well in the synthetic dyes used by the Lancashire firm.[27] Of course, not everybody wanted chintzes for curtaining, and the firm was able to make some use of 'an excellent coarse serge, dyed to quiet but rather characterless colours', which was supplied by a Manchester manufacturer, John Aldam Heaton. But 'this was only a makeshift and could scarcely be used without some additions of positive colour, only to be given by embroidery'.[28]

Carpets posed further problems for Morris. George Wardle, commercial manager of MMF & Co., later recalled that 'at first we had no carpets of our own and when a customer could not afford the cost of one of the fine India carpets which at that time were almost all that could be had of oriental manufacture, we could do nothing for him beyond commending the quietest kind of Brussels or Kidderminster'.[29] A particular problem was that carpet manufacturers used mostly aniline dyes which were very

unstable and faded quickly when exposed to sunlight. Morris was in any case offended by the garish artificiality of the colours, and when making his own carpet designs he was obliged to confine himself to 'peacock blues, rusty reds and olive greens', which were 'deep and rather neutral than crude. Being of deep full tone they would be able to give up something to light and air and still have something left for the purchaser'. The colouring problem was not confined to carpets; most textile manufacturers were wedded to low cost aniline dyes, thus obliging Morris to limit his imagination as house designer and decorator. Yet, for the moment, Wardle tells us, these 'were the best that he could get done', and it was 'with these slender means . . . and Mr Morris's eye for colour' that MMF & Co. began its 'career as house decorators and furnishers'.[30]

Morris himself rejected the superfluous clutter so typical of many middle-class homes: 'have nothing in your houses that you do not know to be useful, or believe to be beautiful', he later told a lecture audience.[31] Not all his clients agreed. An examination of surviving photographs of rooms decorated by the firm shows that the result was often a compromise, especially when Morris was not in complete control of the decorative scheme. Yet he still managed to impart a characteristic style to his interiors; a style based on pure colours and patterns. Morris himself had a strong preference for positive colours, instinctively recoiling from sludgy greens and muddy browns. Reds and yellows often dominated, and deep blues were frequently used, but without ever lapsing into gaudiness; 'the colour schemes were subtle combinations, warm and glowing'.[32] The principles followed were clearly set out in a brochure published by the firm in 1883:

> When all is done, the result must be colour, not colours. If there are curtains or carpet or other finishings to be worked up to, you must consider which of them, if any, shall be the predominant colour of the room, and which the subordinate or auxiliary colour. The walls and wood-work have generally the predominating colour, and the carpet the secondary. The curtains will then either blend with the walls, and help to surround the carpet with a frame of colour contrasting with it . . . or the curtains may be used to harmonize the carpet with the walls. The choice must depend upon the choice of room and the point of departure. . . . Contrasting colour, if strong, must be kept within small quantities; if pale or grey, it may be more freely used. Chairs and sofas give great opportunities for introducing points of bright contrasting colour, and for those high lights and darkest shades which are essential in a complete scheme. Covers need not be uniform. They may be of two or three or four kinds, according to the size of the room and the number of pieces.
>
> If the chief colour be red, it will be desirable to have a large area of white for rest to the eye. Blues, grey, green, and lighter tints of red should be the variants. Contrast with it should be generally avoided; it wants rather quiet than excitement. Whenever white paint may be used for wood-work, choose it in preference to any other. The use of positive colour is very difficult, and

house-painters are peculiarly ignorant of it. Their incapacity may have led to the use of the dull, grey, or even dirty shades, which have become so general since house-decoration has begun to interest educated people. The revolt against crude, inharmonious colouring has pushed things to the opposite extreme, and instead of over-bright colours, we now have dirty no-colours. . . . In this difficulty the use of white is the only way to safety. White is perfectly neutral; it is a perfect foil to most colours, and by judicious toning may be assimilated with any. It is, therefore, manageable without great art.[33]

The effect was generally lighter than the rather sombre Green Dining Room or other projects of the firm's early years. Below the dado rail, woodwork was often painted white; if the wood were particularly attractive, it might be stained or varnished. Between dado and picture rail the walls were usually papered, although on more expensive jobs they might be hung with silk or silk and wool fabrics, stretched over battens fixed to the wall. (This was Morris's own favourite treatment, but it was never particularly popular with clients.) The frieze between picture rail and ceiling was sometimes painted with scrolled foliage or hung with embroideries. Cornices and ceilings were usually painted white, and ceiling papers, which Morris did not like, were seldom used. Although the different sections of the wall received different treatments, they were never artificially accentuated by the use of paper borders; 'panels formed by stripes or cuttings of wall-paper are futile decorations, as such, and they are ridiculous as architecture. Our wall-papers therefore are simple fillings; they imitate no architectural features, neither dados, friezes, nor panellings.'[34]

A typical drawing room decorated by the firm would contain a high wooden mantelpiece, a tiled fireplace, cabinets round the walls, several tables and a variety of seating. Some chairs and sofas would be upholstered and buttoned, and there might be a settle by the fireplace. There might also be wicker chairs with large cushions, and examples from the range of 'Sussex' chairs introduced by the firm in 1864 – simple, traditional styles, rush-seated and stained black or green. Floors were covered with rugs and square or rectangular carpets rather than fitted carpeting.[35]

In the simple but original way in which he combined the elements of an interior, Morris was moving towards a new concept of design: a complete range of products unified by style. But though its antecedents were doubtless to be found in the building and decoration of Red House, it did not spring directly from that source, nor from the quasi-medieval products of MMF & Co.'s early years. The 'Morris style' which later proved so influential was not that of the 1860s, with its heavy furniture and flat panel decoration, but the style which began to emerge in the early 1870s, with Morris's drive to increase the firm's profits.

The creation of a distinctive house look is very much a feature of the world of interior decoration and design today. Indeed, one could argue that

it has become a key factor in business success. Liberty, Habitat and Laura Ashley are three examples which immediately come to mind. But it was a relatively new departure in the 1870s, and very much an innovation as far as Morris & Co.'s middle-class customers were concerned. There were, of course, designers who had been influential and highly respected in their chosen profession, such as Christopher Dresser and Owen Jones, but their work was known to relatively few. The Morris 'look' was perhaps the first to become instantly identifiable by a broad spectrum of the population. The wealthy responded with some enthusiasm. So successful and durable was the 'Morris look' that, as we shall see, it engendered numerous imitations of varying quality.

In the early 1870s, prospective clients frequently asked Morris to visit and advise them on decorating and furnishing.[36] He was also responsible for providing detailed estimates, and for instructing and supervising the workmen charged with executing commissions. As well as the firm's own men, Morris used a small number of trusted subcontractors to carry out the work. One of these was a Cambridge master decorator, Frederick Leach, whom Morris engaged to carry out painted decoration on a number of commissions in and around Cambridge in the later 1860s and early 1870s. According to Bodley, Leach was always carefully instructed by Morris, who was responsible for the design work and the exact shades of the colours to be used. Leach evidently paid close attention to the directions he received, and was considered 'a very capable and able executant'.[37]

Morris also employed, on a rather larger scale, the services of a London firm of builders and decorators, Dunn & Co. He was evidently pleased with the quality of its work, and it carried out painting, paperhanging, plastering, plumbing and woodwork for him for almost twenty years, from 1866 to 1884. One of the first jobs which Dunns undertook for MMF & Co. was the St James's Palace project in 1866/67, for which it received £465. Dunns was also involved in the decoration of the Green Dining Room, receiving a total of £145 between 1867 and 1869. There was relatively little work in 1869 and 1870 – evidently very lean years for MMF & Co. – but thereafter the volume of work undertaken by Dunns began to pick up rapidly, reaching a peak of £2,442 in 1874. Although details of MMF & Co.'s turnover has not survived, the extent of the boom in its trade during the early 1870s can be appreciated by reference to the figures presented in Table 4. As the volume of work grew, Morris had to delegate the task of visiting clients and drawing up estimates to others. To judge from its account book, much of this work was undertaken by Dunns, which typically charged between £0.50 and £1.50 per visit. The growing number of estimates being made confirms that MMF & Co. was taking great pains to promote its products, and was becoming successful in its bid to reach a wider clientele. Of course, not all the firm's quotations were accepted – partly, no doubt, because of its distinctive designs (which were not to

Table 4 Work undertaken for William Morris by Dunn & Co., 1866–81

Year	No. of jobs	Total cost (£)	Charged to Morris (£)	Mean charge (£)	Profits as % of turnover
1866	3	341.65	509.80	169.93	33.0
1867	1	32.00	43.82	43.82	27.0
1868	2	151.47	189.62	94.81	20.1
1869	3	27.00	31.16	10.39	13.4
1870	1	46.84	56.81	56.81	17.5
1871	9	599.18	684.23	76.03	12.4
1872	14	1,225.47	1,565.77	111.86	21.7
1873	22	1,525.11	1,769.27	80.42	13.9
1874	30	2,084.39	2,442.05	81.40	14.6
1875	33	1,036.63	1,220.94	37.00	15.1
1876	26	1,867.99	2,487.74	95.68	24.9
1877	46	2,036.26	2,460.42	53.49	17.2
1878	25	3,901.98	4,531.61	181.26	13.9
1879	31	1,898.24	2,280.17	73.55	16.8
1880	17	578.55	662.95	39.00	12.7
1881	24	1,248.11	1,481.93	61.75	15.8

Source: William Morris Gallery, Walthamstow, File 10.

Table 5 Analysis of work undertaken for William Morris by Dunn & Co., 1866–81: distribution by value

Year	£100			£10.00–£99.99			< £10		
	No. of jobs	Total value (£)	% of year's work	No. of jobs	Total value (£)	% of year's work	No. of jobs	Total value (£)	% of year's work
1866	1	479.24	94.0	1	27.78	5.4	1	2.78	0.6
1867	0	0.00	0.0	1	43.82	100.0	0	0.00	0.0
1868	0	0.00	0.0	2	189.62	100.0	0	0.00	0.0
1869	0	0.00	0.0	1	12.53	40.2	2	18.63	59.8
1870	0	0.00	0.0	1	56.81	100.0	0	0.00	0.0
1871	2	512.89	75.0	4	159.81	23.4	3	11.53	1.6
1872	2	1,256.90	80.3	6	290.99	18.6	6	17.88	1.1
1873	5	1,391.66	78.7	10	350.83	19.8	7	26.78	1.5
1874	7	2,073.22	84.9	7	324.07	13.3	16	44.76	1.8
1875	1	672.50	55.1	13	506.16	41.5	19	42.28	3.4
1876	3	2,124.14	85.4	9	326.06	13.1	14	37.54	1.5
1877	7	1,984.84	80.7	12	416.42	16.9	27	59.16	2.4
1878	6	4,114.43	90.8	8	382.68	8.4	11	34.50	0.8
1879	6	1,895.46	83.1	9	334.96	14.6	16	49.75	2.3
1880	2	420.07	63.4	5	207.46	31.3	10	35.42	5.3
1881	1	1,109.81	74.9	13	335.53	22.6	10	36.59	2.5
1866–70	1	479.24	57.7	6	330.56	39.8	3	21.41	2.5
1871–75	17	5,907.17	76.9	40	1,631.86	21.2	51	143.23	1.9
1876–80	24	10,538.94	84.8	43	1,667.58	13.4	78	216.37	1.8
1866–81	43	18,035.16	80.4	89	3,965.53	17.7	132	417.60	1.9

Source: William Morris Gallery, Walthamstow, File 10.

everybody's taste in the 1870s), and partly because of its above average prices.

Nevertheless, the volume of business won by MMF & Co. was on the increase (see Table 5). Once again, Morris was well served by his social and artistic connections. Rossetti and Burne-Jones had their homes decorated by the firm. The decoration of the Morris family's rooms at Queen Square, another project upon which Dunn was employed, also served as an advertisement for the firm. George Wardle commented that 'the decoration of the drawing rooms in Queen Square in which both Mr Morris and Mr Webb had part was original and though extremely simple, very beautiful. No doubt this was talked about and a desire created to have the same methods of decoration applied elsewhere.' Likewise Webb, an architect with a growing reputation, 'was glad to have his houses finished by Mr Morris, when he could so far prevail with the client'.[38] He was probably responsible for the introduction of a number of fashionable clients like George and Rosalind Howard. Howard, who later became ninth Earl of Carlisle, was himself an accomplished artist, while his wife ran the family estates and was 'renowned for her forthright style and opinions'.[39] The Howards soon became personal friends of William and Janey Morris, and their London house, 1 Palace Green, built by Webb between 1868 and 1872, was decorated by the firm between 1872 and 1882. Their other homes, Naworth Castle and Castle Howard, also had carpets, tapestries and textiles supplied by Morris.[40] Other friends included the Ionides family, who were lovers of Pre-Raphaelite art and intimates of the Morris circle. They now gave their social blessing to the venture, informally spreading the word that MMF & Co. was the only truly artistic design firm in London. Ready access to the fashionable homes of Kensington, Knightsbridge, Mayfair and Belgravia was an invaluable business asset.

Meanwhile, stained glass had not been forgotten. The firm decided that it should try to recapture lost ground in this market through advertising, and reducing costs by allowing more frequent repetitions of existing designs. Ten per cent of the original fee would be paid to the designer except for those designs which were always intended for serial production. Edward Burne-Jones, for instance, received £27.50 for the re-use of old cartoons in 1871, £54.65 in 1872, £61.00 in 1873 and £60.00 in 1874.[41] Demand for MMF & Co. windows was again rising in consequence of a strong recovery in the level of non-residential building. At the same time sales were given an additional boost by the spreading fashion for stained glass windows as a memorial for a deceased loved one. The number of commissions won by MMF & Co. shot up from just six in 1871 to a peak of thirty-three in 1873 (See Figure 2).

As the quantity of work undertaken at Queen Square increased, Morris was obliged to look for a new home. In November 1872, he wrote that 'we must, it seems, turn out of this house next spring, for Wardle wants it all

for the business'.[42] Towards the end of the year, the Morrises moved to Horrington House, situated in a quiet suburb between Hammersmith and Turnham Green. Although they considered it undesirably small, it was nonetheless substantial by twentieth-century standards. Here the family lived for six years. At Queen Square, Morris kept two rooms for himself, a study and a bedroom, which allowed him to remain for the night whenever he desired. The family's old drawing-room on the first floor was turned into a showroom, and the upper floors became workrooms.

With Morris taking more and more responsibility for administrative and production matters, and with only Burne-Jones, Webb and Morris retaining an active role in designing, the firm had already moved quite radically away from the original idea of a free association of collaborating artists. The partners' awareness of the market and its potentialities was far sharper than it had been in the 1860s; they saw too that the market for interior design was less fiercely competitive than that for stained glass, and allowed a greater variety of products. There was also a recognition of the need to adopt a more flexible approach, manifested by a readiness to compromise with customers. Relations with customers were very important if MMF & Co. was to break into a wider market. Accordingly, the firm's publicity began to exploit the names of its principal designers, Morris and Burne-Jones, emphasising the value of original styling.

There are also some signs that Morris was beginning to pay greater attention to costs than he had in the early years of MMF & Co. Subcontractors were obliged to operate on narrower profit margins, as is revealed through an analysis of the account book of Dunn & Co. Between 1866 and 1868 Dunn undertook decorating work for MMF & Co. which earned him a profit equal to 29.3 per cent of turnover. Between 1869 and 1871, a slightly larger volume of business earned him profits averaging 12.3 per cent. The comparable figure for 1871–74 was 15.9 per cent. The firm's designers were also under pressure to charge moderate fees, even though they were themselves partners. Burne-Jones's account book, which records his transactions with the firm, contains a series of complaints about the low fees paid to him. Both Burne-Jones and his wife had a chronic fear of debt and financial insecurity throughout their lives, and the complaints, though couched in a bantering tone, expressed a genuine sense of grievance. They became increasingly frequent after 1870. In September 1871, for example, when Burne-Jones sent a letter requesting £45 for three cartoons of St Hugh, St Peter and St George, Wardle replied, 'I am sorry but the words of the tariff are up to 4 ft £12 and over 4 ft £15', and he reduced the sum due to £36. Burne-Jones, in accepting the judgement, answered that he too was sorry and 'very much more than you'. He also demanded repeatedly but unsuccessfully that

transactions between gentlemen should be in guineas, not pounds.[43]

With the rapid growth in the firm's business, William Morris increasingly became irked by various constraints upon his activities. One problem was the tension which existed between the firm and the market. Morris's forceful character, and desire to shape the market by changing public taste, were frustrated by the need to respond to the dictates of the market-place. This tension was never resolved, and led occasionally to outbursts of verbal violence from Morris, such as the famous occasion on which he told the ironmaster Sir Isaac Lowthian Bell that his life was spent in 'ministering to the swinish luxury of the rich'.[44]

Dependence upon external suppliers for many of the products which the firm needed produced other constraints. The quality of the goods supplied was often below the standard Morris expected. In 1873, for example, when Clarksons printed Morris's second chintz design, *Tulip and Willow*, he was horrified by the result. It had a dark blue ground, and Morris intended that it should be printed using the indigo discharge process.[45] This process, however, had generally been abandoned by commercial textile printers and dyers in favour of newer chemical dyes. Clarksons' use of bright Prussian blue instead of the subtler shades of indigo demonstrated the limitations of the modern dyestuffs, and led Morris to begin an investigation into the old vegetable dyes. He studied old herbals and textbooks, and took advantage of the reorganisation of Queen Square to set up a small dyehouse in the basement, in the old scullery and larder. Here he began a series of experiments which gave him practical experience of the old methods, though he was not as yet able to dye yarn or fabrics on a scale sufficient to meet the firm's needs.

As well as the problem of quality control, there was often a lack of understanding between Morris and Wardle on the one hand, and the supplier on the other, which at times led to embarrassing and costly results. A particularly dramatic instance was when Morris, concerned about the firm's inability to supply an acceptable range of cheap carpeting, produced his first design for a Kidderminster carpet in 1875: 'the manufacturer gravely pointed out to us that the pattern Mr Morris had designed "would never do" – it would not sell – it was not in the style, and he suggested that we should allow his designer to do something for us'. When this objection was overcome and a trial piece made, 'it was a horror, almost unrecognisable'. Morris and Wardle claimed that the drawing had been altered, and that the firm's designer could not draw. In fact, the problem had arisen with the transfer of the original design to the point paper (which showed each individual knot or loop as a dot on squared paper) which the manufacturer used to set up the loom, rather than with the artist's original drawing. After this experience, Morris took great care to point up his own designs and supply them in a form that commercial manufacturers understood, thereby avoiding any further misunderstandings.[46]

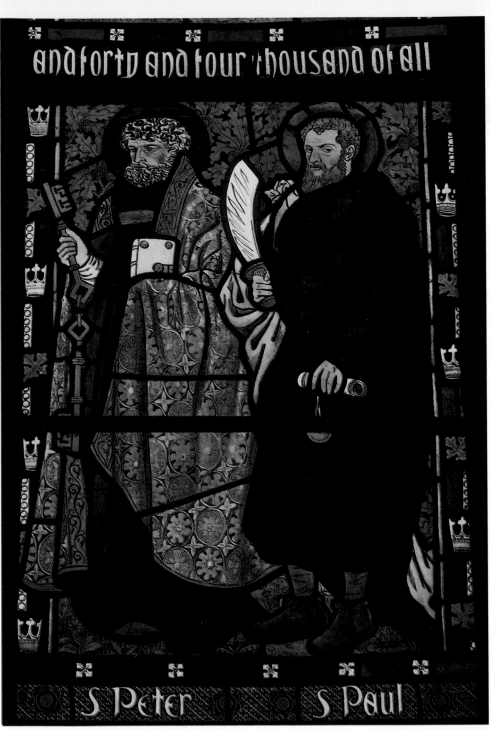

St Peter and St Paul, designed for Middleton Cheney by Ford Madox Brown and William Morris, 1865

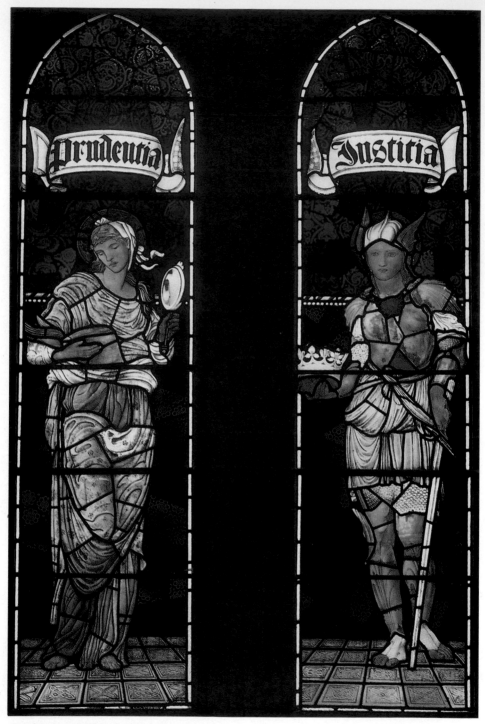

Prudence and Justice, Christ Church, Southgate, 1885. Designed by Edward Burne-Jones

Other problems resulted from the form of business organisation adopted by MMF & Co. Morris was anxious to develop further, but the partnership was now impeding the development of the business. None of the other partners felt strongly one way or the other about the expansion of the firm; for they were all developing their own careers, and MMF & Co. was of no more than peripheral interest to them. Faulkner was earning a living as an Oxford don. Marshall continued to pursue his career as a sanitary engineer. Webb's architectural practice had begun to flourish. And Burne-Jones and Madox Brown were working hard at their painting. Rossetti, although he rarely exhibited, was towards the end of the 1860s earning several thousand pounds a year from his paintings.[47] Thus they tended to view the firm as a source of useful commission work, but were not interested in expansion – or, indeed, in production.

But as the firm was becoming the main source of Morris's livelihood, his quest for financial security had become ever more urgent. As his letters show, he was forever short of money in the early 1870s. In March 1873, for example, when Eiríkr Magnússon asked him for £70 which was owed, Morris replied that

> I will do my best to get the money . . . in about a week's time; if this seems a cold answer, I must ask you to understand that although I seem comfortably off I am always rather short of *cash*: my only important resource being what I can get from the Firm here, which has so many irons in the fire that its banker's book often looks very thin.[48]

Little relief could now be expected in the form of dividends from Devon Great Consols. The decline of the business accelerated in the 1870s, and profits soon became a thing of the past. In 1874 Morris began to dispose of his interest in the company. He sold eighty shares that year, but with the suspension of dividends and the likelihood of further calls on shares the bid price had fallen to just £1.00, so that £80 was all he received. By 1875 the price had recovered to £2.50, and the sale of another 80 shares realised £200 and reduced his total holding to 100 shares. In the same year, Morris decided to resign his directorship. He wrote to his mother on 27 May 1875, telling her 'I have just come from the DGC meeting, and, I suppose, ended my business there, except for receiving my £100, which they were once again kind enough to vote us.'[49]

Now that regular dividends from Devon Great Consols had ceased, Morris's need for a better return on all his hard work for MMF & Co. had become imperative. Accordingly, in August 1874 he announced his desire to wind up the firm and reconstitute it under his sole ownership.[50] It was perhaps predictable that the changing character of the firm and the declining commitment of some partners would create difficulties. For though MMF & Co. was still legally a partnership, meaning that each partner was entitled to an equal share of the profits, much of the hard work

87

which generated them was now being done by Morris and one or two key employees. This did not particularly matter when profits were low, and not really worth arguing over. Indeed, in 1870 when the year's trading profit was only £750 the anomaly was to some extent recognised. The partners agreed to increase Morris's salary to £200 per annum, pay his 'rent, taxes, gas and coals', and give him 10 per cent of net annual profits as bonus. Annual bonuses, set at half the rate paid to Morris, were also conceded to George Wardle and George Campfield (foreman of the glass painters).[51] This arrangement was acceptable in 1870. But now that Morris desperately needed to increase his income, and through his efforts had set the firm on a course which offered the prospect of sustained growth, he was disinclined to provide by his own toil large sums of money for sleeping partners.

Some of the sleeping partners woke up at once, in angry mood. Madox Brown was particularly incensed, and became 'quite determined to hold no personal correspondence with Morris'.[52] He appointed his friend, Theodore Watts, the solicitor and literary critic, to deal with the matter on his behalf. Rossetti and Marshall also asked Watts to act for them in the affair. Burne-Jones, Webb and Faulkner, as might have been expected, remained loyal to Morris. They were amongst his closest friends, and, besides recognising the essential justice of Morris's claim, could see dangers in remaining liable for the debts of the partnership.[53]

A meeting of the firm was held at Queen Square on 23 October 1874 to discuss Morris's proposal. It was attended by Morris, Marshall, Burne-Jones and Webb, but not Rossetti or Madox Brown. Those attending resolved unanimously 'that it is desirable that the firm be dissolved', and 'that in order to ascertain the value of each share in the business 3 persons, not members of this firm, be appointed to act as assessors'.[54] Following the meeting, Morris commented that 'Marshall bore his execution with much indifference and good temper: I suspect that he smelt the advent of the golden shower and was preparing to hold his hat under the spout.'[55] Morris also wrote to Rossetti hoping that he would support a peaceful solution to the dispute, and Rossetti in turn agreed to write to Madox Brown proposing a friendly meeting between the three of them. Brown, however, replied that:

> as to Morris, I could never meet him again with the least pleasure – but even if I could, at the present juncture, it would disturb all our negotiations, which are going on satisfactorily in Watts's hand – for I only wish to be clear of the whole affair which I now blush at having ever belonged to. I wish to be quit of it as soon as I can without ridicule – for I am not inclined to go at Morris's dictation.[56]

A second meeting of the partners on 4 November was attended by Theodore Watts, who argued that 'as in the inception of the firm no member invested either money, nor gave any time or labour without being paid at an agreed rate, the position of the several members ought to be

Ford Madox Brown, n.d.

Dante Gabriel Rossetti, 1863

Edward Burne-Jones at Naworth Castle, August 1874

Philip Webb, painted by C. F. Murray, 1873

Plate 9

considered as equal in respect to their claims on the assets of the firm'. He went on to express Brown's view 'that the goodwill ought to be taken at three years' purchase and ought to be included in the said assets'. This led to a prolonged debate; Marshall stated that in his opinion the goodwill was not worth three years' purchase, but that it might possibly be worth one year's purchase, while Morris, Webb and Faulkner argued that in the event of the dissolution of the firm there would be no goodwill. It was eventually agreed 'to have a balance made out up to Michaelmas 1874 and to summon a general meeting of the firm at the earliest possible period after its completion, to endeavour if possible to come to an amicable adjustment of the process of dissolution'.[57]

The idea of independent assessors was never followed up, and the bitter wrangle dragged on until March 1875 before Morris eventually agreed to pay £1,000 each in compensation to Marshall, Madox Brown and Rossetti.[58] The dissolution of the firm led to a permanent estrangement between Rossetti and Morris, although they still corresponded on occasions over formal matters, and many years were to pass before the breach between Morris and Madox Brown was finally healed. Burne-Jones, who had done very well out of the firm in recent years (his fees rising from £106 in 1871 to £1,013 in 1874), waived his right to any payment, as did Faulkner. Webb made no claim, and also agreed to forgo arrears of salary, totalling £640, to which he was entitled but had never drawn.[59] On 31 March 1875, once all the details of the settlement had been agreed, a circular was published announcing that MMF & Co. had been dissolved and that thenceforth the business would be carried on under Morris's sole ownership and control, trading as Morris & Co. Burne-Jones and Webb, although no longer partners, would continue to supply designs for stained glass and furniture.[60]

Morris was hard put to find the money needed to pay off the partners. At the beginning of March 1875 he wrote to Fairfax Murray that he was 'scraping everything together to pay my thieves of partners, who have come to some kind of agreement with me, if they don't cry off before the law-business is settled; which drags on confoundedly, and to say the truth bothers me more than I quite like to confess'.[61] Evidently, Morris considered that Madox Brown, Rossetti and Marshall were quite unreasonable in their insistence upon receiving a share of the firm's assets. On 25 March 1875, after the firm had finally been dissolved, he complained to his mother that:

> I have been working very hard lately, & have been much bothered by this law business the past 6 weeks: my recalcitrant partners have behaved so badly that I felt half inclined more than once to throw the whole affair into Chancery: but law is too ticklish a matter to throw one's whole chances of livelihood into it: and I think I have done the best after all: though 'tis a deal of money to pay for shear nothing, and I doubt if their claims would have been recognised in the

Court of Chancery – however 'tis all done now I hope.[62]

Most of Morris's biographers have been equally critical of the stand made by Madox Brown, Rossetti and Marshall.[63] In this they follow Mackail, who believed it quite wicked that

> each of the partners, who had confessedly contributed nothing beyond a trifling sum towards the capital, and who had been paid at the time for any assistance they gave towards the conduct of the business, was entitled to an equal share of the value of the business which had been built up by the energy, the labour, and the money of Morris alone.[64]

There is, of course, another side to the story. The disgruntled partners believed they deserved some reward for efforts made in earlier years, and that Morris was seeking to exclude them just as the firm began to make worthwhile profits. Rossetti's importance to the firm in its infancy has already been highlighted. Not only was he the mentor of the younger men; he was also, as an established artist with many connections, the person largely responsible for generating early commissions and building goodwill. Similarly, Madox Brown, as 'one of the earliest and most convinced pioneers in the way of furniture and furnishings both artistic and practical', had made a big contribution to the early progress of the firm.[65] And he had continued to furnish designs for stained glass whenever called upon. By 1874, as noted earlier, Madox Brown had produced about 150 cartoons for the firm – a total surpassed only by Burne-Jones. Certainly, it was Morris who had undertaken the lion's share of the work since the mid-1860s, but he had received a fair salary as business manager, and, like the other partners, he had been paid for his designs, including fees for repeated use.

Any court of law would have had to take account of these points and the fact that for fourteen years all the partners had remained liable for the firm's debts. As risk-sharers, Rossetti, Madox Brown and Marshall felt entitled to an equal share of the profits and assets of the firm, just as they accepted 'joint and several' liability for its debts. It is wrong simply to dismiss their claims as untenable and stemming from base motives. Whatever Morris believed, it is quite possible that a court would have upheld their claims to substantial compensation.

Yet even if one accepts the logic of their argument, it is hard to resist the conclusion that Morris's disaffected colleagues, in differing degrees, got more out of the firm than they had put into it. Morris made the mistake of not acting sooner, before the furnishing and decorating business had really taken off and profits were flowing in. Even so, the balance of sympathy must lie with him, for while the other partners had been building their own careers, he had devoted much of his time to MMF & Co., and now had to look to the firm for his livelihood. Through necessity, Morris had become a committed man of business, intent on expanding

trade and working hard to acquire an income that would safeguard his financial future, and the well-being of his family. As he wrote to Aglaia Coronio in February 1873:

> I should very much like to make the business quite a success, and it can't be, unless I work at it myself. I must say, though I don't call myself money-greedy, a smash on that side would be a terrible nuisance; I have so many serious troubles, pleasures, hopes and fears, that I have not time on my hands to be ruined and get really poor; above all things it would destroy my freedom of work, which is a dear delight to me.[66]

1 Mackail, *Life*, Vol. I, p. 213.
2 P. Lubbock (ed.), *The Letters of Henry James* (1920), Vol. I, pp. 17–18.
3 On the affair, see J. Marsh, *Jane and May Morris* (1986), pp. 62–73, 197.
4 Mackail, *Life*, Vol. II, p. 349.
5 Kelvin, *Letters*, Vol. I, p. 172, to Aglaia Coronio, 25 Nov. 1872, and p. 216, 5 March 1874.
6 I. Taylor, *Victorian Sisters* (1987), pp. 41, 80–4, 120–2.
7 Kelvin, *Letters*, Vol. I, p. 133, to Charles James Faulkner, 17 May 1871.
8 Marsh, *Jane and May Morris*, pp. 90–2.
9 Quoted in Vallance, *William Morris*, p. 191.
10 Henderson, *Life, Work and Friends*, pp. 131–3.
11 Kelvin, *Letters*, Vol. I, p. 172, to Aglaia Coronio, 25 Nov. 1872.
12 E. V. Gordon, *An Introduction to Old Norse*, 2nd ed. revised by A. R. Taylor (Oxford, 1957).
13 Vallance, *William Morris*, pp. 197, 212–13.
14 Kelvin, *Letters*, Vol. II, p. 229. to Andreas Scheu, 15 Sept. 1883.
15 For a detailed account of the Morris family's mining interests, and the decline of copper mining in Devon and Cornwall, see C. E. Harvey and J. Press, *William Morris, His Family and West of England Mining Enterprise* (forthcoming) and *idem*, 'The City and Mining Enterprise: The Making of the Morris Family Fortune', *Journal of the William Morris Society*, Vol. IX, No. 1 (autumn 1990).
16 V & A, 86. ss. 57, Warington Taylor to Dante Gabriel Rossetti, autumn 1867.
17 Kelvin, *Letters*, Vol. I, p. 164n; Sewter, *Stained Glass*, Vol. II, pp. 44–6.
18 B. R. Mitchell and P. Deane, *Abstract of British Historical Statistics* (Cambridge, 1971), pp. 6, 239. In all, the number of residential properties in England and Wales almost doubled between 1851 and 1901, from 3,432,000 to 6,710,000.
19 P. Mathias, *Retailing Revolution* (1967), p. 6.
20 Mathias, *Retailing Revolution*, p. 13; W. H. Fraser, *The Coming of the Mass Market* (1981), p. 15.
21 Based upon estimates by J. C. Stamp, *British Incomes and Property* (1916), p. 448. The question as to which occupational groups benefited most remains the subject of considerable controversy. For recent contributions to the debate, see J. G. Williamson, *Did British Capitalism Breed Inequality?* (1985) and R. V. Jackson, 'The Structure of Pay in Nineteenth-century Britain', *Economic History Review*, 2nd series, Vol. XL (1987), pp. 561–70.
22 On carpets, see J. N. Bartlett, *Carpeting the Millions: The Growth of Britain's Carpet Industry* (Edinburgh, 1978), passim; C. E. C. Tattersall and S. Reed, *A History of British Carpets* (Leigh-on-Sea, Essex, revised ed., 1966), pp. 17–19, 68–77; L. D. Smith, *Carpet Weavers and Carpet Masters: The Hand Loom Carpet Weavers of Kidderminster, 1780–1850* (Kidderminster, 1986), pp. 17–22. For a description of the different type of machine-woven carpets, see below, Chapter 4. On wallpapers, see E. A. Entwisle, *Wallpapers of the Victorian Era* (Leigh-on-Sea, Essex, 1964, pp. 9–10; G. R. Porter, *The Progress of the Nation* (revised ed., 1912), pp. 405–6.
23 A. Adburgham, *Shops and Shopping, 1800–1914: Where and in What Manner the*

Well-Dressed Englishwoman Bought her Clothes (1964), pp. 284–6; Fraser, *Mass Market*,
p. 129.

24 Entwisle, *Wallpapers of the Victorian Era*, especially pp. 35–40; *idem, A Literary History of Wallpaper* (1960), p. 145; *Who's Who in Business* (1906); Kelvin, *Letters*, Vol. II, p. 463n.
25 Faulkner, *Against the Age*, p. 73.
26 Wardle, 'Memorials', f. 6.
27 This section is largely based upon L. Parry, *William Morris Textiles* (1983), pp. 36–8.
28 Wardle, 'Memorials', ff. 6–7. By the mid-1870s, Heatons was also supplying Morris with Utrecht velvets. Parry, *William Morris Textiles*, p. 42.
29 Wardle, 'Memorials', f. 6.
30 Ibid.
31 W. Morris, *The Beauty of Life* (1880), *Collected Works*, Vol. XXII, p. 76.
32 P. Thompson, *The Work of William Morris*, pp. 74–5.
33 Wardle, *The Morris Exhibit at the Foreign Fair*, pp. 20–1.
34 Ibid., pp. 18, 22–3.
35 P. Thompson, *The Work of William Morris*, pp. 74–5. For a discussion of how rooms in nineteenth-century houses should be treated, see W. Morris, 'Making the Best of It' (c. 1879), *Collected Works*, Vol. XXII, pp. 81–118.
36 WMG, File 11a, circular, 9 April 1877.
37 Jesus College Library, G. F. Bodley to E. H. Morgan, 8 Nov. 1866, quoted in Kelvin, *Letters*, Vol. I, p. 48.
38 Wardle, 'Memorials', f. 5.
39 Marsh, *Jane and May Morris*, p. 149. Also see C. Newall, 'English Painting and Italy', in S. Macready and F. H. Thompson (eds.), *Influences in Victorian Architecture* (1985), pp. 95–7.
40 WMG, Files 15a, 15b.
41 HFAD, MMF & Co., Minute Book, 27 Feb. 1871; Fitzwilliam Museum, Account Book of Sir Edward Burne-Jones.
42 Kelvin, *Letters*, Vol. I, p. 172, to Aglaia Coronio, 25 Nov. 1872.
43 Fitzwilliam Museum, Account Book of Sir Edward Burne-Jones.
44 W. R. Lethaby, *Philip Webb and his Work* (1935), p. 94.
45 For a description, see below, Chapter 5.
46 Wardle, 'Memorials', ff. 8–9. The manufacturer concerned was the Heckmondwike Manufacturing Co.
47 Marsh, *Jane and May Morris*, p. 71.
48 Kelvin, *Letters*, Vol. I, p. 180, to Eiríkr Magnússon, 18 March 1873.
49 Ibid., p. 256, to Emma Shelton Morris, 27 May 1875. The amount received by Morris was actually 100 guineas.
50 William Morris to Theodore Watts, 28 Aug. 1874. Quoted in J. C. Troxell, *Three Rossettis: Unpublished Letters to and from Dante Gabriel, Christina, William* (Cambridge, MA, 1937), p. 71. (Watts later changed his name to Watts-Dunton. The earlier name, as given in the correspondence, is preferred here.)
51 HFAD, MMF & Co., Minutes, 19 March 1870; 27 Feb. 1871.
52 See V & A, 86. ss. 57, Ford Madox Brown to Theodore Watts, 25 Oct. 1874. Also see British Museum, Ashley 3688, William Morris to Dante Gabriel Rossetti, 21 Oct. 1874; H. Rossetti Angeli, *Dante Gabriel Rossetti: His Friends and Enemies* (1949), p. 115.
53 See, for example, HFAD, DD/348/14, May Morris to Sydney Cockerell, 11 May 1938. The activities of Marshall in particular were giving cause for concern. Morris, who was extremely critical of his alcoholism, revealed in October 1874 that Marshall had set up shop on his own. Orders had been placed in the name of MMF & Co., and headed notepaper printed bearing the words 'Morris, Marshall & Co., 9 Fenchurch Street (and at 26 Queen Sq: Bloomsbury)'. He was censured by the other partners and requested 'to carry the business no further'. HFAD, MMF & Co., Minutes, 23 Oct. 1874. Also see Kelvin, *Letters*, Vol. I, p. 234, to Dante Gabriel Rossetti, 21? Oct. 1874; V & A, 86. ss. 57, Dante Gabriel Rossetti to Theodore Watts, 25? Oct. 1874.
54 HFAD, MMF & Co., Minutes, 23 Oct. 1874.
55 Kelvin, *Letters*, Vol. I, pp. 235–6, to Dante Gabriel Rossetti, 24 Oct. 1874.

56 H. Rossetti Angeli, *Rossetti*, p. 115.
57 HFAD, MMF & Co., Minutes, 4 Nov. 1874.
58 WMG, J191, Mackail Notebooks, Vol. I, f. 10.
59 Fitzwilliam Museum, Cambridge, Account Book of Sir Edward Burne-Jones; City of Birmingham Museum and Art Gallery, Account Book of Philip Webb.
60 Mackail, *Life*, Vol. I, p. 307.
61 Kelvin, *Letters*, Vol. I, p. 245, to Charles Fairfax Murray, 11 March 1875.
62 Ibid., p. 249, to Emma Shelton Morris, 25 March 1875.
63 See, for example, Henderson, *Life, Work and Friends*, p. 150.
64 Mackail, *Life*, Vol. I, p. 307.
65 H. Rossetti Angeli, *Rossetti*, p. 115. On the importance of Madox Brown as a designer, see Watkinson, *Pre-Raphaelite Art and Design*, pp. 149–51.
66 Kelvin, *Letters*, Vol. I, p. 178, to Aglaia Coronio, 11 Feb. 1873.

Chapter 4

Experimentation and growth:
Morris as designer–craftsman, 1875–81

With the reconstitution of Morris & Co. under his sole ownership, William Morris was freed from many restrictions – legal, financial and commercial – and he set out, with his usual vigour, to complete what he had begun in recent years. His endeavours, through elevating the status of the designer and encouraging originality in design, contributed to a revolution in the decorative arts. The 'Morris look', with its rich colours, simple elegance, naturalistic inspiration and flowing lines, became familiar to the public at large. Within a decade, his designs and products were widely admired throughout the western world. All this required a tremendous amount of hard work, and sound commercial judgement.

The immediate priority was to give his customers more choice, inspiring Morris to produce a whole range of sumptuous new designs. In May 1875 he wrote to a friend that he was 'up to the neck in turning out designs for papers, chintzes and carpets and trying to get the manufacturers to do them'.[1] The years which followed were the most creative of Morris's career in business. Between 1875 and 1885, he made 21 designs for wallpapers, 32 for printed fabrics and 23 for woven fabrics, together with perhaps 24 for machine-made carpets and others for hand-made carpets and rugs, tapestries and embroideries (see Table 6). They mark his emergence as an undisputed master of flat pattern design. His wallpapers, Floud tells us, 'demonstrate an instinctive mastery of the art of pattern development hardly reached by even the cleverest of his contemporaries, and bear a classic imprint quite lacking in papers which in their day must have seemed much more *avant-garde*'.[2]

More designs extended the range of products, but there remained the problem of quality in manufacture. Where he could find outside firms capable of meeting his specifications, Morris willingly subcontracted work to them. The new wallpapers, like Morris's early designs, were printed by Jeffrey & Co., and the work was 'done so carefully and with such anxious desire to satisfy all Mr Morris's requirements that there was no necessity to take them more completely into our hands'.[3] Other products too were subcontracted to manufacturers in the trade. In 1875, Morris produced a design for printed linoleum, which was already a very popular cheap floor

covering. The material required specialist expertise and factory production methods, and Morris turned to one of the leading manufacturers of floorcloth – probably Nairns of Kirkcaldy, although it is impossible to identify the firm with any certainty.[4]

Morris also turned to the trade for the production of machine-made carpets. The earliest patterns were for Kidderminster carpets. Kidderminsters – also called double or triple cloths – were in effect composed of two or three separate woven fabrics on top of each other, each of a different colour, with its own weft and warp. The different colours might be brought to the surface wherever the design demanded, thus linking the cloths together. Multiple cloth carpets were less durable than pile carpets, but were cheap, and could be very attractive, if the pattern was bold enough to exploit the limited range of colours available. Two- and three-ply Kidderminsters were made for Morris & Co. in Yorkshire by the Heckmondwike Manufacturing Co.[5]

Within the next few years, the range offered by Morris & Co. grew considerably, with the introduction of other types of machine-made carpets. Brussels and Wilton pile carpets were first produced for the firm in or around 1877. (In a Brussels carpet, raised loops are left in the warp, forming a looped pile. If the loops are cut, leaving a free pile, the result is a Wilton.) Wiltons in particular proved very popular; Parry refers to twenty-four different designs, in a variety of colourways.[6] The Wilton Royal Carpet Factory Co. was commissioned to produce Real and Patent Axminsters to Morris's designs. These were both woven versions of handmade carpets, which traditionally had not been woven, but knotted or tufted from short lengths of yarn. The essential difference between Real and Patent Axminsters was that the power-looms used for Patent Axminsters produced a coarser fabric. In consequence, Morris's designs were necessarily much bolder than for Wiltons or Real Axminsters, and Patents were

Table 6 William Morris designs for wallpapers and fabrics, 1861–96

Period	Wallpapers	Printed fabrics	Woven fabrics	Total
1861–68	6	1	0	7
1869–74	8	1	0	9
1875–80	11	13	16	40
1881–85	10	19	7	36
1886–96	17	2	3	22
1861–96	52	36	26	114

Notes: Some dates are approximate. Two designs tentatively identified as by Morris or J. H. Dearle and two by Morris or Kate Faulkner are included. Designs exclusively for carpets are omitted, but those used for both woven woollens and three-ply Kidderminsters are included.

Sources: C. C. Oman and J. Hamilton, Wallpapers: A History and Illustrated Catalogue of the Collection of the Victoria & Albert Museum (1982), pp. 369–87; L. Parry, William Morris Textiles (1983), pp. 147–72; Victoria & Albert Museum, Box VII.43.G, Morris & Co., Chintzes, Silks, Tapestries, etc. (catalogue, 1912); 57.C.65, Morris & Co., Wallpapers (catalogue, 1912).

considered particularly suitable when large patterns were required.[7] They were often sold as stair carpets in varying widths, and, at about £0.65 per square yard, cost roughly the same as the Wiltons.[8] Handwoven Real Axminsters, which were available to Morris & Co. by the early 1880s, were altogether more expensive. They could be made in very large sizes if required, and represented the finest quality then obtainable. They were priced accordingly; Morris & Co. offered four grades, at £1.20, £1.92½, £2.50 and £3 a square yard.[9]

The woven fabrics which Morris began to design after 1875 were also placed with the trade. The first silk fabrics and silk and cotton mixtures were woven in 1875/76 by the Macclesfield company, Brough, Nicholson & Co. The managing partner, Joshua Nicholson, had set up in business in 1872, and was soon one of the country's leading experts in silk weaving. Morris made several visits to his factory, and they became good friends. Other leading firms were also used, including H. C. McCrea of Halifax, which manufactured silk and woollen mixtures, and Dixons of Bradford, which wove most of the firm's lightweight woollens. Another was Alexander Morton & Co., of Darvel, Ayrshire, which wove muslins (light woven cottons) and 'double cloths' (heavy silk and wool mixtures) for Morris.[10]

Morris's use of these outside contractors is evidence that he had no objection to using machines in manufacturing, as long as quality was not thereby compromised: firms like McCreas and Nicholsons used the latest equipment in their factories, and, in general, Morris was quite happy with the quality of the weaving. The Wilton Carpet Works produced all the Brussels, Wilton and Axminster carpets sold by the firm in Morris's own lifetime, and even when he set up his own weaving-looms he still used Nicholsons for large orders. Moreover, he discovered that fabrics woven by power-loom were best for upholstery work, as handwoven fabrics were too fragile, and tended to wear unevenly.

One thing, however, that did trouble Morris was the low quality of the dyed yarns used by his suppliers. These were generally unattractive and impermanent. Similar problems occurred with fabrics which Morris imported from France. French fabrics had an excellent reputation for quality and design, but they did not satisfy Morris: 'today we have bad accounts of another set of silk curtains of our selling: green this time, dyed at Lyons; as far as dyers are concerned I wish the days of Colbert back again; it was red last time, and Tours'.[11] Most troublesome of all were printed fabrics. Morris's disastrous experience with his *Tulip and Willow* chintz has already been mentioned, and it indicated that the use of Clarksons was no more than a stopgap. By the end of 1875, he had become 'deeply impressed with the importance of our having all our dyes the soundest and best that can be'.[12]

Morris's response to problems of this kind was a straightforward

97

combination of self-confidence and pragmatism: he was quite happy to give outside firms their head if they were up to meeting his requirements; if they were not, then he simply resolved to learn for himself how to do the work properly. This, in effect, was something like serving an apprenticeship in several trades – notably dyeing and weaving (and, much later, printing). Perhaps the most remarkable of these ventures was his mastering of the ancient dyer's craft from 1872 to 1877.

Before the 1830s and 1840s, most textile manufacturers worked with a range of organic dyestuffs, many of which had been continually in use since ancient times. Principal amongst them were indigo, a blue vegetable dye; kermes, a red insect dye, and madder, also red, but of vegetable origin; walnut roots or shells for brown; weld yellow, from the wild mignonette; and other yellow and brown dyes from trees like poplar and willow. Later additions came from the New World; cochineal, a bright red insect dye, and American logwood, which gave a range of reds, yellows and browns. Together, these dyestuffs provided the four basic colours needed; the primaries – red, yellow and blue – and brown. Other colours could be made by combining them; greens, for example, were made with indigo and weld, while black was achieved by dyeing with indigo, followed by walnut roots. Walnut in fact was often used to darken colours – saddening, as it was called.

In the nineteenth century, however, this traditional palette was progressively displaced by new chemical dyes. The first of them was Prussian blue (1810), followed by a rather bright, acid green based on arsenic in the 1830s; rather later came the coal-tar derivatives – the aniline dyes – beginning with mauve in 1856. By the 1870s, textile factories had almost all gone over to the newer chemical dyes, which were cheap and readily obtainable in large quantities. They had the added advantage of being quick-drying, and thus were suited to mechanical application by roller rather than by the old method of hand-blocking. By comparison, the traditional dyestuffs were difficult to use – especially the most permanent of them, kermes and indigo. The work was highly skilled; it was often necessary to use mordants (setting agents), and at times other chemicals had to be printed on to parts of the cloth to make them resist taking up the dye.

The world of commerce, therefore, had no doubts: the new dyestuffs were preferable in every way to the traditional alternatives. Morris, however, having realised that the rich colours of the old fabrics, carpets and tapestries he so much admired were produced by traditional animal or vegetable dyestuffs, was highly critical of the anilines:

> The fact is, that every one of these colours is hideous in itself, whereas all the old dyes are in themselves beautiful colours; only extreme perversity could make an ugly colour out of them. Under these circumstances it must, I suppose, be considered a negative virtue in the new dyes, that they are as fugitive as the

older ones are stable; but even on that head I will ask you to note one thing that condemned them finally, that whereas the old dyes when fading, as all colours will do more or less, simply gradually changing into paler tints of the same colour, and were not at all unpleasant to look on, the fading of the new dyes is a change into all kinds of livid and abominable hues.[13]

It is a measure of Morris's ability as a designer and colourist that he nonetheless managed to provide his clients with attractive and successful decorative work in the early 1870s. But he was becoming increasingly restive with the limitations of the 'provisional' palette which had been forced upon him by the use of modern aniline dyes, with their choice of bright gaudy colours or dull, muddy ones. When he tried to get his fabrics dyed by traditional methods, he found to his dismay that the age-old art of vegetable dyeing had passed almost completely out of commercial use in a mere thirty or so years, and detailed study and careful experimentation were required in order to rediscover it. As noted earlier, Morris began dyeing experiments at Queen Square in 1872, when his family moved out to Horrington House, Turnham Green. He spent a good deal of time searching for old herbals and treatises on dyeing, such as Gerard's *Herbal*, Philemon Holland's edition of Pliny's *Historia Naturalis*, and works by Hellot (Paris, 1750), Matthiolus (Basle, 1543) and Fuschius (Venice, 1590).[14] After careful study, he began to experiment, at first working alone or with a young assistant. About this time, his friends frequently recorded that Morris's hands and clothes were permanently stained with dye, and his uncouth appearance more than once caused servants of friends or clients to refuse him admission to their houses or to redirect him to the tradesmen's entrance. Doubtless such indignities were worth putting up with: all his experiments were successful to some extent, largely because of the careful research which he had undertaken before beginning them.[15]

At Queen Square, Morris was able to produce a variety of wools and silks for the firm's embroideries. But kitchen coppers were too small to produce the large quantities of yarns need for carpets and other woven fabrics; nor was there enough space for textile printing. The solution was found when the firm's manager, George Wardle, introduced Morris to his brother-in-law, Thomas Wardle, who had set up as a silk and calico printer and dyer at Leek, Staffordshire, in 1870.[16] Thomas Wardle himself was experienced in aniline dyeing, but he remembered the older processes of vegetable dyeing from his childhood: his father, Joshua Wardle, had been a leading silk dyer in the 1840s and 1850s. Like Morris, Wardle was interested in the revival of traditional techniques, and agreed to turn one of his two dyehouses over to Morris's experiments.

Morris visited Leek in July–August 1875, and began his work with the help of Wardle and three of his employees. It was the first of many visits over the course of the next two years, as Morris and Wardle experimented tirelessly. A regular correspondence began, with Morris sending detailed

comments on the colour matching and fastness of each bunch of fents (samples) which Wardle supplied. Early in September 1875, for example, he reported:

> if 810 gets any dirtier or redder even but a little than it now is, it will be ruined. In green 968 the lighter colour might be a little fresher: this fent washed very badly, the darkening of the yellow in soap obviously making the evil worse. 967 leaves nothing to be desired if it were only faster: the colour is quite perfect. The fent of marigold (unnumbered) might be a little lighter and brighter: it washed much better than the other greens. . . . 1018 yellow marigold – a bad match, being much too dark: otherwise satisfactory, colour not bad and seems well printed. 1019 tolerable match but rather duller and darker than pattern.[17]

Morris's letters to Wardle – the most important series of business letters to have survived – reveal much about his activities in this period. They show him to have been determined to achieve and maintain the highest standards: 'I mean that I can never be content with getting anything short of the best, and that I should always go on trying to improve on goods in all ways, and should consider anything only tolerable as a ladder to mount up to the next stage.'[18] At first, though, the results were discouraging, and Morris's letters include scathing references to Wardle's head dyer, Kay, who evidently felt that he knew his trade better than Morris. In October 1875, Morris wrote:

> I confess I am quite discouraged: Kay does not seem to be able to do anything, even the simplest matching, and it is all a matter of luck how things go: I believe he thinks we can't do without him and that he can do anything he pleases: I don't suggest sacking him at once in the face of all the present orders, but we can't be forever under his hippopotamus thumb.[19]

A month later, he was complaining that Wardle's dyers had disregarded his orders, which 'almost entirely nullifies whatever advantage may be derived from my artistic knowledge and taste, *on which the whole of my business depends* . . . I will say no more than to beg of you to impress upon them the necessity of following out their instructions to the letter *whatever may be the results*'.[20]

By early 1876 Morris had reason to be more optimistic. In March, in the midst of one of his visits to Leek, he wrote to Georgie Burne-Jones, 'I trust I am taking in dyeing at every pore (otherwise than by the skin of my hands, which is certain). I have found out and practised the art of weld-dyeing, the ancientest of yellow dyes, and the fastest.'[21] A couple of days later, he told Aglaia Coronio:

> I am working in Mr Wardle's dye-house in sabots and blouse pretty much all day long: I am dyeing yellows and reds: the yellows are very easy to get, and so are a lot of shades of salmon and flesh-colour and buff and orange; my chief difficulty is in getting a deep blood red, but I hope to succeed before I come away: I have not got the proper indigo vat for wool, but I can dye blues in the cotton vat and

get lovely greens with that and the bright yellow that weld gives. This morning I assisted at the dyeing of 20 lbs. of silk (for our damask) in the blue vat; it was very exciting, as the thing is quite unused now, and we ran a good chance of spoiling the silk.[22]

Success eventually came, and Wardle took over much of the firm's dyeing and printing. Most important of all, perhaps, was the introduction of a range of block-printed chintzes. The first chintz to be marketed was the *Tulip*, a design registered by Morris in April 1875, and first printed by Thomas Wardle towards the end of that year. By 1878 he was printing fourteen designs for the firm, including *Honeysuckle*, one of Morris's best-loved designs, which was printed on to cotton, silk, velveteen and linen. Some designs, with small square or diaper patterns, drew upon the example of imported Indian textiles, in which Morris took a particular interest.[23]

In addition to block-printing, Wardle began dyeing for woven textiles. By April 1876, Morris was asking him to dye about 200lb. of low quality wool a week for his three-ply Kidderminsters, as the Heckmondwike Manufacturing Co. had agreed to use yarns supplied by Wardle. He added, 'if this could be settled, we could try to make arrangements for the dyeing of our other woollen yarns to be done by you: they are of a finer quality and so would bear a higher price'.[24] The terms were evidently satisfactory, and the first order was placed by the end of the month for sufficient yarn to weave 200 yards of carpet.[25] This part of the work went well, and Morris was able to assure Wardle that 'nothing could be better both to tone and relief of colour.'[26]

Morris soon became eager to extend the range of products dyed at Leek. In May 1876, he asked Wardle whether he would be prepared to dye the firm's piece-goods (serges and Utrecht velvets from the Manchester firm of J. Aldam Heaton) once the dyeing of wool hanks for carpets was under way.[27] Silk and cotton yarns were dyed for the woven fabrics produced for the firm by Nicholsons and McCreas, and about the same time Wardle also began dyeing silks and worsted for embroidery, although Morris felt obliged to apologise for the relatively small quantities involved.[28]

Inevitably, perhaps, some problems remained; Wardle was using a mixture of natural and chemical dyes, set by steam, and blues and greens were much more difficult to get right than yellows or reds. Morris was particularly unhappy about the use of Prussian blue, but he had to make do with it, using a variety of other dyes to mitigate its 'coldness'.[29] The alternative was to use indigo, but technically this was by far the most intractable of the traditional dyes. Wardle made several attempts to use indigo, beginning in 1876, but found it very hard to achieve a solid, unstreaky blue. The indigo vat took several days to prepare, and required constant attention, for the dyer had to be able to recognise when it was

ready. And if it was not kept sealed, the dye 'liquor' quickly oxidised, making it colour-fast and useless for dyeing the cloth. Cloth or yarn had to be dipped evenly, too, because inevitably some oxidation took place in the liquid near the surface of the vat, which dyed less strongly as a result. In October 1876, Morris noted that dyeing silk with the indigo process was still unreliable, because the colours were not fast, and decided to continue with modern chemicals for the time being: 'it seems more than a pity to lose our order as we shall do if we put it off much longer: so I propose to get this silk dyed by you in the fastest modern way possible'.[30] He returned to the subject of indigo dyeing in the following April, when he asked Wardle to dye a small parcel of silk: 'we have more orders coming in for silk, and have a chance of putting that business on its legs if only we can get the indigo dyeing done: I really must implore you to do something to get us started in this line'.[31] But although Wardle did not cease trying to deal with this problem, it was never satisfactorily overcome. Morris was obliged to abandon his plans to begin indigo dyeing on a commercial scale until he could set up his own dyeworks.

Nevertheless, Morris was in no doubt that his experiments in dyeing and printing were crucial to business success, expensive and time-consuming though they may have been: 'for me giving up the dyeing schemes means giving up my business altogether, and to give up the printing would be a serious blow to it, especially as last midsummer our balance showed a loss on that account of £1,023'.[32] Above all, it was his unique eye for colour that set Morris apart from contemporaries; this in turn required him to master the techniques of dyeing and printing. Yet, as a practical man of business, Morris also demonstrated an awareness of manufacturing costs, and was always concerned that the cost of experimentation should not be permitted to drive the cost of the finished goods to an unsaleable level. On 5 November 1875, he agreed to Wardle's proposed prices for the next six months. But he added:

> I must say, though that I hope at the 6 months end you will find it possible to reduce the prices considerably: if not I can't help seeing that the sale is likely to be limited. The prices are more than double Clarkson's for block-printed cloths, and *his* prices are I am sure from the way we began business with him calculated above the usual scale.[33]

Despite these difficulties, the collaboration with Wardle offered many new opportunities which Morris was quick to exploit. Through his mastery of the old vegetable and animal colours – kermes, madder, weld, and so on – Morris was able to maintain the emphasis on quality and durability which was characteristic of his business; and he was also able to create a range of products which was quite distinctive. Morris was delighted with the 'frank full hues of the permanent dyestuffs' now at his disposal, and immediately abandoned the 'provisional' colour schemes used until then.[34] As he told

Wardle: 'I am sure you understand that we want to get something *quite* different from the ordinary goods in the market: this is the very heart of our undertaking since we felt that the ordinary manufacturer throws away precious opportunities that the natural fibres and dyeing drugs give him.'[35]

By 1877, Morris was largely able to delegate the task of dealing with the Leek dyeworks to the managers of his new shop in Oxford Street, Frank and Robert Smith, and turn to new projects which had only now become possible. In particular, his attention was drawn once again to woven fabrics: handmade carpets, brocade weaving and tapestry. But although he continued to use firms in the trade for plain fabrics or large orders, he was no longer content simply to supply yarns to subcontractors; now he wanted to set up his own looms.

In March 1877, Morris wrote to Thomas Wardle:

> I very much want to set up a loom for *brocade* weaving: would it be possible to get a Frenchman over from Lyons under the present circumstances of the trade there? I would give a year's engagement certain to a real clever fellow who would do what I wanted him to do: I am dazzled at the prospect of the splendid work we might turn out in that time.[36]

By brocade, Morris meant a woven cloth with a raised pattern. In particular, he meant the weaving of figured silks, and this, as his letter indicated, was widely regarded as a French speciality. With Wardle's help, a Lyonnais weaver named Louis Bazin was recruited to help start the new venture. Morris hired workshop space in Great Ormond Yard, near Queen Square, and had an upper floor rebuilt with large windows to provide good lighting.[37] Bazin arrived in June 1877, and at once set to work to erect the loom which he had brought with him. This was a Jacquard loom, and, throughout his business career, Morris was to prefer this type of loom to the more traditional hand-loom or draw-loom.

A genuine hand-loom consisted of a frame across which threads were fixed vertically and in parallel (the warp). The weaver had to pass the weft thread by means of a shuttle between the individual fixed warps, much as a skier negotiates a slalom course. The method allowed the weaver complete freedom in his choice of yarn, and in the manner of the weaving. There was no necessity for a regular repeat, and the design was only constrained by the weaver's skill and imagination. It was, however, a very slow process, and had long been replaced by the draw-loom, in which the warp threads lying above the weft were pulled up, leaving a straight, unimpeded path through which the weaver could simply throw his shuttle. This operation, known as forming a 'shed', was done by tying cords or 'leashes' to the warp threads, and attaching them to a rod which could be raised when necessary. If alternate warp threads were raised, a plain pattern would result; but more elaborate patterns could be introduced by raising

103

different combinations of warp threads. Each assembly of leashes and rods was called a 'heddle', and a separate heddle was needed for each horizontal line. This explains why most woven fabrics repeated after a fairly short distance. Even so, weaving was still a slow and labour-intensive occupation; it took a very long time to set up a loom, and the weaver required the assistance of a 'draw boy' to help raise and lower the heddles.[38]

Around the turn of the nineteenth century, however, a new kind of loom was invented by a Frenchman, Joseph Marie Jacquard. Each warp thread could be connected to a hook, which the weaver could move upwards. The operator only needed to raise a selection of the warp threads to make his shed, and a device was needed to prevent some of the hooks from rising. This took the form of a rectangular card, in which holes were punched opposite the hooks that needed to be lifted. A separate card was needed for each shed, and they were presented one at a time in the correct order. For each row of the design, therefore, some warp-threads were raised as their hooks passed through the card, while others were held down, allowing the weaver to throw his shuttle across the loom. The Jacquard loom's advantages over the draw-loom were obvious. Punching holes in a card was a much faster and more reliable process than tying up the leashes to the warp threads. It greatly reduced setting-up time, and, because sets of cards could readily be stored or copied, it was easy to reproduce a design, or switch to a different one.[39] The commercial advantages of the Jacquard loom were soon appreciated, and it was widely used from the 1820s for all types of weaving. Though it could be powered either by hand or by steam, Morris used only hand power.

Those who viewed Morris as a medievalist and anti-industrialist may perhaps have been surprised by his willingness to adopt the Jacquard loom. It was, after all, widely used in the fearsome mills of the industrial north, and, even if the weaver had any aesthetic judgement, he could not use it; for the punched cards controlled the whole operation. But, against this, the Jacquard loom had many advantages. In particular, it offered the designer greater freedom, permitting more sophisticated designs than the draw-loom. Morris's prime concern was always the quality of the product, and the hand-operated Jacquard tended to produce goods of a greater consistency, as well as of higher artistic merit, than the older types of hand-looms. Its use, however, as Parry has noted, did mean that Morris 'handwoven' textiles were 'a far cry from the fabrics associated with the term today'.[40]

Things did not go smoothly at first. For a while, Bazin was seriously ill, and weaving could not start until October 1877. He then started work on Morris's *Willow* pattern, a figured silk which had been adapted from a wallpaper design, but ran he into immediate difficulties with the Jacquard cards, and the design became unrecognisable. Eventually it turned out that he put them in the wrong order, causing Morris to comment that

'these weavers don't understand much about getting a pattern together: they can just weave, and that is all'.[41]

Once this problem was overcome, Morris soon had reason to be pleased with the quality of the work produced at Great Ormond Yard. The *Willow* silk brocade was soon followed by many other woven silk and wool fabrics, for Morris was hard at work on yet more designs. He carefully examined old silks, particularly the collection at the South Kensington Museum (now the Victoria and Albert Museum), and also studied from nature. In 1877 he told Thomas Wardle that 'I am studying birds now to see if I can't get some of them into my next design',[42] and four of his next six designs featured birds. They were *Bird*, a woven wool double cloth first produced in 1878, which was one of Morris's favourites; *Peacock and Dragon* and *Bird and Vine*, of woven wool; and *Dove and Rose*, a silk and wool double cloth. The other two designs were *Flower Garden* and *Acanthus*, originally for furnishing silks, but later also available in mixtures of wool and silk or silk and cotton.[43] From 1877, Morris concentrated on designing for his own looms; only large orders (such as for St James's Palace in 1881) and some of the silk and wool mixtures like *Dove and Rose* were thenceforth placed with outside contractors.

As the volume of work increased, more weavers were recruited. Most of them were old men, experienced workers from the rapidly declining Spitalfields silk industry. Morris's daughter May later commented that 'it was always somewhat pathetic to watch the weavers at work here on their hand looms – old men from Spitalfields who had been prosperous once and had been through bad times, saddened by the changes in industrial life that with its scurry and thrusting aside had passed them by'.[44] Nevertheless, they were an invaluable asset to the firm, and accordingly were relatively well paid. By the end of the decade, the weaving work was going very well, and Morris's only real cause for complaint was the lack of space for any further development.

Even as he was engaged in designing woven textiles for his own looms, Morris was turning his thoughts to the production of carpets and tapestries. In April 1877 he told Thomas Wardle that 'the tapestry is a bright dream indeed; but it must wait until I can get my carpets going . . . Meantime much may be done . . . I saw yesterday a piece of *ancient* Persian, time of Shah Abbas (our Elizabeth's time) that fairly threw me on my back: I had no idea that such wonders could be done in carpets.'[45] It should not, however, be concluded from this that Morris had only just become aware of the splendours of Eastern carpets. He had long been an admirer, and since the days of Red House he had been building up a large and valuable collection of antique rugs and carpets, the finest of which he hung on his walls, in defiance of western practice. He had also become extremely knowledgeable, and from the late 1870s was often consulted on possible acquisitions by the staff of the South Kensington Museum.

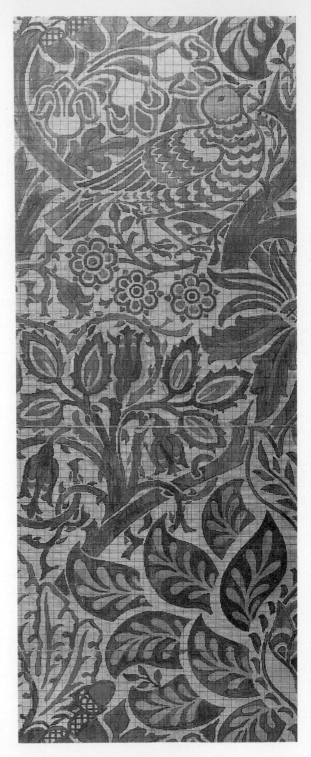

Plate 10 Dove and Rose point paper.
Working drawing for a silk and wool woven
fabric, designed in 1879

Morris did not wish to produce loom-woven carpets, but set out to gain experience in hand-knotting, emulating the Eastern masterpieces he so much admired. This too was something of a venture into the unknown, for hand-knotted carpets were not being manufactured in Britain at the time. He began by a careful examination of an antique Persian carpet, analysing every detail until he fully understood the processes involved. He then set up a frame in a back attic at Queen Square, where a few trial squares were made under his personal supervision. As soon as production began in earnest, more space was needed; and in the autumn of 1878, when Morris's family moved from Turnham Green to Upper Mall, Hammersmith, several carpet frames were set up in the spacious coach-house and stables. As a result, the firm's handmade carpets became known as 'Hammersmith' carpets, and often had a small hammer and capital M woven into the borders, together with wavy lines to represent the nearby Thames. About six young women were recruited, and Morris hired a carpet-knotter from Glasgow to come for a few weeks and teach them how to do the work. The greatest width of the carpet frames at Hammersmith was twelve feet, and each worker was expected to knot two inches of carpet a day.[46]

The technique used in the manufacture of Hammersmith carpets was fundamentally very simple. The warp threads, of worsted or (after 1880) of cotton, ran vertically, and were stretched between two horizontal beams. The weavers sat in front of the loom, and as they worked the completed carpet was wound on to the lower beam, and the warps unwound from the upper. The weavers worked to a pattern prepared on squared point paper – one square representing each knot – which was hung in front of them on the looms. The yarns, which were usually of wool, were cut into two-inch lengths, and each piece was individually knotted around two warp threads. As each row was finished it was beaten down to form a dense mass. Hammersmith carpets were differentiated from Morris & Co.'s Real Axminsters by their denser and deeper pile. In fact, although many of them have proved exceptionally hard-wearing, they were not particularly fine as hand-knotted carpets went, at about 25–28 knots to the square inch. Morris's designs took this into account, having bold patterns and colours without thin lines and fine detail. Evidently, he did not expect too much of his knotters, and also made something of a compromise between his desire for quality and the need for realistic selling prices. Even so, hand-knotted Hammersmith rugs and carpets were very expensive – a 16 foot by 13 foot carpet for Alexander Ionides cost £113 in 1883[47] – and were sold in relatively small numbers compared to the firm's power-loom-woven carpets.

Most of the early examples were rugs. Some were intended for hanging on walls, and accordingly were designed with patterns which worked in one axis only. Larger carpets soon followed. Although Morris's designs changed as he continued his studies into antique carpets and gained

experience as a manufacturer, blues and reds frequently predominated, rather than greens or yellows, and they featured complex curving patterns of acanthus, willow, and other stylised leaves, surrounded by large and striking borders, often in contrasting shades. Morris's big carpets were amongst his loveliest and most successful creations, partly because they were conceived as the central element in an ambitious decorative scheme. Amongst these were designs for Naworth Castle and Rounton Grange, the homes of two of Morris & Co.'s most valued clients, George Howard and Sir Isaac Lowthian Bell. The Naworth carpet must have been made after the firm moved its workshops to Surrey in 1881, as a 30 foot by 15 foot carpet could not have been woven on the comparatively small looms at Hammersmith.

By October 1882 Morris & Co. had produced enough rugs and carpets to supply an exhibition at the firm's new Oxford Street showroom. In the brochure, Morris set out his aims in producing hand-knotted carpets, pointing out that the great tradition of carpet-making was fast fading in the East, and that if it were to be kept alive at all it would have to be through the efforts of western designers and craftsmen. He obviously felt his own efforts to have been successful, later declaring of Hammersmith carpets that 'there are no such carpets made elsewhere, not even in the East'.[48]

Yet Morris had still not satisfied all his ambitions in the field of woven textiles. He had become intrigued, probably through his historical researches, by the possibility of reviving the fading art of tapestry making. In a lecture delivered in 1888, he pronounced that:

> The noblest of the weaving arts is tapestry: in which there is nothing mechanical: it may be looked upon as a mosaic of pieces of colour made up of dyed threads, and is capable of producing wall ornament of any degree of elaboration within the proper limits of duly considered decorative work ... special excellencies can be expected from it. Depth of tone, richness of colour, and exquisite gradation of tints are easily to be obtained in tapestry; and it also demands that crispness and abundance of beautiful detail which was the especial characteristic of fully developed Medieval Art.[49]

The principal reason why Morris held tapestry in such high esteem, it seems, was that, unlike other types of fabrics, it called for no compromise. Only the finest pictorial matter was suitable for the technique: 'the shuttle and the loom beat it on one side, the needle on the other, in pattern-work; but for figure-work 'tis the only way of making a web into a picture'.[50]

Two types of tapestry-loom were in use in the nineteenth century: the upright loom, also known as the high-warp or *haute lisse*, and the horizontal low-warp or *basse lisse*. The *haute lisse* was the more ancient, having been used to create the late medieval Flemish tapestries of the fifteenth and sixteenth centuries which Morris most admired. (They were known as Arras from the town most celebrated for its tapestry work.) The

weaver worked from behind the tapestry, and was able to watch the picture developing by looking through the warp threads at a mirror hanging in front of the loom. Although he followed a design which he marked on the warps, the work was entirely 'freehand', and the weaver was allowed a good deal of artistic licence. It was, needless to say, a highly labour-intensive process, and good quality work was very expensive. Attempts had been made to increase efficiency by making the warps horizontal, and laying the cartoon or pattern on a table, under the warp, for the weaver to follow. The result, however, was mere mechanical copying, and the *basse lisse* was rejected by Morris as artistically debased.

When Morris turned his attention to tapestry, therefore, he naturally turned to the ancient *haute lisse* method. This was still in use at the famous Gobelin factory in Paris, but Morris was intensely critical of the work done there. Its workers were engaged in copying oil-paintings and doing small floral panels: 'a more idiotic waste of human labour and skill it is impossible to conceive', he asserted; arguing that it had lowered the art to the status of a mere 'upholsterer's toy'.[51] For although he believed that 'tapestry at its highest is the painting of coloured pictures with wool upon a warp',[52] he insisted that it should never be mere *imitation* of oil-paintings or the like. He took a similar view of two other workshops, one at Beauvais, and one in Windsor, which still used the old high-warp loom. The latter was the Royal Windsor Tapestry Works, opened under Queen Victoria's patronage in 1876, which specialised in landscapes and other 'realistic' reproduction work. Morris remarked that it 'has most unluckily gone on the lines of the work at the Gobelins, and if it does not change its system utterly, is doomed to artistic failure whatever its commercial success may be'.[53]

Morris first began to study tapestry seriously in the autumn of 1877. He looked up descriptions of the loom and weaving techniques in old books, most notably a French textbook dating from the eighteenth century, and he visited the Windsor works to learn something of the way in which the looms were built, though he could find nothing to admire in its products. Technical knowledge might easily be acquired, but figure-weaving demanded artistic skills of a high order. This Morris understood, as he explained in a letter to Thomas Wardle, setting out the qualifications needed before a person could do first-rate figure work:

1. General feeling for art, especially for its decorative side.
2. He must be a good colourist.
3. He must be able to draw well: i.e. he must be able to draw the human figure, especially the hands and feet.
4. Of course he must know how to use the stitch of the work.

Unless a man has these qualities, the first two of which are rare to meet with and cannot be taught, he will turn out nothing but bungles disgraceful to everyone concerned in the matter.[54]

109

Morris did concede that an exception might be made in the case of 'leaf and flower pieces (greeneries, *des verdures*), which would generally be used to eke out a set of figure-pieces'; these would be within the compass of 'most intelligent people', and 'it would be only by doing these that you could cheapen the work at all'. But 'nobody but an artist' would meet his criteria for figure work, and Morris concluded: 'I have no idea where to lay my hands on such a man, and therefore I feel that whatever I do I must do chiefly with my own hands.'[55]

Before the end of 1878, tapestry had became more than the 'bright dream' of a year earlier. Morris somehow found the time to experiment by having a tapestry-loom installed in his bedroom, where he could practise weaving techniques in the early mornings before going to work. Very soon he had taught himself the basics of the method, and began to weave his first tapestry panel. The design was called *Vine and Acanthus*, although Morris nicknamed it *Cabbage and Vine*. He worked at it through the spring and summer of 1879, keeping a record of his progress in a notebook, which reveals that in all it took him 516 hours to complete.[56]

Having thus familiarised himself with the processes and difficulties of tapestry weaving, Morris began to teach others, so overcoming the difficulties envisaged in his letter to Wardle. He had another loom built at Queen Square, where he taught what he knew to Henry Dearle, who became his first tapestry apprentice. Dearle had previously worked as an errand-boy in the glass-painting workshop, but proved adept in tapestry work, and he in turn soon became responsible for training others. The firm was now ready to begin weaving tapestries on a commercial scale, but as this had to be delayed until the firm had moved to larger workshops in 1881 its description may be left to a later chapter.

By any standards, Morris's achievements in the 1870s were both prolific and diverse. What, then, were the keys to his remarkable productivity in this period? How did he set about doing the things he judged worth doing? To begin with, Morris made the best possible use of his time. He had the enviable ability to switch effortlessly from one activity to another.[57] The sheer variety of his business activities seems to have obviated any need for hobbies (though he enjoyed fishing and boating). And he was always ready, once he had mastered a technique, to pass on his knowledge to others, and leave them to carry out the physical work, thus freeing himself to engage in new interests and commitments.

More important still was the fact that Morris was a thorough professional in all things, with a method of working which he applied to each of his many activities – painting, pattern design, weaving, and dyeing – or indeed to literature and social criticism. His method had four principal dimensions: systematic research and exploration of the topic; identification of best practice and suitable models; experimentation to identify through personal experience the problems involved; and

modification of ideas, techniques or methods to bring his own work to fruition.

This approach demanded a great deal of hard work, for the older methods of production which Morris favoured were more difficult than the newer ones both in the learning and the application. Yet Morris was not simply doing things the hard way out of sentimental loyalty to a bygone age: he was seeking alternatives to the deficiencies of his own time. It will often occur to thoughtful people that, unless the course of history does, as some naïvely believe, follow a set, predetermined path, there have been numerous points when, but for some more or less random factor, that course might have followed a different direction from the one which has led to our present reality. These alternative histories are, of course, entirely hypothetical, and may be illusory, even as possibilities; but that they are indeed imaginable will not be denied. Thus history can be seen as being forever approaching junctions along the road, with no indications as to which choice of route should be preferred. But unlike some rural footpaths, the tracks of history do not peter out: any one of them will lead to somewhere. And it was a view widely held among the Victorian intelligentsia – Morris included – that the road along which they felt themselves to be travelling was a very dangerous and ugly one. The basis of this view, and in particular Ruskin's exposition of it, has already been touched upon. Its implications for Morris were clear: his own age could not supply him with satisfactory models in his chosen field; therefore he had to look elsewhere – that is, largely in the past, before things started to go wrong. He was not engaged in a futile attempt to put the clock back: he was rather looking for old materials, because only then could he find a new starting-point for the development of his ideas.

Mere originality was not enough; as Morris himself stated, 'however original a man may be, he cannot afford to disregard the works of art that have been produced in *times past when design was flourishing*' (our italics).[58] Thus his textile designs, which at first were naturalistic and free-flowing, underwent a radical change in 1876 as a result of his discovery of medieval woven textiles at the South Kensington Museum. Subsequent designs, with a few exceptions, tended to be more formal and symmetrical – such as his *Mohair Damask* of 1876, a design for woven wool and mohair which was based on a linen fabric believed to have been printed in the Rhineland in the fifteenth century. Other designs drew upon woven silks and damasks from medieval Spain and Italy. The link was less direct in the case of printed fabrics, but the medieval example was still a potent influence.[59]

It should be noted nonetheless that Morris's researches were largely of a technical kind. He had, of course, long been familiar with the old works of *art*; now he had learned to understand many of them as *craft*. He had felt the need to do this largely because he saw the older work as superior to

111

most of the new in those almost intangible qualities of texture and finish; rather as most people in our present age, irrationally but irrefutably, prefer wood to plastic. But he owed much of his success as an actual designer to his understanding of the materials used, and the techniques which applied to them. Every material has its own specific nature, which, if the designer works with it, offers rich rewards; if he does not, the result is artistic failure.

Yet Morris did not tie himself completely to earlier models, either as craftsman or as designer. He quite happily adopted any modern techniques which served his purpose, such as the Jacquard loom; the various chemicals used as dye-setting agents; and, later in life, photography as an aid in designing tapestry and typefaces. And while stressing the importance of studying old examples, Morris also believed that the designer was 'bound to supplement that by a careful study of nature, because if he does not he will certainly fall into a sort of cut and dried, conventional, method of designing'.[60] This insistence on working direct from nature was central to the ideas of the Pre-Raphaelite Brotherhood: but was also quite natural to Morris. As a child, he had spent many hours poring over the illustrations in a copy of Gerard's *Herbal*, which was to provide the inspiration for many of his own designs for wallpapers, textiles and stained glass; and throughout his life Morris loved the plants and flowers of the countryside and garden. But even the natural world should not dominate the designer; just as Morris was prepared to learn from the antique, but not to reproduce it, so he was prepared to draw on nature, but not to create purely naturalistic designs.

In adopting this approach to design and experimentation Morris was putting into practice Ruskin's advice on design. Indeed, it is probably true to say that no one went so far as he in following Ruskin's prescriptions. Ruskin not only elevated decorative art, but also made the case, in his various writings, for the artist, designer and craftsman to be seen as one: 'no person is able to give useful or definite help towards the special applications of art, unless he is entirely familiar with the conditions of labour and materials involved in the work'.[61] These sentiments were later echoed by Morris, after years spent mastering the diverse crafts that formed the business of the firm. It is no coincidence that Morris carried on pursuing Ruskin's ideal long after most of the other partners in MMF & Co. had given up. (Madox Brown continued to design furniture at intervals, but was never involved in the practical learning of crafts.) Other important similarities to Ruskin can be identified. 'NEVER encourage imitation or copying of any kind except for the sake of preserving great works', Ruskin had exhorted in 'The Nature of Gothic'.[62] Morris also accepted the Ruskinian notion that goods should not be overfinished. 'NEVER demand an exact finish for its own sake, but only for some practical or noble purpose.'[63] Fitness for purpose was a guiding

Ruskinian principle, and it was reiterated by Morris in his own writings.

By and large, Morris can be seen to have followed Ruskin's prescriptions quite closely. Yet he did not – could not – follow the master to the letter. As he wrestled to develop and market his products, he felt obliged to make compromises; to allow serial production, and sell goods of which he did not entirely approve. Ruskin himself was never more than a theorist and observer. As Morris, the more practical man, grew in experience and confidence, he began to extend and develop his ideas about design and production beyond those of Ruskin.

By the late 1870s, these ideas were reaching a wide audience. Morris's reputation had never stood higher. He had become an external examiner at the South Kensington Museum, and was regularly consulted about purchases for its collections. In the late 1870s and early 1880s, he was also becoming known as a public speaker. His first important lecture, 'The Lesser Arts', was delivered in London to the Trades' Guild of Learning towards the end of 1877, and was followed by many more. This meant that Morris had to work out his ideas thoroughly and coherently; and the texts of his lectures provide a very clear exposition of his artistic *credo*, the fundamentals of which have been set out above. They were often concerned with practicalities. Thus, in 'Some Hints on Pattern Designing', delivered at the Working Men's College in 1881, he made the key observation that 'ornamental pattern work, to be raised above the contempt of reasonable men, must possess three qualities: beauty, imagination and order'.[64]

The need for beauty was obvious, although Morris had much of interest to say about how it might be achieved. In 'Making the Best of It', he described the tints he preferred for colouring walls:

> a solid red, not very deep, but rather describable as a full pink, and toned both with yellow and blue, a very fine colour if you can hit it; a light orangy pink, to be used rather sparingly. A pale golden tint, i.e. a yellowish-brown; a very difficult colour to hit. A colour between these two last; call it pale copper colour. All these three you must be careful over, for if you get them muddy or dirty you are lost. Tints of green from pure and pale to deepish and grey: always remembering that the purer the paler and the deeper the greyer. Tints of pale blue from a greenish one, the colour of a starling's egg, to a grey ultramarine colour, hard to use because so full of colour, but incomparable when right.[65]

He then went on to discuss the juxtaposition of different colours, and the use of colour in pattern-designing, drawing upon historical examples from Persia, France and Italy.[66]

Morris's ideas on imagination were more complex. First, there was 'meaning' – defined as 'the invention and imagination which forms the soul of this art'.[67] Then there was the need for the artist to respond imaginatively to his models: 'True it is that meaning may have come down to us traditionally, and not be our own invention, yet we must at heart

113

understand it, or we can neither receive it, nor hand it down to our successors. It is no longer tradition if it is servilely copied, without change, [which is] the token of life'.[68] Finally, the decorator had to use imagination to overcome the limitations of his medium, for his art could not be imitative to the same degree as that of the painter. Conventionalisation was therefore essential, and this required both inventiveness and imagination. This did not mean, however, that the designer did not need to observe from nature, or possess good drawing skills:

> On the contrary, unless you know plenty about the natural form you are conventionalising, you will not only find it impossible to give people a satisfactory impression of what is in your own mind about it, but you will also be so hampered by your ignorance, that you will not be able to make your conventionalised form ornamental. . . . It follows from this that your convention must be your own, and not be borrowed from other times and peoples; or at least you must make it your own by by thoroughly understanding both the nature and the art you are dealing with.[69]

In his lectures, Morris called for a balance between straightforward naturalism on the one hand and abstract pattern-making on the other – neither of which was acceptable. The extent to which the design should mimic nature, for example, was dependent upon the medium: the coarser the medium, the more stylised the design. It also depended upon the scale of the design; small, frequently recurring ornament should be less naturalistic than larger, freer designs.[70] In all this, as was frequently the case, Morris often echoed the views of Victorian designers like Pugin, Dresser and Owen Jones, who had been influential since the 1850s. It would be quite wrong to view Morris as a revolutionary or isolated figure in the history of design. He was in fact one of many who turned away from the intensely naturalistic, three-dimensional designs which typified the work of industrial designers in the middle decades of the nineteenth century. At the same time, Morris was opposed to purely abstract designs, and rejected the more geometric patterning of Owen Jones, Burges or others like them who drew on Islamic decorative arts. 'You may be sure that any decoration is futile . . . when it does not remind you of something beyond itself', he posited.[71]

Order was another theme to which Morris frequently returned in his lectures. By this he meant two things. First, he devoted a good deal of time to analysing the structure of patterns. In 'Some Hints on Pattern Designing', he described in some detail the basic grids upon which flat patterns might be created – squares, chequers, diagonal stripes, vertical or diagonal meanders, and the like – demonstrating the breadth of his knowledge and understanding with a profusion of historical illustrations.[72] By 'order', though, he also meant working according to the nature of the medium, not straining it, but exploiting its opportunities:

Now order imposes on us certain limitations, which partly spring from the nature of the art itself, and partly from the materials in which we have to work; and it is a sign of mere incompetence in either a school or an individual to refuse to accept such limitations, or even not to accept them joyfully and turn them to special account, much as if a poet should complain of having to write in measure and rhyme.[73]

But even beauty, imagination, and order – the self-contained virtues of the decorative arts – were not enough. For these arts existed not just in themselves, but in the world as a whole; Morris saw this as calling for 'moral qualities'. All his lectures in the late 1870s and early 1880s were essentially concerned with the development of his ideas on the necessity of art as part of everyday living, its contribution to human happiness, and the relationship of art to the burning social questions of the day.[74]

Morris was always insistent that art should not be confined to the leisured and the privileged: 'I do not want art for a few, any more than education for a few, or freedom for a few.'[75] Thus he had no patience with Aestheticism, which saw art as something rare and precious, to be enjoyed only by a refined elite. Not everybody would be capable of great art; but all should be given the opportunity and encouragement to contribute to the full extent of their abilities. The decorative arts might be the 'lesser arts' in comparison to architecture, which was the mother of all the arts, but they were vitally important nonetheless as a means of brightening the daily lives of the people: 'I say that without these arts, our rest would be vacant and uninteresting, our labour mere endurance, mere wearing away of body and mind.'[76]

But Morris was well aware how far this ideal was from the reality of everyday life, and this led him to develop in these lectures a wide-ranging critique of nineteenth-century industrial society. Fundamentally, it seemed to him that the nineteenth century – the 'Century of Commerce', as he called it – had seen an appalling decline in standards. 'England has of late been too much busied with the counting-house and not enough with the workshop', he argued.[77] The manufacturers, 'who never did a stroke of hand-work in their lives', had become 'nothing better than capitalists and salesmen', concerned with profit margins rather than the maintenance of quality. Artists, designers and craftsmen had likewise been forced to respond to the dictates of the market-place for, with the separation of entrepreneurial, design and production functions, their status had been debased, and they had become the hirelings of manufacturers who knew little and cared less about art or industrial design. Hence the prevalence of 'sham' or 'shoddy', as Morris often called the products of nineteenth-century industry.

All aspects of life were affected by this trend. Nineteenth-century housing, for example, was castigated by Morris as 'the basest, the ugliest, and the most inconvenient that men have ever built for themselves, and

115

which our own haste, necessity, and stupidity, compel almost all of us to live in'.[78] The destruction of trees and fields by the sprawl of monotonous, cheaply built suburbs around Britain's great cities was the target of his particular ire. 'How can I ask working-men passing up or down these hideous streets day to day to care about beauty?' he asked.[79] Indeed, Morris's concern over the environment in which his fellow men had to live and work – his attacks on the pollution of Britain's rivers by industrial dyestuffs, or the fouling of her atmosphere by industrial chimneys – mark him as a notable forerunner of today's Green campaigners.

Taken together, Morris's lectures of the late 1870s and early 1880s provide a profound analysis of work and art in industrial society. Solutions to contemporary problems, however, were harder to produce – not surprisingly, considering that many of them continue to plague us today. Indeed, he was distinctly pessimistic about the situation, believing that contemporary civilisation was indifferent or even hostile to art, and recognising the difficulties involved in bringing about a fundamental change in the situation. In the fullness of time, he concluded that art could only flourish if capitalism itself was to disappear; but in these lectures he was still talking in moral rather than Marxian terms. He was clear that the prevalence of 'sham' and the degradation of the human environment was the responsibility of all classes, but was concerned to emphasise that it was primarily the duty of craftsmen to maintain standards. In 'The Lesser Arts', he declared that: 'I say all classes are to blame in this matter, but also I say that the remedy lies with the handicraftsmen, who are not ignorant of these things like the public, and have no call to be greedy and isolated like the manufacturers or middlemen; the duty and honour of educating the public lies with them'.[80]

Morris included in his moral concern not only the quality of the product, but also the use to which the product was put. On the latter point, he would not compromise, as is shown by his activities on behalf of the Society for the Protection of Ancient Buildings (SPAB) or Anti-Scrape, as it came to be known. In 1876–77, his anger began to swell at the drastic restorations then being carried out on many medieval buildings; for the Victorians, as well as rebuilding and repairing genuine dilapidations, felt justified in 'correcting' medieval work which was still sound. Sir George Gilbert Scott was the principal culprit, although many of the other leading architects were also guilty of over-restoration. The trouble stemmed from the Ecclesiologists and their followers, who believed that they had discovered a set of rules governing church architecture. Churches or cathedrals which did not match their prescriptions exactly were deemed to have been constructed by architects who did not fully understand these rules. Moreover, architects like Scott were insistent that buildings should be of a single coherent architectural style (preferably Decorated Gothic). This belief, however, put at risk a good majority of England's medieval

churches, most of which were an amalgam of different styles, and had been extended or modified many times during their existence. Admittedly, the later additions were sometimes of a poorer quality than the early work, but even so they provided a historical record of centuries of devoted care and continuous use. With supreme arrogance, Victorian architects set out to 'restore' Britain's ecclesiastical buildings in conformity with their notions of correctness; Scott, for example, demolished the entire east end of Oxford Cathedral, and rebuilt it in its 'original' Norman style.

Morris, of course, was not the only person concerned about the consequences of restoration. Pugin and Ruskin were both highly critical of the restorers,[81] while the *Athenaeum*'s art critic, F. G. Stephens, had published a number of articles criticising restorers, and Scott in particular. Even the much-maligned architectural profession had mixed feelings about restoration; the author of Butterfield's obituary in the *RIBA Journal*, for example, commented that 'we are wrapt in wonder that he could appreciate so much and spare so little'.[82]

But it was Morris's action and example that proved decisive. His intervention was provoked by the restoration then being carried out by Scott at Tewkesbury Abbey. On the face of it, this was a worthy project: the Abbey certainly needed urgent structural repairs, and much of the interior work was to remove unsightly post-medieval additions. Yet the essential issue was about history and truth on one side and appearance and structural soundness on the other. In a letter to the *Athenaeum* in March 1877, Morris wrote:

My eye just now caught the word 'restoration' in the morning paper, and, on looking closer, I saw that this time it is nothing less than the Minster of Tewkesbury that is to be destroyed by Sir Gilbert Scott. Is it altogether too late to do something to save it – and whatever else of beautiful or historical is still left us on the sites of the ancient buildings we were once so famous for? Would it not be of some use once for all, and with the least delay possible, to set on foot an association for the purpose of watching over and protecting these relics, which, scanty as they are now become, are still wonderful treasures, all the more priceless in this age of the world, when the newly-invented study of living history is the chief joy of so many of our lives? Your paper has so steadfastly and courageously opposed itself to those acts of barbarism which the modern architect, parson, and squire call 'restoration' that it would be a waste of words to enlarge here on the ruin that has been wrought by their hands . . . still there must be many people whose ignorance is accidental rather than inveterate, whose good sense could surely be touched if it were clearly put to them that they were destroying what they, or more surely still, their sons and sons' sons, would one day fervently long for, and which no wealth or energy could ever buy again for them. What I wish for, therefore, is that an association should be set on foot to keep a watch on old monuments, to protest against all 'restoration' that means more than keeping out wind and weather, and, by all means, literary and other, to awaken a feeling that our ancient buildings are not mere ecclesiastical toys, but sacred monuments of the nation's growth and hope.[83]

117

The publication of his letter speedily led to the establishment of the Society for the Protection of Ancient Buildings. Its first meeting was held on 22 March 1877, and founder members included Thomas Carlyle, Holman Hunt, John Ruskin, Leslie Stephen, Coventry Patmore and Edward Burne-Jones.[84] For a year or two Morris acted as honorary secretary: committee meetings were held at 26 Queen Square, and annual general meetings at the firm's Oxford Street showrooms. Webb played an important role on the technical side, and was involved in surveying many of the buildings brought to the Society's attention. In the first fifty years of its existence, the Society took an interest in more than a thousand buildings.[85]

The manifesto, which has been reprinted in every annual report down to the present day, was written by Morris. In it, he forcefully set out his belief that restoration ruined surviving medieval buildings, by attempting to destroy centuries of gradual change and honest repair work and to create a unified and correct architectural style which had never existed. The manifesto concluded with a plea to safeguard all the surviving medieval buildings in Britain from well-meaning but wrong-headed restorers:

> It is for all these buildings, therefore, of all styles and times, that we plead, and call upon those who have to deal with them to put Protection in the place of Restoration, to stave off decay by daily care, to prop a perilous wall or mend a leaky roof by such means as are obviously meant for support or covering, and show no pretence of other art, and otherwise to resist all tampering with either the fabric or ornament of the building as it stands; if it has become inconvenient for its present use, to raise another building rather than alter or enlarge the old one; in fine, to treat our ancient buildings as monuments of a bygone art, created by bygone manners, that modern art cannot meddle with without destroying. Thus, and thus only, shall we escape the reproach of our learning being turned into a snare to us; thus, and thus only can we protect our ancient buildings, and hand them down instructive and venerable to those that come after us.[86]

Morris's commitment to these principles had important implications for Morris & Co.'s stained glass business. The firm announced that it would no longer supply glass for medieval buildings which were undergoing restoration or improvement.[87] Apart from his opposition to restoration in principle, there was the practical consideration that, even where the utmost care was taken, the removal of existing glass inevitably caused considerable damage, and new mullions and tracery were often required as well. This did not amount to a complete ban on work for old churches, though, for Morris continued to supply windows to those with earlier work by the firm, and those which were not considered 'monuments of ancient art'. Even so, this was a costly decision, for his announcement was ill-understood by many potential clients, who wrongly regarded Morris glass as medieval in style, and therefore ideally suited to ancient buildings.[88] In fact, as noted earlier, the principles of its manufacture were

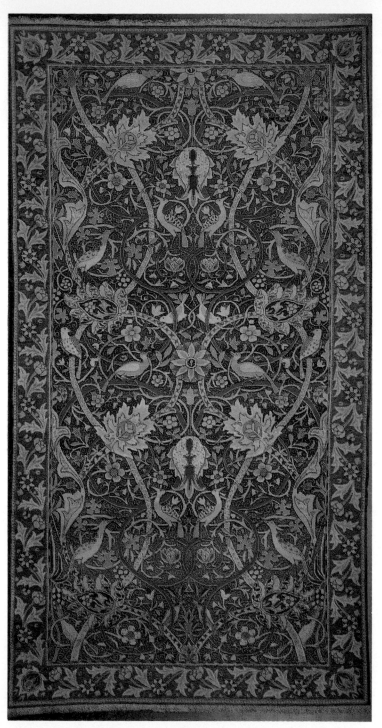

Bullerswood hand-woven carpet, 1889

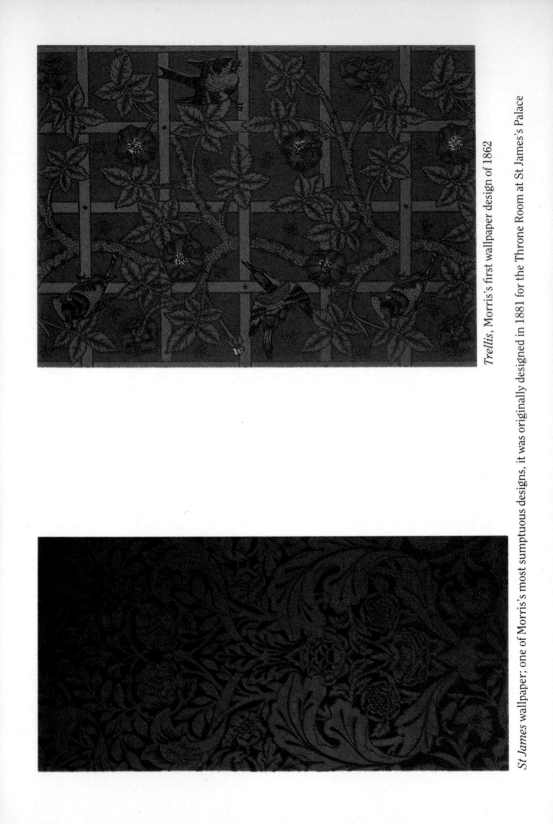

Trellis, Morris's first wallpaper design of 1862

St James wallpaper; one of Morris's most sumptuous designs, it was originally designed in 1881 for the Throne Room at St James's Palace

medieval in inspiration, but essentially the character of Morris glass was modern. The designs of Ford Madox Brown were distinctly unmedieval, and the pictorial style of Burne-Jones anticipated the aesthetic work of the 1880s and 1890s. The rumour spread – apparently fostered by some of Morris & Co.'s rivals – that the firm had given up making stained glass altogether. Morris was obliged to restate his position in a series of advertisements in the *Pall Mall Gazette*, *Athenaeum* and *Saturday Review*, but his business was nonetheless affected for some time. The firm undertook twenty-one commissions a year in 1877 and 1878, but then there was a decline to fourteen in 1879 and eleven in 1880.[89]

Morris was now able to withstand such setbacks. His growing reputation and the excellence of Morris & Co.'s widening range of products attracted important clients, and brought a sharp rise in the volume of business in the later 1870s. Many of MMF & Co.'s early commissions had come from members of the artistic circles within which the partners moved, and some of these early patrons continued to use the firm's services or buy its products. One wealthy member of the artistic community who became one of the firm's most important patrons in the 1870s was George Howard, later ninth Earl of Carlisle. His London house, 1 Palace Green, was built by Philip Webb between 1868 and 1872, and was decorated by Morris & Co. between 1872 and 1882. The dining room was its most impressive feature, with wood panelling and a frieze of panels portraying the story of Cupid and Psyche (started by Burne-Jones, completed by Walter Crane). The decorative work was designed by Morris around 1879. Morris & Co. also supplied carpets, tapestries and textiles for the Howards' other homes, Castle Howard in Yorkshire and Naworth Castle near Carlisle. Many items were specially designed, including a large Hammersmith carpet for the library at Naworth.[90] In 1874, the firm had also provided a set of five stained glass windows for the chapel at Castle Howard. Four of them had designs by Burne-Jones portraying the Annunciation, the Nativity, the Adoration of the Magi, and the Flight into Egypt, while the fifth contained square quarries.[91]

Gradually, however, the firm's clientele was changing, and it began to win a good deal of its business – especially the larger commissions – from a new type of patron. Many of them were the sort of wealthy buyers who, twenty or thirty years earlier, had patronised the Pre-Raphaelite Brotherhood; professional people, or members of the manufacturing and mercantile community, often from a provincial background, who lacked 'the preconceptions of an older and more metropolitan patronage'.[92]

One of the first such clients was Walter Bagehot, the lawyer and constitutionalist. He first became interested in the work of the firm around 1870, and his Somerset home was decorated with some of Morris's early wallpapers, although it can hardly be said to have brought about a revolution in taste amongst his neighbours, many of whom considered MMF &

119

E

Co.'s offerings 'too plain and rather queer'.[93] Nevertheless, when he bought a London house in Queen's Gate Place in 1874 he commissioned the firm to decorate it, writing to a correspondent that '[George] Wardle is doing most of the house, but the great man himself, William Morris, is composing the drawing room, as he would an ode.'[94] Another distinguished member of the financial community for whom Morris worked was Edward Charles Baring, who had bought Membland House, South Devon, in 1870. The house has not survived, and little is known of the work done, although it included the expensive embossed *Chrysanthemum* wallpaper (possibly designed for Membland) and tiles for the bathroom by Morris and De Morgan.[95]

A grander project than Membland was Rounton Grange, near Northallerton in Yorkshire, built for the ironmaster Sir Isaac Lowthian Bell by Philip Webb. It was one of Webb's most important commissions, and was decorated and furnished by Morris & Co. shortly after its completion in 1876. The dining room contained a frieze on the subject of the *Romaunt of the Rose*, designed by Burne-Jones with backgrounds by Morris. It consisted of five panels, and was worked by Lady Bell and her daughters, Ada and Florence, in silk, wool and gold thread on a linen ground. The room was further enriched by a painted ceiling and a Hammersmith carpet. The drawing room also had a large hand-knotted carpet, and wallcoverings of *Flower Garden*, a woven wool and silk fabric. As was generally the case with major commissions at this time, the decorative painting was personally supervised by Morris.[96]

Lowthian Bell's children were also important clients of the firm. Near Rounton Grange was Smeaton Manor, built and decorated by Webb and Morris for Bell's daughter Ada and her husband, Major A. P. Godman.[97] An earlier Webb house, Red Barns, Coatham, near Redcar, was built in 1868 for Bell's son Hugh. It was extended by Webb in 1876 and 1881, and it contained tiles, embroideries, wallhangings and upholstery fabrics from Morris & Co. The *Redcar* carpet was specially designed by Morris for the house in the early 1880s.[98]

But sales were not confined to the very wealthy; in the later 1870s, the firm was becoming highly fashionable amongst the better-off members of the middle classes. The writer Moncure Conway noted that in the new and fashionable Bedford Park estate in West London, laid out by the architect Norman Shaw in 1878, 'the majority of the residents have used the wallpapers and designs of Morris'.[99] The 'Morris look' was also entering into contemporary novels; one of the earliest was a sentimental American novel of 1872, Annie Hall Thomas's *Maud Mahon*, in which one of the characters advised a friend to 'make your walls artistic without the aid of pictures' by turning to 'Morris Papers'.[100] This, of course, was only partly Morris's own doing. In fact, he was not alone in trying to improve taste and the status of interior design, and his firm certainly profited from the

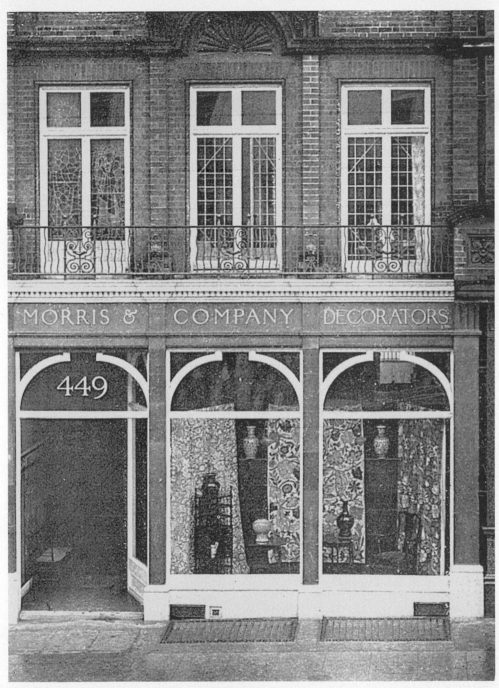

Plate 11 Morris & Co.'s shop, 449 Oxford Street, London

endeavours of others working along similar lines. The growth of its middle-class clientele was fostered by the work of enthusiasts like Charles Eastlake, whose *Hints on Household Taste*, first published in 1868, reached a wide audience; and Agnes and Rhoda Garrett, whose *House Decoration*, written in collaboration with Owen Jones, had gone through six editions by 1879. The Garretts' book appeared in a Macmillan series entitled 'Art at Home', which included *The Drawing Room: Its Decoration and Furniture* (1878) by Lucy Faulkner Orrinsmith, sister of Charles Faulkner and long-time associate of the firm. Then too, Morris developed close links with some of the embroidery societies which sprang up in the 1870s – such as the Royal School of Needlework (1872) and the Leek Embroidery Society, set up in 1879 by Thomas Wardle's wife, Elizabeth. As a result, Morris & Co. became one of the leading suppliers of patterns for 'art needlework'.[101]

In 1877, to help develop this burgeoning middle-class market, the lease was taken on a shop at 264 Oxford Street (later renumbered 449), in a new block of buildings on the corner of North Audley Street. This enabled the full range of goods to be displayed in a fashionable location in the heart of the West End, and released extra workshop space at Queen Square, which

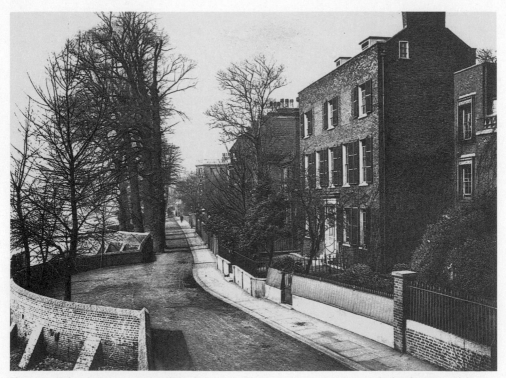

Plate 12 Kelmscott House, Upper Mall, Hammersmith. The basement now houses the headquarters of the William Morris Society

was immediately filled by the increased volume of work. This end of the business was handled by two brothers who had recently been taken on, Frank and Robert Smith, who were later to become junior partners in the firm.[102]

By the later 1870s, then, Morris's commitment to his business was beginning to bear dividends. In a letter to the Austrian socialist Andreas Scheu, written in 1883, Morris said that for the last twenty years he had: 'been working hard at my business, in which I have had considerable success from the commercial side; I believe that if I had yielded on a few points of principle I might have become a positively rich man; but even as it is I have nothing to complain of'.[103] His annual income from the firm had risen substantially, from about £300 in 1870 to reach about £1,800 in the early 1880s.[104] Although he still had to be careful with his money, and often complained of being short of cash, he could afford to continue his experiments, and was able to provide a better standard of living for his family. His girls were growing up, and their home, Horrington House, must have seemed ever more cramped and inadequate.

Early in 1878, Morris began house-hunting. His progress was recorded in a series of letters to Janey, who was with the girls in Italy, staying with George and Rosalind Howard. In March he went to Hammersmith to see a house known as The Retreat. It was a large Georgian house, separated from the Thames by a road and a row of large elms, and he reported to Janey that 'this is practically what we want in a house'. It had a big kitchen and other servants' rooms, main bedrooms for Janey, Jenny, May and himself, a quiet study, two sitting rooms and a guest bedroom. It also had a coach-house and stable, and a long, rambling garden, with delightful lawns, flower beds, an orchard, and a kitchen-garden. This, Morris felt, was 'the least we can do with', adding that 'at the risk of being considered self-seeking, I must say that in the ordinary modern-Cromwell-road-sort-of-house I should be so hipped that I should be no use to anybody; nor do I think that either you or the girls would get on in such a place'. Janey complained that it was too far from central London; Morris concurred, but reported that he was unable to get the sort of house they needed in localities like Knightsbridge or Kensington Square, which were 'quite beyond our means: a fairish house in such places means £250 per ann[um] and they almost always want a premium; which last I *cannot* pay'.[105]

The house was taken from midsummer 1878, and the Morrises moved in during October. It was quickly renamed Kelmscott House after Kelmscott Manor, their beloved summer retreat. Although Morris was careful with his money, he spent almost £1,000 on redecoration, excluding the cost of fabrics and other materials.[106] The most distinguished room at Kelmscott House was the long drawing room, which extended the full width of the house, with five windows looking out over the Thames. Its walls were hung with *Bird* woven wool fabric, one of Morris's personal

favourites, which went into production in 1878. On moving to Kelmscott House Morris finally agreed to Janey's demand for a third maid, and the establishment gradually grew until, by the early 1890s, the family employed six servants: a cook, a young manservant, and four maids.[107]

By the end of the 1870s, therefore, Morris was a successful businessman and a respected and influential designer, who was able to provide himself and his family with an enviable standard of living. As his lectures reveal, however, he was far from complacent about his achievements. Fame, fortune and influence had given him the luxury of choice in his affairs; his integrity and idealism led him to consider how best to make use of the opportunities before him.

1 Kelvin, *Letters*, Vol. I, p. 255, to Charles Fairfax Murray, 27 May 1875.
2 P. Floud, 'The Wallpaper Designs of William Morris', *Penrose Annual*, Vol. 24 (1960), quoted in G. Naylor, *William Morris by Himself* (1988), p. 315.
3 Wardle, 'Memorials', ff. 4–5.
4 Parry, *William Morris Textiles*, p. 75. On Nairns, see A. Muir, *Nairns of Kirkaldy: A Short History of the Company* (Cambridge, 1956); on the linoleum industry generally, see M. W. Jones, *A Comprehensive Account of the History and Manufacture of Floorcloth and Linoleum* (Bristol, 1918); F. Watson, *The Infancy and Development of Linoleum Floorcloth* (1925).
5 Parry, ibid., pp. 59, 77; O. Fairclough and E. Leary, *Textiles by William Morris and Morris & Co., 1861–1940* (1981), p. 49; Tattersall and Reed, *History of British Carpets*, p. 148. Also see J. N. Bartlett, *Carpeting the Millions: The Growth of Britain's Carpet Industry* (Edinburgh, 1978); L. D. Smith, *Carpet Weavers and Carpet Masters: The Hand Loom Carpet Weavers of Kidderminster, 1780–1850* (Kidderminster, 1986).
6 Parry, ibid., p. 79.
7 Wardle, *The Morris Exhibit at the Foreign Fair*, p. 7; Parry, ibid., p. 83.
8 See, for example, V & A, Box III 86 KK (xiv), Morris & Co. invoice to A. A. Ionides, March 1880.
9 Parry, *William Morris Textiles*, p. 84.
10 Double cloths used two warps, one of wool and one of silk. In the weaving, warp threads could be brought to the surface of the fabric to give a variety of effects and textures, with areas of silk or wool, or both. Wardle, 'Memorials', ff. 4–5; Fairclough and Leary, *Textiles by William Morris*, p. 49; Parry, *William Morris Textiles*, pp. 59–60.
11 Quoted in Mackail, *Life*, Vol. I, p. 312.
12 Ibid.
13 W. Morris, 'The Lesser Arts of Life' (1882), *Complete Works*, Vol. XXII, p. 257. Also see *idem*, 'Of Dyeing as an Art', reprinted in *Arts and Crafts Essays, by Members of the Arts and Crafts Exhibition Society* (1893), pp. 196–211.
14 Mackail, *Life*, Vol. I, pp. 314–15.
15 Wardle, 'Memorials', ff. 13–14.
16 The key role played by George Wardle in the firm's history has rarely been acknowledged. Not only did he understand, as Warington Taylor had not, the trade and its practices, but it was undoubtedly at his suggestion that Morris contacted Thomas Wardle. By bringing about their collaboration, he helped to make a major contribution to the history of textile printing and dyeing.
17 Kelvin, *Letters*, Vol. I, pp. 266–7, to Thomas Wardle, 3 Sept. 1875.
18 Ibid., p. 334, 17–30? Nov. 1876.
19 Ibid., p. 272, 28 Oct. 1876.
20 Ibid., p. 275, 5 Nov. 1875.
21 Ibid., p. 292, to Georgiana Burne-Jones, 26 March 1876.
22 Ibid., p. 294, to Aglaia Coronio, 28 March 1876.

23 Parry, *William Morris Textiles*, pp. 46–7, 150.
24 Kelvin, *Letters*, Vol. I, p. 295, to Thomas Wardle, 4 April 1876.
25 Ibid., p. 299, 25 April 1876.
26 Ibid., p. 365, 10 April 1877.
27 Ibid., p. 302, 9 May 1876.
28 Ibid., p. 299, 25 April 1876.
29 Ibid., p. 266, 3 Sept. 1876.
30 Ibid., pp. 327–9, 31 Oct. 1876.
31 Ibid., pp. 363–4, 10 April 1877.
32 Ibid., p. 335, 17–30? Nov. 1876.
32 Ibid., p. 275, 5 Nov. 1875.
34 Wardle, 'Memorials', f. 10.
35 Kelvin, *Letters*, Vol. I, p. 268, to Thomas Wardle, 3 Sept. 1875.
36 Ibid., pp. 357–8, 25 March 1877.
37 Wardle, 'Memorials', f. 14.
38 Tattersall and Reed, *History of British Carpets*, pp. 68–9; P. Thompson, *The Work of William Morris*, p. 100.
39 Tattersall and Reed, ibid., pp. 76–7.
40 Parry, *William Morris Textiles*, p. 61.
41 Kelvin, *Letters*, Vol. I, p. 415, to Jenny Morris, 29 Nov. 1877.
42 Ibid., p. 358, to Thomas Wardle, 25 March 1877.
43 Parry, *William Morris Textiles*, pp. 64–5, 152–3.
44 M. Morris, *Artist, Writer, Socialist*, Vol. I, p. 47. Also see Kelvin, *Letters*, Vol. I, pp. 412–13, to Jane Morris, 23 Nov. 1877.
45 Kelvin, ibid., p. 365, to Thomas Wardle, 13 April 1877.
46 Vallance, *William Morris*, p. 110; P. Thompson, *The Work of William Morris*, pp. 100–1, 104; Henderson, *Life, Work and Friends*, pp. 190–1; Parry, *William Morris Textiles*, p. 87.
47 V & A, Box III 86. kk. xiii, Estimate from Morris & Co. to Alexander Ionides, 2 May 1883.
48 Wardle, *The Morris Exhibit at the Foreign Fair*, p. 9.
49 W. Morris, 'Textiles' (1888), reprinted in *Arts and Crafts Essays, by Members of the Arts and Crafts Exhibition Society* (1893), pp. 23–4.
50 Kelvin, *Letters*, Vol. I, pp. 409–10, to Thomas Wardle, 14 Nov. 1877.
51 W. Morris, 'The Lesser Arts of Life' (1882), *Complete Works*, Vol. XXII, p. 253.
52 Kelvin, *Letters*, Vol. I, pp. 409–10, to Thomas Wardle, 14 Nov. 1877.
53 W. Morris, 'The Lesser Arts of Life' (1882), *Complete Works*, Vol. XXII, p. 254. In fact, it was a commercial failure too, and was forced to close around 1890. Vallance, *William Morris*, p. 113.
54 Kelvin, *Letters*, Vol. I, pp. 409–10, to Thomas Wardle, 14 Nov. 1877. Also see M. Morris, *The Introductions to the Collected Works of William Morris* (New York, 1973 reprint), Vol. I, pp. 371–2.
55 Kelvin, *Letters*, Vol. I, pp. 409–10, to Thomas Wardle, 14 Nov. 1877.
56 See M. Morris, *Introductions*, Vol. I, p. 374. The notebook, together with the original design, is now in the V & A, 86. EE. 88.
57 Morris's son-in-law, Henry Halliday Sparling, later remarked that 'there was something well-nigh terrifying to a youthful onlooker in the deliberate ease with which he interchanged so many forms of creative work, taking up each one exactly at the point at which he had laid it aside, and never halting to recapture the thread of his thought'. H. H. Sparling, *The Kelmscott Press and William Morris, Master Craftsman* (1924), p. 37.
58 *Second Report of the Royal Commissioners on Technical Instruction* (P. P. 1884, XXXI), Q. 1591.
59 See P. Floud, 'Dating Morris Patterns', *Architectural Review*, Vol. CXIII (July 1959), pp. 14–20; P. Thompson, *The Work of William Morris*, p. 105.
60 *Second Report of the Royal Commissioners on Technical Instruction*, Q. 1591.
61 J. Ruskin, *The Two Paths*, in Cook and Wedderburn, *Complete Works of John Ruskin*, Vol. 16, p. 319.
62 J. Ruskin, 'The Nature of Gothic', in *The Stones of Venice*, Vol. II (1853), p. 166.
63 Ibid.
64 W. Morris, 'Some Hints on Pattern Designing' (1881), *Collected Works*, Vol. XXII, p. 179.

65 W. Morris, 'Making the Best of It' (c. 1879), *Collected Works*, Vol. XXII, pp. 100–1.
66 Ibid., pp. 102–6.
67 Ibid., p. 110.
68 Ibid., p. 111.
69 Ibid., p. 107.
70 Ibid. Also see *idem*, 'Some Hints on Pattern-Designing' (1881), *Collected Works*, XXII, pp. 195–6.
71 W. Morris, 'Some Hints on Pattern Designing' (1881), *Collected Works*, Vol. XXII, p. 179. Although Morris disliked Islamic geometric art, he very much liked Persian work; unlike other Muslim peoples, they did draw upon a visual tradition which included the imitation of nature and the human figure.
72 Ibid., pp. 183–6.
73 W. Morris, 'Making the Best of It' (c. 1879), in *Collected Works*, Vol. XXII, p. 106.
74 See Watkinson, *Pre-Raphaelite Art and Design*, pp. 195–6; *idem*, *William Morris as Designer*, p. 48.
75 W. Morris, 'The Lesser Arts' (1877), *Complete Works*, Vol. XXII, p. 26.
76 Ibid., p. 5.
77 Ibid., p. 22.
78 W. Morris, 'Making the Best of It' (c. 1879), *Complete Works*, Vol. XXII, p. 83.
79 W. Morris, 'The Lesser Arts' (1877), *Complete Works*, Vol. XXII, p. 16.
80 Ibid., p. 22.
81 See, for example, B. Ferrey, *Recollections of A. Welby Pugin* (1861), pp. 80–1; J. Ruskin, *The Seven Lamps of Architecture* (1849), passim.
82 *RIBA Journal*, Vol. VII, pp. 242–3.
83 Kelvin, *Letters*, Vol. I, pp. 352–3, to the *Athenaeum*, 5 March 1877.
84 Henderson, *Life, Work and Friends*, p. 197; M. S. Briggs, *Goths and Vandals: A Study of the Destruction, Neglect and Preservation of Historical Buildings in England* (1952), p. 210.
85 Lethaby, *Philip Webb*, p. 150.
86 Quoted in Kelvin, *Letters*, Vol. I, pp. 360–1n.
87 WMG, File 11a, Morris & Co., Circular, 9 April 1877.
88 Wardle, 'Memorials', ff. 23–4.
89 Sewter, *Stained Glass*, Vol. II, pp. 234–40.
90 WMG, Box 15a; Lethaby, *Philip Webb*, pp. 88–9; Parry, *William Morris Textiles*, p. 137; M. Morris, *William Morris: Artist, Designer, Socialist*, p. 57.
91 Sewter, *Stained Glass*, Vol. II, p. 47.
92 Watkinson, *Pre-Raphaelite Brotherhood*, p. 165.
93 Faulkner, *Against the Age*, p. 35.
94 R. Barrington, *The Life of Walter Bagehot* (1912), pp. 412, 442, quoted in Faulkner, *Critical Heritage*, p. 13.
95 WMG, Box 15a; D. Hopkinson, 'A Passion for Building: The Barings at Membland', *Country Life*, 29 April 1982, pp. 1736–40.
96 WMG, Box 15a; Parry, *William Morris Textiles*, pp. 137–8; M. Morris, *Artist, Designer, Socialist*, pp. 58–9.
97 WMG, Box 15a; Parry, *William Morris Textiles*, pp. 137–8.
98 WMG, Box 15b.
99 M. Conway, *Travels in South Kensington* (1882), quoted in I. Bradley, *William Morris and his World* (1978), p. 67.
100 Identified by Faulkner in *Against the Age*, p. 73.
101 C. Woods, 'Sir Thomas Wardle', in D. J. Jeremy (ed.) *Dictionary of Business Biography*, Vol. V (1986), p. 664; P. Thompson, *The Work of William Morris*, p. 110; B. Morris, *Victorian Embroidery* (1962), p. 9.
102 Kelvin, *Letters*, Vol. I, p. 385, to Lucy Faulkner Orrinsmith, 20 July 1877.
103 Ibid., Vol. II, p. 229, to Andreas Scheu, 5 Sept. 1883.
104 Hammersmith and Fulham Archives Department, MMF & Co., Minute Book, 19 March 1870, 27 Feb. 1871; Kelvin, ibid., p. 283, to Georgiana Burne-Jones, 1 June 1884.
105 Kelvin, *Letters*, Vol. I, pp. 457 and 466, to Jane Morris, 12 and 26 March 1878. Also see Henderson, *Life, Work and Friends*, pp. 180–2, 187–9.

106 WMG, File 10, Dunn & Co. account book. This, incidentally, made it the fourth most expensive project ever undertaken by Dunn for the firm.
107 Mackail, *Life*, Vol. I, pp. 371–3; Kelvin, *Letters*, Vol. I, p. 469, to Jane Morris, 2 April 1878. Also see the recollections of Floss Gunner, who became kitchen maid at Kelmscott House in 1891 at £6 a year. 'Maid for Morris', interview in *Isis*, 11 Nov. 1965.

Chapter 5

A Ruskinian dream?
Morris at Merton Abbey, 1881–83

The commercial advance of Morris & Co. in the later 1870s, though gratifying, was not enough to satisfy the business ambitions of William Morris. His instinctive drive towards order and completeness would not let him rest. He was not yet able to put aside the firm, to leave it to develop under its own momentum and the supervision of able subordinates. Morris simply could not settle for anything less than that which he could see in his mind's eye, and the enterprise was still far from reaching that ideal. George Wardle, who observed Morris at close quarters for more than a quarter of a century, was ever aware of his impulse towards perfection and his intolerance of the inferior, even though he had once accepted standards lower than the latest set. Morris, Wardle perspicaciously remarked, was 'capable of trampling on his dead self more resolutely than any man I have known'.[1]

The years immediately following Morris's takeover of the firm were made remarkable by the intensity of his design effort, his mastery of new crafts, and the creation of a whole range of new and much sought-after products. But in continuing the process of remodelling the business, new problems had been created as well as old ones solved. The most obvious of these was that the firm had grown too large for its premises, and the prevailing lack of space threatened to impede fresh initiatives. The workshops at Queen Square and Great Ormond Yard, cramped hives of activity, could not accommodate enough of the looms needed to weave elaborate fabrics and carpets nor the vats and benches needed to print exquisite chintzes. Carpet weaving had been transferred to Morris's coach house at Hammersmith, but this arrangement was clearly unsatisfactory as the 12-foot wide loom installed there could not be used to weave carpets anywhere near large enough for the grander rooms occupied by Morris's wealthier customers. All this meant that many of the carpets and fabrics designed by Morris still had to be put out to the trade for manufacture. Although the results had been mostly satisfactory, Morris had to invest in a new factory if he was to take full advantage of his years of experimentation, and expand the range of products as he desired.

By 1881, the pressure to make this investment had grown very strong

indeed. Few things were more important to Morris than to achieve excellence in the colouring of his wares, and to this end he had made common cause with Thomas Wardle. Together they had done great things in resuscitating the vegetable-dyeing industry in Britain. Morris had thenceforward entrusted Wardle with two key parts of his business: the dyeing of fabrics and raw materials, and the execution of his designs for printed fabrics. His faith in Wardle began to weaken very early in the 1880s as the standard of block printing at Leek progressively fell. Letters of protest, which did nothing to spare Wardle's feelings, flowed freely from Morris's pen, and batch after batch of goods was returned to Leek as unsatisfactory in quality. The following terse note of 9 February 1881 is typical:

> When I saw you last I called your attention to the faults in printing our goods, which were almost always such as would be considered great blemishes by our Customers, and in many cases, so bad as to ruin the effect to an artistic eye.
>
> I am sorry to say that the last goods of African marigold and red marigold sent are worse instead of better: they are in fact quite unsaleable; I should consider myself disgraced by offering them for sale: I laboured hard on making good designs for these and on getting good colour: they are now so printed and coloured that they are no better than caricatures of my careful work.
>
> The effect of this is ruinous to our business, and is sure to make an end of it: the goods you now send are *never* as good as those you sent up two years ago: please to consider my position and to ask yourself what you would expect if you were in my case, and pray do something to set the thing on its legs again.[2]

In defence, Wardle replied that his firm's work was actually improving, not worsening, and that Morris was being unduly fussy in rejecting so many batches of prints. Morris would have none of this. As to what was satisfactory and what was not, there could be 'no appeal against my judgement'. He added that his success depended 'entirely on keeping up the excellence of my goods: the public knows my pretensions in this matter, and, very properly, will not let me be worse than my word: and I am determined whatever may be the cost in all ways not to fail in it'.[3]

The row rumbled on, neither party conceding points to the other. Morris was deeply perturbed, and, feeling that Wardle's shortcomings were jeopardising his business, he resolved to take on dyeing and block printing himself. He wrote to his wife, Janey, towards the end of February 1881, that 'Tom Wardle is a heap of trouble to us; nothing will he do right, and he does write the longest winded letters containing lies of various kinds: we shall have to take the chintzes ourselves before long.'[4] There seems little doubt that Morris was right in his assertion that Wardle was allowing the quality of his work to slip. Wardle had already become involved in the various experiments with silk manufacture and dyeing which were later to make his reputation,[5] and this distraction from the everyday job of running a factory seems to have lain at the heart of the difficulties which

129

Morris suffered. Plainly Morris had come to the end of the line with Wardle. There was no chance of taking a once fruitful collaboration any further. Wardle had never mastered the problematic indigo discharge process, which Morris believed would further enhance his highly distinctive palette of colours. If progress were to be made with the technique, he had no choice but to seize the initiative.

The row with Wardle threw into sharper relief the more general problem faced by Morris & Co: that of maintaining control over the quality of its products when so much depended on the expertise and motivation of others. Goods might be rejected, but this action invariably harmed the firm as much as it did the supplier. The point was made by Morris to Wardle in his usual logical and forthright fashion:

> I have made every allowance *possible*: but beyond a certain point I *cannot* go: just consider what would be the result if I were to stock myself with unsaleable goods: it *must* bring the business to an end; and it would do you no good while it injured me. Consider also if I am likely to be over particular: when we order goods we want them for sale, if we have to send them back it is an injury to our sales: I assure you positively that I have been so far from rejecting pieces on slight grounds, that I have often accepted them when I knew that they were not up to the mark: really when you come to think of it coolly you must see that this is the case.[6]

Whether Wardle took the point we do not know. What we do know is that Morris was brought by the crisis to think hard about the problem of quality control. The outcome was his decision to find a factory in which he could concentrate and extend his direct manufacturing capacity, and do for himself work previously contracted out to others at market prices. He did not expect to save money in this way. His intention quite simply was to guarantee the quality of his goods – the quality that conferred upon the firm a trading advantage of uncertain but undoubted value. That Morris understood the importance of a reputation for quality is confirmed by his evidence before the Royal Commission on Technical Instruction in March 1882 when he remarked that 'beauty is a marketable quality, and . . . the better the work is all round, both as a work of art and in its technique, the more likely it is to find favour with the public'.[7]

It would, of course, have been quite impracticable for Morris to have internalised all his manufacturing activities. Morris & Co. may have had a large product range, with hundreds of designs on offer for wallpapers, textiles and carpets, but the quantities sold were generally small. The firm, after all, had just one retail outlet and a few agents overseas. There was no case for purchasing expensive machinery such as power-looms for weaving plain woollen, cotton or silk fabrics or ordinary Kidderminster, Brussels, Axminster or Wilton carpets. In these cases, it made economic sense for Morris & Co. to continue having its designs worked up by others. Internalisation was only necessary for the highest class of goods, generally

made by hand, in short runs, and requiring only a modest investment in capital equipment. The processes best suited to direct manufacture – in addition to the artistic crafts of stained glass-painting, embroidery and tapestry weaving – were fabric dyeing, the block printing of textiles and wallpapers, the hand-painting of tiles, and the hand-weaving of carpets and figured silk and woollen fabrics.

Morris had no intention of taking on all of these activities. He was at heart a reluctant manufacturer, disinclined to engage in direct production except when it was absolutely necessary to the maintenance of standards. In his view, therefore, manufacturing was subordinate to design and marketing. His main intention was to present the public with a range of products of original design and excellent make which might be combined harmoniously by anyone interested in interior decoration, including himself. If a design could be handed over to a trusted manufacturer for execution at a reasonable cost, then he favoured taking this course. Thus though Morris decided to relieve Thomas Wardle of his dyeing and block-printing work, he never contemplated abandoning Jeffrey & Co. as his wallpaper-printing contractor, even though the hand-printing of wall-papers had much in common with the hand-printing of textiles. And he was perfectly content for the makers of various types of machine-made carpets and fabrics to produce his designs, since he had made each of them in perfect knowledge of what he could expect of the technology employed by a particular manufacturer. Moreover, in certain cases, as with furniture and tiles, he was prepared to buy in articles or lines designed outside the firm, provided the work was in sympathy with his own and was of the requisite standard.

When Morris began his search for new premises in 1881, therefore, his aim was not to manufacture all the articles he needed under one roof, but to concentrate on a limited number of specialities which, in his opinion, could not be produced to the same high standard by any other firm. He was looking for enough space for a stained glass studio superior to that at Queen Square; a dyehouse near a river with water suitable for vegetable dyeing; and large workshops to house cloth printing, textile weaving, carpet weaving and tapestry making. Once the idea of such a 'palace for the decorative arts' had taken shape, born of the necessity to drop Wardle, Morris also began to see that moving from Queen Square might yield benefits other than those of a purely commercial nature. In particular, Morris & Co. might escape the wearying drabness of inner London by locating the new workshops in surroundings more conducive to the health and happiness of its workforce.

The search for new premises was neither long nor difficult. Morris looked first to the Cotswolds, where the passing of the woollen textile industry had left many suitable mills, set amid beautiful countryside, available for rent at modest cost. He was especially delighted by a mill at

131

Blockley, near Chipping Campden, but, according to George Wardle, although the setting was superb, it offered 'too little accommodation with too much inconvenience'.[8] Morris, not without anguish, had to recognise that he needed a site nearer London. He was joined in the search by the pottery expert William De Morgan who, coincidentally, was also looking for new premises. Morris admired De Morgan's work, and had decided to stock his tiles at Oxford Street, rather than have Morris & Co. make its own. He therefore considered that it would be useful to have De Morgan's works located near to his own. Early in March 1881 the two men looked over some big, solid buildings at Crayford, but these, although 'very cheap', were rejected on grounds of inaccessibility.[9] Just a week later, however, they found exactly what they were looking for at Merton in Surrey. It was an old print works, and had formerly been a silk weaving factory run by Huguenot refugees. It stood on the site of Merton Abbey, which had been destroyed by Henry VIII. On 19 March Morris wrote to Janey brimming with enthusiasm and listing all its advantages:

> first, it would scarcely take one longer to get there from Hammersmith than it now does to Queen Sq: next it is already a print-works (for those hideous red and green table cloths and so forth) so that the plant would be really useful to us: 3rd the buildings are not so bad: 4th the rent (£200) can be managed . . . 5th the water is abundant and good. 6th though the suburb itself is woefully beyond conception, yet the place itself is even very pretty: summa, I think it will come to taking it, if we can get it on fair terms:– and there I shall be aforesaid a London bird: if we don't get it, and I don't quite know what we shall do: I expect such places are rare near London.[10]

In the event Morris did get hold of the Merton Abbey works, signing the lease on 7 June 1881, and De Morgan, equally fortunate, found premises conveniently close by.

For a firm the size of Morris & Co. the rejuvenation of the Merton Abbey complex was a major undertaking. The property consisted of a substantial eighteenth-century house, a lodge, various outbuildings, and two large tarred and weatherboarded two-storey sheds set in seven acres of grounds, through which flowed the river Wandle, a tributary of the Thames. The first of the sheds already housed a dyehouse on the ground floor. The upper storey was large enough to accommodate the stained glass painters. The second even larger shed, on the southern bank of the Wandle, was perfect for activities as demanding of space as carpet weaving and block printing. Morris decided to set up his carpet- and tapestry-looms on the ground floor of the building, leaving the whole of the upper storey for printing. A third shed, with just a single storey, would house twenty or so hand-operated Jacquard looms for the production of woven fabrics. The layout of the works, which remained largely unchanged until their closure in 1940, is sketched in Figure 4.

132

Precisely how much it cost Morris & Co. to convert and renovate the

Figure 4 Plan of the Merton Abbey Works

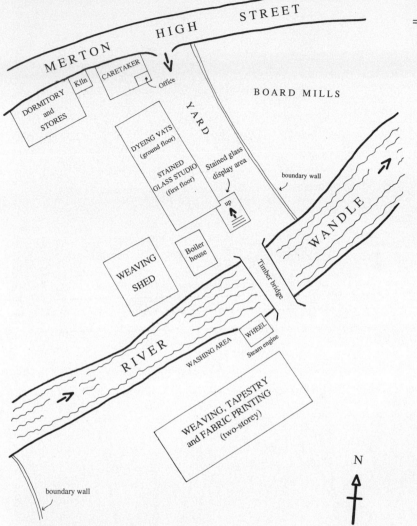

Merton Abbey works is not known. It is clear, however, that the investment must have been substantial relative to the existing capital employed by the business. The workshops had been allowed to deteriorate, and before operations could be moved from Queen Square a thorough overhaul was needed; amongst other things, foundations had to be strengthened and waterproofed, the sides of buildings shored up, roofs heightened and re-tiled, and floors re-laid. Furthermore, specialist plant and equipment had to be installed in all departments. Some tools and plant could be salvaged from Queen Square, but many of the activities to be undertaken at Merton were either new or much larger in scale than before, including

133

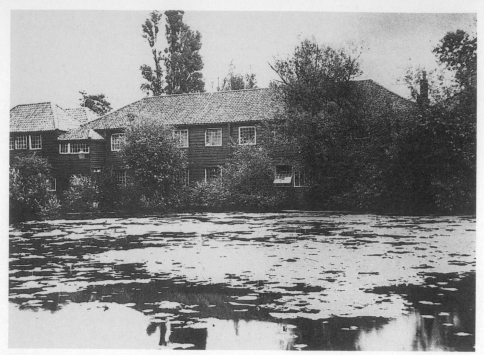

Plate 13 Morris & Co.'s workshops at Merton Abbey, Surrey, with the River Wandle in the foreground. Photographed in the 1890s

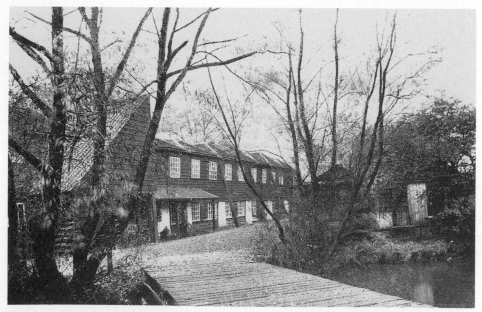

Plate 14 Another view of the Merton Abbey works, looking across the timber bridge

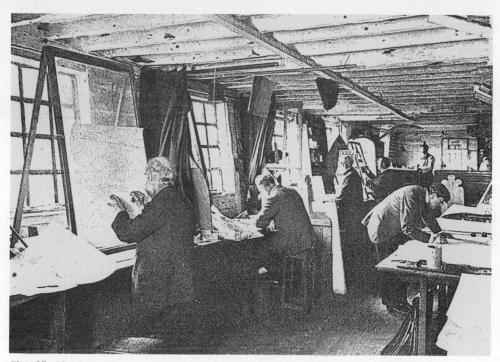

Plate 15 The glass-painters' workshop at Merton in the 1890s

carpet weaving, tapestry, dyeing and printing. Even the dyehouse had to be remodelled, with eight new sunken vats (6-foot cubes) for fabric dyeing, and a number of smaller raised wooden vats for dyeing the yarns needed by the weavers of carpets, textiles and tapestries. It was not until the final days of 1881 (much to Morris's annoyance) that the necessary work was completed and the move made from Queen Square. Even then, it was many more months before the new departments were tooled up and ready for production. Block printing, in fact, did not begin in earnest until late in 1882.[11]

The move to Merton was both gratifying and stressful for Morris. Just before signing the lease he wrote jokingly to De Morgan, bidding 'adieu Blockley, and joy for ever, and welcome grubbiness, London, low spirits and boundless riches'.[12] Commercial judgement had prevailed over love of nature, and, having made the choice, Morris threw himself into making the venture a success. Countless details required attention. More staff had to be recruited for the dyehouse, print shop and weaving departments (by 1884 Morris was employing more than 100 hands). Once the buildings had been modified and improved, workshops had to be laid out and equipment installed, and, when this all was done, the practical problems of each of the trades undertaken had to be overcome.

135

Printing in particular proved a difficult craft, especially the indigo discharge process, which had baffled Thomas Wardle at Leek. Now that he had his own dyehouse, Morris was determined to have the finest cloths, and he laboured night and day until all practical difficulties were overcome. So complete was his success that some years after his death the process was made to seem simplicity itself in a short account of operations at Merton Abbey:

> The cotton cloth is first dyed to a uniform dark shade of blue in one of the large indigo vats, and is printed with a bleaching reagent which either reduces or removes the blue colour as required by the design. Mordants are then printed on the white parts, where red has to come, and the whole cloth is dyed a second time with madder. The process is repeated a third time for yellow, the three colours being superimposed on each other to give green, purple, or orange. All loose colouring matter is then cleared away, and the colours are set by passing the fabric through soap at almost boiling heat. The final treatment is to spread the cloth on the grass with its printed face to the light, so that the whites may be purified and all fugitive colour removed in nature's own way. This process is called 'crofting'.[13]

Morris related the progress of the work in a series of letters to his daughter Jenny. In December 1882 he told her that 'as to our printing: we are really not quite strait yet: I am quite ashamed of it', and at the end of February 1883 he reported that 'we are not getting on quite as fast as we should with printing; it is very tough work getting everything done in due order, the cloths seem to want so much doing to them before they can be printed and then so much doing to them after they are printed'.[14] Only his personal supervision could ensure that the highest standards prevailed, as he made clear to Jenny in March: 'the colour mixer Kenyon is a good fellow, but rather a muddler, and often in order to be sure that a thing is properly done either Wardle or I have to stand over him all the time'.[15] In May he was tied up at Merton, unable to sleep, and 'anxiously superintending the first printing of the *Strawberry Thief*.[16] Thereafter things got steadily better, but in striving for near-perfection Morris continued to push himself hard. As his command of the technology grew, his designs became more ambitious, and in September he wrote playfully to Jenny that

> I seem to have a panic on our not having chintz blocks enough, for I have two more on the stocks: one of them . . . is such a big one that if it succeeds I shall call it Wandle: the connection may not seem obvious to you as the wet Wandle is not big but small, but you see it will have to be very elaborate and splendid and so I want to honour our helpful stream.[17]

The strain of all this activity was compounded by the fact that Morris was at the same time designing at a prodigious rate for printed and woven fabrics (see Table 6). Much of his very best work stems from these years, including his first indigo-dyed fabrics *Rose and Thistle* (1881), *Bird and Anemone* (1881) and *Brother Rabbit* (1882). Other more elegant designs

followed in quick succession: *Eyebright* (1883), *Strawberry Thief* (1883), *Corncockle* (1883), and the stunning Thames tributary series *Windrush* (1883), *Evenlode* (1883), *Kennet* (1883), *Wey* (1883), *Cray* (1884), *Wandle* (1884) and *Medway* (1885). Most of the new patterns took full advantage of Morris's mastery of the indigo vat. Indeed, his delight in the new process was such that, of the nineteen patterns registered by Morris & Co. between May 1882 and September 1885, seventeen were intended for indigo discharge printing.[18]

That he could concentrate on artistic work at a time when the everyday pressures of business were so acute bears eloquent testimony to Morris's remarkable ability to switch without apparent effort from one task to another. But he was not immune from the ordinary doubts and worries of a businessman under stress. Nor was he a physical superman. He suffered terribly from gout, and at times was unable to rise from his bed. And at other times he complained of distressing thoughts brought on by the sheer intensity of his life. In January 1882 he wrote to Georgie Burne-Jones:

> I have perhaps rather more than enough work to do, and for that reason or what not, am dwelling somewhat low down in the valley of humiliation – quite good enough for me doubtless. Yet it sometimes seems to me as if my lot was a strange one: you see, I work pretty hard, and on the whole very cheerfully, not altogether I hope for mere pudding, still less for praise; and while I work I have the cause always in mind, and yet I know that the cause for which I specially work is doomed to fail, at least in seeming; I mean that art must go under, where or how ever it may come up again. I don't know if I can explain what I am driving at, but it does sometimes seem to me a strange thing indeed that a man should be driven to work with energy and even pleasure and enthusiasm at work which he knows will serve no end but amusing himself; am I doing nothing but make believe then, something like Louis XVI's lock-making?[19]

Here in the raw was an idea which haunted Morris more and more, turning him away from conventional radical politics towards socialism. And adding to his sense of uncertainty and discomfort was a more mundane worry: would the move to Merton pay or might it bring financial disaster? Again Georgiana Burne-Jones was privileged to share his thoughts:

> I am much encouraged by your interest in our Merton Crafts, and shall do my best to make it pay so that we may keep it going, though, as I have told you, I can't hide from myself that there is a chance of failure (commercially I mean) in the matter: in which case I must draw in my horns, and try to shuffle out of the whole affair decently, and live thereafter small and certain if possible: little would be my grief at the same. This is looking at the worst side, which I think one ought to do; but I *think* we shall on the whole succeed: though a rich man (so-called) I never either can or will become.[20]

Morris was well aware that commercial success depended on more than design and mastery of technique. From an early stage in his career he had been aware of the importance of marketing, and he had no intention now

of leaving anything to chance. If Merton was to become a paying proposition, then a big effort had to be made to win favour with the public and stimulate demand. Advertising was the most obvious way forward, and in October 1882 two impressive brochures were prepared for circulation to existing and potential customers. The first of these dealt just with carpets, inviting readers to 'inspect the handmade Rugs and Carpets on which we have been engaged for upwards of three years' and offering to 'give estimates and execute carpets of any reasonable size, in design, colouring and quality, similar to the goods exhibited' at Morris & Co.'s showroom in Oxford Street. Hammersmith carpets were described as 'works of art', comparable in quality to the very best Eastern carpets but not imitative in design, being 'the outcome of modern Western ideas, guided by those principles that underlie all architectural art in common'.[21]

The second brochure was more comprehensive, listing the main products and services offered by Morris & Co. with a brief description of each. Uniqueness, beautiful design and colouring, hand manufacture, the use of high-quality materials, and in-house manufacture, were presented as the desirable features of Morris products. At Merton, Arras tapestry was being raised from 'its present state of degradation' through the use of the high-warp loom in the execution of original designs. Morris & Co. had a large stock of designs for carpets which 'we are also now making on our own premises'. All the tiles sold at Oxford Street were hand-painted, and the 'silks and worsteds we sell [for embroidery] are of our own dyeing'. A large portfolio of designs was available for furniture, yet, if a customer wished, Morris & Co. was 'ready to submit designs and estimates for such pieces as have to be planned for special purposes'. A 'great number of furniture prints of our own designs' were always available, as were numerous paper hangings which 'now form a great mass of uncostly surface decoration'. And the firm recently had much increased its stock of woven fabrics, aiming to 'turn out stuffs of good design and genuine materials' in colours 'carefully chosen to harmonize with our styles of decoration'. Readers were reminded in conclusion that 'all the above-mentioned goods are original designs private to ourselves, and that it is only in our Show Room, 449 Oxford Street, that they can be seen together in such a way that one can support the other, and form a congruous style, and so give a true idea of the decoration that we recommend'.[22] In 1882, the Oxford Street premises were extended to provide more display space, the former tenants of the first floor being relocated in an adjacent building.[23]

The need for customers to visit Oxford Street in order fully to appreciate the Morris style inevitably restricted the firm's customers to the metropolitan elite and wealthy provincials who regularly travelled to London. Morris was well aware of this, and while battling to get Merton

set up and running smoothly he determined to take steps to increase provincial and overseas sales of domestic articles such as carpets, fabrics, wallpapers and furniture. In 1882, he decided to open a showroom in Manchester; a wealthy city, and one with a reputation for patronage of the applied arts. The firm showed its wares at the Manchester Fine Art and Industrial Exhibition of 1882, to critical acclaim, and a shop was rented at 34 John Dalton Street, in the prosperous central shopping and commercial district around Albert Square. In January 1883 Morris & Co. opened for business as 'cabinet makers, upholsterers and general house furnishers'. Additional premises were rented shortly afterwards in nearby Brazenose Street for cabinet making and upholstery, and in 1884 the retail side of the business was transferred to Albert Square where the firm traded as 'Art Decorators, Art Furnishers, Manufacturers and Designers'.[24]

The appointment of reliable agents was seen as the best way of making sales in the rich markets of the United States and continental Europe. Morris was exasperated by the generally high level of import duties, often complaining of 'almost prohibitory' tariffs;[25] but he was not put off, recognising that wealthy Germans and Americans were willing to pay premium prices for goods of the highest quality and originality. As early as 1878 he had appointed Cowtan & Tout as his main agent in the United States. By 1883 this function has passed to Elliot & Bulkley of New York, who in turn dealt with specialist retailers in the nation's richest cities. In Boston, for instance, Elliot & Bulkley supplied Joel Goldthwait & Co. with carpets, J. F. Bumpstead & Co. with wallpapers, and A. H. Davenport & Co. with wallpapers, cretonnes, damasks, dress-silks, embroidery silks and crewels. Morris designs had achieved such popularity amongst the well-to-do that United States manufacturers had begun to copy them, obliging him to publish the names of authorised agents, and warning that 'no others can supply the goods we make'.[26]

A timely opportunity to boost sales in the United States came with the organisation of a Foreign Fair at Boston in 1883, attended by buyers from all over the the country as well as local citizens. Production at Merton was by now proceeding smoothly and Morris seized the opportunity to show off the firm's wares. A large stand, with a floor area of 45 feet by 30 feet was rented and divided into six compartments, each featuring a particular class of products. George Wardle prepared a comprehensive guide to the exhibit which took people through the various 'rooms', and provided a commentary on the design, colouring and manufacturing principles which set Morris & Co. apart from ordinary commercial manufacturers. And Wardle himself was on hand to explain further the approach to the decorative arts prevailing at Merton Abbey. As in the brochures prepared for circulation at home, the Boston catalogue sought to persuade potential customers that buying Morris goods ensured quality and originality at prices which, though nominally high, represented good value for money.

It was a remarkable document, not just for its eloquence and persuasiveness, but because of the care taken to explain what Morris & Co. was trying to achieve and how it went about its work.

The nature of good design was one of the most important themes of the Boston catalogue, echoing Morris's oft-repeated view that the designer must learn from 'Nature and History',[27] and that a good design was always natural to the article concerned:

> In the Decorative Arts, nothing is finally successful which does not satisfy the mind as well as the eye. A pattern may have beautiful parts and be good in certain relations; but, unless it is suitable for the purpose assigned, it will not be a decoration. Unfitness is so far a want of naturalness; and with that defect, ornamentation can never satisfy the craving which is a part of nature. What we call decoration is in many cases but a device or way we have learned for making things reasonable as well as pleasant to us. The pattern becomes a part of the thing we make, its exponent, or mode of expressing itself to us; and by it we form our opinions, not only of the shape, but of the strength and uses of a thing.

For William Morris, design was not simply a matter of embellishing an object according to the dictates of the latest fashion, as it was with many manufacturers; it was a matter of the utmost seriousness, requiring the study of classic examples of the art or craft concerned, so as to achieve the truest effect possible.

The importance of a knowledge of historical arts to Morris & Co. was revealed once again, most clearly, in the passages of the catalogue dealing with carpets and tapestry. Nearly the whole of the 1882 brochure on carpets was reprinted, in particular its insistence that the art of carpet weaving was in terminal decline in the East. Wardle added that 'the quality and style of carpet we call Hammersmith is a speciality of Morris and Company. There are no such carpets made elsewhere . . . In all respects they have no rivals, except the few ancient carpets which may be found in the stores.' Similar claims were made for Morris tapestries. After contrasting tapestry making with the high- and low-warp-looms, it was asserted that 'the invention called the low-warp loom did a good deal to bring the art of tapestry weaving to its present state of degradation and deserved neglect. Our efforts to restore to it some of its earlier dignity naturally commenced by a restoration of the ancient method.' The *Goose Girl* tapestry, the first produced at Merton, was exhibited as an example of a magnificent and desirable art form, second only to mosaic as a durable wall decoration. This, based on a design by Walter Crane and measuring 6 feet by 7 feet, was priced at $1,500. Cartoons for two larger designs by Burne-Jones – *Flora* and *Pomona* – were also exhibited at a guide price of $2,500 each.

The impression created by the Boston catalogue, which must have been greatly sharpened in the minds of those who actually visited the Foreign Fair, is of a unique enterprise, in touch with the past but aware of the needs

of the present, preserving old methods and producing goods of exceptional beauty. New designs for woollen fabrics – like the *Violet* and *Columbine* – were displayed for the first time, and it was explained how 'the dyeing is all done by ancient or well tried processes, and no expense has been spared to get from the East the dye-stuffs most suitable for each colour'. Likewise, attention was drawn to a rug with a red centre, said to be 'remarkable as being the first rug dyed with Kermes in Europe' in recent times, making its reds more beautiful and permanent than those made with wools dyed with cochineal. And it was exquisite colouring, combined with the effective use of the hand-loom, which gave Morris woven fabrics a special quality. A design for silk damask called *Flower Garden*, a pattern of 'dark bronzy green, steely blue, copper and gold tints' and of the 'purest make', was specially recommended as an 'admirable wallcovering'. Many other fabrics, made with silk, wool, or a mixture of both, were suggested for a whole variety of uses, from curtains to furniture coverings.

Wardle took particular pleasure in presenting Morris & Co.'s printed cottons and linens to the American public. He was aware that cotton prints had a 'reputation for vulgarity' in the United States and that there was 'much prejudice attached to a material selling for a few cents a yard'. But he considered the material 'in every way suitable for ordinary house-furnishing', provided due care was taken in matters of design and manufacture. With vegetable dyes instead of garish chemical substitutes, printing by traditional wooden blocks instead of steam-powered rollers, and good designs instead of bad ones, it was possible to get superb results. Wardle had no doubt that Morris & Co. had achieved these, describing Morris's *Honeysuckle* design as 'a peculiarly beautiful pattern, quite without parallel in the history of block-printing on cloth'. Equally successful, in his view, was a large framed example of the firm's embroidery, priced at $2,000: 'The workmanship is quite unrivalled. Notice the perfect gradations of shade and colour; how truly the lines radiate with the growth and play of the leafage, and how perfectly the lustre of the silk is preserved, . . . It is emphatically embroidery, and we might say, without affectation, embroidery at its best.'[28]

Morris & Co., evidently, was not a firm lacking confidence in its products. Yet it must have struck many visitors to the Boston Foreign Fair, whatever they thought of the goods, as an unusual enterprise, at odds with conventional thinking on many points. Morris himself, when it was suggested that his was a 'peculiar trade', admitted that this was so, later describing Merton as a 'place which hangs doubtful between the past and the present'.[29] What Morris meant by this is not difficult to understand. He had set himself against the notion that every new technology brought progress, and found that for his purposes the most appropriate processes, techniques and machines were often those declared redundant by the majority of manufacturers. Furthermore, he himself was a far from being a

141

typical businessman. To a remarkable degree, the identity of Morris & Co. was a reflection of his own personality, thought and aspirations. He very rarely employed outside designers because 'it is so very difficult to get a due amount of originality out of them; the designs which one gets are so hackneyed, and there is the same sort of idea harped on about for ever and ever'.[30] The originality which was the hallmark of Morris & Co. was largely the originality of Morris, and in this he was more a medieval master than a modern capitalist.

Nevertheless, whilst Morris & Co. may have looked to past ages for technology and inspiration, the commercial side of the business was very much of the present. Morris knew his markets, and he knew how to arrest the attention of those who could afford to purchase his goods. The shop in Oxford Street, not the factory at Merton, was the strategic hub of his operations. This was the public face of Morris & Co. where his creations were displayed in a tastefully fashionable setting. Apart from George Wardle, his best-paid employees were the commercial managers based at Oxford Street. In 1884, when Morris himself drew £1,800 from the business and Wardle £1,200, the Smith brothers, Robert and Frank, were paid £600 each. These high salaries were paid in recognition of the critical importance of the functions controlled by them: advertising; sales; liaison with clients for internal decoration; stock control; scheduling of production; showroom displays; handling customers' accounts; dealings with overseas agents and shipping; purchasing from outside suppliers; warehousing; supervision of embroidery, upholstery and cabinet-making activities; book-keeping, and general financial management.

The scope of the business and the importance of the co-ordinating role played by Oxford Street is further indicated by Table 7. Besides Merton, Morris & Co. had premises for cabinet making and upholstery at Great Ormond Yard and at Brazenose Street in Manchester, and a little later the firm took a large warehouse at Granville Place off Oxford Street for packaging, storing carpets and fabrics, cleaning and repair of carpets, curtain making and embroidery. Other workers were employed in their homes to execute embroidery designs for wall panels, portières, curtains, table-cloths, bedspreads, fire-screens, and ecclesiastical items such as communion sets, lectern- and pulpit-falls, and altar cloths. The shops in Oxford Street and Manchester, and the agents overseas, were supplied with goods from Merton Abbey and outside suppliers who worked up Morris designs. Once Thomas Wardle had lost his grip on the business, the greatest demand for goods manufactured by other firms was for wall-papers, machine-made carpets and machine-woven fabrics. The Wilton Royal Carpet Factory continued to be a favoured supplier, as were the textile firms of Alexander Morton & Co., Brough, Nicholson & Co., and H. C. McCrea & Co. All Morris wallpapers, as noted earlier, were made exclusively by the trusted firm of Jeffrey & Co. of Islington. William

Table 7 Product range of Morris & Co. after completion of the move to Merton Abbey, 1882

Product or service	Entered production	Main source(s) of designs	Main place(s) of production	At Merton Abbey 1881–83
Stained glass	1861	Burne-Jones	Merton	
Hand-painted tiles	1861	Bought in	William De Morgan's Merton works	
Furniture	1861	MMF & Co., bought in	Great Ormond Yard and Brazenose Street, Manchester	
Embroidery	1861	Morris	Outworkers	
Wallpapers	1864	Morris	Jeffrey & Co., Islington	
Carpets:				
Hammersmith	1879	Morris	Merton	
Kidderminster	1875	Morris	Heckmondwike Manufacturing Co., Yorkshire	
Wilton	c. 1877	Morris	Wilton Royal Carpet Factory Ltd, Wiltshire	
Brussels	c. 1877	Morris	Wilton Royal Carpet Factory Ltd, Wiltshire	
Real Axminster	?	Morris	Wilton Royal Carpet Factory Ltd, Wiltshire	
Patent Axminster	1876*	Morris	Wilton Royal Carpet Factory Ltd, Wiltshire	
Printed fabrics	1868**	Morris	Merton	
Woven fabrics	1876	Morris	Merton (brocade) Alexander Morton & Co., Darvel (silk and wool) J. O. Nicholson, Macclesfield (silk, silk and wool) H. C. McCrea, Halifax (silk and wool) Dixons, Bradford (lightweight woollens)	
Tapestry	1881	Morris, Burne-Jones	Merton	
Linoleum	1875	Morris	Nairn & Co., Kirkcaldy***	
Upholstery service	?	n.a.	Great Ormond Yard	
Interior design and decorating service	1862	Morris	n.a.	
Carpet and fabric-cleaning service	early 1880s	n.a.	n.k.	

Notes: * Date of first registration of design. It is not known when this design went into production, although a second design is known to have been produced in 1880.

** A few printed fabrics were produced for the firm by Thomas Clarkson of Preston. Quantity production began after 1876 as a result of Morris's association with Thomas Wardle.

*** Tentatively identified by Parry.

Sources: H. C. Marillier, *History of the Merton Abbey Tapestry Works* (1927); L. Parry, *William Morris Textiles* (1983); P. Thompson, *The Work of William Morris* (1967); R. Watkinson, *William Morris as Designer* (1970).

De Morgan supplied all the tiles retailed by Morris and used in large commissions for interior decoration. The whole operation was supported by a relatively small capital which Morris had accumulated over the years,

143

amounting to £15,000 in 1884. The turnover of the business was, according to Morris, very large in relation to the capital employed.[31]

When looked at from a purely commercial point of view, Morris & Co. is best described as a small firm with a very forward-looking and positive approach to business. All the signs are that it was efficiently run, and that it had a very clear understanding of its location in the market-place. The firm traded on exclusivity, its goods affordable only by the upper reaches of society. To the privileged, it offered a comprehensive range of products and services for the beautification of the home; and the move to Merton Abbey consolidated and strengthened its position amongst the leading decorative art enterprises in Britain. It was responsive to the demands of the market, offering products of differing qualities at a range of prices, and producing a steady stream of fresh designs and products. Morris & Co. even responded to the call to make dress-silks for fashionable garments, as George Wardle explained at the Boston Foreign Fair:

> It may be thought strange that Mr Morris should concern himself with the colours of ladies' dresses; but it is nevertheless a part of the purpose Mr Morris had before him when he undertook to give us the means of beautifying our homes. Had that even been otherwise, Mr Morris could scarcely have escaped the consequences of the reform he has worked in household decorations generally. In England the calls upon him to provide something that ladies might wear, in rooms he himself had helped to make lovely, were too many to be disregarded, and he offers these as his answer to the demand.[32]

The firm was no head-in-the-sand concern immune from ordinary commercial ambitions: it was in fact a highly innovative enterprise, confident in its ability to move forward and exploit its chosen markets.

Morris also realised that the firm's methods of design and manufacturing could themselves be used to strengthen its position. From the first the Merton Abbey works attracted a steady stream of visitors, and these personal tours, directly or indirectly, helped make the reputation of the firm in the 1880s and 1890s. Two of the first visitors to Merton published accounts of their trips which were widely circulated in Britain and the United States. The first, whose author is unknown, appeared in the *Spectator* on 24 November 1883 under the title 'On the Wandle'; the second, a superbly illustrated article which appeared in the *Century Magazine* in July 1886, was by the American poet and essayist Emma Lazarus, who visited Merton Abbey on 7 July 1883 during her first visit to Europe.

The descriptions provided by these authors of the Merton factory and the work carried on there are in many respects corroborative. Each dwelt at some length on the beauty of the grounds, the River Wandle, the wildlife, and the trees and plants nurtured by Morris. Readers of the *Spectator* were treated to the following evocation:

Passing through the gates from the high road, the mill and Wandle present themselves much mixed up together. The river as we saw it was shimmering in the sunlight . . . Near its edge the stream is shedded-over, to protect some bright brown wooden pegs, turning on a wheel, through the mysteries of which bright blue stuff is dripping and splashing. The opposite bank is a green meadow, where the trees are scantily hung with fading leaves, golden against the blue country distance beyond . . . A party of white ducks, very orange about the feet, are quacking and waddling along the narrow footpath between the mill and the grassy edge of the stream. We are confident that on the premises of no other 'thriving business' should we be allowed to come so near to such nice things as ducks and cows and untouched river-banks. Here is none of the ordinary neat pomposity of 'business premises'.[33]

Emma Lazarus, with no less reserve, waxed lyrical about her walk with Morris through 'an enchanting old garden . . . beside the merry little Wandle' wherein 'under the direction of this poet-husbandman, even the orchard and kitchen garden seemed to wear a certain spontaneous grace'.[34]

The interiors of the various workshops were detailed in no less glowing terms. Of the dyehouse, where the work must have been arduous and dirty, Lazarus reported:

In the first outhouse that we entered stood great vats of liquid dye, into which some skeins of unbleached wool were dipped for our amusement; as they were brought dripping forth, they appeared of a sea-green colour, but after a few minutes exposure to the air, they settled into a fast, dusky blue. Scrupulous neatness and order prevailed everywhere in the establishment; pleasant smells as of dried herbs exhaled from clean vegetable dyes, blent with wholesome odours of grass and flowers and sunny summer warmth that freely circulated through open doors and windows. Nowhere was one conscious of the depressing sense of confinement that usually pervades a factory.[35]

And of the carpet-weaving shed the correspondent of the *Spectator* wrote:

We turn through the doors into a large, low room, where the hand-made carpets are being worked. It is not crowded. In the middle sits a woman finishing off some completed rugs; in a corner is a large pile of worsted of a magnificent red, heaped becomingly into a deep-coloured straw basket. The room is full of sunlight and colour . . . The strong, level afternoon light shines round the figures of young girls seated in rows on low benches along the frames, and brightens to gold some of the fair heads. Above and behind them rows of bobbins of many-coloured worsteds, stuck on pegs, shower down threads of beautiful colours, which are caught by the deft fingers, passed through strong threads (fixed uprightly in the frames to serve as a foundation), tied in a knot, slipped down in their place, snipped even with the rest of the carpet, all in a second of time, by the little maidens . . . The workers may be as tiresome as most young people between the ages of a girl and a woman generally are, but they do not look tiresome in this bright sunlit place, so near the shining river, but merry, and busily happy. It is a delightful workroom, and we turn out of it wishing we could go on longer watching the work done in it.[36]

145

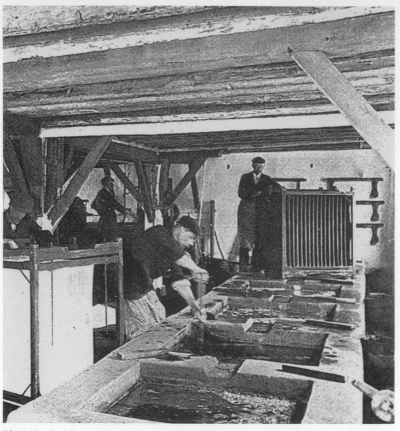

Plate 16 Small vats at Merton, used for dyeing embroidery and weaving yarns. Larger vats, sunk into the ground, were used for dyeing lengths of cloth

To complete the contrast with the forbidding mills of industrial Britain, the authors pointed to the elevated principles at the heart of Morris & Co. The first of these was that the workers should be at one with their employer and contented in their labours. To Emma Lazarus it seemed that 'Mr. Morris's factory is a noble and successful solution' to many of the problems of working people. Morris provided work that was not excessively arduous or tedious, in clean, healthy and pleasant surroundings. He encouraged the development of skills, making the workman 'feel himself not the brainless "hand", but the intelligent cooperator, the *friend* of the man who directs his labour'. He paid good wages 'whatever the low-water record of the market-price of men' and never did illness or misfortune 'mean dismissal and starvation'. In short, 'Mr. Morris seems to have borrowed all that was sound and admirable from the connection between the medieval master-workman and his artist-apprentices.' He was a rare employer, skilled in each of the trades carried out in the factory, who had 'redis-

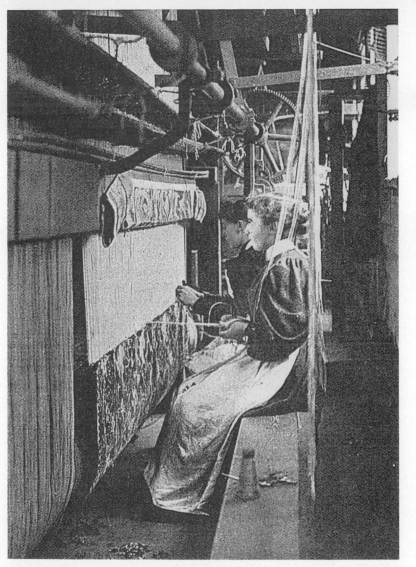

Plate 17 Women carpet-weavers at Merton Abbey

covered lost methods and carefully studied existing processes'. As a result, his artisans felt that he understood 'their difficulties and requirements', and that he could justly estimate and reward their peformance. Thus an admirable relationship was 'established between employer and employed, a sort of frank comradeship, marked by mutual respect and good-will'.[37]

The second principle seen to be at work at Merton Abbey was that the factory primarily existed not as a mere source of profit but as a source of beautiful goods, well made and of real value to the purchaser. The reporter

147

for the *Spectator* stated emphatically that 'genius of inventiveness and the love of beauty are the ruling principles, not the making of money'. Morris & Co. strove for a standard of excellence:

> which has no place at all in the ordinary manufacturer's horizon, but is quite outside and beyond it. If a piece of ordinary machinery can only be used in part to carry out the conception, however easy or and inexpensive the use of it would be, it is not used, but something else invented or adapted which shall carry out what is wanted as perfectly as it is possible to carry it out. If a dye is beautiful in colour, but it does not give a fast colour, no time is spared in inventing a combination which will make it fast. The ordinary manufacturer, even were he to perceive the beauty of the colour, would see no advantage in overcoming the difficulties and expense in order to use it.[38]

The author went on to describe Morris as a 'real artist' who would spare 'no time, trouble or money' in his quest for perfection. His motivation was, quite simply, 'an instinct for beauty, a love of it for its own sake'. It was this instinct, Emma Lazarus observed, which inspired his mission to 'revive a sense of beauty in home life, to restore the dignity of art to ordinary household decoration'. In this he was seen to have been remarkably successful, single-handedly revolutionising 'English taste in decorative art'.[39]

These eloquent tributes to the work of William Morris at Merton Abbey were sincerely meant. Both authors clearly had sympathy with Morris's views on the social purpose of the decorative arts which he put forward in five lectures delivered between 1878 and 1881 and published in volume form in 1882 under the title *Hopes and Fears for Art*. Lazarus quotes extensively from his lecture of 1878 on the 'The Lesser Arts', while the author of the *Spectator* article goes further, correctly identifying Morris as a disciple of John Ruskin:

> Here, at last, can we see some practical outcome of the principles of which Mr Ruskin is the prominent teacher. Here are examples of what the human machinery can do at its best, heart, head and hand all in the right places relative to one another . . . No wonder that the character of the work done on the Wandle has a high distinction in it, if, as we believe to be the case, it is worked out from feelings and principles so very uncommon, so very different from those which inspire manufacturers as a rule. Too much of our civilisation in these days tends to an artificiality without refinement, to elaborated vulgarity, to luxury which at the same time is costly and coarse. This work, on the contrary, is uncommon because it is so natural, so indicative of the pure, ungreedy side of human nature, so real an outcome of individual choice.[40]

Others who have since written on Morris and Merton Abbey have taken up the same theme. Essentially, the business has been seen as something unique, apart from the pack, very different from other firms because it was run on Ruskinian lines, flouting the rules of competitive commerce. For Henderson, whose portrait of Morris & Co. is very typical, the workshops at

Merton were no less than 'the realisation of a Ruskinian dream'.[41]

That Morris was powerfully influenced by Ruskin in his thought and actions is beyond dispute. We have already observed, in Chapter One, how Ruskin's elevation of the decorative arts confirmed Morris in his choice of career; and in Chapter Four we saw how Ruskinian notions shaped his approach to design and craftsmanship. Morris freely acknowledged his debt. When speaking in 1878 on the subject of the pleasure that might be had from creative work, and contrasting this to the horror of modern factory life, he stated emphatically that Ruskin had already said 'the truest and most eloquent words that can possibly be said on the subject'; adding, apologetically, that anything he might say could 'scarcely be more than an echo of his words, yet . . . there is some use in reiterating a truth, lest it be forgotten'.[42] Many years later, towards the end of his life, Morris again paid tribute to Ruskin, writing in his preface to the Kelmscott edition of *The Nature of Gothic* that

> ethical and political criticisms have never been absent from his criticism of art: and, in my opinion, it is just this part of the work, fairly begun in 'The Nature of Gothic' and brought to its culmination in that great book 'Unto this Last', which has had the most enduring and beneficient effect on his contemporaries, and will have through them on succeeding generations.[43]

What Morris found most appealing in the moral and ethical writings of Ruskin is the uncompromising rejection of the widely-held belief that industrial growth would progressively raise the quality of life in countries like Britain. Even before he had encountered Ruskin, Morris had found one of the leading passions of his life, 'hatred of modern civilisation', but it was through Ruskin that he 'learned to give form to [his] discontent'. In *Unto this Last*, in particular, Ruskin argues that Britain's industrial society was morally degenerate and pernicious in driving the labouring classes into cultural and material poverty. The politico-economic thinking of Mill and others, which supported the new liberal industrial order, he saw as correspondingly flawed, particularly because of its lack of any credible moral or ethical component. Ruskin's own writings are imbued with indignation at the complacent indifference of those with power towards the misery of the labouring masses. He accepted the need for a social hierarchy, and for political power to reside with an educated elite, but it was equally necessary, in his view, for merchants and manufacturers to adopt a system of values which prized social harmony rather than individual profit. His purpose as social critic was to encourage the rich and powerful, individually and collectively, to behave in a paternalistic, co-operative, and socially responsible fashion, according to his own prescriptions. Only in this way might society be regenerated.

A condition for social improvement was that the business class should

149

be turned away from the warfare of naked competition towards co-operation and self-restraint. In his various writings, and particularly those to which Morris turned time and time again, he proposes a set of rules, which, if accepted by merchants and manufacturers, might transform society for the better. Self-regulation on the part of those with economic power was, in essence, Ruskin's solution to the evils of poverty, personal degradation, ignorance, and the appalling squalor and ugliness of the nation's industrial towns and cities.

The first thing demanded of businessmen by Ruskin was that they should recognise the true social purpose of business. Individual gain, or profit, should never be a goal in itself; rather, the businessman has the vital function of supplying the public with goods of the highest quality and utility, and at a prices which fairly reflect costs of production. He argues in *Unto this Last* that it is no more the function of the businessman 'to get profit for himself than it is a clergyman's function to get a stipend', for while 'the stipend is a due and necessary adjunct' it is not 'the object of life'. Likewise, profit is not 'the object of life to a true merchant', whose real purpose is 'to understand the very root qualities of the thing he deals in, and the means of obtaining it and producing it; and he has to apply all his energies to producing it or obtaining it in perfect state, and distributing it at the cheapest possible price where most needed'.[44]

Those businessmen who rejected the public service model in favour of that of personal greed stamped themselves, according to Ruskin, as forever 'belonging to an inferior grade of personality'.[45] And it was these people who were to blame for some of the worst evils of society. The practice of adulteration – that of driving down prices through lowering standards of manufacture and the quality of raw materials – was a particular target for Ruskin, who perceived that the working classes received in exchange for all their hard work nothing but inferior food, clothing, and shelter, and a few grotesque trifles. It was the duty of principled businessmen to withstand the pressure to make or distribute shoddy goods; dedicating themselves instead to 'forging the market' for items of real quality. His thoughts on the matter lead to this recommendation in *The Two Paths*:

> if you resolve from the first that, so far as you can ascertain or discern what is best, that you will produce what is best . . . it only rests with the manufacturer whether he will . . . make his wares educational instruments, or mere drugs of the market. You should be, in a certain sense, authors: you must, indeed, first catch the public eye, as an author must the public ear; but once you gain your audience, or observance, and as it is in the writer's power to educate as it amuses – so it is in yours to educate as it adorns . . . let it be for the furnace and the loom of England, as they have already richly earned, still more abundantly to bestow, comfort on the indigent, civilization on the rude, and to dispense, through peaceful homes of nations, the grace and preciousness of simple adornment, and useful possession.[46]

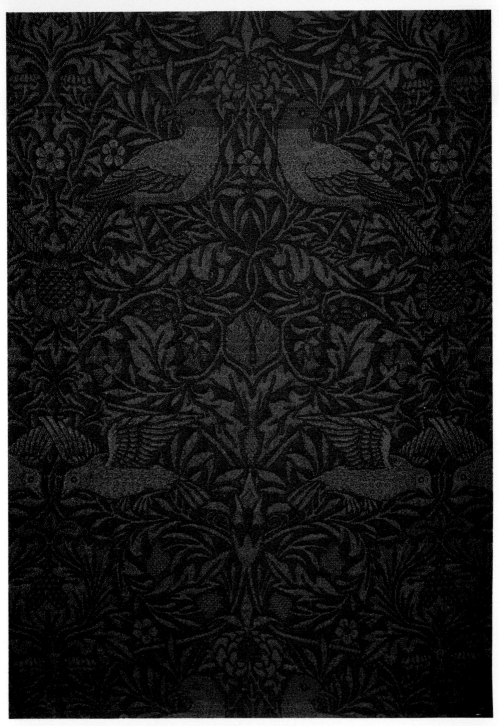

Bird woven woollen fabric, 1878; one of Morris's own favourites

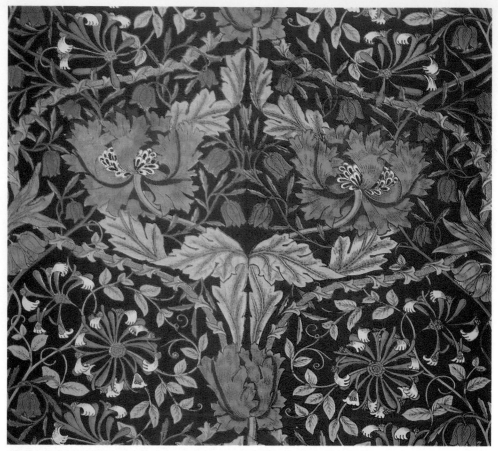

Honeysuckle, 1876: a popular Morris design, printed by Thomas Wardle

Ruskin's vision of the socially responsible businessman, as one who put purpose before profit and education before convenience, was accepted as an ideal by William Morris: he set for himself the very highest standards in design and manufacture; he preferred to set new trends rather than merely follow fashions; he never wasted an opportunity, at exhibitions or in publicity materials, to educate the public. And in his own public pronouncements, in the late 1870s and early 1880s, he took up a position very similar to that of Ruskin. Adulteration, shoddy and profitmongering were all topics about which he felt deeply, as he revealed when addressing a group of designers and craftsmen in 1878:

> I know that the public in general are set on having things cheap, being so ignorant that they do not know when they get them nasty also . . . I know that the manufacturers (so-called) are so set on competition to its utmost, competition of cheapness, not of excellence, that they meet the bargain-hunters half way, and cheerfully furnish them with nasty wares at the cheap rate they asked for, by means of what can be called no prettier name than fraud.[47]

He went on to recommend to his audience that they themselves accept the honour of 'educating the public . . . so that we may adorn life with the pleasure of cheerfully *buying* goods at their due price; with the pleasure of *selling* goods that we could be proud of both for fair price and fair workmanship; with the pleasure of working soundly and without haste at *making* goods that we could be proud of'.[48] Here, in essence, was the business philosophy of Morris & Co.

Besides instruction on the social purpose of business, Morris took from Ruskin many of his ideas on labour, technology and the organisation of production. The ruthless pursuit of competitive advantage was seen as the ultimate curse because from it followed all manner of evil consequences. In striving to beat the competition, manufacturers were driven to demand ever more of their employees, to intensify production, and bind the worker inextricably to the rhythm of a machine. Mechanisation was not seen by Ruskin as a bad thing in itself, but the consequences he often found objectionable. When it led to an extension of the division of labour, men became mere adjuncts to machines; thus all pleasure in labour was lost, and the labouring classes dehumanised. Nowhere did Ruskin express this better than in *The Nature of Gothic*:

> We have much studied and perfected, of late, the great civilized invention of the division of labour; only we give it a false name. It is not truly speaking, the labour that is divided; but the men:– Divided into mere fragments of men – broken into small fragments and crumbs of life . . . And the great cry that rises from all our manufacturing cities, louder than their furnace blast, is all in very deed for this,– that we manufacture everything except for men . . . to brighten, to strengthen, to refine, or to form a single living spirit, never enters into our estimate of advantages. And all the evil to which that cry is urging our myriads can be met only . . . by a right understanding, on the part of all classes, of what

At Merton Abbey
1881–83

151

F

kinds of labour are good for men, raising them and making them happy; by a determined sacrifice of such convenience, or beauty, or cheapness as is only to be got through the degradation of the workman, and by an equally determined demand for the products and result of healthy ennobling labour.[49]

Once again, Ruskin looks to the individual businessman, the employer of labour, to recognise the truth of his observations and organise production in a more satisfactory manner. In *Unto this Last*, the master of large numbers of men is likened to a military officer or pastor in having responsibility for 'the kind of life they lead; and it becomes a duty, not only to produce what he sells, but how to make the various employments involved in the production, or transference of it, most beneficial to the men employed'.[50] This involved ensuring that men are set to work at a 'tranquil rate, not producing a maximum in a given time'. Workmen, moreover, should be allowed to vary their work and contribute intellectually to the creative process, thus engaging 'their heads and hearts in what they are doing'.[51] And, if the factory were a place of simple beauty, rather than the typical dank and cluttered shed, the workers might show themselves capable of genuinely excellent work.

Morris followed Ruskin unequivocally in seeing the degradation of labour as the greatest of all social evils. He thought it natural that a man should enjoy work, as proper work demanded the exercise of the creative faculties, not mere drudgery. When addressing a group of fellow-craftsmen in 1878 he suggested that it was unlikely that 'anybody here . . . would think it either a good life, or an amusing one, to sit with one's hands before one doing nothing – to live like a gentleman, as fools call it'.[52] Useful work had a noble, life-enhancing quality; but this was quite different from the sterile toil insisted upon by most employers. Competition and the division of labour not only reduced the quality of goods, but also the quality of life itself. Workmen were forced to work harder, for longer hours, to the detriment of their health, and were completely subordinated to the machine. This he expressed very crisply when he insisted that 'worthy work carries with it the hope of pleasure in rest, the hope of pleasure in using what it makes, and the hope of pleasure in our daily creative skill. All other work but this is worthless; it is slaves' work – mere toiling to live, that we may live to toil.'[53]

This did not mean that Morris failed to recognise that machinery might be of value or that a factory might be a pleasant place to work. But he did make important distinctions between types of machinery and types of factory. Machinery could be divided into the modern, 'to which man is auxiliary', and 'the old machine, the improved tool, which is auxiliary to the man, and only works as long as his hand is thinking'.[54] The old type of machine reduced tedious labour and improved the quality of goods produced, while leaving the workman in control of the process and the speed

of execution. Thus the work retained the elements of creativity and relaxation which Morris saw as essential to a decent life.

As for factories, these were often brutal places, devoid of all beauty, virtual prisons for a dehumanised workforce. Yet the factory could be transformed into a place of learning, where craft skills passed from one generation to another, and in which useful work was done in a relaxed co-operative atmosphere. The alternative factory, a far cry from the reality of the day, was described by Morris in 'A Factory As It Might Be' (1884) as providing 'work light in duration, and not oppressive in kind, education in childhood and youth. Serious occupation, amusing relaxation, and more rest for the leisure of the workers, and withal that beauty of surroundings, and the power of producing beauty which are sure to be claimed by those who have leisure, education, and serious occupation.'[55]

Morris and Ruskin were at one in believing that the purpose of business was to produce goods of real value and beauty, and that a still higher purpose would be served if these goods were produced in relaxed, comfortable workshops, using machines which enhanced rather than degraded the skills of the workman. But it would be wrong, nevertheless, to explain Merton Abbey as simply the practical outcome of Morris's devotion to Ruskin.

It is true that Morris did produce goods of great beauty and of superlative quality, and that these things were accorded the highest priority. Furthermore, he never used modern machines that reduced the worker to the status of a cog, always preferring the old type that gave the operative the chance to exercise a skill, and to control the rate of throughput. Merton was more a collection of craft workshops, with an air of tranquillity, than a modern industrial establishment. It seems that his employees responded warmly to this atmosphere, and to the pleasant setting. Some tended flower and vegetable plots within the complex, and all benefited from the care of a benign management. Morris was genuinely respected, even loved, by many of his workers. One of his printers at the Kelmscott Press, where a similar regime prevailed, later said of him:

> Well, if all employers were like him, we should hear of no more troubles between employers and employed, He was generous and fair, and not indifferent to the feelings and welfare of those who served him. His idea was that a man should not be a working-man as we understand the term, but that he should be a workman in the best sense of the word; that he should take a high interest in his work; that he should have good surroundings; the very best materials to use; and should not be harried at his work by the everlasting thought of how the job was to pay him.[56]

Morris was, quite evidently, a caring employer whose philosophy of work and social purpose brought real and immediate benefits to those in his employ.

153

This, however, did not make Merton Abbey an establishment apart from all others, a kind of paradise which Morris would have recognised as approaching an ideal. His workpeople may have been better off than many elsewhere, but the degree of their advantage was never enough to lift them much above the norm for the working classes. Morris claimed to pay wages 'above the ordinary market price', though by precisely how much we do not know; we can only assume that the premium above the going rate for a particular trade was on the whole fairly modest, since Morris was always very conscious of the need to keep costs down and prices at a level which would not unduly deter sales. Most workers were paid on a piecework basis 'according to the custom of their trade',[57] and there is nothing to suggest that their working day was much shorter than in other establishments of a similar size. Morris & Co. employees were not free to enjoy their work in the leisurely, contemplative way recommended by their master: piecework for long hours is, by its very nature, intense and demanding of energy.

Nor did working for Morris & Co. offer the rewards of creative expression or intellectual exploration. Morris employed older technologies mainly because they gave him, as designer and manufacturer, the close control over the production process which he felt he needed. His technological

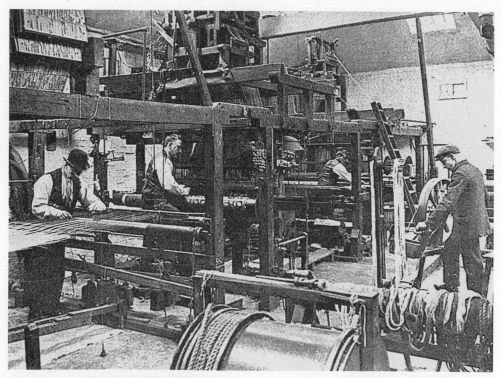

Plate 18 Jacquard weaving-looms at Merton Abbey. The punched cards can be seen at top left. On the right, an apprentice winds hands of wool on to bobbins

choices were made, first and foremost, for artistic and commercial reasons, rather that for reasons of social philosophy. In fact, many of his workers had very little personal influence over the production process: their choices were few; the division of labour quite fine. From Jacquard loom-weaving to vegetable dyeing, the work was arranged to satisfy Morris, leaving the individual worker barely elevated in status from his or her counterpart elsewhere. Even the tapestry-weavers had little freedom to interpret a design; most worked on backgrounds and draperies, leaving the difficult parts such as hands and faces to Dearle or one or two others.

Morris was acutely aware that the employment he offered fell short of both his and Ruskin's ideal. He felt himself caught up in a commercial system which, for one reason or another, prevented him from sharing with his employees the pleasures of the creative process. This he explained in a letter to Emma Lazarus in April 1884:

> except with a small part of the more artistic side of the work I could not do anything or at least but little to give this pleasure to the workmen; because I should have had to change their method of working so utterly, that it should have disqualified them from earning a living elsewhere: you see I have got to understand thoroughly the manner of the work under which the art of the

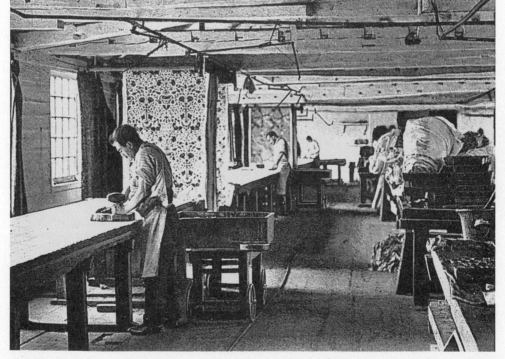

Plate 19 Block-printing chintzes at Merton Abbey. Dye-pads and other equipment were carried by the wheeled trolley, which would be pushed down the track as the printer worked along the fabric

Middle Ages was done, and that it is the *only* manner of work which can turn out popular art, only to discover that it is impossible to work in that manner in this profit grinding Society.[58]

In other words, to keep his own business moving forward, Morris felt compelled to control the look, finish and cost of his products, and their presentation to the public. His was a modern enterprise, employing modern workers, which had to abide by the rules of competitive commerce, not those of the medieval guild.

It is thus important, when considering the influence of Ruskin on Morris, to keep to the fore the difference between theory and practice. Morris as craftsman and designer followed Ruskin in practice as well as theory, but as an employer and manufacturer he found it much more difficult to implement the ideas of the sage. This at times caused him to despair, as is revealed in his letters to Georgiana Burne-Jones and Emma Lazarus. Ruskin had revealed the root cause of the discontent and ugliness which fouled the modern age; he had not, however, provided a complete solution. Morris knew from deep personal experience that any attempt at social regeneration through the actions of a morally uplifted business class was doomed to failure; quite simply because the forces of competition were bound to overwhelm the efforts of the individual. This realisation – at the very time when he was setting up Merton – chilled William Morris to the core. Despite all his best efforts, over two decades in business, the cause for which he had laboured seemed no further forward: the cause of *art which is made by the people and for the people, as a happiness to the maker and the user*.[59]

1 Wardle, 'Memorials', f. 11.
2 Kelvin, *Letters*, Vol. II, p. 10, to Thomas Wardle, 9 Feb. 1881.
3 Ibid., p. 18, 16 Feb. 1881.
4 Ibid., p. 23, to Jane Morris, 23 Feb. 1881.
5 Woods, 'Sir Thomas Wardle', pp. 661–5. He also became involved in importing Indian silks, and opened a shop in London.
6 Kelvin, *Letters*, Vol. II, p. 22, to Thomas Wardle, 18 Feb. 1881.
7 *Second Report of the Royal Commissioners on Technical Instruction*, Q. 1580.
8 Mackail, *Life*, Vol. II, pp. 32–3; Wardle, 'Memorials', ff. 18–19.
9 Kelvin, *Letters*, Vol. II, pp. 31–2, to Jane Morris, 10 March 1881.
10 Ibid., p. 33, 19 March 1881.
11 Ibid., p. 143, to Jenny Morris, 19 Dec. 1882.
12 Ibid., p. 42, to William De Morgan, 16 April 1881.
13 Morris & Co., *A Brief Sketch of the Morris Movement* (1911), pp. 40–1.
14 Kelvin, *Letters*, Vol. II, pp. 143 and 159, to Jenny Morris, 19 Dec. 1882 and 28 Feb. 1883.
15 Ibid., p. 174, 14 March 1883.
16 Ibid., p. 190, 14 May 1883.
17 Ibid., p. 223, 4 Sept. 1883.
18 Parry, *William Morris Textiles*, p. 49.
19 Kelvin, *Letters*, Vol. II, p. 95, to Georgiana Burne-Jones, 19? Jan. 1882.
20 Ibid., p. 121, 23 Aug. 1882.
21 V & A, Box I. 276. A, Morris & Co., brochure, 1882.

22 Ibid.

23 *Cabinet Maker and Art Furnisher*, Vol. 3 (1882), p. 160.

24 *Slater's Manchester and Salford Directory* (Manchester, 1883–86); *Kelly's Directory of Manchester and Suburbs* (1887); Kelvin, *Letters*, Vol. II, p. 149, to Jenny Morris, 9 Jan. 1883; *Cabinet Maker and Art Furnisher*, Vol. 3 (1883), pp. 83–4, 99, 160.

25 Wardle, *The Morris Exhibit at the Foreign Fair*, p. 15; Kelvin, *Letters*, Vol. II, p. 134, to Catherine Holiday, 9 Nov. 1882.

26 Wardle, ibid., p. 30.

27 W. Morris, 'The Lesser Arts', *Collected Works*, Vol. XXII, p. 15.

28 Wardle, *The Morris Exhibit at the Foreign Fair*, passim.

29 *Second Report of the Royal Commissioners on Technical Instruction*, QQ. 1561–2; Kelvin, *Letters*, Vol. II, p. 207, to Emma Lazarus, 12 July 1883.

30 *Second Report of the Royal Commissioners on Technical Instruction*, Q. 1563.

31 Kelvin, *Letters*, Vol. II, p. 283, to Georgiana Burne-Jones, 1 June 1884.

32 Wardle, *The Morris Exhibit at the Foreign Fair*, pp. 12–13.

33 *Spectator*, 24 Nov. 1883, p. 1508.

34 E. Lazarus, 'A Day in Surrey with William Morris', *Century Magazine*, Vol. 32 (July 1886), p. 394.

35 Ibid., pp. 390–1.

36 *Spectator*, 24 Nov. 1883, p. 1508.

37 Lazarus, 'A Day in Surrey', pp. 391–2.

38 *Spectator*, 24 Nov. 1883, p. 1508.

39 Ibid.

40 Ibid., p. 1509.

41 Henderson, *Life, Work and Friends*, p. 232.

42 W. Morris, 'The Lesser Arts' (1877), *Collected Works*, Vol. XXII, p. 5.

43 J. Ruskin, *The Nature of Gothic*, preface by Morris to the Kelmscott edition, 1892.

44 J. Ruskin, *Unto this Last*, in Cook and Wedderburn, *Collected Works of John Ruskin*, Vol. 17, p. 40.

45 Ibid., p. 39.

46 Ibid., Vol. 16, pp. 344–5.

47 W. Morris, 'The Lesser Arts' (1877), *Collected Works*, Vol. XXII, p. 22.

48 Ibid., pp. 22–3.

49 J. Ruskin, 'The Nature of Gothic', in *The Stones of Venice*, Vol. II (1853), p. 165.

50 J. Ruskin, *Unto this Last*, in Cook and Wedderburn, *Complete Works of John Ruskin*, Vol. 17, p. 41.

51 J. Ruskin, *A Joy Forever*, in ibid., Vol. 16, p. 37.

52 W. Morris, 'The Lesser Arts' (1877), *Collected Works*, Vol. XXII, pp. 5–6.

53 W. Morris, 'Useful Work versus Useless Toil' (1884), *Collected Works*, Vol. XXIII, p. 100.

54 W. Morris, 'The Aims of Art' (1886), *Collected Works*, Vol. XXIII, p. 87.

55 W. Morris, 'A Factory as it Might Be' (1884), reprinted in G. D. H. Cole (ed.), *William Morris: Stories in Prose; Stories in Verse; Shorter Poems; Lectures and Essays* (1948), p. 654.

56 H. H. Sparling, *Kelmscott Press and William Morris, Master Craftsman* (1924), p. 83.

57 Lazarus, 'A Day in Surrey', pp. 396–7; Kelvin, *Letters*, Vol. II, p. 275, to Emma Lazarus, 21 April 1884.

58 Kelvin, ibid., p. 275, 21 April 1884.

59 W. Morris, 'The Art of the People' (1879), *Collected Works*, Vol. XXII, p. 47.

Socialism and the
mature enterprise, 1883–91

The years between 1877 and 1883 stand out in the life of William Morris as a rich period of intellectual exploration in which his thought on art and society became progressively deeper, more tightly ordered, and farther reaching. As it did so, his despair at the limitations of Ruskinian ideas began to grow. His response to the moral and political challenge which this implied was no less positive than his earlier response to artistic and technical problems had been. By 1883, he had become a convinced revolutionary socialist, having tried and failed to bring about radical change through conventional party politics.

Morris's initiation into politics had come in December 1876 when the British government looked set to support the Turks in their dispute with Russia over the Balkans. Morris, like many of his contemporaries, was horrified by the treatment meted out by the Ottoman Empire to its Christian subjects in Bulgaria, and was outraged that Disraeli's government should so much as think of supporting the Turks, even as a means of resisting Russian expansionism. The Eastern Question Association was launched at a conference organised by the Liberal MP, A. J. Mundella. Morris was elected treasurer, and in May 1877, following the outbreak of war between Russia and Turkey, he published the pamphlet, *Unjust War: To the Working-men of England*, in which he railed against:

> greedy gamblers on the Stock Exchange, idle officers of the army and navy . . ., worn-out mockers of the clubs, desperate purveyors of exciting war-news for the comfortable breakfast-tables of those who have nothing to lose by war; and lastly, in the place of honour, the Tory Rump, that we fools, weary of peace, reason and justice, chose at the last election to represent us.[1]

Following the Congress of Berlin in June 1878, the danger of British intervention receded, but Morris remained troubled by the way in which the strength of the Liberal Party's opposition to war diminished when faced with the jingoism of the electorate.

In the following year, Morris entered deeper into the political fray as treasurer of the newly-established National Liberal League. This was to serve as a rallying-point for the London Radical Clubs, trade unions, and

various middle-class liberals, including Morris and other radicals from the Eastern Question Association.[2] The League's first major undertaking was to bolster the progressive wing of the Liberal Party during the general election campaign of 1880. Morris, very much under Gladstone's spell, was a forceful campaigner. After the Liberal victory, the NLL acted as a pressure group which sought to keep Gladstone mindful of his election pledges of 'peace, retrenchment and reform', but it quickly became clear that the government intended to ignore the League. Irish and imperial affairs brought matters to a head. In 1881, Gladstone's government introduced the Coercion Bill, which suspended *habeas corpus* in Ireland, and in the following year he sanctioned intervention in Egypt to put down the nationalist revolt led by Arabi Pasha. Morris was by now deeply disillusioned with party politics and he promptly resigned from the NLL.

His experience of the Eastern Question Association and the National Liberal League convinced him that the existing political parties had neither the will nor the ability to fight for a true measure of social justice. As he told C. E. Maurice, the son of the Christian Socialist leader F. D. Maurice, his hopes that 'one might further real socialistic progress by doing what one could on the lines of ordinary middle-class Radicalism' had been confounded; he had come to the conclusion that 'Radicalism is on the wrong line . . . it is made for and by the middle classes, and will always be under the control of rich capitalists', and 'as to real social changes, they will not allow them'.[3] In his correspondence with Maurice, he also revealed the more personal factors which underlay his decision to become a socialist:

> in looking into matters social and political I have but one rule, that in thinking of the condition of any body of men I should ask myself, 'How could you bear it yourself? what would you feel if you were poor against the system under which you live?' I have always been uneasy when I had to ask myself that question, and of late years I have had to ask it so often, that I have seldom had it out of my mind: and the answer to it has more and more made me ashamed of my own position, and more and more made me feel that if I had not been born rich or well-to-do I should have found my position *un*endurable, and should have been a mere rebel against what would have seemed to me a system of robbery and injustice. Nothing can argue me out of this feeling, which I say plainly is a matter of religion to me: the contrasts of rich and poor are unendurable and ought not to be endured by either rich or poor.[4]

By the beginning of 1883 Morris was ready 'to join any body who distinctly called themselves Socialists'.[5] At this time, according to E. P. Thompson, 'modern Socialism was on its point of emergence from the advanced radicalism of the previous decade'.[6] Between 1860 and 1880, he tells us, 'no consistent Socialist propaganda – not even of a dozen or twenty members – had existed in Britain'.[7] Admittedly, Marx and Engels were living in London and in contact with working-class and Radical groups,

and in all Britain's big cities there were political refugees from Russia, France, Austria and Germany. But the refugees were riven by bitter disputes, and had little in common with British working-class movements or the 'Old Guard' who represented the link between the Chartists and Radicals and the new socialism. Around the turn of the 1880s, however, socialism started to gain a foothold amongst the London workers through the efforts of people like Joseph Lane and Frank Kitz. Socialist ideas were also beginning to attract the interest of a few middle-class intellectuals, including Henry Mayers Hyndman, the so-called 'Father of English Socialism', Henry Salt, an Eton schoolmaster dismissed for his support of Henry George, and Ernest Belfort Bax, later one of Morris's closest associates.[8] Following their lead, Morris became one of a small number of

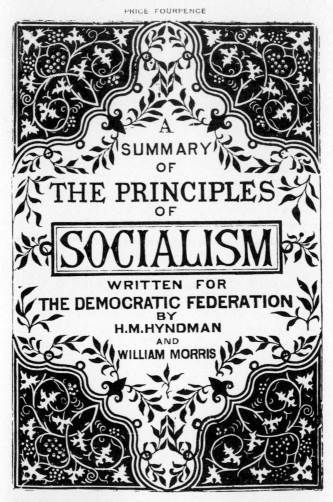

Plate 20 Cover designed by Morris for *A Summary of the Principles of Socialism* by H. M. Hyndman and William Morris (1884)

people, including such well-known figures as Tom Mann, John Burns and Tom Maguire, who turned to socialism in 1882–83 in search of a means of bringing about social and political change. As Morris himself put it:

> the consciousness of revolution stirring amidst our hateful modern society prevented me, luckier than others of artistic perceptions, from crystallising into a mere railer against 'progress' on the one hand, and on the other from wasting time and energy in any of the numerous schemes by which the quasi-artistic of the middle classes hope to make art grow when it no longer has any root.[9]

Thus when Morris joined Hyndman's Democratic Federation in January 1883 he was numbered amongst the pioneers of English socialism. By the middle of the year he was a member of its executive, and a regular speaker at its public meetings. Early in the following year, when the party changed its name to the Social Democratic Federation (SDF), he became involved in writing for its new weekly paper, *Justice*, which he helped to sell on street corners. His first major contribution to socialist literature was *A Summary of the Principles of Socialism*, written with Hyndman, and published in 1884.

In these years, he worked hard to deepen and refine his own ideas, and to understand those of the main socialist authorities; notably Karl Marx, whose *Capital* he first read early in 1883. His own views were shaped by the fact that he had come to socialism by a rather unorthodox route: the conviction that the existing social order spelled death to art along with any possibility of a general improvement in the quality of life for ordinary people. In reply to a correspondent in the *Manchester Examiner*, who suggested that he should not mix up art with broader social issues, Morris reiterated his view that the question of popular art was emphatically a social question. 'What business have we with art unless all can share it?', he asked, contrasting the enjoyment he derived from his work with 'the unpraised, unrewarded, monotonous drudgery which most men are condemned to'.[10] Socialism was Morris's way of turning his burning sense of moral outrage to positive effect. In his lectures and writings he repeatedly asserted that the creation of a genuinely socialist society demanded a moral revolution, not just an economic one.[11] To quote once more from E. P. Thompson:

> Morris's claim to greatness must be founded, not on any single contribution to English culture, but on the quality which unites and informs every aspect of his life and work. This quality might best be described as 'moral realism'; it is the practical moral example of his life which wins admiration, the profound moral insight of his political and artistic writings which gives them life.[12]

It is important to stress the originality and depth of Morris's thinking because he has often been criticised, both at the time and subsequently, for the 'unscientific' and 'impractical' character of his socialism. Engels, his

161

foremost critic, regarded Morris as naïve and muddle-headed – a 'settled sentimental socialist'.[13] Morris himself fuelled this myth, describing himself as a man 'careless of metaphysics and religion, as well as of scientific analysis, but with a deep love of the earth and the life on it, and a passion for the history of the past of mankind'. On the same occasion, he remarked that: 'whereas I thoroughly enjoyed the historical part of *Capital*, I suffered agonies of confusion of the brain over reading the pure economics of that great work'.[14] It is also true that he was not a successful politician in the conventional sense; he was far too individualistic, and was not always able to communicate effectively with working people, to whom his vision of a bright socialist future, in which co-operation replaced conflict and beauty replaced ugliness, must often have seemed remote and lacking in realism. In the depressed economic conditions of the 1880s, the masses found more to comfort them in the messages of the trade unionists and parliamentarians fighting for social reforms and higher wages.

But, as always, it is important not to underestimate Morris. He may have found it necessary to think hard about Marx's economic ideas, yet he grappled with them in typically persistent fashion until he had gained a thorough understanding of the main arguments and supporting evidence. (It is perhaps worth noting that he had to read a French edition of *Capital*. Thompson remarks that 'the literature of Socialism in English was ridiculously small. Not even the *Communist Manifesto* was in print.')[15] He took on board the theory of surplus value, and Marx's thesis on the alienation of the proletariat – an idea which, in essence, he had arrived at independently. He fully understood the importance of class conflict, and firmly rejected individual action as a means of bringing about social and political change. As he told the Manchester philanthropist Thomas Coglan Horsfall in October 1883: 'I think the basis of change must be the antagonism of classes . . . Commercialism, competition, has sown the wind recklessly, and must reap the whirlwind: it has created the proletariat for its own interest, and its creation must and will destroy it: there is no other force which can do so.'[16] On another occasion, he remarked that:

> I am bound to act for the destruction of the system which seems to me mere oppression and obstruction: such a system can only be destroyed, it seems to me, by the united discontent of numbers; isolated acts of a few persons of the middle and upper classes seeming to me (as I have said before) quite powerless against it: in other words the antagonism of classes, which the system has bred, is the natural and necessary instrument of its destruction.[17]

Certainly, there were important differences between Morris and Marx. But it would be quite wrong to see either his personal interpretation of capitalism or his special concern for art as indicative of wayward thought and flabby idealism.[18] And in some ways, Morris's perceptions were deeper than those of Marx. In viewing socialism 'through the eyes of an artist',[19]

he brought to the fore important cultural and social issues largely neg-
lected by socialist writers. Marx, in fact, had little or nothing to say about
the place of art under capitalism or socialism. Moreover, it might be
argued that Morris considered more deeply the practical questions as to
how the socialist revolution might be brought about and how society
might be reconstructed thereafter. In his first speech as a socialist, 'Art,
Wealth and Riches', to the Royal Institution in Manchester in March 1883,
and in his famous lecture 'How We Live and How We Might Live', in 1885,
he delivered with stunning force the message that art was vital to life and
that it could only flourish in a society liberated from the destructive forces
of commercial warfare.[20] The message was repeated over and over again
throughout the 1880s in a long series of captivating lectures and articles.

Morris saw himself as a practical socialist involved in the day-to-day
work of building a socialist movement with a real prospect of casting aside
the existing social order. As a leading member of the SDF, he spared
neither time nor money in his support for the cause.[21] Inevitably, how-
ever, he soon became involved in one of the bitter disputes over ideology
and tactics which divided the socialist movement in the 1880s. As the SDF
grew in strength, Hyndman's authoritarian style of leadership began to
arouse resentment and hostility. So too did his tendency towards back-
stairs intrigue, and his desire to transform the SDF into a 'parliamentary'
party and fight for specific reforms. Morris and a majority of the SDF's
committee castigated what they saw as political opportunism, and in
December 1884 they left to set up their own party, the Socialist League.
Educational and propagandist in its emphasis, the League was firmly
committed to non-participation in parliamentary politics. Its newspaper,
Commonweal, went into print in February 1885 with Morris as editor (and
as provider of a large part of the necessary funds). 'In less than two or three
years,' says Thompson, 'Morris had become one of the two or three
acknowledged leaders of the Socialist movement in England.'[22]

This was not achieved without an enormous amount of effort. As well as
editing and financing Commonweal – which became a weekly in May 1886
– Morris was its most prolific contributor. His efforts included a regular
feature called 'Notes on Passing Events', literary reviews, short stories, and
longer fictional works, including A Dream of John Ball and News from
Nowhere. On Sundays, he could often be found selling the paper on East
End street corners. He attended innumerable committees and meetings,
and threw himself into public speaking, both indoors and outdoors,
throughout Britain. A detailed analysis of his activities is given in LeMire's
Unpublished Lectures of William Morris: it reveals that between 1883 and
1889 he attended 484 public meetings – an annual average of sixty-nine –
and spoke at the great majority of them. In 1887, the peak year, he
attended 105 meetings, speaking or lecturing at 101 and chairing four.[23]

To the concern of his wife and non-socialist friends he began to appear in

163

the local courts as witness, defendant, and provider of funds for libel fines and surety for bail. The mid-1880s was a time of unemployment and distress for many sections of the working population, and serious unrest seemed more likely than at any time since the 1840s. The prospect of street violence was cause enough for the police and courts to adopt an increasingly hostile attitude towards street-corner meetings and demonstrations. One of the key events of the period was the SDF's demonstration in Trafalgar Square on 8 February 1886, when Hyndman and other socialist leaders addressed between eight and ten thousand unemployed workers. The ensuing march to Hyde Park turned into a riot, causing panic and outrage amongst the well-to-do. In the next eighteen months, there were numerous attempts to break up socialist meetings and arrest street-corner speakers for obstruction. Despite this, demonstrations by the unemployed continued throughout 1887, and by November Trafalgar Square was the scene of almost daily meetings. The Commissioner of Police responded by banning all public meetings in the Square, causing radicals and socialists of all persuasions to speak out in defence of free speech. On Sunday 13 November – Bloody Sunday – as large contingents of demonstrators converged on the Square, they were attacked and dispersed by police, aided by 300 troops with fixed bayonets. Three of the demonstrators died, and large numbers were injured.

Morris, who marched with the Socialist League contingent, was struck by the ease with which the authorities broke up the demonstrators. The incident brought home to him the fact that the establishment would not shy from using force to defend its privileges, and that a well-drilled, well-armed military force could hold in check even a very large and agitated body of working-class revolutionaries. He concluded that the time was not yet ripe for revolution, and that when the time came victory would not be won without much personal sacrifice and bloodshed.

Morris was also troubled by the increasing factiousness of the international socialist movement, and by the growing influence of those who favoured a parliamentary or reformist route to socialism. The reformers – 'gas and water' Fabian socialists and collective bargaining trade unionists – depressed him because of their willingness to tolerate capitalism, cleansed only of its worst material abuses. In 1890, he told the Scottish socialist John Bruce Glasier that 'socialism is spreading, I suppose on the only lines on which it could spread, and the League is moribund simply because we are outside those lines, as I for one must always be'.[24] And within the Socialist League all was not well. In May 1890, the executive committee was captured by anarchists. Morris was expelled from the editorship of *Commonweal*. He persevered with the League until the end of the year before withdrawing his support. Together with 120 other members of his local branch, he left to form the Hammersmith Socialist Society.[25] Its main activities were regular Sunday meetings and lectures

in the coach-house at Kelmscott House. The Society did attract well-known speakers like Bernard Shaw, Annie Besant, Sidney Webb, John Burns and Keir Hardie, but the audiences were small and primarily bourgeois, and the Society cannot be said to have played a large part in the development of British socialism. Morris's withdrawal from the Socialist League really marked the end of his day-to-day involvement in socialist campaigning,[26] although he remained committed to revolution as the only way of destroying capitalism and bringing about a truly socialist society. As he told the Fabian, Sidney Webb, in 1895, 'the world is going your way at present, Webb, but it is not the right way in the end'.

Morris's commitment to socialism, deep and passionate though it was, did not release him from the need to earn his living. The work of the firm continued to occupy much of his time. Once the transfer of operations to Surrey was complete, he continued to visit Merton two or three times a week, working a full day, and often staying overnight. As his son-in-law Henry Halliday Sparling later noted: 'he retained the full control of all materials, methods and processes, keeping a vigilant eye upon the product, and lending a hand anywhere and anywhen did he see need'.[27] Moreover, his enthusiasm for the work continued unabated. His most prolific days as a designer of printed and woven textiles were over by 1885, but he worked hard at several highly prestigious decorative projects, such as 1 Holland Park, the London home of Alexander Ionides, and Clouds, built by Philip Webb for the Wyndham family. Hammersmith carpets and special wallpapers were designed for the large, elegant rooms of the mansions occupied by the firm's wealthiest clients. Towards the end of his career, in fact, Morris made more designs for wallpaper than he did for either printed or woven fabrics (see Table 6).

Tapestry weaving, perhaps, was the art which gained most from Morris's efforts at this time. Experiments had begun at Kelmscott House and Queen Square in the late 1870s; but only when sufficient workshop space became available did Morris establish a new department. The first commercial production was the *Goose Girl*, designed by Walter Crane and woven by J. H. Dearle and two assistants. It was completed early in 1883, and was exceptional as the only figure tapestry produced by the firm in Morris's lifetime not based on a design by Edward Burne-Jones. Morris never lost his admiration for the work of his old friend, commissioning a steady stream of large designs, which he enhanced through the provision of complementary backgrounds and other decorative details. Their first collaboration resulted in the allegorical figures of *Pomona* and *Flora*.

These works, however, were quite modest in comparison with several of those which followed. *The Adoration of the Magi*, completed in 1890 for the chapel of Exeter College, Oxford, was one of the finest, measuring 8 feet 8 inches by 13 feet. This sold for £500.[28] Even more important was the series of panels illustrating the *Quest for the San Graal*, commissioned for

the dining-room of Stanmore Hall, Middlesex, by the Australian mining entrepreneur William Knox D'Arcy. The main panels were 8 feet high, and the entire series took nearly four years to complete. This was very expensive art indeed, with prices ranging from 12 to 16 guineas (£12.60–£16.80) per square foot.[29]

A clear description of tapestry-making at Merton Abbey is provided by Aymer Vallance. It was not usual for Burne-Jones to supply full-size cartoons; his original drawings for the Stanmore series, for example, were no more than 15 inches high. The composition of the panels, and especially of the groups of figures, was worked out with his usual care, but, we are told:

> for the rest, there was little else beyond slight colour-tinting to serve as guide in the execution of the work. Such being the condition in which the designs came into Messrs Morris & Co.'s hands, it was necessary for each of these drawings to be enlarged by photography, in squares varying in size and number according to the full dimensions required. These enlarged sections were then fitted together, and the whole, now of the proper size, submitted, together with a small coloured sketch showing the scheme of colouring proposed by the firm, to the designer for his approval or revision.[30]

This procedure, whilst ensuring that the intentions of the designer were

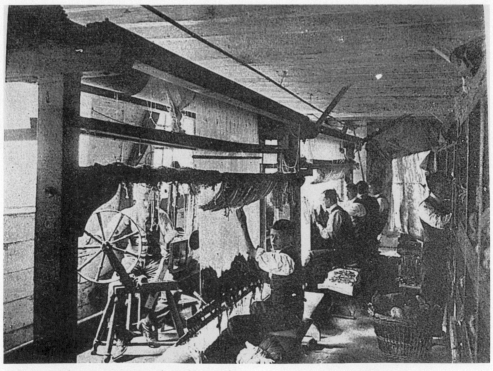

Plate 21 High-warp tapestry weaving at Merton Abbey

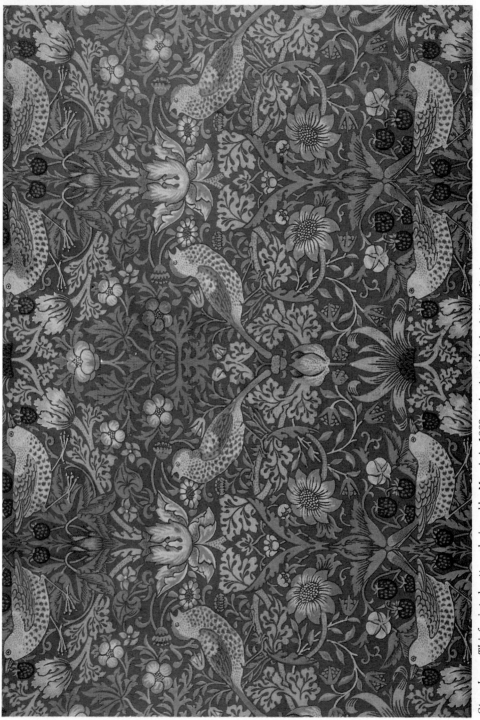

Strawberry Thief printed cotton; designed by Morris in 1883 and printed by the indigo discharge process

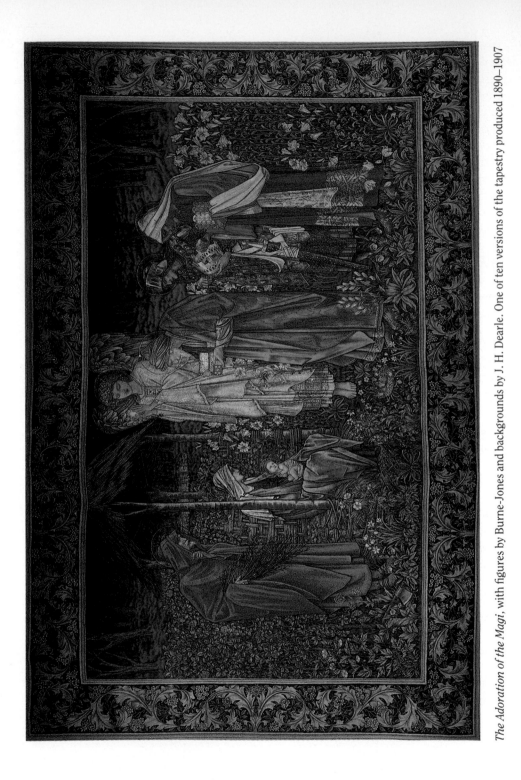

The Adoration of the Magi, with figures by Burne-Jones and backgrounds by J. H. Dearle. One of ten versions of the tapestry produced 1890–1907

respected, meant that some small degree of latitude was still allowed to the individual worker in weaving backgrounds and verdures – something which Morris thought a virtue. Yet, as with stained glass, Morris took responsibility for the overall appearance of the tapestry; integrating Burne-Jones's figures into the overall composition, designing patterns for draperies and the like, and overseeing the choice of colours used by the weavers.[31] And besides all this, Morris made five tapestry designs of his own: *Woodpecker* (1885), *Lily* (1885), *Forest* (1885, with animals by Philip Webb), *Minstrel* (1890) and *Orchard* (1890).

Morris evidently continued to play an important role in the affairs of the firm. Yet, given the extent of his political commitments, it was necessarily a role different in kind and less intensive than that played when he was building up the business. This he recognised by delegating responsibility for day-to-day management to others. Throughout his business career, Morris had the knack of getting the best out of his senior colleagues and workpeople. He appointed managers who combined enthusiasm, shrewdness and integrity, and allowed them considerable freedom to carry out their designated tasks. They did not let him down, for they shared the same high principles and artistic standards.

Morris's ability to inspire others shone through in his relationship with George Wardle, Morris & Co.'s general manager from 1870 to 1890. In the 1880s, Wardle frequently represented Morris & Co., and at times – most notably in the catalogue he prepared for the Morris exhibit at the Boston Foreign Fair of 1883 – his pronouncements on what constituted good design and manufacture were virtually indistinguishable from those of his employer. After the move to Merton, Wardle took overall charge of operations at the factory. His contribution to the success of the Morris enterprise has rarely received the recognition it deserves. A similar comment might be made about the Smith brothers, Frank and Robert, who ran the commercial side of the business, and J. H. Dearle, Morris's pupil as a designer, who supervised the tapestry, weaving, and fabric-printing departments. By the end of the 1880s, Dearle had become so proficient as a designer that his patterns were brought into production alongside those of Morris. He soon began to develop his own style, less imaginative than that of his mentor, but distinguished by excellent draughtsmanship, and displaying a sound knowledge of Middle Eastern designs. Some of his best designs are still sometimes mistaken for those of Morris. It was natural for Dearle to become the firm's principal designer after Morris's death in 1896.

In the 1880s, too, Morris's daughter May began to make an important contribution to the work of the firm. Although she produced a small number of designs for wallpapers and textiles, embroidery was her particular forte. She had learned much from her parents, both of whom were highly skilled in needlework techniques, and had also received formal training at the South Kensington School of Design. In 1885, at the age of

167

twenty-three, she took charge of Morris & Co.'s embroidery department. She was responsible for winning and overseeing large commissions, producing estimates and invoices, and generally supervising the work of the embroiderers employed by Morris & Co. Most of these were outworkers, but May also had the use of rooms at Kelmscott House, where she instructed pupils and trained apprentices. May was an accomplished designer and needleworker. Fourteen pieces designed or worked by her were displayed in 1890 by the Arts and Crafts Exhibition Society. Her assistants included Mary De Morgan, sister of the potter, Mrs George Jack, whose husband became the firm's chief furniture designer in the 1890s, and W. B. Yeats's sister, Lily.[32]

Delegation of responsibilities to able people meant that Morris's contribution to the firm could be more selective without risking a decline in business performance. Indeed, the profitability of Morris & Co. seems to have risen to new heights in the 1880s. Much of this success stemmed from the peculiar quality of its product range, for Morris had created a recognisable style, the 'Morris look', which set the firm apart from its rivals. All his earlier research and experimentation may have been expensive and time-consuming, but by the mid-1880s Morris & Co. was reaping rich rewards from the variety and artistic integrity of its products.

Yet the prosperity of Morris & Co. continued to be founded in large measure on commercial ability, not just on the excellence and distinctiveness of its products. It was a prudently managed business, organised in a thoroughly professional manner from Oxford Street by Frank and Robert Smith. Due attention was paid to costs, prices, profit margins, and the preparation of detailed estimates. If an estimate exceeded £500, advances were required as the work progressed, to ease the problem of cash flow.[33] Additional charges were made 'for attendance to view such buildings or rooms as are proposed for us to decorate'.[34] And by the late 1880s, as Morris's personal reputation soared, he felt obliged to ration his time by charging fees for personal visits to the homes of clients – 5 guineas (£5.25) in London, and £20 elsewhere. He made it clear to his managers, however, that the charges did not apply to 'well known and useful customers, and does not apply to my going to see work in progress or schemed out when we think it desirable, but only to stop fools and impertinents'.[35]

Equal care was taken in the preparation of invoices, which set out very plainly the firm's terms of trade. Morris & Co. never sold at discount prices, and prompt payment was demanded of all customers, whatever their rank or social standing. Prices were 'for ready-money payments', and the warning was issued that 'all sums unpaid after one month from the delivery of the account will be charged with interest at the rate of 5 per cent per annum'.[36] These were not the sort of terms to which the better-off had become accustomed: the disdain which many of them felt for tradesmen was notorious, and they expected long periods of credit. Many bills were

only rendered annually. Another break with convention was to mark the names, dimensions and prices of all items sold at the shop in Oxford Street. At the time, it was still the practice in high-class shops to avoid labelling, although the Morris approach was shared by the newer types of retailers, like the multiples and department stores which rose to prominence in the last quarter of the nineteenth century.

Ownership of a large and growing stock of designs of enduring appeal was of vital importance to Morris & Co. The position of the firm in the market was almost uniquely secure; so much so that favoured designs could be repeated time and time again over many seasons. Morris designs for printed fabrics, most of which dated from the later 1870s or the early 1880s, retained their popularity down to the First World War and beyond; out of thirty-five designs by William Morris, all but two were still available in 1912. The same was true of woven fabrics (nineteen out of twenty-five designs available in 1912) and wallpapers (fifty out of fifty-two designs). And a range of rush-seated Sussex chairs, introduced by MMF & Co. in the 1860s, was still advertised in the furniture catalogue for 1912.[37] Even designs for the higher forms of decorative art were repeated over the years as circumstances demanded. Cartoons for stained glass were regularly re-used from 1871 onwards. Likewise, commercial pressures led to the repeated use of designs for hand-knotted carpets and tapestries. Thus the *Bullerswood* carpet, first made for the Sanderson family in 1889, was twice repeated, as was the *Holland Park* carpet, originally made for Alexander Ionides. Of the tapestry designs produced in the 1880s, *Flora* was re-woven at least ten times, and *Pomona* five. Burne-Jones's *Adoration of the Magi* was widely admired and repeated nine times, although with different borders.[38]

Its leadership of the market may have allowed Morris & Co. some flexibility in setting prices, but not to the extent that it could completely ignore those of its rivals. All the firm's products faced competition of one sort or another from the many firms seeking the approval of fashionable society. In wallpapers, more than forty manufacturers were fighting for a share in the market.[39] Many of these catered for less well-lined pockets, and their products were often undistinguished in quality and taste. But there were always a few big firms, like Jeffrey & Co. and Essex & Co., which were more overtly commercial than Morris & Co., yet nonetheless marketed attractive designs of a high standard. Jeffrey & Co., besides printing Morris's patterns, engaged leading designers on its own account, including Walter Crane, William Burges, Charles Eastlake, Herbert Horne and E. W. Godwin, whilst Essex & Co. offered designs by Lindsay Butterfield and by C. F. A. Voysey, who is known to have produced over 100 designs for wallpapers.[40]

Likewise, Morris & Co.'s machine-made carpets had to compete with the products of large and dynamic manufacturers. John Crossley & Son of

Halifax, a manufacturer of Kidderminster carpets, produced almost a third of the nation's carpeting in the third quarter of the nineteenth century. The leading firm in Axminsters was James Templeton & Co. of Glasgow, which made excellent imitations of Persian and Turkish carpets, and initiated technical improvements which substantially reduced costs and prices.[41]

Nor was Morris & Co. unchallenged in the field of interior decoration. By the 1880s there were several other firms looking for custom, including the new breed of professionals like the Garretts and longer-established firms like Crace & Co., which had a good reputation amongst the rich and fashionable.[42] Moreover, Morris & Co.'s success encouraged emulation. In 1879 the firm of Watts & Co. was formed by the architects George Gilbert Scott, G. F. Bodley and Thomas Garner to provide a wide range of furnishings for their clients. Watts & Co. sold top-quality machine-made fabrics, embroideries and wallpapers, as well as stained glass, metalwork and furniture. In 1883 Thomas Wardle was encouraged by Morris's example to set up shop in New Bond Street, London, trading as 'Wardle & Co., Art Drapers, Embroiderers and Decorative Furnishers'.[43]

Other more heavily capitalised retailing ventures had also begun to appear. Maples sold furniture in a large store in Tottenham Court Road, and, as with rivals like Jackson & Graham and Gillows, it manufactured high-quality pieces in its own workshops, besides drawing upon the better East End cabinet makers.[44] Then, too, this was a period which saw the growth of department stores: Harrods, originally a grocer's, opened a furniture department in the 1880s, and soon drapery and house furnishing were given pride of place over groceries and provisions.[45] By the 1880s and 1890s there were quite a number of stores, like Shoolbreds, Whiteleys, John Barkers and Maples, where £150–£200 could furnish a middle-class home in some comfort.[46] Perhaps the nearest rival to the Morris business, however, was the firm of Liberty & Co. Established in 1875 by Arthur Lasenby Liberty, it quickly grew to become one of the haunts of the Aesthetic Movement. By the mid-1880s, Libertys was manufacturing a wide range of its own goods and importing luxury items from the Far East; it had numerous departments specialising in silks, furniture, embroidery, carpets, curios and porcelain, and could offer a complete interior decoration service.[47] Like Morris's own company, the best of his rivals were modern enterprises offering many different products of congruous design. Customers willingly patronised them as they could satisfy most of their wants in one visit, saving time and reducing the possibility of selecting items which did not match.

The firm's specialities – tapestry and stained glass – also met with competition, though of different degrees. Its tapestries, which it justly advertised as unequalled in quality of design and manufacture, easily held the field against such moderate opposition as the Royal Windsor Tapestry

Works. But throughout the 1880s, notwithstanding Burne-Jones's growing fame as an artist, Morris & Co.'s stained glass faced a severe challenge both from regenerated old rivals like Lavers, Barraud & Westlake and from more progressive designers like Selwyn Image and Christopher Whall.[48]

Customers, therefore, had many options, and, in general, would have compared prices and quality before making any purchase. Even the more prosperous of the Victorian middle classes were cost-conscious, for the maintenance of a respectable household made many demands upon their incomes. Long years of experience, therefore, had taught Morris that prices must ultimately reflect costs of production; and that if costs were not kept strictly under control, prices would be driven upwards and customers would go elsewhere. He drove a hard bargain with his suppliers in consequence, and was never slow to remind them of the realities of commercial life: 'as to the price per yard named by you the only thing *we* have to consider is the possibility of our selling the cloths at a profit', he once informed Thomas Wardle.[49] In similar vein, he often used to warn Catherine Holiday, his most skilled embroideress, who produced stunning tablecloths, bedspreads and *portières* for sale on commission by the firm, that if her prices were set too high then goods would sit on the shelves unsold for long periods. He suggested that she make some smaller pieces, like cushion covers, which would be more saleable and keep turnover moving.[50]

The need to keep prices within the limit the market would bear meant that Morris could not afford to let labour costs rise to unsupportable levels, whatever his thoughts on the evils of long hours and low pay. Yet, by the standards of the day, he was a good employer who paid wages above the prevailing market rate, while charitably retaining the services of a few workers past their prime or lacking useful skills. This we know from George Wardle, and confirmation is provided in letters from Morris to Georgiana Burne-Jones and Emma Lazarus. To the former he explained that his ordinary employees 'either work as day-workers, or are paid by the piece, mostly the latter: in both cases they get more than the market-price for their labour; two or three people about the place are of no use to the business and are kept on the live-and-let-live principle, not a bad one I think as things go'.[51]

It is clear that Morris made no attempt to run the firm in accordance with socialist principles. He remained, indeed, a rather conventional employer – benevolent rather than grasping, certainly, but by no means unique in that. As has been said, the workforce on the whole both liked and respected him greatly; but he was still 'the Master', whose status, as measured by lifestyle, was far higher than that of the men. Evidently, though, Morris was uneasy about the situation he found himself in, and felt constrained to explain why he rejected profit-sharing as a social

solution. He laid his theoretical position before Emma Lazarus thus:

> I ought to say why I think mere profit sharing would be no solution to the labour difficulty: in the first place it would do nothing towards the extinction of *competition* which lies at the root of the evils of today: because each *cooperative* society would compete for its corporate advantage with other societies, would in fact so far be nothing but a joint-stock-company – in the second place it would do nothing towards the extinction of exploitage, because the most it could do in that direction would be to create a body of small capitalists who would exploit the labour of those underneath them quite as implacably as the bigger Capitalists do: . . . in the third place the immediate results would be an increase of overwork amongst the industrious, who would of course always tend upwards towards the small capitalist class abovesaid: this would practically mean putting the screw on all wage-earners, and intensifying the contrast between the well to do and the mere unskilled; . . . Thus, you see, so accursed is the capitalist system under which we live, that even what should be the virtues of good management and thrift under its slavery do but add to the misery of our thralldom, and indeed become mere vices, and have at last the faces of cruelty and shabbiness.[52]

To Georgiana Burne-Jones he explained why he found profit-sharing and the equalisation of remuneration unacceptable in more personal terms:

> Now to be done with it I will put my own position, which I would not do to the public because it is by no means typical, and would therefore be useless as a matter of principle. Some of those who work for me share in the profits formally: I suppose, I made the last year or two about £1800. Wardle about £1200, the Smiths about £600 each; Debney & West £400 – all share directly in the profits: Kenyon the colour-mixer, & Goodacre the foreman dyer have also a kind of bonus on the goods turned out . . . Now as you know I work at the business myself and it could not go on without me, or somebody like me: therefore my £1800 are pay for work done, and I should justly claim a maintenance for that work; shall we say £4 per week, (about Kenyon's screw) or £200 per annum; that leaves £1600 for distribution among the 100 people I employ besides the profit sharers; £16 a year each therefore; now that would I admit be a very nice thing for them; but it would not alter the position of any one of them, but would leave them still members of the working class . . . It seems to me that the utmost I could do would be little enough, nor should I feel much satisfaction in thinking that a very small knot of working-people were somewhat better off amidst the great ocean of economic slavery.[53]

This is the argument of an honest man in difficulties; for Morris is unable to deny that £16 is, after all, £16, and that his employees would be better off having it than not. Furthermore, if Wardle and the rest were to have thrown their surpluses into the pool, the £16 would more than double. The 'very small knot of working people' might have had very different feelings from Morris about their being 'somewhat better off'. But Morris's difficulty seems to arise from his effort to present the case in an entirely theoretical way. It could be argued more practically that the firm depended disproportionately on Morris's remarkable abilities, and that he needed his

superior status as a means of maintaining his authority.

Morris evidently felt driven, as a businessman who wished to stay in business, to observe the rules of competitive commerce, and this, among other things, meant ensuring that his workforce was both disciplined and productive. His method, whenever possible, was to use the carrot rather than the stick. The payment of premium wages should be seen in this light. He respected wage differentials, as set by conditions in the labour market and by craft conventions, but in ensuring that his employees felt well treated he encouraged self-discipline, extra effort, and attention to quality. Further benefits of a generous wages policy were a low turnover of labour (reducing training costs) and a complete absence of industrial unrest. Morris was not alone in seeing these advantages, nor in believing that it was financially rational to treat people fairly, and he was strictly conventional in the general application of piece-work as a spur to efficiency. He was conventional also in his respect for craft privileges, such as allowing skilled men the freedom to take on their own apprentices.[54]

None of this meant that Morris was a soft touch as an employer. He commanded the respect of ordinary workers, not simply through paying good wages, but also through close supervision, care for the product, and meticulous attention to detail. And when he thought that anyone was slacking, he was tough enough to give them a jolt through making 'a great show of taking their time & so forth'.[55] Equally, his managers and foremen, those who took a share in the profits of the enterprise, or who were paid according to departmental results, were expected to impose a due sense of discipline and order. Their own pay was performance-related for obvious reasons, and the relatively high salaries offered by Morris may be read as another sign of his implicit acceptance of the forces of supply and demand.

Morris, in short, handled his business in a straightforwardly pragmatic way. Although he believed that his activities in the firm were not inconsistent with his socialist campaigning, he seems to have decided early on that the two worlds were better kept apart. The result of these policies was that Morris & Co. was never in danger of being priced out of the market; and of its more expensive goods the firm could – and did – claim that high quality and durability ensured customers received full value for money. The emphasis on 'the luxury of taste' rather than 'the luxury of costliness', first set out in the firm's prospectus of 1861, remained a characteristic theme of its publicity in the 1880s and 1890s.[56] Another feature of the firm's marketing strategy in this period was the continued expansion of its range to exploit its reputation. A brochure of the early 1880s listed products under twelve headings: '1st Painted Glass Windows. 2nd 'Arras' tapestry woven in the high warp loom. 3rd Carpets. 4th Embroidery. 5th Tiles. 6th Furniture. 7th General House Decorations. 8th Printed Cotton Goods. 9th Paper Hangings. 10th Figured Woven

173

Table 8 Morris & Co.'s range of fabrics and wallpapers by 1890

Width	Price range	Number of designs	Designs
Wallpapers			
21″	£0.53 to £0.80 per roll	12	Acanthus, Autumn Flowers, Chrysanthemum, Double Bough, Fruit, Jasmine, Lily and Pomegranate, Norwich, Pimpernel, Pink and Rose, Vine, Wreath
21″	£0.40 to £0.50 per roll	14	Autumn Flowers, Daisy, Double Bough, Garden Tulip, Honeysuckle (MM), Irish (JHD), Larkspur, Lily, Powdered, Scroll, Trellis, Vine, Wild Tulip, Wreath (ceiling)
21″	£0.28 to £0.39 per roll	21	Arcadia (MM), Bird and Anemone, Bruges, Christchurch, Daisy, Fritillary, Hammersmith, Horn Poppy (MM), Indian, Iris (JHD), Larkspur, Marigold, Pink and Rose, Poppy, Powdered, Rose, Sunflower, Venetian, Wallflower, Willow, Willow Bough
21″	£0.21 to £0.25 per roll	17	Acorn, Arcadia (MM), Bird and Anemone, Branch, Ceiling, Christchurch, Grafton, Horn Poppy (MM), Larkspur, Mallow (KF), Marigold, Pink and Rose, Poppy, Queen Anne (RE), Sunflower, Venetian, Willow
21″	£0.13 to £0.20 per roll	10	Apple, Bird and Anemone, Borage (ceiling), Carnation* (KF), Diaper, Loop Trail (KF), Mallow (KF), Spray (RE), Sunflower, Venetian
21″	price unknown	2	Bower, St. James's
Total number of different designs for wallpaper		53	
Printed textiles			
36″	£0.21 to £0.39 per yard	9	African Marigold, Cray, Honeysuckle, Large Stem (RE), Lodden, Rose, Strawberry Thief, Trent (JHD), Wandle
36″	£0.16 to £0.20 per yard	13	African Marigold, Bluebell (Columbine), Carnation (KF), Evenlode, Honeysuckle, Jasmine Trail (Jasmine Trellis), Large Stem (RE), Little Chintz, Lodden, Medway, Pomegranate, Rose, Wey
36″	£0.11 to £0.15 per yard	16	Avon (JHD), Bluebell (Columbine), Carnation (KF), Coiling Trail (RE), Eyebright, Flowerpot, Indian Diaper, Kennet, Lea, Marigold, Peony (KF), Snakeshead, Tulip, Tulip and Willow, Wey, Windrush
36″	£0.07 to £0.10 per yard	11	Bird and Anemone, Brother Rabbit, Corncockle, Eyebright, Iris, Kennet, Lea, Marigold, Rose and Thistle, Tulip, Wreathnet
36″	price unknown	3	Borage, Larkspur, Sunflower and Acanthus (WM or KF)
27″	£0.20 to £0.23 per yard	4	Cherwell (JHD), Florence (JHD), Severn (JHD), Wey
27″	£0.12 to £0.15 per yard	2	Cherwell (JHD), Severn (JHD)
24″	£0.23 per yard	1	Acanthus
Total number of different designs for printed fabrics		43	
Woven fabrics and velvets			
1. Woollen fabrics			
72″	£1.25 per yard	1	Peacock and Dragon
	£1.18 per yard	1	Violet and Columbine
	£1.13 per yard	1	Tulip and Net (JHD)
	£1.00 per yard	2	Bird and Vine, Campion
54″	£1.13 per yard	2	Sunflower (JHD), Vine (JHD)
	£0.99 per yard	1	Ispahan
	£0.93 per yard	1	Golden Stem (JHD)
	£0.90 per yard	1	Peacock and Dragon
	£0.83 per yard	1	Bird
	£0.58 per yard	1	Mohair Damask*

Width	Price range	Number of designs	Designs
50″	£0.65 per yard	1	Indian Diaper*
	n.k.	1	Acanthus
36″	£0.43 per yard	4	Campion†, Honeycomb*†, Tulip and Rose*†, Vine and Pomegranate*† (WM or KF)

2. Silk and woollen fabrics

Width	Price range	Number of designs	Designs
72″	£1.43 per yard	1	Tulip and Net (JHD)
54″	£1.38 per yard	1	Anemone*
	n.k.	2	Brocatel (WM or JHD), Honeycomb**
52″	£0.63 per yard	1	Helena* (JHD)
36″	£0.83 per yard	1	Dove and Rose
	n.k.	1	Swivel**
27″	£0.65 per yard	1	Flower Garden
	n.k.	1	Persian Brocatel (JHD)

3. Silk fabrics

Width	Price range	Number of designs	Designs
63″	£2.25 per yard	2	Oak**, St James**
	£1.68 per yard	2	Oak**, St James**
54″	£2.60 per yard	2	Brocatel (WM or JHD), Persian Brocatel (JHD)
	n.k.	1	Anemone
50″	n.k.		Acanthus
27″	£0.98 per yard	2	Flower Garden, Kennet*
	£0.93 per yard	1	Larkspur*
	£0.63 per yard	1	Small Figure (Silk Damask) (JHD)
	n.k.	1	Willow

4. Silk and linen, silk and cotton, and woven cotton fabrics

Width	Price range	Number of designs	Designs
72″	n.k.	1	Madras Muslin
54″	£1.38 per yard	1	Golden Bough (WM or JHD)
	£0.63 per yard	1	Tulip and Rose*
50″	£0.33 per yard	1	Indian Diaper
	n.k.	2	Acanthus, Swivel**
36″	n.k.	2	Crown Imperial*, Swivel**

5. Velvets

Width	Price range	Number of designs	Designs
24″	£0.45 per yard	1	Utrecht Velvet* (RE)

Total number of different designs for woven fabrics		33	

Notes: This table indicates the range of designs available to Morris & Co. by 1890. They were not all in continuous production, but could be manufactured in relatively short runs whenever needed for stock, or to special order. Prices are taken from a set of catalogues distributed by Morris & Co. around 1912. Similar data are not available for 1890, but, since prices are not likely to have changed dramatically over the intervening period, the 1912 figures are included here in order to indicate the general level and range of Morris & Co. prices.

* machine-printed or power-woven.
** initially power-woven by contractors, later hand-woven at Merton.
† three-ply woven woollen.
JHD J. H. Dearle.
KF Kate Faulkner.
RE reproduction of old design.
n.k. not known.

Sources: L. Parry, *William Morris Textiles* (1983), pp. 147–72; C. C. Oman and J. Hamilton, *Wallpapers: A History and Illustrated Catalogue of the Collection of the Victorian and Albert Museum* (1982), pp. 369–87; Victoria & Albert Museum, Box VII.43.G, Morris & Co., *Chintzes, Silks, Tapestries, etc.* (catalogue, c. 1912); 57.C.65, Morris & Co., *Wallpapers* (catalogue, c. 1912).

Stuffs. 11th Furniture Velvets and Cloths. 12th Upholstery.'[57] Within each of these categories items varied considerably in size, sophistication and price. The ability to offer customers goods of varying grades was especially important. By the 1880s and 1890s Morris's designs were available in all the principal types of Victorian carpets – Wilton, Axminster, Brussels and Kidderminster – costing anything from £0.27½ to £3.00 a square yard.[58]

Similarly, by 1890, the Smiths could offer customers at the Oxford Street showrooms a total of fifty-three designs for wallpapers, forty-three for printed fabrics, and thirty-three designs for woven fabrics. Of course, this is not to suggest that all these designs were in continuous production; but they were all available when needed for stock, or to special order. Block-printing and weaving on the Jacquard loom, in fact, were processes well suited to relatively short production runs. The choice of wallpapers was particularly wide, with prices ranging from £0.13 to £0.80 a roll. Printed fabrics varied in price from £0.07 to £0.39 a yard, depending on the fabric used, the number of colours, and the complexity of the production process. *Honeysuckle*, a Morris design of 1876, and one of his personal favourites, required the use of more than a dozen different blocks, and as a result was one of the firm's most expensive printed fabrics. Prices also varied according to the colourway, for some were more tricky to print than others. The most expensive of all Morris's woven textiles was *Granada* (1884), a silk velvet woven with gilt thread. The experimental run cost £10 a yard, and, not surprisingly perhaps, it was not considered a commercial proposition. More typical of the woven fabrics were the figured silks and silk mixtures, which were available in a variety of qualities, widths and colourways. The cheapest were fabrics woven on power-looms by contractors; three-ply woollens at £0.43 a yard, like *Tulip and Rose*, and the embossed *Utrecht Velvet* at £0.45 a yard. The latter was a reproduction of seventeenth-century furnishing velvets; it was 'discovered' by Morris in 1871, and was produced in large quantities. In 1912, fourteen different colourings were listed in the firm's catalogue.[59]

More and more of the firm's products thus came within the reach of middle-class customers with modest incomes. Most people bought wallpapers, fabrics and carpets in Oxford Street for inclusion in their own decorative schemes, rather than having their whole house, from cellar to attic, decorated by the firm. Likewise, throughout the 1880s and 1890s, Morris & Co. made and sold a limited number of large, high quality pieces of embroidery at high prices; but small items such as cushion covers, workbags, fire-screens and the like were increasingly important, most being sold for £0.75–£1.50.[60] Embroidery was, of course, a suitably respectable occupation for middle-class women, and, in addition to selling finished work, Morris & Co. met this demand by offering embroidery kits; most of the firm's designs were available with the pattern ready-traced on silk, or as transfers.[61]

Some completely new products were sold by the firm in the 1880s and 1890s, notably light fittings and other metalwork by William Arthur Smith Benson, which were sold in large quantities from the mid-1880s.[62] Benson also made designs for the expanding furniture section of the business. As noted earlier, Morris & Co. took a workshop for cabinet making and upholstery in Manchester in 1883, and seven years later it took over the furniture-manufacturing business of Holland & Son in Pimlico.[63] A limited range of 'rich inlaid cabinets and suites of fine construction and design' was added to the 'joiner-made' furniture, such as that in stained oak and ash, which had been popular since the 1860s.[64] Before his retirement in 1890, most designs came from Philip Webb. The role of chief furniture designer then passed to the American George Jack, who had taken over Webb's architectural and design practice. According to a brief sketch of the Morris business written early in the twentieth century, 'the best of the designs have a restraint and dignity which sets them quite apart from most modern furniture'.[65]

In the 1880s and 1890s, ecclesiastical business was clearly less important to the firm than its secular business. Nevertheless, a perusal of its early twentieth-century catalogues suggests that it was ready to provide virtually anything that a church might require: stained glass and tapestries; a full range of vestments, 'made in accordance with the standard set forth by the Ornaments Rubric of the Church of England'; a great variety of embroidered frontals, stoles, offertory bags and the like; complete communion sets; church furniture, including carved oak and pine chairs, hymn boards, lecterns and vestment chests; metalwork, such as lamps and chandeliers, crosses, candlesticks, ewers, chalices, patens and offertory dishes, in silver, brass and bronze; and a selection of kneelers and carpets 'specially suitable for the covering of sanctuaries and chancels'. By the early twentieth century, even complete altars, chancel screens and lych-gates could be supplied to special order.[66]

The commercial shrewdness of Morris & Co. was further manifested in the effective exploitation of two of its greatest assets: the reputations of its principal designers, Burne-Jones and Morris. Originally, when the main task had been to establish the identity of the firm, the partners had agreed to keep secret the names of individual designers.[67] This policy was later reversed, and, after 1875, Morris & Co. was quick to take advantage of Burne-Jones's rising popularity. He is known to have produced at least 270 cartoons for stained glass between 1872 and 1878; an average of one every 8½ days. This seems all the more remarkable when one considers his achievements as a painter during these years. Thereafter, he produced fewer designs, but the firm was able to draw upon the large stock which it had built up.[68]

In the 1870s, Burne-Jones exhibited few paintings in public, relying for sales on the patronage of wealthy collectors. All this was to change with the

opening in 1877 of the Grosvenor Gallery, the showplace of the Aesthetic Movement. He was one of its leading exhibitors, and, for the next ten years, until its closure in 1887, all of his important pictures were shown there. He subsequently became one of the stars of the New Gallery in Regent Street. In the 1880s and early 1890s, when his reputation was at its peak, his work commanded high prices. He was lionised by fashionable society, and much in demand as a portrait painter. It was thus with some degree of pride that Morris & Co. announced in 1882 that 'Mr Burne Jones entrusts us alone with the execution of his cartoons for stained glass.'[69]

Burne-Jones, it should be said, received no special favours from the firm, notwithstanding the intimacy of his friendship with Morris. Indeed, he appears to have felt much undervalued, making repeated requests to be paid in guineas rather than pounds (in 1866, 1874 and again in 1887), and often complaining that the fees he received were 'ludicrous and inadequate'. In December 1887, for instance, when invoicing the firm for two cartoons for St Philip's, Birmingham, at £200 each, he lamented that:

> my wages have been assessed at a sum, a pittance so contemptible, that the idea for one moment occurred to me to hand over the despicable amount for parochial distribution . . . I have done my work, I have also learnt a lesson for which I did not stipulate, and for which I tender my thanks to the Firm . . . I have learnt the character of business transactions at last.[70]

Georgiana Burne-Jones and some later writers have portrayed these outbursts as typical of Burne-Jones's offhand sense of fun; and, indeed, when faced with the little account book in which they appear, the accompanying brilliant comic sketches of the artist (thin and ragged) and his employer (portly and swilling fine wine) do serve to modify the apparent bitterness of tone. Sewter, however, points out that

> while there is an element of bantering humour, as usual, in these comments, it is impossible not to feel that Burne-Jones suffered from a very real sense of grievance, and hoped he could touch Morris's conscience. When compared with the prices he was obtaining for his paintings and watercolours, the fees allowed him for his cartoons were indeed small.[71]

Nonetheless, whether fair or not, Burne-Jones's income from Morris & Co. (an average of £389 per annum for thirty-eight years) was really quite substantial, and, given the longevity of the association, must have been valued by him. The commissions he undertook are listed in an account of his financial transactions with the firm now held at the Fitzwilliam Museum in Cambridge. This is summarised in Table 9. From this it can be seen that Burne-Jones was credited with £12,883 between 1861 and his death in 1898. His earnings peaked between 1871 and 1875, when he received £3,493 in total. This was a very large sum, and it in part explains his unswerving support for Morris during the partnership crisis of 1875. Undoubtedly, he wished for the firm to continue come what may, and he

could only have seen the claims of Rossetti, Madox Brown and Marshall as damaging to his own interests. He showed the same positive commitment to the enterprise at other times also. He lent money to the firm at times when liquidity was a problem: between 1865 and 1867 he paid over a total of £197, and in 1876, when cash was short after Morris had paid off his disgruntled former partners, he advanced a further £50.

Burne-Jones, throughout his life, seems to have suffered from a sense of financial insecurity, and this no doubt coloured his attitude towards Morris & Co. The firm may not have paid him as well as he would have liked, but the money continued to flow in quite regularly, which was useful to an artist otherwise dependent for his livelihood on occasional sales. He

Table 9 Analysis of Edward Burne-Jones's account with Morris & Co., 1861–98

| | | Credited to account | | | | Debited from account | | | | |
| | | % shares of credits | | | | | % shares of debits | | | Average payment |
Period	Total credits (£)	Com- mission income	Royalties	Other*	Total debits (£)	Cash	Insurance	Household items**	Number of commissions	per commission (£)
1861–65	647.88	82.6	—	17.4	603.13	81.6	—	18.4	110	4.86
1866–70	704.00	80.6	—	19.4	759.33	60.3	13.7	26.0	55	10.31
1871–75	3,129.09	94.5	4.6	0.9	3,043.77	60.0	22.8	17.2	125	23.66
1876–80	1,986.55	83.5	13.9	2.6	2,078.90	34.2	43.6	22.1	61	27.91
1881–85	1,523.01	87.7	12.2	0.1	1,548.02	22.6	61.0	16.4	29	46.07
1886–90	1,765.00	92.9	7.1	—	2,395.96	58.4	35.5	6.0	18	91.11
1891–95	2,493.10	88.2	11.8	—	1,610.53	88.0	—	12.0	11	200.00
1896–98	618.00	68.8	31.2	—	844.10	93.6	—	6.4	7	60.71
1861–98	12,866.63***	88.0	9.4	2.6	12,883.73***	57.8	27.2	15.0	416	27.21

Notes: *Included under other credits are payments for attendance at meetings (1862–64), capital returned, goods returned, and cash loaned to the firm when it was having liquidity problems (1865–67 and 1876).
**Wine purchases made through the firm are included with household items.
***The small disagreement between the total credit and total debit figures is the result of recording or arithmetic errors in the original source and/or in transcription.

Source: Fitzwilliam Museum, Cambridge, Account Book of Sir Edward Burne-Jones.

used a large part of the money he earned from the firm between 1870 and 1890 to build up a retirement fund with the Sun Life Assurance Co.[72] Another large slice of his earnings went on direct purchases from Morris & Co. of furniture and other household goods, including wine. Less than 60 per cent of his income was taken in the form of cash.

A further advantage for Burne-Jones of his association with Morris & Co. was that the terms on which he was paid improved progressively with time. As the firm's reputation grew, it could charge higher prices and so pay Burne-Jones at a higher rate. Thus, although the flow of work dwindled after 1875, the average payment for each commission rose in compensation to a peak of £200 in 1891–95. Prestigious commissions were especially rewarding. In 1887 Burne-Jones was paid £400 for two cartoons

for St Philip's, Birmingham, and in 1893–94 he was paid £600 for windows at Ashton-under-Lyne. His fees for tapestry designs, moreover, were on a higher plane altogether than those for stained glass. He received £250 for *The Adoration of the Magi*; and £1,000 for the *San Graal* tapestries. After 1871 he was paid a royalty each time one of his designs was repeated. Over the period 1861–98 as a whole, royalties amounted to a tenth of the total sum credited to his account, peaking at 13.9 per cent in 1876–80.[73]

Even more important to Morris & Co. than the reputation of Burne-Jones was that of Morris himself. He was a famous figure, and his very name drew fashionable people to take an interest in his art, whether or not they agreed with his political ideas. His conversion to socialism appears to have done little to deter customers. Nor did his lofty attitude and forthright opinions. George Wardle enjoyed telling the story of how, on one celebrated occasion, a customer commented on the brightness of some Hammersmith carpets, saying he had been led to expect more subdued colours. This infuriated Morris who had no wish to be famed for dull, muddy colours. He informed the customer that if he wanted dirt, he could find it in the street. The customer left, and did not come back.[74] But, odd incidents like this apart, Rossetti was surely correct in observing that Morris's 'very eccentricities and independent attitude towards his patrons seems to have drawn [them] around him'.[75]

The firm was not slow to exploit the celebrity of its owner. Morris was always available to advise wealthy customers on big decorative schemes and expensive purchases. In a brochure of the early 1880s, it was announced that thenceforth interior design would 'be under the special supervision of Mr WILLIAM MORRIS, who will personally advise Customers as to the best method and style of Decoration to be used in each case'.[76] This arrangement lasted until 1889 when J. H. Dearle was promoted to replace Morris as the firm's consultant on interior design and decoration.[77]

One of the rewards of fame was an increase in the number of large commissions. At the beginning of the decade, Morris & Co. was invited to undertake further work at St James's Palace. First came a small order for carpets and rugs, quickly fulfilled early in 1880, and between May 1880 and March 1881 the Palace's entrance and staircases were decorated at a cost of £4,799. The firm then worked from July 1881 to March 1882 on the main suite of State Rooms. In the Picture Gallery, the ceiling was papered, the cornice painted, and a new chimney-piece installed. Old silk hangings from other rooms were re-dyed and fitted in the gallery, and its ottomans reupholstered in *Utrecht Velvet*. In Queen Anne's Drawing Room, wall-hangings were cleaned and refitted, cornices painted and curtains and other draperies re-dyed, whilst in the Council Chamber Room and the Throne Room the walls were hung with *St James* silk damask, one of Morris's grandest designs. This phase of the work cost a total of £4,868.

The lesser State Apartments and some minor rooms were redecorated between December 1881 and March 1882 (£722), and finally in March 1882 Morris & Co. contracted to provide new curtains and embroidered valances for the State Rooms at a cost of £2,025.[78]

Another impressive project – and one of the best documented – was 1 Holland Park, owned by Alexander Ionides. Morris & Co. was commissioned to decorate and furnish the house in March 1880, and work continued until October 1888. Webb took charge of structural alterations, while the entire decorative scheme was under Morris's personal control. This helped to give it coherence, causing one commentator to observe that 'the real charm of the house is that it is a consistent example of the use of fabrics and patterns designed by Mr Morris'.[79] The total cost was £2,361.[80]

Of the many other commissions won by Morris & Co. during these years, two deserve special mention: Clouds, the Hon. Percy Wyndham's house at East Knoyle, near Salisbury, and Stanmore Hall in Middlesex. Clouds was the *pièce de résistance* of Philip Webb. It was built between 1881 and 1886, and decorated throughout by the firm. The work had barely been completed when, in December 1889, much of the interior was gutted by fire, owing to the carelessness of a chambermaid. Undeterred, Webb and Morris began afresh, taking another three years to redecorate the damaged rooms. Fortunately, some of the moveable articles were saved, including two large Hammersmith carpets. One of them, named after the house, was specially designed for the drawing-room, and was the biggest yet made by Morris & Co., measuring 39 feet by 12 feet. The other, a copy of the *Holland Park* carpet, was sited in the main hallway, which featured Morris tapestries, woven hangings and upholstered chairs. Photographs of other rooms show machine-woven *Tulip and Lily* Kidderminsters in the passages, and loose covers on the furniture of *Avon* or *Cray* printed cotton.[81]

Morris & Co. participated in the decoration and furnishing of Stanmore Hall between 1888 and 1896. Its owner, William Knox D'Arcy, a fabulously rich Australian mining magnate, wanted a home which reflected his new-found wealth.[82] His requirements were met by Stanmore Hall, an early Victorian mock Tudor Gothic castle which had been enlarged in the 1880s by the architect Brightwen Binyon. Its central feature was the dining-room, which had Morris tapestries depicting the quest for the Holy Grail, and a version of the *Clouds* carpet even larger than the original. Other carpets included copies of the *Holland Park* and *Swan House* designs for the drawing room, and some newly-designed Hammersmith rugs. Morris & Co. was responsible for the decoration of the entrance hall and the staircase, which was designed by W. R. Lethaby.[83] Various pieces of furniture were made by the firm, most notably an inlaid bureau designed by George Jack and a set of early Georgian-style dining-chairs.[84]

An article in *The Studio* in September 1893 described the work at Stanmore in rather gushing tones: 'Messrs William Morris & Co. have had

181

a free hand, not merely in such matters as usually fall within the scope of decorators, but in the hangings, furniture, and carpets.' After commenting on the *San Graal* tapestries, the reviewer went on to praise other aspects of the dining room:

> the carpet is perhaps the most noteworthy item in a splendid room, since it is one of Mr Morris's most successful designs and large enough to extort admiration on that ground alone. The ceiling, in delicately moulded plaster, also commands attention, and yet keeps its place. The painted ceilings, both in the entrance hall and staircase, deserve study, not because they are 'hand-painted', but because of their beautiful forms and dainty colours. The delicate tones, like those of embroidery on old white silk, are in shades of pinks, purples, tender greens, and spring yellows, on a pale creamy ground, the whole bright yet light . . . This lightness of the ceilings and carpets, with the untouched oak of much of the panelling and furniture, gives an air of gaiety.

The reviewer concluded that the whole effect was one of 'sumptuous decoration kept within proper proportion. One has but to compare Stanmore Hall with houses of equally elaborate adornment to feel that in this respect it has no rival.'[85] D'Arcy was obviously a valuable and ambitious customer, but Morris seems to have had little sympathy with his requirements, and he was content to leave J. H. Dearle to oversee the work.[86]

In 1884, at a time when many manufacturers were complaining of the depressed state of the economy, Morris wrote to his mother that 'our business is pretty good considering the bad state of trade throughout the country'.[87] Fashion and middle-class sensibilities were running in the right direction for Morris & Co. The solid comfort of the early Victorian period was now castigated in works such as Mrs Orrinsmith's *The Drawing Room*, first published in 1878, as 'the very headquarters of commonplace, with its strict symmetry of ornament and its pretentious uselessness'.[88] The trend, in fashionable quarters, was away from ostentation and display towards what became known as 'art furnishing'. Its general principles were:

> to reduce the amount of furniture and to create more space in rooms. Heavily upholstered furniture was eschewed in favour of wooden-framed chairs and settees with loose cushions. Sombre furnishings, gilding and such colours as crimson were banished in favour of paler tones and white-painted joinery work . . . Throughout, an air of casualness and informality was aimed at, with symmetry in furnishing schemes being discouraged. Finally, and most important of all, shams and deceits were forbidden: furniture which disguised the way it was made, or the materials of which it was made, was regarded as dishonest and therefore to be avoided.[89]

The trend was encouraged by the growing literature on interior decoration, of which Morris was a beneficiary, as well as being a source of inspiration to it. Influential novelists and writers referred to Morris

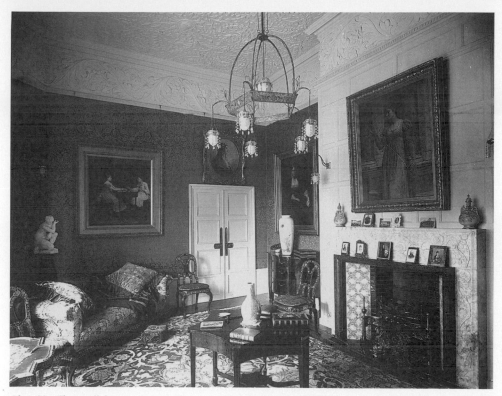

Plate 22 The small drawing-room at Stanmore Hall, Middlesex, 1891. Fireplace by W. R. Lethaby; walls hung with *St James* damask

interiors in their books,[90] academics and their wives 'religiously clothed their walls . . . with Morrisian designs',[91] and though George du Maurier and Linley Sambourne satirised Morris interiors in *Punch*, they were themselves clients of the firm.[92] As Linda Parry has noted: 'it became a fashionable imperative for all self-respecting London households to possess at least one item of Morris manufacture'.[93] Even Morris's competitors acknowledged the superiority of his fabrics and wallpapers, and the firm began to supply large quantities of goods to the trade. In textiles, the main demand was for woven fabrics rather than chintzes, for 'whereas the *avant garde* were always quick to use printed cottons in their homes . . . the more conventional London decorator preferred the richness of effect gained from woven fabrics and silk in particular'.[94] London, of course, led the way, and it was some time before the provincial middle-classes responded with similar enthusiasm to Morris or new ideas on the beautification of the home.

As a well-known and much-respected figure, Morris's opinions on art, design and manufacturing standards were taken very seriously by his contemporaries. His work for the South Kensington Museum continued

183

until his last illness, and in 1882 he was asked to give evidence before the Royal Commission on Technical Instruction. The Commission, under the chairmanship of Sir Bernhard Samuelson MP, a Cleveland ironmaster, was one of several which examined the state of Britain's education system in the second half of the nineteenth century. Its formation was a response to concern over rising international competition and the apparent superiority of French, German and American scientific and technical training. It heard evidence from many leading industrialists and educationalists. Morris's fellow-witnesses included Dr William Siemens; Godfrey Wedgwood, the senior partner in Wedgwood & Sons; the ironmaster Sir Isaac Lowthian Bell; Sir Philip Cunliffe-Owen, the Director of South Kensington Museum; Professor T. H. Huxley; and Thomas Wardle, who submitted a report on the silk textiles industry in Britain.[95]

Morris was called before the Commission as an authority on the design and manufacture of high-class consumer goods; an increasingly important sector of the market, and one in which French goods were generally presumed superior to British. He was questioned at length on the deficiencies of domestic products, and the steps which might be taken to improve the competitive position of British manufacturers. The printed version of his evidence covered eleven pages, and began with the observation that English designers lacked the mastery of style exhibited by their French counterparts. This, he suggested, was what gave the French 'superiority in the European markets in certain classes of goods, which they undoubtedly possess'. English designers displayed an innate love of beauty, but they lacked the training and thoroughly systematic approach of the French. Yet, while Morris admired the cleverness of French designs, he did not accept that emulation of the French approach to design was the best way for Britain to 'establish a trade and a reputation for goods of a high class'. French designers, based in Paris, were not fully conversant with the manufacturing techniques and materials used in provincial industrial centres like Lyons, often with unfortunate results. Sterility in design should be avoided through a deep knowledge of the manufacturing process, and Morris thought it better 'as a matter of competition . . . not to attack the French on their ground at all, but to try to produce our own styles'. When Sir Bernhard Samuelson, seeking clarification, asked him whether he considered that the designer should acquaint himself with the exigencies of the machine and the material in which the design was executed, Morris replied: 'yes, I speak as strongly as I can upon that. I think that is the very foundation of all design.'

On the crucial issue of how Britain should meet the challenge of the French in the markets for high-class goods, Morris recommended 'an education all round of the workmen, from the lowest to the highest, in technical matters, as well as others; and that this should be obtainable in several centres of industry'. Training in drawing was important to give an

understanding of form – although Morris objected to what he called 'mere mechanical finish' – and he believed that 'everybody ought to be taught to draw just as much as everybody be taught to read and write'. At a more advanced level, students attending schools of art and design should have ready access to workshops where they might become conversant with manufacturing methods. Equally, they needed instruction on how to draw from nature, and the opportunity to examine very closely 'good old examples' of their specialist craft or closely-related crafts. This led Morris to insist upon the importance of museum collections, not just in London, but in each of the manufacturing centres of the land. This he considered 'a positive necessity . . . I do not see how they could get on without it'. He believed, moreover, that such museums would not only benefit designers and workers; the public also needed a technical education, 'so that you may get a market for excellence and not for appearance'. He also suggested that the formal training offered by schools of art and design needed to be complemented by workshop training: 'the old system of apprenticeship, by which workmen learned their craft, is a good deal broken down now, and nothing as yet has taken its place'.[96]

The Commission publicised the cause of technical education in Britain, though its recommendations were in fact very conservative. It nonetheless helped shape political opinion, paving the way for the 1889 Technical Instruction Act, which empowered local authorities to raise money for technical education.[97] Morris's main influence on contemporary thought, however, was not through official channels, but through the work of a younger generation of architects, designers and craftsmen which, from the 1880s, sought to implement the principles enunciated in his lectures and confirmed by his example. This has become known as the Arts and Crafts Movement, although it was made up of many individuals and groups, sometimes with conflicting opinions. Amongst the most important were the Century Guild, the Art Workers' Guild, the Arts and Crafts Exhibition Society, and the Guild of Handicraft.

The first of these was the Century Guild, founded by A. H. Mackmurdo in 1882. Mackmurdo had studied under the Ecclesiologist architect James Brooks, who encouraged him to design furnishings, wallpapers, and other works of decorative art. He met Morris at meetings of the Society for the Protection of Ancient Buildings, and, like so many others of his generation, took from him the desire to raise the status of the lesser arts, and the idea that decorative art was vital to the spiritual elevation of humanity; one of a series of lectures he delivered to the Manchester Royal Institution in 1881 was entitled 'Art and its Relation to Life'. Mackmurdo's principal associates were Herbert Horne, best known for his wallpaper designs and metalwork, and Selwyn Image (stained glass and embroidery), who were largely responsible for the Guild's influential magazine, the *Hobby Horse*, first published in 1884. Other associates included Clement

185

Heaton, who specialised in metalwork and enamelling; William De Morgan, the potter; and the artist Heywood Sumner. Although it had workrooms and agents in London and Manchester to sell its wares, it was 'primarily an association of artists with a shared concern to sustain the highest qualities of design and execution'.[98] Some of its members were both designers and producers, others designers only; for whilst the Guild emphasised the supremacy of the designer and artist over the manufacturer it did not insist on the unity of design and manufacture which both Ruskin and Morris regarded as an ideal. Quite a few of its members designed for the trade, and Mackmurdo himself positively approved of modern machines as a means of spreading good design practice and educating the customer; they were 'a liberating force that would free men to spend more time in pursuit of the idea of beauty itself'.[99] Thus Mackmurdo was more inclined than Morris to see good in industrialisation, and more optimistic about the potential benefits of an alliance of artist and manufacturer.[100]

Members of the Art Workers' Guild (1884) took a rather different position from that of Mackmurdo. They shared the desire to improve public taste and to elevate the position of the decorative arts, but they did not favour mass production: workshops and studios run by artistically-inspired craftsmen was their ideal, not factories managed by enlightened capitalists. They also opposed the professionalisation of architecture, which was seen as an art, not a profession, and thus they represented a stand against the 'establishment' – the RIBA and Royal Academy. The Art Workers' Guild was much more substantial than the Century Guild, consisting mainly of painters, designers and craftsmen who worked alone or in small communities; inevitably, it was less dominated by a single individual. It embraced a considerable range of ideas and opinions, although many of the leading lights, including W. A. S. Benson, Walter Crane, Henry Holiday, and J. D. Sedding, were followers of Morris and had a sound grasp of his ideas on art, design and manufacture.

The Art Workers' Guild met frequently to share ideas and examine work of current interest, and through these exchanges there emerged the idea of a regular exhibition to raise the standing of the decorative arts relative to the fine arts. In 1886 the Arts and Crafts Exhibition Society was founded by Benson, Crane, Day, William De Morgan, and W. R. Lethaby. Its first exhibition was held in the New Gallery in Regent Street in the autumn of 1888. Morris was sceptical about the need for such exhibitions, and he doubted their chance of success. He told Benson that

> the general public don't care one damn about the arts and crafts; and our customers can come to our shops to look at our kind of goods; and the other kinds of exhibits would be some of Walter Crane's works and one or two of Burne-Jones: those would be the things worth looking at: the rest would tend to be of an amateurish nature, I fear.[101]

He nevertheless wished the new Society every success, and when, contrary to his expectations, the exhibitions did prove popular with the public, he willingly offered his help. Lectures became an important part of the Society's programme. Morris himself spoke on tapestry, textile design and architecture, and it was Emery Walker's Arts and Crafts lecture on printing (1888) which helped bring about the establishment of Morris's Kelmscott Press.[102]

When reviewing the third exhibition of the Arts and Crafts Exhibition Society, staged at the New Gallery in 1890, W. B. Yeats singled out Morris as the true progenitor and inspiration of the Arts and Crafts Movement:

> But for these 'arts and crafts' exhibitions . . . the outer public would hardly be able to judge of the immense change that is going on in all kinds of decorative art and how completely it is dominated by one man of genius . . . Only a small part of the exhibits are from Morris & Co., and yet all the numberless people who send work, from the well-known firm that made the high fireplace in the north gallery to the lady who illuminated the copy of Coventry Patmore's poems in the balcony, are under the same spell'.[103]

Numbered amongst those under Morris's spell were C. R. Ashbee and W. R. Lethaby. Ashbee, a dedicated follower of Ruskin and Morris, trained as an architect under G. F. Bodley. He went on to found the School of Handicraft in 1887, and the Guild of Handicraft a year later. His aim was to offer a workshop-based training in design and craft production. He was an accomplished designer, and probably followed Ruskinian prescriptions more closely than any of his contemporaries, Morris included. He is often charged with naïvety in his attempts to foster the spirit of the medieval guild system, and the Guild's move to the Cotswolds from London in 1902, away from its established clientele, is generally seen as a mistake. It was wound up in 1908. Ashbee's reputation, however, was considerable; as Crawford has remarked, 'amongst art students and amateurs who took the *Studio* and the *Art Journal* as their guide, Ashbee and the Guild were names to conjure with'.[104] Lethaby, like Ashbee, trained as an architect. He was a founder member of both the Art Workers' Guild and the Arts and Crafts Exhibition Society, and 'of all the younger men, he came closest to Morris in his ideas – lecturing and writing in a terse, provocative style on art and architecture'.[105] Although an accomplished architect and furniture designer, his most important contribution to the arts in Britain was as teacher and leader of the younger generation. The Central School of Arts and Crafts, of which he became head in 1894, embodied many of the ideas of Morris and the Arts and Crafts Movement, especially the belief that good design depended upon an understanding of the medium, and that this could best be achieved through practical experience.[106]

It was partly though the work of younger, proselytising designer-craftsmen like Ashbee and Lethaby that Morris's influence extended

187

beyond Britain to mainland Europe. Ashbee's writings were highly regarded abroad, and his work was exhibited in Austria, Belgium and Germany.[107] Lethaby too was well known on the Continent, and his Central School provided 'if not the model, certainly the inspiration of much continental teaching and training in design and the crafts'.[108] Morris came to be perceived as the well-head from which flowed the British revival in the decorative arts. Siegfried Bing sold Morris fabrics in Paris at his influential *Maison de l'Art Nouveau*, and Hermann Muthesius's *Das Englische Haus* (1904) introduced his ideas on art and design to the Werkbund and later the Bauhaus. Amongst others, van der Velde and Gropius, the founders of the Bauhaus, paid tribute to the Arts and Crafts Movement and the ideas and work of William Morris. As Ray Watkinson has noted, although 'stylistically, the characteristic Bauhaus product was utterly alien to anything of Morris's own production', it was nevertheless 'made in his spirit'.[109]

One could point to numerous other individuals, or groups of individuals, who in more recent times have also acknowledged and responded to the example and inspiration of William Morris. It is perhaps futile to speculate on how the master would have viewed their efforts. What is certain, though, is that to the end of his life Morris remained convinced of the limited social value of his own artistic endeavours, and he could only have viewed those of his disciples in the same critical light. It was his mature judgement that under capitalism individual artists and craftsmen could raise cultural standards for only a small minority of the people. Until revolution brought release, art must remain the prisoner of an economic system driven by greed, not real human needs. It is ironic that Morris's influence began to grow in the 1880s, at the very time when he had begun openly to proclaim that art could not flourish under the existing social order. Revolution, he came to realise, was not just around the corner, yet he never waned in his commitment to socialism or in his belief that the solution to society's ills lay in collective rather than individual action.

1 Quoted in Mackail, *Life*, Vol. I, pp. 349–50.
2 E. P. Thompson, *Romantic to Revolutionary* (2nd ed., 1977), p. 261. In this section, we draw heavily on Thompson's work – as indeed must anyone interested in Morris's socialist career. Useful introductions are to be found in Faulkner, *Against the Age*, and Henderson, *Life, Work and Friends*.
3 Kelvin, *Letters*, Vol. II, p. 199, to Charles Edmund Maurice, 22 June 1883.
4 Ibid., 1 July 1883.
5 Ibid., p. 231, to Andreas Scheu, 15 Sept. 1883.
6 E. P. Thompson, *Romantic to Revolutionary* (2nd ed., 1977), p. 297.
7 Ibid., p. 276.
8 Ibid., pp. 276–300.
9 W. Morris, 'How I became a Socialist', *Justice* (1894), *Collected Works*, Vol. XXIII, pp. 280–1.
10 Kelvin, *Letters*, Vol. II, pp. 173–4, to the Editor, *Manchester Examiner*, 14 March 1883. The exchange followed his lecture to the Manchester Royal Institute on 'Art, Wealth and

Riches' on 6 March. It was his most outspoken critique of capitalist society to date.

11 See E. P. Thompson, 'The Communism of William Morris', in S. Nairne (ed.), *William Morris Today* (1984), p. 135.

12 E. P. Thompson, *Romantic to Revolutionary* (2nd ed., 1977), p. 717.

13 Friedrich Engels to Laura Lafargue, 13 Sept. 1886, quoted in Faulkner, *Against the Age*, p. 144.

14 W. Morris, 'How I became a Socialist', *Justice* (1894), *Collected Works*, Vol. XXIII, pp. 278, 280.

15 E. P. Thompson, *Romantic to Revolutionary* (2nd ed., 1977), p. 305.

16 Kelvin, *Letters*, Vol. II, p. 238, to Thomas Coglan Horsfall, 25 Oct. 1883.

17 Ibid., pp. 202–3, to C. E. Maurice, 1 July 1883.

18 Such a view of Morris was given short shrift in Thompson's 1976 postscript to the second edition of *Romantic to Revolutionary*, but nonetheless tends to persist.

19 Kelvin, *Letters*, Vol. II, p. 230, to Andreas Scheu, 15 Sept. 1883.

20 *Collected Works*, Vol. XXIII, pp. 3–26, 143–63.

21 He was well aware of the resulting contrast between Ruskin and himself. 'You must understand,' he once wrote, 'that though I have a great respect for Ruskin and his works (besides personal friendship) he is not a socialist, that is not a *practical* one.' Kelvin, *Letters*, Vol. II, p. 305, to Robert Thomson, 24 July 1884.

22 E. P. Thompson, *Romantic to Revolutionary* (2nd ed., 1977), p. 302.

23 E. D. LeMire, *Unpublished Lectures of William Morris* (Detroit, 1969), pp. 234–90, Appendix I, 'A Calendar of William Morris's Platform Career'.

24 Henderson, *Letters*, p. 321, to John Bruce Glasier, 19 March 1890.

25 E. P. Thompson, *Romantic to Revolutionary* (2nd ed., 1977), pp. 565–72.

26 His disengagement from the bitter squabbles did mean that he was able to work for the unification of the various socialist groups in the 1890s. In December 1892, for example, the Hammersmith Socialist Society set up a special sub-committee led by Morris, empowered to 'promote the alliance of Socialist organisations in Great Britain'. Ibid., p. 605.

27 H. H. Sparling, *The Kelmscott Press and William Morris, Master Craftsman* (1924), p. 32. Also see Wardle, 'Memorials', ff. 22–3.

28 See H. C. Marillier, *History of the Merton Abbey Tapestry Works* 1927), p. 32; Fairclough and Leary, *Textiles by William Morris*, p. 61.

29 Vallance, *William Morris*, pp. 119–21; Parry, *William Morris Textiles*, p. 106.

30 Vallance, *William Morris*, pp. 121–2.

31 Opinions differ as to how successfully he integrated Burne-Jones's languid figures into the overall composition of Morris & Co. tapestries. See, for example, P. Thompson, *The Work of William Morris*, pp. 102–3.

32 WMG, J56, William Morris to Emma Shelton Morris, 27 Dec. 1885; Marsh, *Jane and May Morris*, pp. 168–70, 217–19.

33 For example, an advance of £2,000 was secured before work began in the early 1880s on the decoration of the State Rooms at St James's Palace. C. Mitchell, 'William Morris at St. James's Palace', *Architectural Review* (Jan. 1947), p. 39. Also see Kelvin, *Letters*, Vol. II, p. 591, to Julius Alfred Chatwin, 2 Nov. 1886.

34 WMG, File 11a, Morris & Co. circular, 9 April 1877. Also see V & A, Box III. 86. kk (xiv), Morris & Co., estimates and invoices.

35 Kelvin, *Letters*, Vol. II, p. 622, to Frank or Robert Smith, 24 Feb. 1887.

36 Ibid., p. 591, to Julius Alfred Chatwin, 2 Nov. 1886.

37 V & A, Box VII. 43. G, Morris & Co., *Chintzes, Silks, Tapestries, etc.* (catalogue, 1912); 57. C. 65, Morris & Co., *Wallpapers* (catalogue, 1912); 57. C. 67, Morris & Co., *Specimens of Furniture and Interior Decoration* (catalogue, 1912).

38 Parry, *William Morris Textiles*, pp. 90, 95, 108–13.

39 C. C. Oman and J. Hamilton, *Wallpapers: A History and Illustrated Catalogue of the Collection of the Victoria and Albert Museum* (1982), p. 65.

40 Ibid., pp. 63–5; E. A. Entwisle, *Wallpapers of the Victorian Era* (Leigh-on-Sea, 1964), pp. 34–40.

41 See J. N. Bartlett, *Carpeting the Millions: The Growth of Britain's Carpet Industry* (Edinburgh, 1978), passim.

42 Moreover, Crace, unlike Morris & Co., had the reputation of providing tasteful yet relatively cheap decorative schemes. See, for example, Mordaunt Crook, *William Burges and the High Victorian Dream*, p. 302.

43 C. Woods, 'Sir Thomas Wardle', in D. J. Jeremy (ed.), *Dictionary of Business Biography*, Vol. V (1986), p. 661. It closed in 1888, however, having created difficulties with one of his major customers, Libertys.

44 P. Kirkham, *The London Furniture Trade, 1700–1870* (1988), pp. 63–4, 68, 160.

45 Harrods, *1849–1949: A Story of British Achievement* (1949), p. 37.

46 W. H. Fraser, *The Coming of the Mass Market, 1850–1914* (1981), p. 194.

47 A. Adburgham, *Liberty's: A Biography of a Shop* (1975), passim.

48 Harrison, *Victorian Stained Glass*, pp. 63–5.

49 Kelvin, *Letters*, Vol. I, p. 273, to Thomas Wardle, 2 Nov. 1875.

50 Ibid., p. 402, to Henry Holiday, 24 Oct. 1877; pp. 417–18, to Catherine Holiday, 4 and 6 Dec. 1877.

51 Ibid., Vol. II, p. 283, to Georgiana Burne-Jones, 1 June 1884.

52 William Morris to Emma Lazarus, 21 April 1884, reprinted in *Spectator*, Vol. 32 (1886), p. 397.

53 Kelvin, *Letters*, Vol. II, p. 283, to Georgiana Burne-Jones, 1 June 1884.

54 Ibid., p. 26, to Thomas Wardle, 28 Feb. 1881.

55 Ibid., p. 29, to Jane Morris, 3 March 1881.

56 See, for example, WMG, File 11a, Morris & Co., circular, n.d., c. 1881.

57 V & A, Box I. 276. A.

58 V & A, Box I. 276. A; Box III 86 KK (xiv), Morris & Co. invoice to A. A. Ionides, March 1880; Fairclough and Leary, *Textiles by William Morris*, p. 49; Parry, *William Morris Textiles*, p. 84.

59 V & A, Box VII. 43. G, Morris & Co., *Chintzes, Silks, Tapestries, etc.* (catalogue, c. 1912); Parry, *William Morris Textiles*, p. 147.

60 V & A, 86. cc. 31, Morris & Co., Record of Embroidery Work, Nov. 1892–Nov. 1896. Also see Parry, *William Morris Textiles*, p. 29.

61 B. Morris, *Victorian Embroidery* (1962), pp. 91, 110.

62 B. Morris, 'Introduction', in Arts Council, *Morris & Co., 1861–1940: A Commemorative Centenary Exhibition* (catalogue, 1961), p. 11.

63 *Slater's Manchester and Salford Directory* (1883–86); Vallance, *William Morris*, p. 123.

64 Morris & Co., *A Brief Sketch of the Morris Movement* (1911), p. 50.

65 Ibid., p. 51.

66 See, for example, V & A, 47. L. 93, *Church Decoration* (catalogue, n.d.).

67 Hammersmith and Fulham Archives Department, DD/235/1, MMF & Co., Minute Book, 10 Dec. 1862.

68 Sewter, *Stained Glass*, Vol. I, p. 46; Arts Council catalogue, 1975, p. 70; Harrison and Walters, *Burne-Jones* (1973), Appendix I, pp. 187–90.

69 V & A, Box I 276. A. Also see Fitzgerald, *Burne-Jones*, p. 182; Harrison and Walters, *Burne-Jones*, pp. 126, 148; Arts Council, *Burne-Jones: The Paintings, Graphic and Decorative Work of Sir Edward Burne-Jones, 1833–98* (1975), pp. 7–9.

70 Fitzwilliam Museum, Cambridge, Account Book of Sir Edward Burne-Jones, Nov.–Dec. 1887.

71 Sewter, *Stained Glass*, Vol. I, p. 20.

72 Sun Life first began to offer endowment policies in 1864. They were attractive because tax relief was allowed on the premiums.

73 Fitzwilliam Museum, Cambridge, Account Book of Sir Edward Burne-Jones. Also see Fairclough and Leary, *Textiles by William Morris*, p. 61; P. Fitzgerald, *Edward Burne-Jones: A Biography* (1975), p. 260

74 Wardle, 'Memorials', ff. 10–11.

75 Theodore Watts-Dunton's recollections in *The English Review*, (Jan. 1909), quoted in E. P. Thompson, *Romantic to Revolutionary* (2nd ed., 1977), p. 109.

76 WMG, File 11a, Morris & Co., circular, n.d., c. 1881.

77 See, for example, Kelvin, *Letters*, Vol. II, pp. 407–8, to Jenny Morris, 24 March 1885.

78 PRO, WORK19 19 and 20; E. Shepherd, *Memorials of St. James's Palace* (1894), pp. 128–32, 364; Mitchell, 'William Morris at St. James's Palace', pp. 38–9.

79 G. White, 'An Epoch-Making House', *The Studio*, Vol. XIV (1898), p. 103.
80 Ibid., pp. 102–12; V & A, Box III. 86. kk. (xiv); WMG, Box 15a; Parry, *William Morris Textiles*, pp. 139–40.
81 WMG, Box 15b; Parry, *William Morris Textiles*, p. 141; M. Morris, *Artist, Designer, Socialist*, p. 58.
82 On the origins of D'Arcy's fortune, see G. Blainey, *The Rush that Never Ended: A History of Australian Mining* (Melbourne, 1963), pp. 232–47.
83 On Lethaby and Stanmore Hall, see G. Rubens, *William Richard Lethaby: His Life and Work* (1986), pp. 107–11.
84 WMG, Box 15b; Fairclough and Leary, *Textiles by William Morris*, pp. 53, 61; Marillier, *History of the Merton Tapestry Works*, p. 19; Parry, *William Morris Textiles*, 143–4.
85 *The Studio* (Sept. 1893), quoted in Vallance, *William Morris*, pp. 124–5.
86 In a letter to Georgiana Burne-Jones, Morris described it as 'a house of a very rich man – and such a wretched uncomfortable place: a sham Gothic house of fifty years ago now being added to by a young architect of the commercial type – men who are very bad'. P. Henderson, *The Letters of William Morris to his Family and Friends* (1950), pp. 322–3, to Georgiana Burne-Jones, 10 June 1890.
87 Kelvin, *Letters*, Vol. II, pp. 321–2, to Emma Shelton Morris, 16 Sept. 1884.
88 L. F. Orrinsmith, *The Drawing Room* (1878), p. 1.
89 A. Forty, *Objects of Desire: Design and Society, 1750–1980* (1986), pp. 111–12.
90 Faulkner, *Against the Age*, p. 73; Parry, *William Morris Textiles*, p. 130.
91 *Daily Telegraph*, 5 Oct. 1896.
92 P. Fitzgerald, *Edward Burne-Jones: A Biography* (1975), p. 101.
93 Parry, *William Morris Textiles*, p. 130.
94 Ibid., p. 69.
95 *Second Report of the Royal Commissioners on Technical Instruction* (P. P. 1884, XXXI), passim.
96 Ibid., Evidence of William Morris, QQ. 1561–1669.
97 See, *inter alia*, G. W. Roderick and M. D. Stephens, *Education and Industry in the Nineteenth Century* (1978), pp. 72–3, 156.
98 S. Evans, 'The Century Guild Connection', in J. H. G. Archer (ed.), *Art and Architecture in Victorian Manchester* (Manchester, 1985), p. 252.
99 Watkinson, *William Morris as Designer*, pp. 70–1.
100 See Evans, 'The Century Guild Connection', pp. 250–68; Harrison, *Victorian Stained Glass*, p. 63; L. Lambourne, *Utopian Craftsmen: The Arts and Crafts Movement from the Cotswolds to Chicago* (1980), pp. 36–52; A. Vallance, 'Mr Arthur H. Mackmurdo and the Century Guild', *The Studio*, Vol. 16 (1899), pp. 183–92.
101 Kelvin, *Letters*, Vol. II, p. 730, to William Arthur Smith Benson, 31 Dec. 1887.
102 Reprinted in *Arts and Crafts Essays, by Members of the Arts and Crafts Exhibition Society* (1893); also see Watkinson, *William Morris as Designer*, pp. 71–3. On the Kelmscott Press, see below, Chapter 7.
103 W. B. Yeats, 'An Exhibition at William Morris's', *Providence Sunday Journal*, 26 Oct. 1890, quoted in Stansky, *Redesigning the World*, pp. 270–1.
104 A. Crawford, *C. R. Ashbee: Architect, Designer and Romantic Socialist* (1985), p. 406; Lambourne, *Utopian Craftsmen*, pp. 124–30; Watkinson, *William Morris as Designer*, pp. 73–4.
105 Watkinson, ibid., p. 75.
106 Rubens, *Lethaby*, pp. 170–94.
107 Crawford, *Ashbee*, pp. 406–16.
108 Watkinson, *William Morris as Designer*, p. 75.
109 Ibid., p. 78.

Chapter 7

Morris, Kelmscott
and the firm, 1890–1940

A man's outlook on life is inevitably transformed over the years by his experience of it. As ambitions and hopes are turned into fulfilments or disappointments, a past is created; and the past demands of an older man the sort of consideration which the young tend to accord exclusively to the future. Thus Morris, in the late 1880s, no longer saw the firm in the same light as did the enthusiastic young idealist of 1861. The hoped-for aesthetic revolution had not happened: the firm's products, for the most part, adorned only the homes of the wealthy – hardly a fact which a revolutionary socialist could rejoice over. In any case, the original aesthetic aims of the firm, while never abandoned, had had to come to terms with the need to trade profitably. This need had been met. Morris & Co., by 1889, was a solid organisation with a promising enough future.

Morris had good use to make of the time set free by his gradual withdrawal from the firm. His literary career had been more or less in abeyance since the publication of *Sigurd the Volsung* at the end of 1876 – a time which marked the beginning of a critical and intensely busy phase in Morris's life. None of his activities in the years that followed – the designing and manufacturing, the theoretical consideration of his ideas about the decorative arts and the social order, or his involvement in political action – were likely to generate poetry of the kind of *Guenevere*, *The Earthly Paradise* or *Sigurd*. Although he published *The Pilgrims of Hope*, a socialist poem set against the background of the Paris Commune, in 1885, he was not entirely happy with it, and it proved to be his last long poem. In the following year, though, came the first of his great socialist prose works, *A Dream of John Ball*, written for the Socialist League's journal, *Commonweal*. He had not originally intended to write this story himself, at first suggesting the idea of a serial about Wat Tyler as something that one of his colleagues might tackle. The colleague demurred, claiming to lack 'the epic faculty'. Morris's reply was characteristic: 'epic faculty be hanged for a yarn, Confound it man, you've only got to write a story.'[1] This incident seems to have acted as a kind of trigger, for Morris not only took on the task of producing the story, but also entered into a new period in his writing which continued to the end of his life. The *Dream*

is a fantasy, in which the writer imagines himself back in Kent in the year 1381, at the time of the poll-tax rebellion. Of course, like the later *News from Nowhere*, it has a primarily political intention; and Morris's instinctive feelings about socialism are nowhere more powerfully stated than in Ball's great sermon in Chapter Four on the fellowship of Man:

> Forsooth, brothers, fellowship is heaven, and lack of fellowship is hell: fellowship is life, and lack of fellowship is death: and the deeds that ye do upon earth, it is for fellowship's sake that ye do them, and the life that is in it, that shall live on and on forever, and each one of you part of it, while many a man's life upon the earth from the earth shall wane.[2]

But the *Dream*, in its straightforward evocation of the world of medieval humanity, also makes a direct appeal to the imagination, regardless of doctrine; and this, not purely the socialist message, really seems to have fired Morris.

The real literary breakthough, however, came with *The House of the Wolfings*, published in 1888. In writing this tale – a celebration of the primitive Germanic virtues as displayed when the Roman Empire was at its zenith – Morris effectively created his own ideal literary medium: according to Mackail, 'for the first time since *The Earthly Paradise* had been completed, [he] was writing with complete enjoyment and perfect ease'.[3] It is not hard to see why. His long love-affair with the Middle Ages had provided all the necessary ingredients: from Norse legend and medieval romance he derived the feel for mystery and magic; and from the Sagas, a high, heroic tone. The result, the first of the long prose romances (so-called; though Morris by no means eschews verse in them), was the precursor of seven works of a similar type, whose production formed the bulk of Morris's literary output during these last years of his life. They confirm Morris as one of the most inventive authors of his day, although they did not generate much attention amongst his contemporaries.[4]

But the project which most absorbed Morris during these last years was the Kelmscott Press. Back in the late 1860s he had taken a passing interest in the possibilities of 'fine print'; but nothing had come of it. The foundation of the Press owed much to Morris's friendship with Emery Walker, a fellow socialist and neighbour, who was an expert on all aspects of printing from incunabula (early printed books) right down to the methods of his own time. Morris had, in Sparling's account, 'more than once, during his talks with Walker, expressed a desire to "have a shot" at [designing a type face], and an intention "one of these days" to "see what can be done" '.[5] Sparling also points to a specific event as marking 'the first certain date in the history of the Kelmscott Press'. This was a lecture on printing by Walker, delivered at the first Arts and Crafts Exhibition on 15 November 1888; and on this day, says Sparling, Morris decided to turn intentions into deeds.

In fact, Sparling probably overstated Walker's contribution, for Morris's interest in printing and publishing had already been awakened by his work on *The House of the Wolfings*. This book, which went on sale only a week or so after Walker delivered his lecture, was published by Charles Jacobi's Chiswick Press, and Morris himself was actively involved in determining its design and typeface. He undoubtedly discussed the project with Walker, and may well have encouraged Walker – a very diffident man – to lecture on his speciality. Certainly, the lantern slides used to illustrate the 1888 lecture were made from incunabula in Morris's own library.

It should also be borne in mind that, whatever part Walker's lecture might have played in bringing Morris to a decision, there were quite unconnected circustances which made the decision possible. In particular, by this time it must have been clear to Morris that the Socialist League was not only causing him a good deal of expense, but was also terminally ill. His involvement in it did drag on until the end of 1890; but only, as Thompson says, 'for the sake of old loyalties and friendships, and for the sake of keeping *Commonweal* in being'.[6] Yet, as we have seen, during his years of active socialism, his direct involvement with the firm had been reduced to a fraction of his earlier commitment. After 1889, when J. H. Dearle took charge of all important commissions, very little was required of Morris. In consequence, he was freed to spend a good deal of 1889 studying old books and techniques of book printing. He responded with all his customary scrupulous dedication; by the end of the year he was ready to start designing books in earnest.

Before Morris could give himself over fully to printing, however, the affairs of Morris & Co. had to be reorganised and placed on a sound long-term footing. In theory, a number of options were open to him. He could have capitalised on the financial success of the firm by selling out privately, or by floating Morris & Co. as a limited liability company. The firm had gained an enviable position during the 1880s, and by the end of the decade it was returning a net profit every year in excess of £6,000. The business, at a conservative estimate, was worth in the region of £60,000, and with this kind of money Morris could have secured an annual income of between £2,000 and £2,500 from investments in gilt-edged securities. But in practice this option was not open to him. If Morris & Co. had passed into the wrong hands, its standards and all it stood for might well have been lost once profit replaced excellence as its *raison d'être*. Morris could not have endured this.

There was a further, less obvious, reason why he could not seriously contemplate the outright sale of Morris & Co. He had grown accustomed during the 1880s to drawing a salary large enough to support the cause of socialism as well as an affluent domestic lifestyle. A large income meant personal freedom, and Morris needed this all the more as he planned to throw himself seriously into the design and production of books. Money

was needed to buy plant, pay wages and purchase raw materials. Moreover, he wished to build up his personal collection of rare books, both as an inspiration for his own work and as a source of pleasure. The £2,000 to £2,500 a year he might draw from safe investments was simply not enough to satisfy him. He needed his income from Morris & Co. to continue undiminished whilst leaving active management in the hands of others, and at the same time progressively liquidating part of his investment for use elsewhere.

The solution to Morris's problem was to bring in junior partners with the integrity to respect the ideals of Morris & Co. and the ability to assume full responsibility for its business affairs. George Wardle had served Morris loyally as general manager, and was the obvious candidate for promotion, but he was ill, and on the point of retirement. Next in line were the Smith brothers, Robert and Frank, about whom surprisingly little is known. The two men had worked for Morris on the commercial side of the business since at least the mid-1870s, when one of them was based at Queen Square and the other at Oxford Street.[7] Later, the Smiths were appointed joint commercial managers, and by 1884 each was earning £600 a year. Morris obviously had great respect for the business acumen of the brothers; he had worked closely with them for many years and had formed a high enough opinion of their character and abilities to hand over the leadership of the firm to them.

The deed of partnership signed by Morris and the Smiths on 19 March 1890 is a revealing document. Having learned from bitter experience that business partnerships sometimes turn sour, Morris was careful to specify that the agreement would run for just three years in the first instance, and that thereafter either party could dissolve the partnership simply by giving one year's notice. It was intended that the Smiths should build up their investment in the business, as Morris ran his down, to the point where each brother held one-quarter of the partnership capital and Morris one-half. From 31 December 1889, Morris's personal account was to be credited with 50 per cent of net profits and correspondingly each of the Smiths was to be credited with 25 per cent. The brothers' drawings from the firm were limited to £40 per month apiece (any remaining profits being reinvested to build up their stake in the partnership capital), whereas Morris was to draw £3,000 a year. It was further stipulated that he should reduce his stake in the business by £1,000 a year and receive interest on the capital he had invested in the firm at 5 per cent a year.[8]

The logic of the agreement is quite plain. If all went well, it was projected that within ten years or so the Smiths would own half of the capital invested in the business. Throughout that period they were to be rewarded by a half-share in the profits of the business: a good return for all the effort they would need to put in to keep the enterprise moving forward. Morris in return would gain from the hard work and loyalty of the Smiths. As they

195

built up capital, his share would decline, providing him with the funds he needed to invest in antique books and the Kelmscott Press. Furthermore, he would have the certainty of a high and regular income, drawing £250 monthly, plus interest on his partnership capital amounting to more than £1,000 per annum. In short, this was an agreement which was favourable to both sides: Morris could look forward to wealth, security and abundant free time; the Smiths had the prospect of becoming rich men.

Fair treatment all round was also the watchword when it came to making provision for disagreements between the partners, or other circumstances which might lead to the dissolution of the partnership. Again Morris must have been anxious to avoid any repetition of the unpleasantness which surrounded the demise of Morris, Marshall, Faulkner & Co. If either junior partner chose to withdraw from the firm, it was agreed that he would be paid a sum equal to his share of the partnership capital, plus an amount equal to the average of his share of the annual net profit for the past three years, plus a further amount equal to two-thirds of his share in the profits for the past three years, as goodwill and in compensation for all rights over patterns, designs and the like. In the event of Morris's death, it was agreed that the Smiths would have six months to decide if they wished to carry on with the business. If they decided to do so, they would have to pay Morris's executors a sum of money calculated on the same basis as if they themselves had chosen to leave the partnership. If, however, they decided not to continue trading, it was agreed that the firm should be sold to the highest bidder. The cash from the sale would then be used to pay each partner or their executors their share in the partnership capital. Any remaining cash would be divided between the partners or their executors in proportion to their entitlement to profits. Between Morris's death and the transfer of the business to the Smiths or its sale to a third party, interest was to remain payable on the partnership capital at the agreed rate of 5 per cent a year. Morris's executors were to have the power to veto any agreement to sell or otherwise dispose of the firm or any part of its assets.

These provisions, though carefully drawn to protect the interests of his wife and daughters, are imbued with the essential sense of fairness so characteristic of Morris. The agreement is not one-sided; the same formulae and restrictions apply equally to all parties. Morris made no attempt to build into the equation any allowance for the fact that the firm's designs and processes, its most important assets, were the product of his personal gift and efforts. The rights of partners were strictly proportional to their entitlement to profits and their share of the partnership capital. Yet the business had long had the capacity to generate sales and profits far greater than might be suggested by its meagre capital. When the partnership agreement with the Smiths was signed, the partnership capital was just £26,431, of which £26,036 was credited to Morris and £395 to the

Smiths. With profits estimated at £8,528 for 1890 and £9,658 for 1891, it can be seen that the Smiths were being allowed to buy very cheaply into a highly profitable venture. The capacity of the firm to make profits bears eloquent testimony to the strength of its position in the market-place; a strength which depended ultimately on the inimitable genius of Morris himself.

Yet Morris never had cause to regret his decision to take the Smiths into partnership on advantageous terms. The brothers evidently continued to apply themselves vigorously to the efficient management of Morris & Co. The 1890s were prosperous times for the firm. Domestic sales and commissions continued at a high level, and, after falling to a low level in 1891, the number of stained glass commissions won by the firm moved strongly upwards (see Figure 5). Profits were equally buoyant, averaging £8,868 per annum for the six years between 1890 and 1895. It can be seen from Table 10 that Morris's share of the profits totalled £26,604 for the same years, an average of £4,434 per annum. This rate of return was equal to 18.7 per cent of his share capital. The Smiths must have been delighted. By the end of 1895 they had managed, from a standing start, to increase their share of the partnership capital to £12,420. They now held 36 per cent of the capital of Morris & Co. and looked set to achieve equality with Morris within a few years. Morris, in fact, had been able to reduce his investment in the firm to £21,774 through the policy of withdrawing £1,000 per year in addition to his entitlement of £3,000. When all elements of his income from the firm are added together, it can be seen that Morris drew more than £5,000 per annum from the business between 1890 and 1896.

Figure 5 Number of stained glass commissions received by Morris & Co., 1891–1940

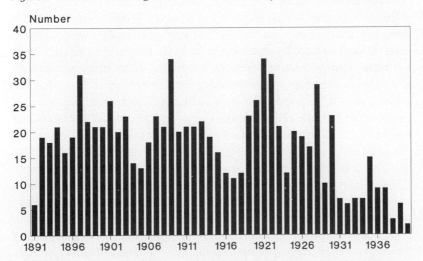

Source: A. C. Sewter, *The Stained Glass of William Morris and his Circle* (New Haven, CT, 1975), Vol. II, *passim.*

Table 10 Estimated earnings and drawings of William Morris from Morris & Co., 1890–95*

Year	Morris & Co. net profit (£)	Morris's share of net profit (£)	Cash withdrawn by Morris			
			Regular salary (£)	Interest on capital (£)	Capital withdrawn (£)	Total drawings (£)
1890	8,529	4,264	3,000	1,264	750	5,014
1891	9,658	4,829	3,000	1,244	1,000	5,244
1892	9,617	4,808	3,000	1,223	1,000	5,223
1893	7,552	3,776	3,000	1,154	1,000	5,153
1894	9,750	4,875	3,000	1,141	1,000	5,141
1895	8,102	4,051	3,000	1,089	1,000	5,089
Total, 1890–95	53,207	26,603	18,000	7,114	5,750	30,864
Average, 1890–95	8,868	4,434	3,000	1,186	958	5,144

Notes: *The profit figures for 1893–95 are actual figures. Those for earlier years are estimated on the basis of data contained in the file relating to Morris's estate created by the Estate Duty Office of the Inland Revenue (see below).

Source: Based upon information contained in PRO, IR59/173, especially the Deed of Partnership between William Morris and Frank and Robert Smith, 19 March 1890, and various papers supplied to the Estate Duty Office by Morris & Co.

When William Morris began to concentrate his production activities at Merton Abbey in 1881, he was uncertain as to whether the expansion and diversification of his direct manufacturing capacity would ever pay off. Events proved his commercial judgement to have been sound. Morris & Co. gained in strength in the 1880s, and continued its advance in the 1890s under the leadership of Frank and Robert Smith despite Morris's withdrawal from active management. The appointment of the Smiths, and the decision not to sell off the firm in 1890, offer further evidence of soundness of Morris's business judgement. He was never growth-minded, as the figures in Table 11 confirm, but he had learned to budget well and keep costs down. The balance sheet drawn up at 31 December 1895, the only complete financial statement we have for Morris & Co., provides a picture of a tightly-ordered and soundly-based enterprise of middling size. The firm had very little capital tied up in buildings and equipment, and its main assets were in more or less liquid forms, in cash, debts and stocks of finished goods. These liquid assets were worth more than fourteen times the amount of money owed to trade creditors. Morris & Co., by the mid-1890s, could hardly have been in a more healthy financial position.

From early in 1890, therefore, Morris was completely free to devote himself to setting up the Kelmscott Press. At the same time, his writing, which would obviously feature in his plans for the Press, continued to flow. *The House of the Wolfings* had been followed in November 1889 by *The Roots of the Mountains*, another tale of primitive Germanic heroism. Both of these works may be read as romances pure and simple by anybody who just wants to read a story; but they also belong to the canon of socialist

literature. The quasi-allegorical equation has the freedom-loving Goths, who hold their land in common, and treat the whole tribe as one brotherhood, representing the militant working classes, struggling to overthrow the decadent Roman or Hunnish slave-societies, which represent the forces of capitalism. (Morris himself made the analogy explicit in an 1890 number of *Commonweal*, in which he calls for socialists to 'be our own Goths, and at whatever cost break up again the new tyrannous Empire of Capitalism'.)[9]

The spirit of socialism also informs the next major work – *News from Nowhere*, which was serialised in *Commonweal* from 11 January to 4 October 1890. *News* is a kind of literary diversion, in that it does not belong to the genre of romance which Morris was developing; indeed, though it is probably his most famous work, it would quite possibly have not been written at all, but for a book by an American socialist, Edward Bellamy, called *Looking Backward*. This utopian vision of the year 2000 depicts a highly-centralised society dominated by great cities and scientific triumphalism. It is hard to imagine an ideal of socialism more remote from Morris's own, or one more expressive of two men's different cultural backgrounds. In Morris's utopia, or Nowhere, life is predominantly rural and unmechanised, lived in surroundings which strongly suggest fourteenth-century England. The monstrous ugliness of the industrial cities has been swept away; mass production is no more; men and women make their own wares. Of course, really useful scientific advances are not rejected: the people are fit and healthy and live to great ages; and an

Table 11 Morris & Co.: balance sheet at 31 December 1895

	(£)	(£)
Liabilities		
Partnership capital:		
W. Morris	21,774	
F. and R. Smith	12,420	
		34,194
Reserves		200
Creditors		2,484
Expenses unpaid		818
Total liabilities		37,696
Assets		
Leases: Merton and Granville Place		475
Plant and machinery		2,210
Stables		79
Stock at cost of production		15,218
Debtors		17,080
Cash		2,634
Total assets		37,696

Source: PRO, IR59/173.

unspecified, unpolluting energy-source powers barges up and down the country's rivers. Nowhere is not, however, completely bland: sexual jealousy still torments people; and (Morris here perhaps acknowledging his own famous tempers) people could still fly into rages, sometimes with fatal consequences. The point Morris makes is that such occasional turmoil can be dealt with in the society he describes without resort to penal or other institutions.

With *News from Nowhere* completed – a parting literary gift, perhaps, to the Socialist League – Morris reverted to romance proper. His enthusiasm had, if anything, grown since *The House of the Wolfings*; the stories were no mere devices to pass time spent away from work on the Kelmscott Press. As he wrote to Janey, 'I have begun another story, but I do not intend to hurry it – I must have a story to write now as long as I live.'[10] The new work was most likely *The Story of the Glittering Plain*, which he completed in the spring of 1890. The 'glittering plain' of the title (which is central to the story, but not the whole of it) is a pseudo-utopia where everything is beautiful but rendered spurious by a lack of spiritual values. It may be taken as a deliberate corrective to *News from Nowhere*, though the theme is quite capable of sustaining itself without outside reference.

The Glittering Plain started in serialisation in June 1890, but for the rest of the year, Morris was mainly preoccupied with the work of the Kelmscott Press. Morris and Walker had from the outset very clear ideas of what they hoped the Press would achieve. Walker, in his lecture to the Arts and Crafts Exhibition Society, had made a number of practical points concerning the appearance of the printed page. Decoration, he asserted, should, however it was handled, be subordinated to legibility. This meant in turn that typefaces should be well designed, and pages should be easy to read. The amount of white space between words needed to be kept to a minimum, the object being to avoid unsightly 'rivers of white' running down the page. Equally important, pages had to be designed as facing pairs, not singly. And finally, he stressed the importance of good-quality materials and the highest standard of presswork to ensure the print was even across the page and from one sheet to another.[11]

Morris himself, reflecting later on the origins of the Press, wrote:

I began printing books with the hope of producing some which would have a definite aim of beauty, while at the same time they should be easy to read and should not dazzle the eye, or trouble the intellect of the reader by eccentricity of form in the letters. I have always been a great admirer of the calligraphy of the Middle Ages, and of the earlier printing which took its place. As to the fifteenth century books, I had noticed that they were always beautiful by force of the mere typography, even without the added ornament, with which many of them are lavishly supplied. And it was the essence of my undertaking to produce books which it would be a pleasure to look upon as pieces of printing and arrangement of type.[12]

This was no small undertaking. Setting up the Press had proved to be a slow process, with the best part of 1889 spent in the study of printing, binding and papermaking. Morris had also started a small collection of fifteenth-century incunabula to examine as models of type and ornament; while the search for high-quality materials went on well into 1890. Only a handsome paper made of unmixed linen rag was considered suitable. Eventually a supplier was found in October, when Walker accompanied Morris to Joseph Batchelor's mill at Little Chart, Kent. Batchelor was able to provide a close copy of a fifteenth-century Italian paper, and he subsequently made three papers for the Kelmscott Press. (One of these was later marketed more widely as 'Kelmscott Handmade', with Morris's approval.) Vellum, supplied by the firms of Henry Band of Brentford, Middlesex, and William Turney & Co. of Stourbridge, Worcestershire, was used as an expensive alternative to paper for limited runs of many Kelmscott books. Ink of the right quality and blackness was obtained from Shackell, Edwards & Co. of London, and later from Janecke of Hanover.[13]

After discussions with Emery Walker, Morris began to design his own founts. The first of these, which came to be known as the 'Golden' type (after Caxton's *Golden Legend*, which had been originally projected as the Press's first title) was a 14 point Roman type, modelled on the work of Nicolas Jenson, a French printer working in Venice towards the end of the fifteenth century. Two others were subsequently designed and cast. These were types based on medieval German examples; the 'Troy' of 18-point size, and the 'Chaucer', a smaller version in 12 point. As always, Morris did not slavishly copy, but worked hard to create his own typefaces on the basis of the medieval models. His method was to have photographic enlargements made of the founts he most admired, and then modify them until he was satisfied with his own version.[14]

By January 1891 everything was ready. A cottage was taken at 16 Upper Mall, Hammersmith, and a second-hand Albion hand press installed.[15] Morris's son-in-law Henry Halliday Sparling later observed that 'except for the change from wood to iron and substitution of levers for the screw, this press was essentially similar to Caxton's; indeed, at the end of an hour or so, Caxton would have been at home with the [Kelmscott] Press as a whole'.[16] The press was operational by November 1891, and two others and a proving press were added later on. The only concession to modern methods was the inking of the type by rollers. Morris did not try to avoid the 'embossing' effect – the denting of the paper by the type, which can be seen on the other side of the sheet. Far from sharing the contemporary view that this was a fault, Morris seems to have felt that such evidence of the manufacturing process in the finished product lent it a human, living, quality, which avoided any sense of what Sparling calls 'a feelingless metallic efficiency'.[17]

The first title to enter production was Morris's *The Story of the*

Glittering Plain, now preferred to the *Golden Legend*, because the Press had not as yet the right size of paper to accommodate the longer work. Morris had originally intended to strike off only twenty copies for his friends; evidently he felt the operation had still to be thoroughly tested, and furthermore the change of plan meant that certain decorated initial letters, suitable for the large quarto *Legend*, were not quite right for the small quarto *Glittering Plain*. But word of the project was out among the public, and had generated such interest that Morris decided to print 200 paper copies, 180 for sale, and a few also for sale on vellum. His publishers, Reeves & Turner, sold all 180 within a few days, for 2 guineas each, and two of those on vellum, at 12 and 15 guineas. The new venture had had a most auspicious start. Within months, the Kelmscott Press had to rent larger premises at Sussex Cottage, 14 Upper Mall, which remained the home of the Kelmscott Press for the rest of its brief existence. It was conveniently situated next to the photo-engraving works of Walker & Boutall in which Emery Walker was a partner.[18]

A listing of the sixty-six volumes printed at the Kelmscott Press before its closure early in 1898, drawn up by Sydney Cockerell and later reprinted in Sparling's history of the Kelmscott Press, provides valuable data on the operation of the Press before and after Morris's death in October 1896.[19] It is apparent from the listing, as Table 12 confirms, that Morris and his associates had a definite strategy which governed the selection of materials for publication. Morris's own works were accorded a high priority, except for *The House of the Wolfings* and *The Roots of the Mountains*, the originals of which had been produced to a good standard by C. T. Jacobi's Chiswick Press. Almost as numerous as Morris's own works, and more important to the Press in terms of income, were medieval texts which particularly appealed to Morris, either as works of literature or as important landmarks in the history of printing. A third important class of book was made up of works of English poetry by authors from Shakespeare down

Table 12 Kelmscott Press: number of volumes produced and value of production by type, 1891–98

Type	Number of titles	Number of paper copies printed	Number of vellum copies printed	Total gross value* (£)
Works by William Morris	23	7,460	206	15,945
Works by modern poets	13	4,017	98	6,573
Medieval works	22	7,375	337	22,941
Other works	8	2,550	36	4,840
Totals	66	21,402	677	50,299

Note: *Gross production values are computed on the basis of sales price multiplied by number of copies printed.

Source: S. C. Cockerell, 'An Annotated List of All the Books Printed at the Kelmscott Press', in H. H. Sparling, *The Kelmscott Press and William Morris* (1924), pp. 148–72.

to recent times. Many of these were mentioned in a list of Morris's favourite authors which had been published in the *Pall Mall Gazette* in 1886, including Coleridge, Shelley and Keats.[20] Finally, there were books which Morris printed on commission, for friends and commercial publishers, and miscellaneous works, like Ruskin's chapter on 'The Nature of Gothic', for which Morris had never lost his admiration.

More than a half of the volumes printed at the Kelmscott Press were set in the Golden type. This was preferred by Morris for works which he considered modern in character; all but one of the editions of modern poetry; fourteen volumes of his own, including the eight volumes of *The Earthly Paradise*; and the miscellaneous group of commissioned and other works. The only medieval work set in Golden type was the three-volume Kelmscott reprint of Caxton's translation of Jacobus de Voragine's *The Golden Legend*. For the great medieval classics and works more medieval than modern in spirit, Morris, as one might expect, preferred those founts based on Gothic examples, the Chaucer and Troy types.[21] The Chaucer type, being smaller than the Troy, was the more frequently used of the two, and was selected by Morris for the Kelmscott editions of his later prose romances, *The Wood Beyond the World*, *The Well at the World's End*, and *The Water of the Wondrous Isles*, as well as for the most lavish of all Kelmscott productions, *The Works of Geoffrey Chaucer*. The Troy type was used for three of the five books reprinted from Caxton originals, including the first book printed in English, the two-volume epic by Raoul Lefevre, *The Recuyell of the Historyes of Troy*, and one of Morris's personal favourites, *The History of Reynard the Foxe*.

The selection, preparation, printing and publication of so many high-quality books in the space of but a few years speaks well of the Kelmscott Press, and of the individuals associated with it. Morris, by this stage in his career, had certainly mastered the art of delegation, and the Press was evidently much more than a one-man band. The Smith brothers had a small stake in the business, as junior partners, but it was Emery Walker who Sparling says 'acted as and virtually was a partner in all but name, taking his full share in the labours, cares and anxieties involved'.[22] Likewise, Sparling himself, though less technically knowledgeable than Walker, played an important part in running the business. He was secretary to the Press with responsibility for day-to-day administrative matters, and, in addition to this role, he took responsibility, as editor, for the production of three of the five Caxton reprints. When Sparling resigned in 1894, following the breakdown of his marriage to Morris's daughter May, he was replaced by Sydney Cockerell. Cockerell proved to be a superb manager, demanding very high standards, and meticulous in his attention to detail. An important editorial role, and presumably also a strategic role in selecting material for publication, was played by Morris's old friend, the publisher, F. S. Ellis. Ellis personally took charge of as many as thirteen

books, including the three-volume *Golden Legend*, important collections of modern poetry such as the multi-volume *Poetical Works of Percy Bysshe Shelley*, and the majestic Kelmscott *Chaucer*, for which he received an editorial fee of £150.[23]

The Works of Geoffrey Chaucer was the product of a mighty artistic collaboration, and the most completely successful of all Kelmscott projects. The idea for an edition of Chaucer illustrated by Burne-Jones first took definite shape in 1892, at which time about sixty designs were envisaged. In the event, eighty-seven remarkable woodcut illustrations were produced. These were drawn by Burne-Jones and translated to harmonise with the Chaucer type by R. Catterson-Smith, before being engraved with great skill by W. H. Hooper. To complement these, Morris designed a woodcut title, 14 large borders, 18 different frames around the illustrations, and 26 large initial words. The subscription list for the 425 paper copies and 13 vellum copies was closed even before printing began in August 1894. A second press was put to work on the *Chaucer* in January 1895 when additional premises were taken at 21 Upper Mall. Even then, the book was not finished until May 1896, a year and nine months after the printing of the first sheet. The paper copies sold for £20 and the vellum

Plate 23 William and May Morris with the workforce of the Kelmscott Press. Henry Halliday Sparling is standing behind May Morris

copies for 120 guineas (£126), realising in all more than £10,000; a sum equal to a fifth of the combined sales value of all the volumes printed at the Kelmscott Press.

What Morris gave to the Chaucer project was typical of his efforts for the Kelmscott Press as a whole. The first contribution he made was as decorative artist, as the designer of elegant founts, page layouts, borders, title-pages and special lettering. Just how active he was on this front is brought home by Sparling, who estimated that 'of titlepages, borders, decorative initials and marginal ornaments, he designed a total of no less than six hundred and sixty-four in little more than six years'.[24] His second contribution was that of the master-craftsman. As in all aspects of his work, Morris took the greatest care in selecting the best materials available for the job, and in insisting upon the highest standards of manufacture. W. H. Bowden, foreman of the Kelmscott printers, later recalled that

> the spirit of competition never entered the doors of the Kelmscott Press. Everyone had plenty of time allowed to him, so that he might put forth his best effort. No man ever detested a botch more than William Morris; he was a firm believer in the old-fashioned maxim that if a thing is worth doing at all, it should be done well.[25]

The third contribution made by Morris to the Kelmscott Press was that of the scholar and man of letters. Indeed, the Press might be taken as a unification of all his life stood for; a reconciliation of the literary and intellectual with the visual and artistic; of the practical with the idealistic; of the past with the present. Morris was the author of twenty-three of the sixty-six Kelmscott volumes, the editor of one, and the translator of another four. It was he, moreover, assisted by Ellis, who determined what books the Press should produce. In this sense, there is truth in the assertion that the Kelmscott Press was William Morris, and it was this that his executors had in mind when they decided that it should close immediately on completion of the work in hand at the time of his death.

The final, less elevated contribution made by Morris to the success of the Kelmscott Press was that of the experienced man of business. It is clear that Morris brought to his final venture the same approach as he had to any of his earlier projects for Morris & Co. The sequence of events was a familiar one: first, the idea; then a period of most painstaking and extensive research; and a further period spent acquiring a thorough mastery of all the necessary techniques. The production, too, was directed at a similar market, or at one even more refined. Just as Morris & Co. offered goods at a range of prices and qualities, from high works of art down to simple domestic articles, so too the Kelmscott Press produced books of differing size, lavishness of illustration, and consequently price. The average price of a paper volume was £2.19; but around this there was considerable variation, so that thirty-six volumes went on sale at £1.50 or less. Only

eleven volumes on paper cost more than £5, with the *Chaucer* in a league of its own at £20. Typically, a vellum edition of a work cost between five and six times its paper counterpart, and these were very much the preserve of the wealthy collectors.

These prices stirred up controversy in certain quarters, and deserve some consideration, as does the whole commercial aspect of the Kelmscott Press. Sparling quotes 'anonymous attacks' as accusing Morris of 'preaching socialism and going away to prepare books which none but the rich could buy'.[26] This is a familiar kind of argument, and one which may perhaps be dismissed with the thought that beautiful books, however limited the public's access to them, do not make the world a worse place. But Sparling seemed to think that the charge required a more substantial rebuttal, and devoted some space to the proposition that Morris never intended the Kelmscott Press to make money. Thus he says of *The Gittering Plain* that 'there was no thought of offering any [copies] for sale, nor did Morris desire that any public notice be taken of what he still regarded as a private and personal experiment'; that Morris had to be protected from himself – 'the friends and assistants who took charge of the business side of things looked out against his losing money, seeing no reason for him being out-of-pocket in addition to giving his personal work . . . for nothing'; and 'that he had never contemplated the sale of any book whatever at any price, until forced to do so by finding that there was a real and widespread demand for his books'.[27]

The idea that the Kelmscott Press was in essence non-profit-making has been reiterated by later writers. The most knowledgeable of these is William Peterson, whose *Bibliography of the Kelmscott Press* contains a wealth of detail on all aspects of the books produced by Morris. Peterson states that the Press 'was in effect an amusing diversion for Morris' which he fully expected would cost him money.[28] Its commercial success accordingly is seen as an incidental consequence of artistic genius rather that something which Morris may have striven for as a matter of course. There is evidence to support such an interpretation. Morris's own public statements on the aims of the Press, for example, invariably concerned artistic priorities rather than financial objectives. When asked in 1895 why he had founded the Press he replied loftily:

> Oh, simply because I felt that for the books one loved and cared for there might be attempted a presentation, both as to print and paper, which should be worthy of one's feelings. That is all. The ideas we cherish are worth preserving, and I fail to see why a beautiful form should not be given to them . . . My wish was to show that a book could be printed in beautiful type, on beautiful paper, and bound in beautiful binding, just as more frequently we do the opposite to this.[29]

[facing] Plate 24 Opening page of the Prologue to the Kelmscott *Chaucer*. Typography and ornament by William Morris, illustration by Sir Edward Burne-Jones. Printed at the Kelmscott Press, Hammersmith, 1896

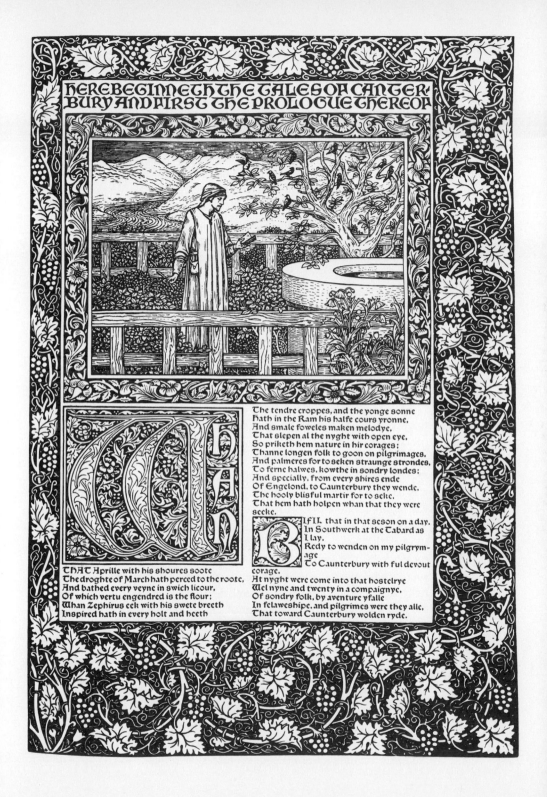

HERE BEGINNETH THE TALES OF CANTER
BURY AND FIRST THE PROLOGUE THEREOF

The tendre croppes, and the yonge sonne
Hath in the Ram his halfe cours yronne,
And smale foweles maken melodye,
That slepen al the nyght with open eye,
So priketh hem nature in hir corages;
Thanne longen folk to goon on pilgrimages,
And palmeres for to seken straunge strondes,
To ferne halwes, kowthe in sondry londes;
And specially, from every shires ende
Of Engelond, to Caunterbury they wende,
The hooly blisful martir for to seke,
That hem hath holpen whan that they were
seeke.

BIFIL that in that seson on a day,
In Southwerk at the Tabard as
I lay,
Redy to wenden on my pilgrym-
age
To Caunterbury with ful devout
corage,
At nyght were come into that hostelrye
Wel nyne and twenty in a compaignye,
Of sondry folk, by aventure yfalle
In felaweshipe, and pilgrimes were they alle,
That toward Caunterbury wolden ryde.

WHAN THAT Aprille with his shoures soote
The droghte of March hath perced to the roote,
And bathed every veyne in swich licour,
Of which vertu engendred is the flour;
Whan Zephirus eek with his swete breeth
Inspired hath in every holt and heeth

In the same interview he was at pains to reject the idea then current that the high prices charged by him meant that Kelmscott books made large profits. 'I can assure you,' he declared, that 'if the people who go about talking of my profits could see my balance sheet, they would speak quite differently.' In the case of the *Chaucer*, the 'cost will hardly be covered by the subscriptions', and with the *Beowulf* the effect of several sheets getting spoiled in the printing was to convert a profit into a loss so that 'the book is sold at less than what it cost me to produce it'.[30]

The Kelmscott Press, it is quite clear, was no ordinary commercial venture. Morris's primary objectives were artistic, not financial; and he was quite right to point out that profit margins might be tight and that on occasion misfortune might produce a loss. But, this said, it is hard to believe that Morris would have set different standards at the Press from those he had set for Morris & Co. It would have run against the grain for him to have set up any enterprise in a careless, unprofessional fashion. All Morris's creative endeavours gave him pleasure, but this did not make them merely amusing diversions. His was a serious purpose, and that purpose demanded that he stay in business. To do this he had to trade at a profit. To trade at a profit he had to keep down costs, stimulate demand, and fix his prices at a remunerative level. The Kelmscott Press was a remarkable creative adventure; it was also a commercial concern with orthodox financial aspirations.[31]

All the signs are that the Press conducted its affairs on sound financial lines. In the early years, as may be seen from Table 13, it was policy to concentrate on production whilst leaving distribution in the hands of commercial publishers, Reeves & Turner and Bernard Quaritch. This was initially a sensible division of labour, as specialist marketing knowledge was useful in drawing the attention of bibliophiles to the rare quality of Kelmscott productions. But once there was an assured market for the books, and publishing amounted to little more than running a subscription list for limited editions, there was simply no point in paying someone 25 per cent of the selling price for the service. Hence, at the appropriate point, around the end of 1892, Morris decided that the Kelmscott Press was strong enough to handle its own publication and distribution, with the exception of books actually commissioned by commercial publishers or private individuals.[32] This caused Bernard Quaritch to complain to his son that 'Mr. W. Morris wishes to have *all* the profits of the Kelmscott Press, he will retail himself the "Godfrey of Bouloyne" – he will be the loser by it, but it will be a nuisance to me on account of the Chaucer.'[33]

Morris did not lose by the decision to market his own books. Most sold out very quickly, there being a coterie of collectors eager to subscribe in advance of the date of publication. Announcements of new titles were sent regularly to individual customers and booksellers, and lists of books

printed and in press were circulated several times a year. Special lists were printed for customers of Morris & Co. It was obviously desirable to make as many direct sales as possible, but booksellers were encouraged to place orders through the offer of a discount of 15 per cent on the retail price. On occasion, better terms might be offered to an intermediary placing a large advance order. Quaritch, for instance, acted in this capacity for the Kelmscott *Chaucer*, taking sixty-three volumes at a discount of 25 per cent. Quaritch proceeded to anger Morris by offering the book at a discount of 20 per cent to his trade customers, effectively undercutting Morris who had planned to offer the trade his usual 15 per cent. Morris was

Table 13 Kelmscott Press: number of volumes produced and value of production, 1891–98

| Year | Distribution of titles | | | | Number of copies printed | | Value of production (£)* | | | |
	Total no. of titles	Reeves & Turner	Kelmscott Press	Other	Paper	Vellum	Gross value of paper copies	Gross value of vellum copies	Total gross value	Total net value
1891	2	2	—	—	500	19	1,050	247	1,297	972
1892	10	4	—	6	3,700	31	8,133	642	8,775	6,581
1893	12	5	4	3	5,135	136	8,692	1,069	9,761	8,287
1894	11	—	8	3	3,435	87	5,014	522	5,536	4,956
1895	7	—	6	1	2,475	67	3,280	422	3,702	3,628
1896	10	—	10	—	2,572	81	12,338	2,108	14,446	14,446
1897	13	—	13	—	3,060	244	5,606	888	6,494	6,494
1898	1	—	1	—	525	12	263	25	288	288
Total 1891–98	66	11	42	13	21,402	677	44,375	5,924	50,299	45,654

Note: *Gross production values are computed on the basis of sales price multiplied by number of copies printed. Net production values are calculated on the basis of 75 per cent of gross values for volumes not distributed directly by the Kelmscott Press; and 100 per cent of gross values for those distributed by the Kelmscott Press.

Source: S. C. Cockerell, 'An Annotated List of All the Books Printed at the Kelmscott Press', in H. H. Sparling, *The Kelmscott Press and William Morris* (1924), pp. 148–72.

obliged to match Quaritch. Even so, business was business, and Morris agreed to sell Quaritch a further fifty-three copies at a reduced discount of 15 per cent.[34]

Morris's thinking on the commercial side of printing and publishing is revealed in surviving contracts and correspondence between the Kelmscott Press and various publishers.[35] He seems to have distinguished between three main functions: publication, distribution, and production. The publisher was responsible for identifying likely titles and for the funding of the project, accepting all the financial risks in exchange for the prospect of a good return on his investment. Distribution and production were not such high-risk activities. Distribution involved circulating lists and announcements, processing orders, invoicing, and other administrative tasks. The job of the manufacturer was to arrange for the

printing and binding of the book in accordance with the specifications and standards of the publisher. The Kelmscott Press was at first concerned solely with production. The publishing function was taken on after a very short time, and distribution followed in April 1893. After that time, most books were produced, distributed and published by the Press, although distribution and publication were handled by others in a few cases.

The publishers who commissioned books from Morris generally handled their own distribution. Quaritch sponsored the three volumes of *The Golden Legend* for which he paid £1,350. As editors Morris and Ellis received twelve free copies each from the print run of 500. Quaritch had to donate a further five copies to the copyright libraries, leaving him 471 to sell at £5.25 per copy. At this price Quaritch could look forward to generating a gross income of £2,473, from which he would have to meet distribution expenses and discounts to trade customers. There was clearly ample scope for profit at the original price, but, following favourable reviews in *The Times* and *The Library*, he began to ease up the price by degrees to £10.50. This Morris regarded as sharp practice, and it probably confirmed him in his decision to take on the publication side of the business himself.[36]

Other publishers were more scrupulous than Quaritch in their business dealings. Morris printed Tennyson's *Maud* for Macmillan in 1893. The 500 paper copies sold very quickly at the retail price of £2.10, generating a gross income of more than £1,000. Macmillan paid Morris £400 for the work done, approximately 40 per cent of total sales revenue. The direct costs of production for the book totalled £202.70.[37] *Maud* was evidently very lucrative both for Macmillan and the Kelmscott Press. The same was true of Rossetti's *Hand and Soul* which Morris printed for the American firm of Way & Williams. Five hundred paper copies and fifteen vellum copies were printed for sale to the public, generating a gross income in the region of £270. Morris was paid £135. His direct costs of production amounted to £105.[38]

The correspondence between the Press and Way & Williams is particularly instructive because it gives an insight into Morris's view of the proper relationship between costs and prices, and the division of gross revenues. Way & Williams asked for guidance on pricing and Morris proposed that for a short volume of this kind they might expect to generate enough sales to sell out if they charged double what he proposed to charge them (he was asking £0.25 per paper copy). Morris undertook to distribute the book in England for a further 25 per cent of the retail price, which he calculated would be necessary to cover advertising, discounts, distribution costs, and enough profit to make it worthwhile.[39] From this it would seem Morris had in mind that, very roughly, the producer of a volume might expect to receive 50 per cent of gross revenues, the distributor 25 per cent, and the publisher 25 per cent. This is borne out by returns for Wilfrid Scawen

Blunt's *The Love Lyrics and Songs of Proteus*. This was a commissioned work for which Blunt paid £195 (£150 for printing and £45 for binding) for 305 copies, or £0.64 per copy. Of the copies printed and bound, 220 were offered for sale through Reeves & Turner who sold them all without difficulty at 2 guineas (£2.10) each. Reeves & Turner paid Blunt £342, retaining £120 for themselves – a rate of commission equal to 26 per cent. Morris thought this a very satisfactory outcome all round, informing Blunt in March 1892 that 'when Reeves pays up the whole there will be a good balance in your favour without reckoning on the copies you keep. So I think we may congratulate ourselves on a success.'[40]

Figures of this kind, and widespread popularity of Kelmscott books, explain why Morris decided to publish and distribute on his own account. This is not to suggest that the business was completely free from risk. Morris invariably used one achievement as a platform for new and higher things; and, in this case, his artistic ambition was channelled towards the production of an edition of Chaucer that would rank amongst the finest books of all time. After two financially successful years, in 1892 and 1893, a large part of the resources of the Kelmscott Press was turned over to the project. Morris, as ever, was prepared to invest heavily in things about which he cared deeply. No expense was spared. The direct cost of producing 425 paper copies and thirteen vellum copies was a staggering £7,217, expended over a period of three years. The gross value of the books was £10,128, but if this sum is trimmed by 25 per cent to allow for costs of distribution, making £7,596, it can be seen that Morris was not exaggerating when in 1895 he claimed that the *Chaucer* would yield little or no profit.

The simplest and most likely explanation of the failure of the finest of all Kelmcott productions to generate a profit is that Morris announced his prices and took orders at too early a stage, before the full costs of the project were known. Its instant success indicates that a lot more could have been charged for a book which from the first was eagerly sought after by dealers. Morris miscalculated. He was not reluctant to make money by satisfying the desires of the rich, and in general tried to fix his prices at a level sufficient to yield a fair profit. His correspondence with Ellis reveals that both men took note of the marketability of a title. They did not always get it right. Lady Wilde's translation of Meinhold's *Sidonia the Sorceress*, for instance, lacked appeal at £4.20 for 236 pages, and it remained in stock until the Press closed down in 1898.

By and large, however, it would appear that most Kelmscott books were a financial success. There are not sufficient surviving data to permit the calculation of gross and net profit rates for all titles. But production figures and retail prices are available from Cockerell's list, and direct cost of production figures for thirty-three books have been abstracted by Peterson from the Kelmscott Press ledger now held at the Pierpont Morgan Library

in New York. It is thus possible, on the basis of these data, to calculate the ratio of gross income to operating costs for thirty-three Kelmscott titles, individually and collectively. The weighted average ratio for all thirty-three titles is 1.94 to 1. In other words, gross income from sales was almost double the sum needed to meet costs of production. Even when overheads and distribution expenses, including trade discounts, were taken into account, there was still a fair margin for profit. Of course, there was considerable variation between titles. At the upper end of the profit range were some of Morris's own titles.*The Life and Death of Jason* and *The Earthly Paradise* had gross income-to-cost ratios of 3.47 to 1 and 3.46 to 1 respectively, compared to 1.4 to 1 for the *Chaucer* and 1.46 to 1 for *Beowulf*. The highest income-to-cost differential, with a ratio of 12.79 to 1, was that of the 26-page *Syr Isambrace*; the lowest ratio, at 1.31 to 1, was that of the three-volume *Poetical Works of Percy Bysshe Shelley*, which cost £832 to produce.[41]

The overall picture is that of a financially healthy business with considerable scope to charge premium prices for its products. And this picture is confirmed by the only surviving financial statement for the Kelmscott Press, a balance sheet drawn up at 31 December 1895 (Table 14). Not much can deduced from this other than that firm was in a very solid financial position, with plant and machinery written down to a low figure, and sufficient liquid assets to cover its debts many times over. We also know that even in the year ended 31 December 1895 – when unusually high costs were incurred through the preparation of the *Chaucer* (see Table 13) – the Smith brothers still made a profit of £24.80 on their small stake in the business.

Table 14 Kelmscott Press: balance sheet at 31 December 1895

	(£)	(£)
Liabilities		
Capital (W. Morris)		5,643
Creditors		326
Expenses unpaid		38
Total liabilities		6,007
Assets		
Plant and machinery		100
Stock		
– materials	559	
– printed books	959	
	——	1,518
Work in progress		818
Debtors		2,368
Cash		1,203
		6,007

Source: PRO, IR59/173.

It is clear, in view of the artistic and financial importance of the *Chaucer*, that Morris's plans for the Kelmscott Press included a substantial role for Edward Burne-Jones. For much of the 1880s the two had gone their different ways, as both became less active in the firm and Morris devoted more and more time to politics. But their friendship had lost none of its underlying warmth. Burne-Jones, it is true, disapproved of Morris's socialist campaigning; unlike his wife, he simply could not see how deeply and passionately Morris felt about socialism. In the days before Morris had taken to politics, he had been a frequent visitor to the Grange, especially for Sunday breakfast. These visits had become fewer, and also shorter, with Morris often dashing off to attend meetings or deliver lectures. Now Burne-Jones and Morris resumed their former intimacy; the two men, perhaps, becoming even closer friends than before through their collaboration.

From Cockerell's list of books printed at the Kelmscott Press, it is evident where Burne-Jones's talents were to be chiefly deployed. That he produced eighty-seven designs for the *Chaucer*, but only eighteen for the rest of the Press's output, scattered among thirteen volumes, indicates that his work was to be dedicated to the most ambitious projects – firstly, the *Chaucer*; then the planned *Froissart*, and the *Morte d'Arthur*, which Mackail says was to have had 100 illustrations by Burne-Jones, and would have surpassed even the *Chaucer* in magnificence. Thus, if the Press had had a longer history, it would have passed through several phases, which could be named after whichever of these major projects was in hand at the

Plate 25 Colophon used for quarto books of the Kelmscott Press

213

given time. Morris even had ideas for following the *Morte d'Arthur* with a text of a King James I Bible: enough, all told, to keep the presses working for anything up to another ten years. Included in Peterson's list of twenty-seven projected editions are many Morris favourites, including the novels of Scott and Dickens and Ruskin's *Unto This Last*.[42]

The artistic partnership between Morris and Burne-Jones, fruitful as it was, was not without its difficulties, particularly for Burne-Jones. For there were important differences in temperament between them, reflected in their literary tastes. Burne-Jones had what may be termed a southern, or Mediterreanean, inclination; whereas Morris was of the rarer type which looks to the North to feed its imagination. Burne-Jones was far from sharing Morris's love of the Icelandic sagas and the Eddaic poetry, and was evidently disconcerted when Morris blithely asked him to do twenty-five or so designs for *Sigurd the Volsung*. Morris could have had no more loyal and loving friend than Burne-Jones; yet when *Sigurd* was finally published after Morris's death, it appeared with only two illustrations in it.[43]

The *Chaucer* also caused Burne-Jones one or two problems. It was not just that his heart was moved more deeply by Malory's profound, melancholic sense of noble but vanished antiquity than by Chaucer's immediate, here-and-now vivacity: he also had reservations – which Morris emphatically had not – about what some might consider the vulgarity of some of the *Canterbury Tales*. Nevertheless, there is no doubt that the completion of the work gave both men the most profound pleasure. Modern assessments are not invariably sympathetic, the Chaucer type being perhaps too elaborate for some tastes, and some might think that on the 100 or so heavily-ornamented pages (out of 554) the text itself is overwhelmed. But these are matters of taste and fashion rather than artistic truth. The Kelmscott *Chaucer* was in its time thought to be a magnificent and tasteful artefact; the years since its publication have provided no compelling reason for dissenting from that verdict.

For Morris, the years of the Kelmscott Press may have been the most satisfying of his artistic career – a true blend, at last, of the literary and visual arts. Other aspects of his life were more problematical. The collapse of the Socialist League, and indeed the general lack of progress of the socialist movement as a whole, were a grievous disappointment to him, but one which he bore with resignation rather than bitterness. He did not, however, give up his political activities. As noted earlier, the Hammersmith Branch of the Socialist League was reconstituted as the Hammersmith Socialist Society, and went on meeting at Kelmscott House 'twice a week for several years'.[44] Morris now accepted that the socialist revolution would not happen in his own lifetime; and, after a serious illness in 1891, he was in any case less capable than before of sustained, vigorous campaigning. But his conviction that only in a socialist society could men and women live decent lives never weakened in the slightest;

nor was he willing to accept what might be termed the Social Democratic compromise, which he seemed to see as leading to a society in some ways more corrupt than that produced by rampant capitalism. Morris's point was that a pure capitalist system, with its attendant evils of exploitation, inequality, poverty, ignorance and disease, displays its warts quite unmistakably – most of all to those who suffer under it – and is therefore certain to face constant challenges to its legitimacy. A social democracy, on the other hand, might alleviate these obvious evils by providing the working classes with more or less adequate incomes, education and health care, thus bribing them into accepting the status quo. To Morris this meant accepting a society still fundamentally sick; continued inequality; dull, unrewarding labour; the mass-production of worthless goods; the dominance of the profit motive; and the universal acceptance of shoddiness and bad taste which inevitably follows when people's creative instincts are stifled. A hundred years ago, of course, this argument was largely theoretical. Nowadays, in post-war western Europe, it can be put to the practical test; and though its validity may be a matter of opinion, there is no reason to suppose that, if Morris himself could somehow cast his eye over the modern world, he would see anything to make him change his mind.

Political frustration was not Morris's only problem during these years. Also a matter of record is his deep worry about the health of his daughter Jenny, who had suffered since her teenage years from severe epilepsy. There is evidence which almost suggests that the very devotion of these two to each other had the power to make them both ill; Morris's attacks of gout not infrequently followed periods of stress or anxiety, such as might be caused by a deterioration in Jenny's condition; and Jenny for her part, in 1891, seems to have agonised over the possibility that she might be the unwitting cause of her father's illness to the extent of suffering the delusion that she had actually killed him.[45] Fortunately, their twin afflictions did not feed off each other in any very methodical way, and during the rest of the year both patients made good, if not permanent recoveries. As far as can be ascertained, Jenny did not markedly deteriorate between the time of that attack and Morris's death, though the family must always have been aware of the potential for disaster.

Less clear from the record is how much Morris was concerned about his other daughter. In 1884, May embarked on a very strange sort of love affair with George Bernard Shaw, who, though himself a member of the Fabian Society, was on good terms with many members of the Socialist League. The relationship evidently entailed no physical intimacy, because Shaw himself felt unable to make any sort of commitment to May. His plea was that he had not enough money to maintain a wife and family. It is more likely that Shaw simply did not *want* a wife and family, being quite content with close friendship; whatever the truth of the matter, May evidently

decided at some stage that enough was enough, and in 1887 she became engaged to Henry Halliday Sparling, whom she had met the previous year. Sparling was an intense young man on the extreme left of the socialist movement, a profound admirer of William Morris, and, though highly intelligent, not especially talented. The marriage, which was solemnised in June 1890, had little chance of success; it duly began to fall apart two years later when May picked up anew the threads of her romance with Shaw. For a time, Shaw actually lived with the Sparlings. His sudden departure after about a year caused the indignant Sparling to complain bitterly that Shaw had left him with 'a desolate female who might have been an iceberg so far as future relations with her husband went'. There is about all this a curious echo of the *ménage à trois* at Kelmscott some twenty years earlier; but Sparling, without children to consider, or the stoical temperament of Morris, went off to live in Paris, effectively ending the marriage.[46]

Janey Morris felt the break-up keenly, evidently believing that the family honour had been tarnished. She wrote in May 1894, about a month before the Sparlings officially separated, that she felt 'at this moment as if I should never visit or see friends again'. No communication could more clearly illustrate that quality in the Victorian attitude to sexual matters which the present age conventionally takes for the rankest hypocrisy. The letter from which it is quoted was written to W. S. Blunt, and from 1888 to the late summer of 1892, Blunt and Janey had been lovers. Their relationship, in its full physical intimacy, was in fact far more compromising than anything that happened between May Morris and Shaw. Nor did the sentiments expressed in Janey's letter apparently inhibit her from making an amorous approach to Blunt later the same year.[47]

What Morris himself thought about all this is not known, but can be plausibly guessed at. It is likely that he was not unduly concerned about May's and Sparling's separation, except in so far as it affected May's happiness. He certainly did not fall out with Sparling; his stated views on the subject of marriage are inconsistent with moral censoriousness (see, for instance, Chapter Nine of *News from Nowhere*); and he would not have been worried, as Janey was, about falling from grace in the eyes of respectable society. As far as his wife's infidelity was concerned, it is quite possible that by this time he was past caring. He had in any case been for many years far closer to Georgie Burne-Jones than to Janey. The deep sympathy between Georgie and Morris had its origins in the trying times that had threatened both their marriages; the passage of time had done nothing to weaken a relationship which, whilst it always remained quite blameless, was as satisfying to Morris as any he enjoyed with a woman.

Yet not even the closest friendships can last forever. In Georgie Burne-Jones's *Memorials* of her husband, two photographs of Morris are reproduced, one dated January 1889, the other, September 1895. In the former, it is possible to see the face of a man past his prime, perhaps, but still

strong, full of vigour, and determined. The latter shows a man definitely old, rather tired, yet endlessly benevolent. His recovery from the illness of 1891 was evidently not as complete as had been hoped; the serious damage to his constitution began to assert itself. At the start of 1895, no crisis appeared to be imminent, and work on all fronts – the *Chaucer*, the Saga Library, and his own romances – was proceeding satisfactorily.[48] But as the summer came and passed, Morris's strength steadily diminished. His shaggy hair and beard were now quite white. The legendary stamina had gone; Morris could no longer work for hours at a stretch. From his former stoutness of body, he had shrunken to an emaciated state, and he suffered from a persistent, worrying cough. Sleeplessness troubled him, too, as it seldom had before; with characteristic strength of will, he spent hours of enforced wakefulness working on another romance. His uncertain temper had settled, or at least had been brought under control. He was, of course, fully aware of all this; at the end of August, he wrote: 'I was thinking just now how I have wasted the many times when I have been "hurt" and (especially of late years) have made no sign, but swallowed down my sorrow and anger, and nothing done.'[49]

Illness did not affect his intellectual or creative power, as his continuing output of designs for the Press, in particular for the *Chaucer*, shows; and in December he started his last story, *The Tale of the Sundering Flood*. But any account of the months from December to the end of February makes sad reading, as door after door to the outside world silently closed for good. On 25 December, at the funeral of Sergius Stepniak, he made his last open-air speech; on 5 January, he gave his last Sunday lecture at Kelmscott House; on 30 January came his last attendance at a meeting of SPAB. On 22 February he went with Burne-Jones to see the famous physician, Sir William Broadbent; Georgie Burne-Jones's diary recorded on the following day 'No Morris to breakfast'; and in her *Memorials* she adds 'nor did he ever come again in the old way'.[50] Sir William confirmed the existence of diabetes and other complications, doubtless aggravated by the sheer intensity of Morris's life.

In the early months of 1896, he enjoyed occasional periods of remission, but these were invariably followed by further deterioration. His plans for the Kelmscott Press, which had included a lavish edition of Froissart's *Chronicles*, gradually narrowed down to a simple determination to see the *Chaucer* completed. The end of the task was at last in sight. Burne-Jones had finished the eighty-seventh and last picture just after Christmas, and Morris had produced designs for the binding by the early spring. Sometime in early April or early May two more chapters of his life closed; he was at Kelmscott Manor for the last time, and while there he wrote his last piece of socialist literature – an article for the magazine *Justice*. On 8 May, shortly after returning to Hammersmith,

the printing of the *Chaucer* was at last completed; on 2 June, the first two copies were delivered from the binders, one for Morris, the other for Burne-Jones.

By now Morris's distressed family and friends were faced with the realisation that he was slowly dying. Their grief was all the sharper in view of his hitherto seemingly indestructible strength, which for some months they had had to watch melting away. The doctors could think of nothing but prescriptions for changes of air, but these did little if any good. On such advice, he spent much of June in Folkestone; and in July, too ill for any work, he embarked on a last sea voyage – to Norway, intending to sail up the coast as far as Spitzbergen. Yet all this time, Morris was still definitely Morris. As his strength permitted, he continued with writing *The Sundering Flood*, and designing letters and borders for the Press; and his enthusiasm for old books remained as vibrant as ever. In May, he sent Cockerell to Stuttgart with a blank cheque, to acquire a Bestiary (it cost him £700), and in June he paid £1,000 to Lord Aldenham for a Psalter. The Morris of old is also evident in his attitude to the completed *Chaucer*, as observed by Burne-Jones: '[he] doesn't think any more about it. He's quite removed it out of his mind as he always does with anything he's finished.'[51]

The journey to Norway turned out to be worse than useless. Of it, Burne-Jones said, the day after Morris's death: 'when he came back from that uncomfortable voyage that made him so miserable, poor dear thing, and took him away from all his friends and did him no good, it was quite clear what would soon be'.[52] Morris returned to England on 18 August; within a day or two his illness had worsened. His urgent desire to be moved from Hammersmith to Kelmscott clearly could not be fulfilled. In his last days, he still showed no sign of intellectual decay; though physically too weak to write any but the shortest notes, he persisted with *The Sundering Flood* by dictation, finishing it on 8 September, and still managed to carry on designing. But emotionally, he was afflicted (or perhaps one should say, blessed) with a degree of heightened sensibility which left him prone both to tears and to intensity of affection. One of the last messages he managed to pen himself was to Georgie; it finished: 'come soon. I want a sight of your dear face.' He seems, too, to have discovered new joy in music. Mackail tells how Arnold Dolmetsch brought some virginals to Kelmscott House, and 'a pavan and galliard by William Byrd were what Morris liked best. He broke into a cry of joy at the opening phrase and after two pieces had been repeated . . . was so deeply stirred that he could not bear to hear any more.'[53] The day after finishing *The Sundering Flood*, Morris signed his will. On 2 October, he could no longer recognise his old friend Burne-Jones: on 3 October, he died, peacefully and undistressed.

The funeral was a quiet affair, but only in the sense that relatively few mourners attended; for the natural world was in a state of high turbulence. Having been brought to Lechlade by train from Paddington, the coffin was

placed in a gaily-painted farm cart strewn with willow boughs and vines.[54]
Thence it was accompanied by the mourners through a pelting south-
westerly storm, against a backdrop of rich autumnal fertility, to Kelmscott
parish church, which was itself decked with all manner of fruits and
vegetables in celebration of the harvest festival. No images could have been
more fitting at the celebration of Morris's life. The rain stopped briefly as
the burial service was read out over the grave, and 'there was silence that
could be heard, when the last words ceased to break it'.[55]

His business and financial affairs were left in the hands of his wife, Janey,
and two trusted friends, F. S. Ellis and Sydney Cockerell. Ellis and
Cockerell were granted probate, and accepted responsibility for carrying
out the instructions left by Morris in his will. These were to hand over to
Janey the entire contents of Kelmscott House and Kelmscott Manor, with
the exception of the library and original manuscript copies of his own
published works. Janey was to be allowed to select £500 worth of books
from the library; Ellis was to be given the manuscripts as a gift for acting as
an executor and trustee for the Morris estate (Cockerell was to be given
£100 for the same reason). All remaining assets, including the greater part
of his collection of rare books, were to be sold for cash, and the proceeds
invested in safe stocks and securities and placed in a trust fund adminis-
tered for the benefit of his family by Janey, Ellis and Cockerell. The will
specified that the fund should pay £100 per annum to Emma Oldham
(Morris's sister) during her lifetime, £150 per annum for life to Elizabeth
Burden (Morris's sister-in-law), and £250 per annum to his daughter May.
The remainder of the annual income from the trust fund was to be paid to
Janey Morris, out of which she was charged to care for his elder and
much-loved daughter, Jenny, who continued to suffer from severe bouts of
epilepsy. When Janey died, her share of the income from the trust fund was
to be divided equally between May and Jenny; the trustees taking responsi-
bility for the care of Jenny.

Ellis and Cockerell had considerable trust placed in them as executors.
Morris had few investments, with no capital in stocks and shares, but the
assets he had were in forms which required some skill to liquidate without
loss of value. His main assets, besides the household effects which passed
directly to Janey, were his collection of rare books and illustrated manu-
scripts; a sum of £5,700 which had been lent to Mr Hobbs, the owner of the
Kelmscott Manor estate; the capital value of the Kelmscott Press; and,
most valuable by far, his stake in Morris & Co. He gave his executors
considerable freedom to decide how best to dispose of these assets, and
over the timing of any sales. Morris was well aware, as we know from his
correspondence, that selling in haste might drive down values and reduce
the size of the family trust fund.

In December 1896 Cockerell and Ellis undertook a detailed appraisal of
the library, and arrived at a total valuation of £20,500: £12,500 for the

illustrated manuscripts and £8,000 for the early printed books, which were about 800 in number. Charles Fairfax Murray, an artist, collector, and an intimate of Morris's circle, agreed to purchase the entire library for £20,000, but the agreement was amicably rescinded after he had paid £2,000 for some two dozen books and manuscripts. The rest of the library was subsequently sold for £18,000 in April 1897, to a Lancashire manufacturer and connoisseur, Richard Bennett. Thus the executors were able to realise considerably more than the valuation of £10,000 originally submitted to the Inland Revenue.[56]

The mortgage on the Kelmscott Manor estate, which had been taken by Morris to secure his loan to Mr Hobbs, was not called in. It paid interest at 3 per cent, and its capital value was less than the sum originally lent to Hobbs. Ellis and Cockerell had the estate professionally valued at £4,000; and they had to explain to the Inland Revenue that Morris had only made the loan because 'early in 1895 [he] became very desirous that he should not be forced to leave the house . . . to which he was very much attached. He would have been forced to leave it if Mr Hobbs, from whom he rented it, had not been able to buy the whole estate.' They felt it best simply to draw the interest and allow Morris's wife and daughter to take over Morris's tenancy of the property. Eventually, Hobbs defaulted and the Morrises secured the ownership of the Kelmscott Manor estate, including its farmlands and cottages.[57]

The Kelmscott Press, as a going concern, also posed problems for Ellis and Cockerell. It was not possible simply to close down the operation and sell off the remaining stock: work had begun on several books before Morris's death, others had been announced and subscriptions taken, and still more volumes were needed to complete the Kelmscott edition of Morris's *The Earthly Paradise*. Work continued under the management of the executors until March 1898. The last book issued, very appropriately, was *A Note by William Morris on His Aims in Founding the Kelmscott Press, together with a Short Description of the Press by S. C. Cockerell, and an Annotated List of the Books Printed Thereat*. It is not possible to say precisely how much was realised from the liquidation of the Press, but it is almost certain to have been a good deal more that the estate valuation figure of £5,643 given in Table 15. This is because the Inland Revenue was prepared to accept, for estate duty purposes, the figure for Morris's personal capital investment given in the balance sheet for 31 December 1895 (see Table 14) as a proxy for the realisable asset value of the business. The Estate Duty Office thus remained ignorant of the large influx of cash in 1896–98 from sales of the Kelmscott *Chaucer* and other more profitable works, and consequently the authorities must have underestimated the value of the business.

In contrast, the figure of £29,829 specified in Table 15 as the value of Morris's interest in Morris & Co. is authentic; equal to the amount due to

his executors from his junior partners, Frank and Robert Smith. The method of valuing the business, and the terms on which it could be handed over to the surviving partners, were specified very clearly in the partnership agreement of 19 March 1890. The Smiths, after negotiations with Ellis and Cockerell, decided to carry on the business, paying the due sum into the Morris family trust fund. It is not known how they found the money or the period over which it was paid; however, they would have had no trouble in raising a loan secured on the assets of such a profitable enterprise as Morris & Co. It was a very good deal for them, and it gave the firm's employees the kind of security in continuity which Morris must have intended to achieve.

Table 15 Valuation of the estate of William Morris

	(£)	(£)
Liquid assets		
Cash	334	
Money lent on mortgage	4,002	
Insurance policy on death	1,000	
	———	5,336
Personal assets		
Household goods (including library)	20,436	
Value of manuscripts	124	
Copyright of works	750	
	———	21,310
Morris & Co.		
Capital in business	21,360	
Goodwill as per deed of partnership	8,469	
	———	29,829
Kelmscott Press		5,643
Total value of estate		62,118

Source: Based upon information contained in PRO, IR59/173, especially Form A5, an affidavit sworn by Jane Morris on 19 May 1897.

The reputation of Morris & Co. remained enviable, despite Morris's withdrawal in the early part of the decade, and there was every reason to believe that the firm would enjoy a prosperous future. The Smiths were not old and had already proved themselves thoroughly efficient general managers. John Henry Dearle was promoted to the position of Art Director, and his experience was solidly founded on that of Morris himself. Furthermore, many of the firm's existing designs for wallpaper, carpets and other fabrics were still eminently marketable. The stained glass department, likewise, was enjoying a resurgence in popularity; commissions continued to flow in, and its order book was bulging, as may be inferred from Figure 5. Of course, it remained to be seen how the firm, and Dearle in particular, would respond to any marked change in the public's taste in decorative style.

For the most part, the business carried on for several years much as it

221

had done in Morris's own days. The shift in emphasis towards furniture production and retailing begun some years earlier was continued, and Morris & Co. became known as a supplier of choice antiques and high-class reproduction cabinet work. There was little new thinking on design. Burne-Jones carried out only one significant piece of work for the firm after Morris's death – a cartoon for a stained glass window at Hawarden church, commissioned by the Gladstone family – before he too died, in June 1898. In stained glass, carpets, wallpapers and textiles it fell to J. H. Dearle, as Morris's effective successor, to produce the bulk of any new artistic work. Most notable were half a dozen designs for printed cottons and a rather larger number for woven textiles. Dearle, though, must have felt himself very much under the shadow of Morris; he was therefore content for output to consist largely of the master's designs.[58]

In 1905, the Smiths evidently decided to relinquish control of Morris & Co. Their reasons were probably twofold: they must by then have been in their fifties, and thinking of their own long-term future; and the firm, at a difficult time, needed an injection of funds if it were to gain fresh impetus. Most of the new money came from Henry Currie Marillier (1865–1951), who had lived at Kelmscott House since 1897. His practical experience of the decorative arts appears to have been confined to engraving and metalwork. He had, however, a great admiration for Morris furnishings, and he was an expert in the history of tapestry. At the time the Smiths approached Marillier, he was a partner with W. A. S. Benson in an art company facing severe difficulties. Not surprisingly, the idea of joining Morris & Co. had great appeal. The firm transferred its assets to a newly registered limited liability company – Morris & Co. Decorators Ltd – in exchange for cash and fixed interest bearing securities known as debentures. The cash came from the issue of shares to Marillier and the Hon. Claude Lambton, and, together with the debentures, went to the Smiths, who, like Dearle, took up some of the £45,000 worth of shares issued by the new concern. On the first board of directors, the Smiths and Dearle were joined by Marillier (managing director), John Withers (company secretary), W. A. S. Benson, and Claud Lambton, whose place had been effectively paid for by his mother-in-law, a friend of Janey Morris.[59]

Marillier came to believe that he had been duped by the Smiths into investing in a business which was on the slide, complaining later in life that in 1905 the business was actually making a loss.[60] This may or may not have been true, but in any case it seems likely that the trading difficulties of that year were no more than a temporary problem. Certainly sales of stained glass slumped badly in 1904–05, but they recovered strongly in 1906; and it was in the nature of the firm that any year's profit and loss account could be transformed by one or two large commissions. The real, underlying difficulty goes rather deeper; for ultimately it proved impossible to maintain the artistic strength and integrity of the firm as it

had been in Morris's time, though many years would pass before this became a fatal deficiency. Thus it appears that some of Dearle's designs were passed off as Morris's; that designs were transferred from one medium to another (such as the use of wallpaper patterns for printed cottons); and that a typical response to changing tastes would be simply to take an old design and modify it. The originality in which the firm had always taken great pride was rapidly becoming a thing of the past. The reputation which was part of Morris's legacy was not sustainable in the long term.

Marillier's immediate anxieties, however, turned out to be largely unjustified, and Morris & Co. continued to be both fashionable and profitable until the outbreak of the First World War. Marillier took a very positive view of the value of publicity. His most notable effort was the publication in 1911 of *A Brief Sketch of the Morris Movement*, a combined account of the firm's history and current activities, in which it was stressed that the change of management had 'involved no deviation whatever from the traditions and methods of manufacture, which continue as before, under the same direction as in William Morris's lifetime'.[61]

Marillier was entirely justified in this claim, on which he was now trading heavily and successfully. In the same year as the *Brief Sketch* appeared, there came commissions of enormous value to the firm's prestige, as it was asked to supply embroidered cloths and thrones for the coronation of King George V, and the royal chairs for the investiture of the Prince of Wales.[62] The stained glass business continued to do well, as did printed fabrics and wallpapers; the fact that the designs were for the most part not especially original does not seem to have greatly affected their popularity. The tapestry section, however, was beginning to show signs of decline. This was understandable in view of the excessive reliance on designs by Burne-Jones. Clearly, customers would not be willing to pay the highest prices for mere reproductions, and even if they were the market would inevitably become saturated. Attempts to use other designers, popular artists like Heywood Sumner or Byam Shaw, were not particularly successful. But there was no urgent cause for alarm: in 1912 Morris & Co. secured the valuable contract for the maintenance of the collection of tapestries at Hampton Court Palace.

The outbreak of war in 1914 came as a severe but far from devastating blow. Many of the firm's workers disappeared into the armed forces; by 1917, stained glass sales had fallen to the lowest point since 1891; and the tapestry section had to be closed in 1916. Even so, 1917 saw the shop moved to grander premises at 17 George Street, just off Hanover Square. After the war, business soon picked up again. Sales of stained glass soared during the years 1919–21; the tapestry section reopened in 1922; and for a time the firm's distinctively-patterned chintz textiles again found favour. In 1925, the firm was renamed Morris & Co. Art Workers Ltd, and

diversified further into pottery, glassware and ironwork.[63] Yet what seemed to be a promising future proved illusory. In the years following the cataclysm of the Great War, no assumptions, artistic or otherwise, went unchallenged. In an age of intellectual ferment, full of new ideas, theories, and images, Morris & Co. seems simply to have ignored the trends, content to supply the ever-diminishing market for its now undoubtedly old-fashioned products. By the end of the 1920s, the firm had quite lost its old vitality. Edward Payne, who came to Merton in 1929 (for how long he does not say), describes how 'there were shadowy figures in the gloom, waiting for orders from head office, who were transmitting orders from a dwindling set of clients as the tastes of the time changed'.[64] Another employee, a weaver called Percy Sheldrick, who was with the firm about nineteen years, later recalled that the few art students who did come to Merton received very little encouragement and soon left.[65]

The decline of Morris & Co. from this time on was assured. It failed to regenerate its artistic strength, either from its own ranks or by recruitment. The training of apprentices was unsystematic, even desultory, so that as the older craftsmen retired or died, they left behind no adequate successors. Edward Payne tells how when he returned to Merton in 1935 there was no one there who could draw, presumably a result of Dearle's death in 1932. One old dyer actually retired refusing to pass on his knowledge at all, with the result that afterwards the 'colours were never so good, or so easily matched'.[66] A kind of fatalism, or, at least, lethargy, seems to have spread through the firm at this time – did no one there think it worthwhile to work out for himself how to dye wool properly? The contrast between all this and the dynamism of Morris's own approach could not be greater.

That the firm's standards fell once it had lost Dearle is therefore no surprise. His son Duncan, who succeeeded him at Merton Abbey, evidently did not have his father's appetite for the job, nor his technical ability, and has been blamed for accelerating the decline.[67] Perhaps, all things considered, he may be accorded a little sympathy instead, for his seven years in charge cannot have been happy ones. In 1935, Marillier succumbed to the strain imposed by the contemplation of inevitable failure, and suffered a nervous breakdown. When the Second World War began four years later, it was clear that Morris & Co. had not the strength to ride out this new storm as it had the earlier one. In May 1940 the firm went into liquidation.

1 H. H. Sparling, *The Kelmscott Press and William Morris, Master Craftsman* (1924), p. 103.
2 W. Morris, *A Dream of John Ball* (1886–87), *Collected Works*, Vol. XVI, p. 230.
3 Mackail, *Life*, Vol. II, p. 213.
4 On Morris's romances, see Hodgson, *Romances of William Morris*.
5 Sparling, *Kelmscott Press*, p. 8.
6 E. P. Thompson, *Romantic to Revolutionary* (2nd ed., 1977), p. 519.

7 Kelvin, *Letters*, Vol. I, p. 365, to Lucy Faulkner, 20 July 1877. Although mere speculation, it is possible, given the fact that many of Morris's employees were recruited through personal contact or recommendation, that the Smiths were related to George Wardle's wife, Madeleine Smith. Her brother, for example, was an architect in London, although nothing is known about his family.

8 PRO, IR59/173, Morris & Co., Articles of Partnership, 19 March 1890.

9 W. Morris, 'The Development of Modern Society', *Commonweal* (July/August 1890), p. 261.

10 Quoted in M. Morris, *Introductions to the Collected Works*, Vol. II, p. 412.

11 E. Walker, 'Letterpress Printing', Arts and Crafts Exhibition Society lecture, 11 Nov. 1888. A revised and expanded version, jointly authored by Walker and Morris, was published in *Arts and Crafts Essays* (1893), pp. 111–33.

12 W. Morris, *A Note by William Morris on his Aims in Founding the Kelmscott Press* (1898), reprinted in Sparling, *Kelmscott Press*, p. 135.

13 W. S. Peterson, *A Bibliography of the Kelmscott Press* (Oxford, 1982), pp. xxii–xxv, xxviii.

14 P. Thompson, *The Work of William Morris*, pp. 139–40; Peterson, *Bibliography of the Kelmscott Press*, pp. xxi–xxii; *idem* (ed.), *The Ideal Book: Essays and Lectures on the Arts of the Book by William Morris* (1982), pp. xxiv–xxviii.

15 Watkinson, *William Morris as Designer*, pp. 61–2; A. Isherwood, *An Introduction to the Kelmscott Press* (1986), p. 4.

16 Sparling, *Kelmscott Press*, p. 68.

17 Ibid., p. 70.

18 Peterson, *Bibliography of the Kelmscott Press*, p. 93.

19 S. C. Cockerell, 'An Annotated List of All the Books Printed at the Kelmscott Press in the Order in which they were Issued', in Sparling, *Kelmscott Press*, pp. 148–74.

20 Kelvin, *Letters*, Vol. II, pp. 514–17, to the Editor, *Pall Mall Gazette*, 2 Feb. 1886.

21 It should perhaps be noted that although they lean towards the Gothic, they are not what most people today mean by 'Gothic' script.

22 Sparling, *Kelmscott Press*, p. 73.

23 Pierpont Morgan Library, New York, Kelmscott Ledger.

24 Sparling, *Kelmscott Press*, pp. 68–9.

25 Quoted in Sparling, *Kelmscott Press*, p. 83.

26 Ibid., p. 77.

27 Ibid., pp. 75–8.

28 Peterson, *Bibliography of the Kelmscott Press*, p. xl.

29 'The Kelmscott Press: An Ilustrated Interview with William Morris', *Bookselling* (1895), reprinted in Peterson, *The Ideal Book*, p. 107.

30 Ibid., p. 111.

31 See, for example, P. Faulkner (ed.), *Jane Morris to Wilfrid Scawen Blunt: The Letters of Jane Morris to Wilfrid Scawen Blunt together with Extracts from Blunt's Diaries* (Exeter, 1986), p. 53.

32 Mackail, *Life*, p. 281.

33 Quoted in Peterson, *Bibliography of the Kelmscott Press*, p. 43.

34 Ibid., p. 110.

35 Ibid., section E.

36 WMG, J531, Letter Book of the Kelmscott Press, S. C. Cockerell to Walter T. Spencer, 14 Nov. 1894; Peterson, *Bibliography of the Kelmscott Press*, pp. 21–3, 191.

37 Peterson, ibid., pp. 47, 194–5.

38 Ibid., pp. 195–6.

39 Ibid., pp. 195–6.

40 V & A, Box III. 86. KK. xiii, William Morris to Wilfrid Scawen Blunt, 12 March 1892. All copies were sold within a fortnight. Faulkner, *Jane Morris to Wilfrid Scawen Blunt*, p. 65, 26 April 1892.

41 Cockerell, 'Annotated List', passim; Peterson, *Bibliography of the Kelmscott Press*, passim.

42 Cockerell, ibid.; Peterson, ibid., pp. 145–53.

43 Peterson, ibid., p. 135.

44 Mackail, *Life*, Vol. II, p. 240.

45 P. Faulkner, *Wilfrid Scawen Blunt and the Morrises* (1981), p. 33; Marsh, *Jane and May Morris*, p. 222.

46 H. Pearson, *Bernard Shaw* (1942), p. 197; Marsh, ibid., pp. 227–8.

47 Faulkner, *Wilfrid Scawen Blunt*, p. 36.

48 Mackail, *Life*, Vol. II, p. 309.

49 Ibid., p. 318.

50 G. Burne-Jones, *Memorials*, Vol. II, p. 277.

51 M. Lago (ed.), *Burne-Jones Talking: His Conversations, 1895–1898* (1981), p. 109.

52 Ibid., p. 115.

53 Mackail, *Life*, Vol. II, p. 334.

54 Ibid., p. 348.

55 G. Burne-Jones, *Memorials*, Vol. II, p. 289.

56 PRO, IR59/173, Probate Valuation, 27 Oct. 1896. The full sale price was disclosed in a note to the authorities on 7 May 1897 (Form D1). On Morris's library, see P. Needham, 'William Morris as Book Collector', in Pierpont Morgan Library, *William Morris and the Art of the Book* (New York, 1976), pp. 44–6. Bennett kept 239 of the choicest printed books and thirty-one manuscripts, and the remainder were sold at the salerooms of Sotheby, Wilkinson & Hodge on 5–10 December 1898. The 1,250 lots raised £10,992, the highest price being £225 for a twelfth-century testament. *Athenaeum*, 7 Jan. 1899. Bennett's collection was sold to the Pierpont Morgan Library in 1902.

57 PRO, IR59/173, F. S. Ellis and S. C. Cockerell to R. Crask, Somerset House, 28 Jan. 1897.

58 See O. Fairclough, 'Morris & Company after William Morris', *Antique Collector*, Vol. 5 (1982), pp. 112–15; L. Parry, 'Morris & Company in the Twentieth Century', *Journal of the William Morris Society*, Vol. VI, No. 4 (1985/86), pp. 11–17.

59 Ibid.

60 Parry, ibid., p. 12.

61 Morris & Co., *Brief Sketch of the Morris Movement*, p. 59.

62 V & A, 57. C. 67, Morris & Co., *Specimens of Furniture and Interior Decoration* (catalogue, c. 1912); Fairclough, 'Morris & Co. after William Morris', p. 112.

63 Parry, 'Morris & Co. in the Twentieth Century', p. 14.

64 WMG, Reminiscences of Edward Payne.

65 Ibid., Reminiscences of Percy Sheldrick.

66 Ibid., Reminiscences of Edward Payne.

67 Ibid., Reminiscences of Percy Sheldrick.

Conclusion

Art, enterprise
and ethics

William Morris was a man of extraordinary creative energy who dedicated his life to the cause of art. Personal experience convinced him that as a matter of right all men and women should have the leisure to enjoy creative work, pleasant surroundings, and beautiful objects. His views on art, on its potential and its purpose, were very different, and more far-reaching, than those which have formed part of the intellectual currency of recent times. Art, as Morris saw it, should not be the preserve of a small minority of professionals of refined taste and sensibilities, but should be a universal activity, natural to life, work, and leisure. He wished to live in a society which eschewed the production of inferior wares of ugly appearance, made without pleasure by tormented workers. He believed that in a decent society, which strove for beauty and relaxation instead of profit and personal advantage, the only goods worth making would be the necessities of life, and objects which were a source of pleasure to maker and user alike. Hence his famous dictum: *'art which is made by the people and for the people, as a happiness to the maker and the user'*.[1]

Morris set down his views on the necessity of art to civilisation in a remarkable lecture first published in 1887 under the title 'The Aims of Art'. He began with a brief analysis of his own psychological make-up. Then, taking a giant intellectual leap, he proceeded to speak for mankind on the basis of this knowledge. In his account, Morris described himself as existing at any waking moment in one of two dominant moods: 'the mood of energy and the mood of idleness'. Morris alternated between these two states: 'the moods are now one then the other, always crying out in me to be satisfied'. The energetic mood demanded of him that he be at work either 'making something or making believe to make it'. He needed an objective, or as he put it a 'hope', which 'is sometimes big and serious, and sometimes trivial, but without which there can be no happy energy'. If he did not apply himself constructively when feeling energetic, he became 'mopish and unhappy'. The idle mood was one of relaxed contemplation wherein memory was a boundless source of amusement. When feeling idle, he wished to let his 'mind wander over the various pictures, pleasant or terrible, which my own experience or my communing with the

thoughts of other men, dead or alive, have fashioned in it'. If ever forced to work when in the mood of idleness, then Morris became unhappy, to the point, he said, of wishing himself dead.

These observations were profoundly important to Morris. They are the foundation stone of his moral critique of capitalist society and his social theory of art. He believed, quite simply, that 'all men's lives are compounded of these two moods in various proportions, and this explains why they have always, with more or less toil, cherished and practised art'. Art had a vital part to play in helping people make the most of whichever mood currently had grip of them. In the mood of idleness, works of art offered a man a source of amusement 'so that the vacancy which is the besetting evil of that mood might give place to pleased contemplation, dreaming, or what you will; and by this means he would not so soon be driven into his workful or energetic mood: he would have more enjoyment, and better'. The first essential aim of art was thus to produce beautiful objects which might bring happiness through restraining the restlessness which makes 'hapless men and bad citizens'. The second essential aim was to ennoble work. It was not enough for a person in energetic mood to gain happiness through mere toil; there must be 'hope' in the work; labour must be creative, directed toward the realisation of a satisfying objective. He summed up his thoughts in a few eloquent words:

> Therefore the Aim of Art is to increase the happiness of men, by giving them beauty and interest of incident to amuse their leisure, and prevent them wearying even of rest, and by giving them hope and bodily pleasure in their work; or, shortly, to make man's work happy and his rest fruitful. Consequently, genuine art is an unmixed blessing to the race of man.

The capacity for art to enrich the lives of all members of society, and not just a privileged minority, stemmed, according to Morris, from the fact that artistic possibilities existed in many kinds of human activity. He rejected the definition of art solely as an expression of elevated thoughts and feelings, enshrined in works of painting, sculpture, literature, music, and architecture. Each of these was to be encouraged, and their finest products were acknowledged as a rich source of human happiness; but it was in craftsmanship and the decorative arts that Morris believed humanity would find its salvation. His art was the art of the people, not that of the establishment. 'You must understand,' he said,

> that this production of art, and consequent pleasure in work, is not confined to the production of matters which are works of art only, like pictures, statues, and so forth, but has been and should be a part of all labour in some form or other: so only will the claims of the mood of energy be satisfied.

Many everyday articles – fabrics, pottery, glassware, furniture, clothing, metalwares – might be satisfying as works of decorative art, besides serving a practical purpose. Indeed, almost every object produced might be

enhanced through superior design and craftsmanship. If the right conditions prevailed, every worker might also be an artist, however modest his wares. To achieve this, it had to be recognised that the worker must have freedom to decide when to work, and for how long, and at what pace. Equally, the work must be worthwhile, directed at the production of goods for which a real need existed, not cheap trifles or the shoddy manufactures which Morris so despised.[2]

These radical ideas on the nature of art, labour and human happiness were based squarely on Morris's experience as a worker in the decorative arts. It is true, as we have seen, that Morris was powerfully influenced by Ruskin and others in thought and deed, but, unlike Ruskin, he needed practical knowledge of a subject before he felt able to pronounce upon it. He built on, added to, and ultimately transformed Ruskinian perceptions, to create a theory of art and society which was very much his own. And the very force and conviction of his arguments stemmed ultimately from a sense of inner certainty which could only have been gained through long years of artistic endeavour. He breathed fresh life into a succession of arts and crafts; stained glass, wallpapers, printed and woven textiles, carpet making, tapestry, embroidery, and book printing all gained from his efforts. In each case he completely mastered the principles and techniques of design and manufacture, and, whenever necessary, he acquired the practical skills of the hand-worker as well as those of the designer and organiser of production. Morris delighted in the work, and this, more than any abstract argument, convinced him that all working people might, if society was properly ordered, find deep satisfaction in the creative process.

His own output as a designer was prodigious. In the 1860s, his attention was given over mainly to stained glass. Most of the 150 or so cartoons which can be traced to Morris were produced between 1861 and 1868; many, but by no means all, being for lesser figures and backgrounds.[3] Before the move to Merton Abbey, it was he who also took charge of the overall composition of hundreds of Morris & Co. windows, including, crucially, the leading, borders, and choice of colours. Many of these windows rank amongst the finest works of art of the nineteenth century. The particular beauty of Morris glass, notwithstanding the contributions made by Rossetti and Madox Brown, is the product of Morris's mastery of composition and colouring, and Burne-Jones's sympathetic portrayal of biblical figures. Morris provided the settings for the jewels of Burne-Jones's art, and their fruitful collaboration was extended in the 1880s and 1890s when Morris ventured into tapestry weaving and book printing. Here again they achieved great things: the *Adoration of the Magi* and the Kelmscott *Chaucer* setting standards in tapestry and illustrated book production respectively which few could ever hope to match.

Through his work in stained glass, tapestry and book illustration, William Morris made a worthy contribution to the fine arts; but it was as a

decorative artist that he found his true *métier*. He began making designs for wallpapers in the 1860s, and he has been credited with a total of fifty-two patterns for wall and ceiling papers. In the 1870s, he branched out into textiles, designing for printed fabrics, woven fabrics and carpets. He made a combined total of at least sixty-two designs for fabrics, most of which appeared before he began to devote much of his time to socialist propaganda in the mid-1880s. Twenty-four carpet designs were produced as Wiltons, ten as Kidderminsters, and two as Patent Axminsters. Morris also made numerous designs for hand-woven Hammersmith rugs and carpets.[4] The most fitting comment on his work is that the best of his patterns have retained their appeal down to the present day. Indeed, his designs continue to inspire such admiration that they may fairly be regarded as a major and valuable part of the cultural legacy of nineteenth-century Britain.

Several factors contributed to Morris's success in the art of flat pattern design. His lectures on pattern-designing demonstrate that he had a very deep understanding of the fundamental elements that might be used to make a recurring pattern. In 'Some Hints on Pattern-Designing' he discussed the possibilities and limitations of various forms and structures, which provided the skeletons which the designer 'clothed with flesh'. Morris went on to show how these could be used in designing for wallpapers, printed fabrics, woven fabrics, tapestry, and carpets. In each case he was at pains to point out that the physical properties of the material and the method of manufacture, whilst imposing constraints upon the designer, suggested what would make for a beautiful pattern and what would not. One important rule was that 'the more mechanical the process, the less direct should be imitation of natural forms'. Thus in the 'cheap' but 'useful art of paper staining' the designer must 'eschew that bastard imitation of picture, embroidery, or tapestry-work, which, under the name of dado-papers, are so common at present'. Even when well designed, these were 'a mistake' because 'they do not in the least fill the place of patterns of beautiful execution or of beautiful materials, and they weary us of these better things by simulating them'. Tapestry weaving, in contrast, was not a mechanical art, the 'loom being a tool rather than a machine', and in this case a more direct representation of nature was possible: 'you really may almost turn your wall into a rose-hedge or a deep forest, for its material and general capabilities almost compel us to fashion plane above plane of rich, crisp, and varying foliage with bright blossoms, or strange birds showing through the intervals'.

What Morris did was to work out from his own experience a set of principles which determined how the designer should approach a particular task. These principles, once assimilated, were immensely valuable to the decorative artist, because they allowed him to focus his

mind on the purely creative aspects of the work. On the colouring of wallpapers, for example, because the material was

> commonplace and the manufacture mechanical, the colour should above all things be modest; though there are plenty of pigments which might tempt us into making our colour very bright or even very rich, we shall do well to be specially cautious in their use, and not to attempt brightness unless we are working in a very light key of colour.

Printing on cloth, however, offered more possibilities for the colourist, as the 'material is so much more interesting that we may indulge in any brightness we can get out of genuine dyes, which for the rest have always some beauty of their own'. Figured woven cloths offered still richer possibilities for the designer, calling him

> to design in a bolder fashion and on a larger scale than for the stiffer and duller-surfaced goods; so we will say that the special qualities needed for a good design for woven stuff are breadth and boldness, ingenuity and closeness of invention, clear definite detail joined to intricacy of parts, and, finally, a distinct appeal to the imagination by skilful suggestion of delightful pieces of nature.[5]

The derivation and observation of a set of rules of good design, however, could not alone have made William Morris a great designer. Form might be learned; but the special quality of his patterns stemmed from the bold and imaginative treatment of his subject matter. Nature inspired many of his designs, yet he never resorted to the realism and three-dimensionalism typical of the mid-nineteenth century. He believed that designs should always appeal to the imagination: 'in all patterns which are meant to fill the eye and satisfy the mind, there should be a certain mystery'.[6] He 'conventionalised nature', at once avoiding excessive realism and 'vagueness'. He held that all decorative art should be suggestive rather than imitative of life. It had the noble purpose of reminding us of 'the outward face of the earth, of the innocent love of animals, or of man passing his days between work and rest'. Nature should not be described in all its details 'because scientific representation of them would again involve us in the problems of hard fact and troubles of life, and so once more destroy our rest for us'. Through conventionalising natural forms, imagination might instil a sense of mystery and wonder, and noble forms created 'where one thing grows visibly and necessarily from another'.[7] In this way, Morris imparted to his patterns a vital living quality – a timelessness – which the work of lesser designers almost invariably lacks.

Morris's literary output is less easy to evaluate. That he has not for many years been seen as part of the mainstream of nineteenth-century literature is probably due in part to the great unevenness of his output, particularly evident in his verse. Furthermore, in a reversal of the normal course of development, much of his finest poetry appears in *The Defence of Guenevere and Other Poems*, which was his first published work. The

231

J

modern reader who turns from this to *The Earthly Paradise* – a work held in high regard in Morris's own lifetime – is likely to be disappointed; for here is too often lacking that quality of imagination which can render fresh and vivid what otherwise remains ordinary. Nor does the sheer length of Morris's narrative poems commend itself to modern readers. Both *The Life and Death of Jason* and *Sigurd the Volsung* run to more than 10,000 lines; even more daunting today are the twenty-four tales told over 42,000 lines in *The Earthly Paradise*. More pertinent criticisms are that Morris neglected characterisation in favour of visual description; and that these too often fall away from charm into mere prettiness while tending towards a certain sameness of mood of which the reader eventually wearies. The best of the *Guenevere* poems evade these strictures; and 'The Lovers of Gudrun' stands apart from most of Morris's work in the extent to which the thoughts and emotions of the characters dominate the narrative, even to excess. The 'Gudrun', Morris's first significant response to his discovery of Norse literature, was followed a few years on by *Sigurd the Volsung*, which Morris himself considered to be the best of his epic poetry. Critics at the time noticed in *Sigurd* a distinct change in the temper of the poet – a greater manliness, a shift away from melancholy *Weltschmerz* to a more heroic, or stoical, view of life. From the sagas, Morris had drawn both literary inspiration, and inner strength at a time of great distress; but *Sigurd* was his last attempt at reworking any of them. He was disappointed that it failed to capture the attention of the public, and perhaps he realised that new versions would in the end always be eclipsed by their great originals; but he also found that the style he had evolved in performing the office of translator could be put to composing original prose works of his own.

The late romances have been much censured for the artificiality of their language; the core of Morris's own case can be found in a letter of 1885 to an aspiring young poet:

> You see things have very much changed since the early days of language: once everybody who could express himself did so beautifully, was a poet for that occasion because all language was beautiful. But now language is utterly degraded in our daily lives, and the poets have to make a new tongue each for himself: before he can even begin his story he must elevate his means of expression from the daily jabber to which centuries of degradation have reduced it.[8]

Though we may well be justified in questioning the historical truth of this statement, we need not also deny the validity of the sentiment which lay behind it: the standard language of late nineteenth-century England was not suited to Morris's literary purpose, and he therefore had to create another kind of language which was. That he should choose to develop a medieval model is entirely typical of Morris. The resulting style is by no

means hard to read, and from the very first sentences of the romances, it serves to create an atmosphere appropriate to the subject matter.

Assessments of Morris's literary achievements, therefore, have been mixed. But whatever modern criticism may make of Morris as a writer, there is no doubt that he spoke with a voice which his own age thoroughly understood – though it was the voice of the poet of *The Earthly Paradise*, not that of the author of the prose romances. At the time of his death he was unquestionably one of the most respected figures of the English literary scene.

Yet despite his achievements as a writer and designer, and the general approval with which much of his work was received, Morris came to believe that his art counted for little when set against the all-consuming greed and ugliness of the age in which he lived. In a letter to Andreas Scheu in 1883, he wrote:

> In spite of all the success I have had, I have not failed to be conscious that the art I have been helping to produce would fall with the death of the few of us who really care about it, that a reform in art which is founded in individualism must perish with the individuals who have set it going. Both my historical studies and my practical conflict with the philistinism of modern society have forced on me the conviction that art cannot have real life and growth under the present system of commercialism and profit-mongering.[9]

He reiterated this view whenever occasion demanded; writing to the editor of the *Daily Chronicle* towards the end of his life that 'there should be no illusions as to the future of art': it could not be kept 'vigorously alive by the action, however energetic, of a few groups of specially gifted men and their small circle of admirers amidst a general public incapable of understanding or enjoying their work'.[10] Morris denounced capitalism for elevating the pursuit of private profit as the central goal of life, and competition as the driving force of the economic system. Competition drove down costs of production, and in the process drove down the quality of life. More was demanded of workers for less reward. They became slaves tied to machines, unable to derive even the slightest pleasure from their labour. Leisure was denied them. Without leisure they lacked the capacity to enjoy art; without dignified work they had no opportunity to express themselves as artists. Thus was life made wretched for the masses, compelled to lived in cramped conditions, in dirty towns, devoid of all beauty. And for the rest, life could be little better, for they had to live amidst the general misery, as upholders of a morally corrupt system, which stripped them of the potential for healthy human growth as much as it did those whom they suppressed.

That Morris held and openly expressed views such as these caused consternation in many quarters. Burne-Jones had little sympathy with this aspect of the message he was delivering in the 1880s and 1890s. Likewise,

233

when the leading spirits of the Arts and Crafts movement first sought approval from one whom they regarded as a champion, Morris was rather discouraging in the advice he offered.[11] And there were many others, with no firmly held political views, who simply could not reconcile Morris's utterances on art and society with his position as an entrepreneur and supplier of luxurious goods to the well-to-do. He was frequently depicted by his critics as a paradoxical or hypocritical figure: a wealthy artist who ran a prominent business whilst at the same time preaching the essential incompatibility of art and capitalism.

Morris, it is clear, was no ordinary businessman. Yet it must be recognised that Morris & Co. was not divorced from the conventional business world: it had to cope with similar problems to those confronting any firm operating in a competitive environment. And, driven by necessity, Morris emerged in the 1870s as an accomplished entrepreneur. He was not a careless or woolly-minded businessman; he was a practical man of powerful intellect and drive who well understood the rules of capitalist enterprise. A sharp eye for commercial opportunity was as much a part of Morris as was the fierce, almost evangelical, ambition to improve public taste and forge the market. His revival of production methods which were obsolete or in decline was a manifestation of sound business sense, symptomatic neither of a naïve love of the archaic nor an aggressive distaste for all things mechanical. He was an active participant in the commercial world, and, by any reasonable standard, he may be judged to have been very successful in it.

This is not to say that Morris was a typical nineteenth-century entrepreneur motivated primarily by the prospect of personal gain. From the first, Morris & Co. was dedicated to raising standards of design and execution in a number of ancient trades. Morris never lost sight of this goal, and throughout his career in business he was always keen to improve the look and quality of the goods he produced. The firm was the vehicle through which he realised his artistic ambitions, and through which he sought to raise awareness of the potential of the decorative arts. For this reason, Morris & Co., though limited in size, may be held up as one of the most important business ventures of the Victorian era. In his own time, Morris exerted a powerful influence upon Victorian ideas of design and taste. Subsequently, others have followed him in developing the marketing concept of easily recognised 'house styles'. And any number of designers, artists, craftsmen and architects have acknowledged the importance of his ideas and example to their work – C. F. A. Voysey, C. R. Ashbee and W. R. Lethaby amongst them. What is more, Morris & Co. demonstrated that there was a market for better-quality products which did not compete solely on price, and that industry had to concern itself far more with considerations of taste and quality. Even large factory-based textile companies like Alexander Morton & Co. responded to Morris's influence by

commissioning designs from well-known artists and designers like Voysey and Lewis F. Day.

The success of Morris & Co. in advancing the cause of the decorative arts owed much to the sagacity of Morris's business ideas and the aptness of his methods. Morris fully appreciated that if the firm was to succeed in meeting its wider objectives, then it must trade profitably and secure a strong position in the market-place: the *cause* could hardly be well served by a feeble enterprise forever on the point of bankruptcy. From the late 1860s onwards, when Morris really began to take its affairs in hand, the firm was consistently profitable, and after the mid-1880s it was very lucrative indeed. Morris knew his markets, and he knew how to exploit them. He kept the name of the firm before the public, winning and maintaining a reputation for the highest standards of design and manufacture. Equally, he knew his costs, and he was vigilant in keeping them down. Neither suppliers nor workers found Morris an easy touch, though he was always willing to pay well for work of the highest standard. He was obsessive about quality, and he turned his obsession into a business asset. The firm became known for its use of traditional methods, machinery, and processes. Its hand-woven fabrics and carpets and its hand-printed textiles and wallpapers all fetched premium prices. Vegetable dyeing was not an easy craft to master, but it helped give the Morris range of goods a distinctive quality for which the firm's customers showed no hesitation in paying.

Morris & Co. was a highly innovative small business which, if its owner had so desired, could have grown into a much larger concern. More designs could have been turned over for machine production; more shops could have been opened; more agents could have been appointed overseas. All these were possibilities which Morris recognised and rejected. He was never interested in growth for its own sake. When the firm did grow, it was not through increasing the scale of production *per se*, but through widening its activities in order to control quality or extend the range of products. Growth beyond this point would have required changes which Morris could not have tolerated. Drawing in capital and professional management from outside would have reduced his personal freedom, and, worse still, would have made still heavier demands upon his time. Detachment from the everyday realities of design and manufacture would have followed, leaving him in a position no different from the ordinary commercial manufacturer.

Living small but fairly certain was a much more enticing prospect for William Morris, and it is to this end that his business policies were directed. His customers were privileged members of society with relatively high and secure incomes. They could afford the prices he had to charge in order to cover the costs of producing high-quality goods in limited quantities, or in providing labour-intensive decorative art services. Thus, while

235

Morris cut himself off from the much bigger markets served by mass production suppliers, he had the compensation of never having to reduce his standards below a level acceptable to himself. Furthermore, his markets, with the exception of stained glass, were relatively free from the regular fluctuations in demand which characterised the lower end of the luxury trades. This was certainly comforting to him; throughout his business career he showed himself anxious to maintain his income at a level which placed him in the upper reaches of Victorian society. He was far from being an avaricious man, but from his earliest days he had enjoyed a high standard of material well-being, and he had no wish to lower his sights, either for himself or his wife and children. The sheer effort Morris put in to building up his business between the late 1860s and the middle of the 1880s can be explained in part by this very simple fact.

Morris & Co., in remaining small and independent, offered other advantages to its owner. Most importantly, it was easily managed, and Morris was able to delegate much routine administrative and supervisory business to George Wardle, the Smith brothers, and later J. H. Dearle. He was freed to spend more of his time creatively, planning large decorative schemes, experimenting with techniques and processes of production, and, above all, designing. The firm offered support, in one way or another, for all his artistic, cultural, literary, and political ventures, for the greater part of his adult life. It was, indeed, part of the weave of his life; the over-arching project which of necessity consumed the greater part of his waking hours. It provided him with a vehicle for his researches in the history and methods of the decorative arts. It gave him a clear sense of direction; making demands, setting challenges, and offering tangible rewards. It represented security; a base from which he could step out and engage the world without threatening his livelihood. The independent spirit which pervades all Morris's work is that of a man in command of his own destiny. He could use his resources – his money and his time – as he saw fit. Socialism was the beneficiary in the 1880s; in the 1890s he felt able to launch into another round of creative endeavour with the founding of the Kelmscott Press.

That Morris continued to run a prosperous business after he had become an active opponent of the existing social order does not mark him down as insincere in his espousal of socialism. Indeed, of all human failings, insincerity is perhaps the very last that might be attributed to him. He was at times embarrassed by his unusual position as a wealthy revolutionary socialist, as his correspondence makes clear, but he never deviated from the straightforward reasons he gave for refusing to redistribute the greater part of his income to those less fortunate than himself. Any such action, he reasoned, could only benefit a small group of people, and, whilst they might enjoy a little extra money, it would make no difference whatsoever to their position in society: chronic inequalities in the distribution of

income and wealth were deep-seated social problems which could not be solved by individual action. It was far better for individuals in his position to throw themselves and any spare resources they might have into the work of socialist agitation, pressing for the revolution which one day would overthrow the repressive order of capitalism. Hence Morris's decision after joining the socialist movement to make his contribution to the cause principally through the donation of time, talent and energy. Besides this, he spent a considerable sum of money subsidising the Socialist League newspaper *Commonweal*, which he edited for five years between 1885 and 1890.

The works of social criticism which flowed from Morris's pen from the late 1870s to near the end of his life represent his third outstanding contribution – ranking alongside his work as decorative artist and story-teller in poetry and prose – to the cultural heritage of Victorian Britain. For most of his conscious life, he felt himself at odds with the age in which he lived, and was naturally sympathetic to the writings of those who stood in opposition to prevailing values and ideology. Ruskin was by far the most significant of these, and once Morris had been spurred into action with the Eastern Question Association and the Society for the Protection of Ancient Buildings, it was to the great sage that he looked for ideas and inspiration. Morris's early lectures, published collectively under the title *Hopes and Fears for Art*, are cast in the Ruskinian mould.[12] They are incisive as works of social *criticism*, but they are not deep works of social *analysis*. On the whole they lack the intellectual force, completeness and depth which are the hallmarks of Morris's writings after he had committed himself to socialism. In Marx, he found a set of tools – theories of competition, capital accumulation, class warfare, and economic crisis – which could be used to explain *why* society was so wasteful of human life, and *how* such wastefulness might be ended and the beauty of life restored.

As a socialist, Morris transcended Ruskinism. Notions of art and labour remained central to his thought, but he now explored them within a more extensive and robust intellectual framework. In the light of Marxism, Morris could dismiss Ruskin as impractical in his belief that society might be reformed by individual action and example. This, at least, was a conclusion which his own experience had forced upon him. Few of his socialist colleagues had the direct experience of 'commercialism', 'profit-mongering', and 'economic warfare' which running a business provided. Morris had tried, and in his view failed, to effect change through individual action. The struggle had made him despondent, and it was with a tremendous sense of relief that he abandoned the lone effort in favour of collective action. Morris was ripe for socialism. Having discovered that fundamental change could only be achieved though collective struggle, he gave himself over fully to the revolutionary cause. A world in which art flourished remained his objective, but he now felt that this demanded of

237

him more than simply turning out beautiful objects for the gratification of a tiny minority of his fellow citizens. It could do little harm for Morris & Co. to continue doing this, though he personally had the obligation to agitate for a reformed society which would bring about its end.

Morris was as energetic in his socialism as he had been previously in building up the firm. He was a prominent figure, serving between January 1883 and December 1884 as a leading light of the Social Democratic Federation, and between January 1885 and November 1890 as the founder, treasurer, and newspaper editor of the Socialist League. He sold newspapers on the streets, spoke at rallies and demonstrations, got himself arrested, attended meetings by the score, and lectured at gatherings throughout the country.[13] All the while, in his eight years of active politics, he was busy writing books, articles, and editorials, on many aspects of socialism. With H. M. Hyndman, leader of the Social Democratic Federation, he wrote a *Summary of the Principles of Socialism* which was published in the spring of 1884. In 1887, with Ernest Belfort Bax, at the time sub-editor of *Commonweal*, he wrote, under the heading 'Socialism From The Root Up', a series of articles on topics covered in the first volume of Marx's *Capital*. These were later revised and published together in 1893 under the title *Socialism: Its Growth and Outcome*. His socialist poem, *Pilgrims of Hope*, and his fictional accounts of life before and after capitalism, *A Dream of John Ball* and *News from Nowhere*, also first appeared in *Commonweal*, in 1885, 1886–87 and 1890 respectively, and other articles from that journal were republished in 1888 in *Signs of Change*. Meanwhile, aside from the enormous contribution he made to *Commonweal*, he wrote in full between forty and fifty lectures, many of which have since been published.[14]

Through his writings and lectures, William Morris made an original, important, and enduring contribution to the canon of socialist thought. He does not rank with the grand theorists of scientific socialism, as a rigorous logician completely in command of the tools of Marxian economic analysis. What is outstanding in his work, however, is the brilliance with which he communicated the most fundamental Marxian concepts and insights, and the particular subjects to which he applied them. Morris was a first-class propagandist, a practical socialist whose mission, as the membership card he designed for the Democratic Federation declared, was to 'educate', 'agitate', and 'organise'. In this work he drew heavily upon his knowledge of the decorative arts, his earlier ideas on art and labour, and his perceptions of medieval society. In many of his writings he proceeded by contrasting aspects of life under capitalism with the situation prevailing before the dawn of the modern age. In others, his method was to compare the present with life in the future under socialism. Thus he created a series of sharply contrasting images, as in 'Useful Work versus Useless Toil', 'How We Live and How We Might Live', and 'True and

False Society'.[15] The intention was to reveal the 'innate moral baseness' and 'ugly disgraces' of the existing social order, whilst suggesting the necessity of socialism. In each case, the argument was driven forward and given coherence by the use of Marxian ideas on history, economics, and revolution. Similarly, the utopian *News from Nowhere* is firmly fixed within a broadly Marxist framework.

The real joy of Morris's socialist writings is that they speak directly to the individual even when treating grand social themes. His approach to the reader or listener was very personal and disarmingly straightforward; his prose a model of clarity. In one of his very best lectures, 'How We Live and How We Might Live', for example, he covered a remarkable range of topics, each related, from the meaning of revolution to the nature of economic warfare, exploitation, and inequality.[16] He used notions like surplus value, monopoly power, and imperialistic rivalry, without labouring over definitions, but with a refreshing crispness and exactitude. This enabled him to explore a set of issues close to his heart, and to which he returned time and time again. Socialism was the bearer of a better life, in which inequality, material deprivation and excessive toil gave way to a regime which cherished comradeship, creativity and personal freedom. Once society was organised efficiently and decent values prevailed, its resources might be used to satisfy real human needs. Priority would be given to ensuring that the people enjoyed good health, and that they had access to a liberal education; 'opportunity, that is, to have my share of whatever knowledge there is in the world according to my capacity or bent of mind'. There would be more opportunities for leisure, for the enjoyment of travel, sport, and art. Work would no longer be burdensome and unrewarding, but pleasurable and creative, and all places of work would be pleasant, unlike the 'crowded, unwholesome, squalid, noisy dens' then so common. And, beyond this, Morris demanded that 'the material surroundings of . . . life should be pleasant, generous, and beautiful'; in a socialist society people 'would find it difficult to believe that a rich community such as ours, having such command over Nature, could have submitted to such a mean, shabby, dirty life as we do'.[17]

Morris added a dimension to socialist thought which is as relevant today as it was in his own time. This has been described by E. P. Thompson as a special quality which stemmed from his moral criticism of society, and permeated all his activities, giving them a certain unity otherwise belied by the range and quantity of his productions.[18] Even so, it is staggering to think how much he achieved. In each of his main spheres of activity – the decorative arts, literature, and social criticism – he excites admiration, both for his talent and his productivity. He furthermore proved himself a capable organiser, with Morris & Co., the Society for the Protection of Ancient Buildings, the Socialist League, and the Kelmscott Press. The formation of each of these organisations, for one reason or another,

represents a landmark in the cultural history of Britain. How could one man have accomplished so many things?

There is no simple answer to a question of this kind. It is obvious that Morris had a remarkable capacity for work, and interesting that modern psychology provides a general two-state model of motivation similar to that described by Morris in his lecture on 'The Aims of Art'.[19] Reversal theorists refer to his mood of energy as the telic state of mind, and his mood of idleness as the paratelic state of mind. They follow him in believing that individuals periodically switch from one to the other of these two states. In the telic state the individual is 'primarily oriented towards . . . some essential goal or goals'; in the paratelic state 'the individual is primarily oriented towards . . . some aspect of his continuing behaviour and its related sensations'.[20] Thus in the telic state people will wish to be engaged in something they think important, whereas in the paratelic state they will be inclined towards play and relaxation. Discontent is experienced when an activity is forced upon an individual which is not consonant with his current mental state. All this conforms with Morris's observations. But what is really interesting is that research by reversal theorists suggests that, while all individuals switch states, the division of time between one state and the other varies very considerably from one person to another, and that the propensity to spend time in the telic state increases as people reach maturity. It would seem that Morris was one of the rare breed of individuals for whom the telic state, or will to work, was predominant, and that he had the capacity and self-regulation to switch most beneficially between states. Certainly, his desire to work hard and reach targets became stronger as he got older, and remained with him almost to the very end. It is also notable, as Burne-Jones observed, that Morris mainly derived his pleasure from the anticipation of reaching a goal, and that once a thing was done, it was quickly set aside in favour of the next challenge. Again, this behaviour is in line with that predicted by reversal theory.

More tangible factors can also be brought forth in part explanation of Morris's exceptional productivity. First amongst these is the fact that he was a very clear-sighted, *practical man*, with a tried and tested method of working. In discussing his approach to socialism, Thompson noted:

> Morris was not a man given to polite turns of phrase or to rhetoric. All his life it had been his business to *make* things. Whether tiles or tapestry or paper, no detail was too trivial to catch his attention. Now that he had decided that it was necessary to make a revolution, he set about the business in the same manner. First, it was necessary to find out through study *how* a revolution was made. Next, it was necessary to get down to the details of making it, 'turning neither to the right hand nor to the left till it was done'.[21]

The same steadfast approach prevailed in other departments of his life. He

always researched a subject thoroughly, whenever possible through the close examination of fine examples of the class of work in which he had become interested. Having worked out the principles on which a work of art was constructed, he turned to consider materials and practical aspects of the production process. Only when the groundwork had been laid did he feel confident enough to begin working creatively in the field. When fired up, he learned quickly, and the thoroughness of his approach ultimately made for a higher level of personal efficiency. This is not to say that Morris mechanistically worked through a series of stages, for we know that he was capable of carrying out many tasks in parallel, but simply that he was meticulous in all his works.

Morris would surely have made his mark in any age. But he was nonetheless fortunate to have been exposed during the course of his life to a rich variety of influences which stimulated both his intellect and imagination. He was steeped from an early age in Romanticism in its various forms. The novels of Scott, the poetry of Keats, and the theology and ritual of the Oxford Movement confirmed him in his intuitive rejection of ordinary bourgeois values and aspirations. He discovered in the medieval past a world in which different values had prevailed, wherein art and love of beauty thrived and the human spirit had not yet been crushed. Chaucer, Froissart and Malory furnished his mind and stimulated his creative impulse. In *Past and Present*, Carlyle gave substance to the idea of the medieval as a sort of high ground from which might be observed the deformities of modern life wrought by the sickness of the cash nexus. Ruskin added depth to this perspective, providing Morris with ideas on art and work which sustained him for many years and lent momentum to his decision to become a worker in the decorative arts. Many others were infected by the spirit of medievalism, not least the architects of the Gothic Revival, from whom Morris gained a deeper understanding of form and structure. From Rossetti and Pre-Raphaelitism he gained something less tangible but no less important: the idea that all works of art, whether fine or decorative, whilst drawing on natural forms for inspiration, should have about them a mysterious or suggestive quality that might lift the observer beyond the normal confines of present reality.

These influences on Morris's thought and actions did not make their mark entirely through his reading. He had the friendship, at critical stages in his career, of talented individuals who helped awaken and direct his ambitions. His circle included leading Gothic Revival architects, Pre-Raphaelite painters and poets, the mighty Ruskin, and, later, some of the best minds of the early socialist movement. He may have stood against the values of the age, at the cutting edge of thought, but equally he was caught up in some of the strongest and most vital movements of the nineteenth century. His ability to engage so vigorously in these movements owed a not a little to his good fortune in life. Before leaving Oxford he had a private

income sufficient to enable him to fund the *Oxford and Cambridge Magazine*, and for the next fifteen years or so he had enough money from the same source to allow him to experiment without threat to his well-being or that of his family. By the time his income from mining investments had begun to run dry, he was well placed to make a fortune of his own in business. This was not accomplished without a mighty effort which impelled him to scale new heights in the decorative arts. Once Morris & Co. had been remodelled to his satisfaction, and his financial future secured, he was ready, willing, and able, to pursue the cause of art through direct confrontation with the establishment. Thus did he reach maturity.

The special qualities that made William Morris one of the greatest Englishmen of modern times can never fully be known. We may take note of his exceptional creative energy, of his sure method, of the rich sources of influence upon him, and of his personal good fortune; yet there remains the elusive ingredient which gives his life and work a unique quality that calls forth admiration and respect. Those who were privileged to know him were often struck by his clarity of thought, eye for detail, feeling for history, large-mindedness, lack of vanity, nobility of purpose, forthright manner, resolve, and plain common sense. Each shines through in the works of art, literature and criticism, from which future generations may continue to draw inspiration.

1 W. Morris, 'The Art of the People' (1879), *Collected Works*, Vol. XXII, p. 47.
2 W. Morris, 'The Aims of Art' (1886), *Complete Works*, Vol. XXIII, pp. 81–97.
3 Sewter, *Stained Glass*, Vol. I, pp. 60–1.
4 Table 6. Also see Parry, *William Morris Textiles*, passim.
5 W. Morris, 'Some Hints on Pattern Designing' (1881), *Collected Works*, Vol. XXII, pp. 195–205.
6 W. Morris, 'Making the Best of It' (c. 1879), *Complete Works*, Vol. XXII, p. 109.
7 W. Morris, 'Some Hints on Pattern Designing' (1881), *Collected Works*, Vol. XXII, p. 109.
8 Kelvin, *Letters*, Vol. II, p. 483, to James Frederick Henderson, 6 Nov. 1885.
9 Ibid., p. 230, to Andreas Scheu, 15 Sept. 1883.
10 P. Henderson, *The Letters of William Morris to his Family and Friends* (1950), pp. 355–6, to the *Daily Chronicle*, 10 Nov. 1893.
11 Ashbee Journals, 4 Dec. 1887, quoted in A. Crawford, *C. R. Ashbee: Architect, Designer and Romantic Socialist* (1985), p. 28; Kelvin, *Letters*, Vol. II, p. 730, to William Arthur Smith Benson, 31 Dec. 1887.
12 W. Morris, 'Hopes and Fears for Art', *Collected Works*, Vol. XXII, pp. 3–152.
13 E. LeMire, *The Unpublished Lectures of William Morris* (Detroit, 1969), Appendix I, 'A Calendar of William Morris's Public Career', pp. 234–90; Kelvin, *Letters*, Vol. I, p. xliv.
14 Many are in *Complete Works*, Vols. XXII–XXIII, but also see LeMire, *Unpublished Lectures of William Morris*, especially Appendix II, 'Checklist of Morris's Speeches and Lectures', pp. 291–322.
15 *Complete Works*, Vol. XXII, pp. 3–26, 98–120, 215–37.
16 Ibid., pp. 3–16.
17 Ibid., pp. 21–2.
18 E. P. Thompson, 'The Communism of William Morris', in S. Nairne (ed.), *William Morris Today* (1984), pp. 129–35.
19 M. J. Apter, *The Experience of Motivation: The Theory of Psychological Reversals* (1982).
20 Ibid., p. 47.
21 E. P. Thompson, *Romantic to Revolutionary* (2nd ed., 1977), p. 303.

Index

The William Morris Society

The life, work and ideas of William Morris are as important today as they were in his lifetime. The William Morris Society exists to make them as widely known as possible.

The many-sidedness of Morris and the variety of his activities bring together in the Society those who are interested in him as designer, craftsman, businessman, poet, socialist or who admire his robust and generous personality, his creative energy and courage. Morris aimed for a state of affairs in which all might enjoy the potential richness of human life. His thought on how we might live, on creative work, leisure and machinery, on ecology and conservation, on the place of the arts in our lives and their relation to politics, as on much else, remains as challenging now as it was a century ago. He provides a focus for those who deplore the progressive dehumanisation of the world in the twentieth century and who believe, with him, that the trend is not inevitable.

The Society provides information on topics of interest to its members and arranges lectures, visits, exhibitions and other events. It encourages the reprinting of his works and the continued manufacture of his textile and wallpaper designs. It publishes a journal twice a year, free to members, which carries articles across the field of Morris scholarship. It also publishes a quarterly newsletter giving details of its programme, new publications and other matters of interest concerning Morris and his circle. Members are invited to contribute items both to the journal and to the newsletter. The William Morris Society has a world-wide membership and offers the chance to make contact with fellow Morrisians both in Britain and abroad.

Regular events include a Kelmscott Lecture, a birthday party held in March, and visits to exhibitions and such places as the William Morris Gallery, Red House, Kelmscott Manor and Standen. These visits, our tours and our short residential study courses enable members living abroad or outside London to participate in the Society's activities. The Society also has local groups in various parts of Britain and affiliated Societies in the USA and Canada.

The Society's headquarters are at Kelmscott House, Hammersmith, Morris's home for the last eighteen years of his life. Kelmscott House was named after Morris's country home, Kelmscott Manor: in the coach house alongside, Hammersmith carpets were woven and later the Hammersmith Socialist Society met.

For further details, write to: The Hon. Membership Secretary
 Kelmscott House
 26 Upper Mall
 Hammersmith
 London W6 9TA